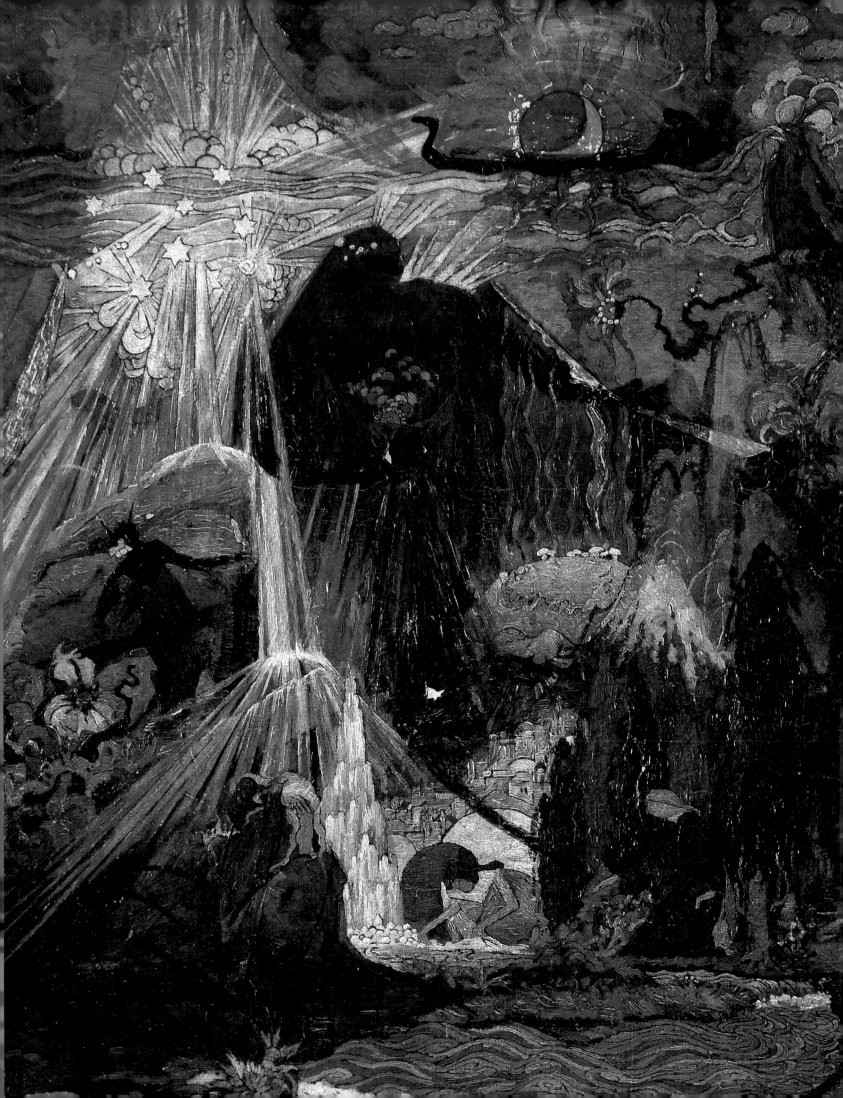

Oil Paintings in Public Ownership in Surrey

The Public Catalogue Foundation

Andrew Ellis, Director
Sonia Roe, Editor
Stella Sharp, Surrey Coordinator
Andy Johnson, Photographer

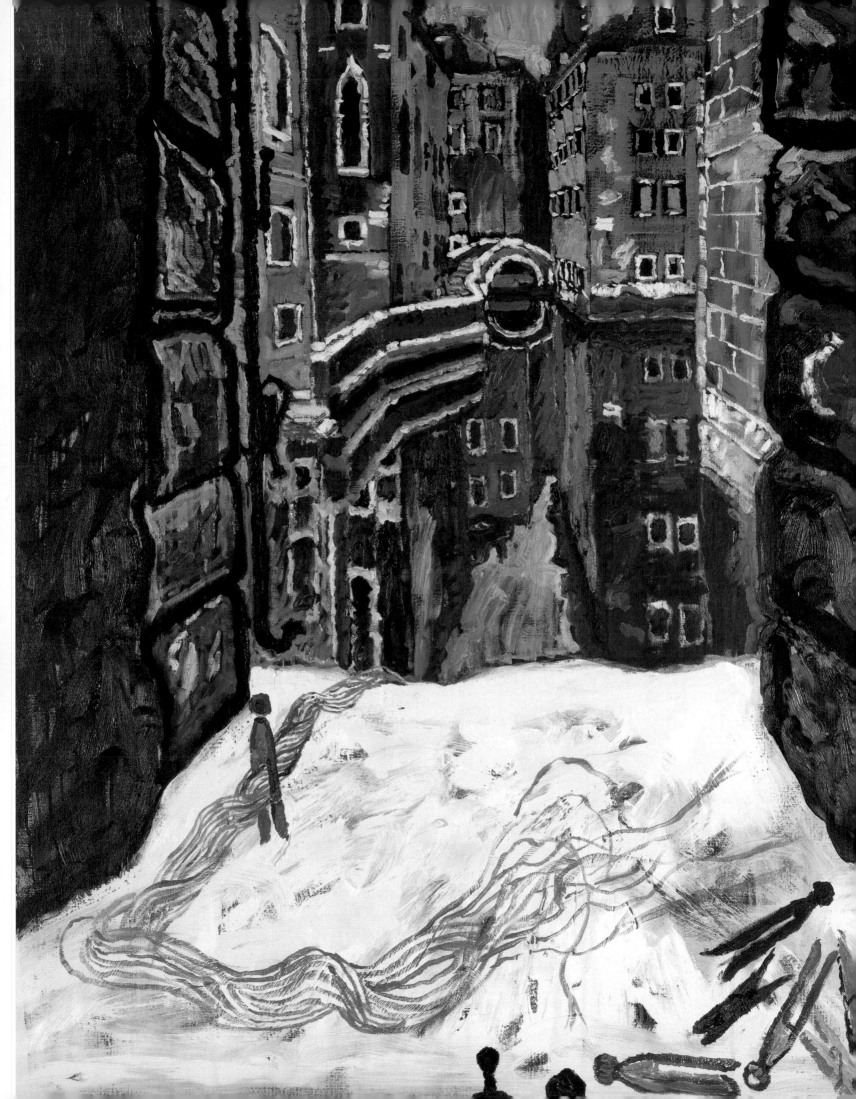

Foreword

It has to be said. Surrey is distinctly odd.

Most counties will have a key gallery – at Leeds in West Yorkshire, at Ipswich in Suffolk, or at York in North Yorkshire.

Surrey is the home of the local collection – and of the improbably glorious one-off of which there are two: Watts Gallery in Compton and Royal Holloway in Egham, both utterly distinct from one another yet linked by county, period and didactic intent and by the very richness of their idiosyncratic collections.

For the rest, one can only be amused or amazed – or both. The county's collections range from the Brooklands Collection of aviation and motor racing paintings to that of a gentleman's outfitter in Egham, the Oliver Collection; from a Joseph Wright portrait of Peter Labilliere who was buried upside down on Box Hill in Dorking to the portrait of Louisa Egerton in Weybridge, found in an air raid shelter and bought by the donor for a penny; from the portrait in Godalming of Jack Phillips, chief telegraphist on the Titanic who was still transmitting as he drowned, to John Russell's *Micoc and Tootac*, from the Sydney H. Sime Collection in Worplesdon to the Lockton Collection in Warlingham; 58 unique creations in total.

Yet if you want to revert to the mainstream, wander back to the Royal Holloway and admire a grand Landseer or a Herkomer, a Bratby or a Pollock. But try not to miss the collection in Farnham, not least for the paintings there by Sir John Verney who has also given this country one of the finest Second World War army memoirs, *Going to the Wars*.

Perhaps a county that lies within such easy reach of the great London museums has a powerful need to heed itself. Proudly local, Surrey does heed itself, as this catalogue vividly shows. We are all the better for that.

As usual, our Foundation is grateful to all those whose contributions have made this volume possible. In particular, I would like to thank Pat Grayburn, our Master Patron, for all her help raising funds for this catalogue. We are particularly grateful to the Peter Harrison Foundation, the first and largest donor behind this volume. I would also like to thank the collections for all their assistance, in particular Julia Dudkiewicz at Watts Gallery who spent considerable time ensuring the Watts painting information was complete. Finally, a big thank you to our co-ordinator on this catalogue Stella Sharp.

Fred Hohler, Chairman

The Public Catalogue Foundation

The United Kingdom holds in its galleries and civic buildings arguably the greatest publicly owned collection of oil paintings in the world. However, an alarming four in five of these paintings are not on view. Whilst many galleries make strenuous efforts to display their collections, too many paintings across the country are held in storage, usually because there are insufficient funds and space to show them. Furthermore, very few galleries have created a complete photographic record of their paintings, let alone a comprehensive illustrated catalogue of their collections. In short, what is publicly owned is not publicly accessible.

The Public Catalogue Foundation, a registered charity, has three aims. First, it intends to create a complete record of the nation's collection of oil, tempera and acrylic paintings in public ownership. Second, it intends to make this accessible to the public through a series of affordable catalogues and, after a suitable delay, through a free Internet website. Finally, it aims to raise funds through the sale of catalogues in gallery shops for the conservation and restoration of oil paintings in these collections and for gallery education.

The initial focus of the project is on collections outside London. Highlighting the richness and diversity of collections outside the capital should bring major benefits to regional collections around the country. The benefits also include a revenue stream for conservation, restoration, gallery education and the digitisation of collections' paintings, thereby allowing them to put the images on the Internet if they so desire. These substantial benefits to galleries around the country come at no financial cost to the collections themselves.

The project should be of enormous benefit and inspiration to students of art and to members of the general public with an interest in art. It will also provide a major source of material for scholarly research into art history.

Financial Supporters

The Public Catalogue Foundation would like to express its profound appreciation to the following organisations and individuals who have made the publication of this catalogue possible.

Donations of £10,000 or more

The Peter Harrison Foundation

Donations of £5,000 or more

Hiscox plc
Stavros S. Niarchos Foundation
The Manifold Trust

The Monument Trust
Garfield Weston Foundation

Donations of £1,000 or more

Barlow Robbins LLP
C. J. R. & Mrs C. L. Calderwood
The John S. Cohen Foundation
Professor Patrick & Dr Grace
 Dowling
Mrs M. A. G. Fenston

Mrs Patricia Grayburn, MBE DL
The Keatley Trust
Sir Idris Pearce
Stuart M. Southall
Surrey County Council
University of Surrey

Other Donations

Peter & Ruth Bareau
Mr & Mrs Gordon Bates
Mrs Handa Bray, MBE DL
H. J. C. Browne
Mr & Mrs Mervyn Charlton
Lewis & Mary Elton
Olga & Claude Fielding
Sarah Goad, Lord Lieutenant of
 Surrey
Guildford Borough Council

Howell & Susanna Harris Hughes
Sir Brian Hill
Mr & Mrs David Hypher
Lord Lane of Horsell
Mr M. J. Moss
Leszek & Pat Muszynski
Mr & Mrs A. O'Hea
Mrs Jennifer Powell
Sir Alfred & Lady Shepperd

National Supporters

The Bulldog Trust
The John S. Cohen Foundation
Hiscox plc
The Manifold Trust

The Monument Trust
Stavros S. Niarchos Foundation
Garfield Weston Foundation

National Sponsor

Christie's

Acknowledgements

The Public Catalogue Foundation would like to thank the individual artists and copyright holders for their permission to reproduce for free the paintings in this catalogue. Exhaustive efforts have been made to locate the copyright owners of all the images included within this catalogue and to meet their requirements. Copyright credit lines for copyright owners who have been traced are listed in the Further Information section.

The Public Catalogue Foundation would like to express its great appreciation to the following organisations for their great assistance in the preparation of this catalogue:

Bridgeman Art Library
Flowers East
Marlborough Fine Art
National Association of Decorative and Fine Art Societies (NADFAS)
National Gallery, London
National Portrait Gallery, London
Royal Academy of Arts, London
Tate

The participating collections included in the catalogue would like to express their thanks to the following organisations which have so generously enabled them to acquire paintings featured in this catalogue:

Alfred McAlpine Donation
Dorking and District Preservation Society
The Friends of Guildford House
The Friends of the Museum of Farnham
The Friends of Surrey Heath Museum
G. Jarvis and Co.
MLA/ V & A Purchase Grant Fund
National Art Collections Fund (The Art Fund)
Potter, Kempson and White, Solicitors
R. C. Sherriff Rosebriars Trust
Royal County Surrey Hospital
Shell Research
Sunbury Art Group
Surrey Heath Borough Council
The Contemporary Art Society
The Esmée Fairbairn Foundation
The Legrew Trust, Chaldon
The Museum and Galleries Commission
The S. A. Oliver Charitable Settlement
The Wheen family of Chobham
West Ewell Social Club

Catalogue Scope and Organisation

Medium and Support

The principal focus of this series is oil paintings. However, tempera and acrylic are also included as well as mixed media, where oil is the predominant constituent. Paintings on all forms of support (e.g. canvas, panel etc) are included as long as the support is portable. The principal exclusions are miniatures, hatchments or other purely heraldic paintings and wall paintings *in situ*.

Public Ownership

Public ownership has been taken to mean any paintings that are directly owned by the public purse, made accessible to the public by means of public subsidy or generally perceived to be in public ownership. The term 'public' refers to both central government and local government. Paintings held by national museums, local authority museums, English Heritage and independent museums, where there is at least some form of public subsidy, are included. Paintings held in civic buildings such as local government offices, town halls, guildhalls, public libraries, universities, hospitals, crematoria, fire stations and police stations are also included. Paintings held in central government buildings as part of the Government Art Collection and MoD collections are not included in the county-by-county series but should be included later in the series on a national basis.

Geographical Boundaries of Catalogues

The geographical boundary of each county is the 'ceremonial county' boundary. This county definition includes all unitary authorities. Counties that have a particularly large number of paintings are divided between two or more catalogues on a geographical basis.

Criteria for Inclusion

As long as paintings meet the requirements above, all paintings are included irrespective of their condition and perceived quality. However, painting reproductions can only be included with the agreement of the participating collections and, where appropriate, the relevant copyright owner. It is rare that a collection forbids the inclusion of its paintings. Where this is the case and it is possible to obtain a list of paintings, this list is given in the Paintings Without Reproductions section. Where copyright consent is refused, the paintings are also listed in the Paintings Without Reproductions section. All paintings

in collections' stacks and stores are included, as well as those on display. Paintings which have been lent to other institutions, whether for short-term exhibition or long-term loan, are listed under the owner collection. In addition, paintings on long-term loan are also included under the borrowing institution when they are likely to remain there for at least another five years from the date of publication of this catalogue. Information relating to owners and borrowers is listed in the Further Information section.

Layout

Collections are grouped together under their home town. These locations are listed in alphabetical order. In some cases collections that are spread over a number of locations are included under a single owner collection. A number of collections, principally the larger ones, are preceded by curatorial forewords. Within each collection paintings are listed in order of artist surname. Where there is more than one painting by the same artist, the paintings are listed chronologically, according to their execution date.

The few paintings that are not accompanied by photographs are listed in the Paintings Without Reproductions section.

There is additional reference material in the Further Information section at the back of the catalogue. This gives the full names of artists, titles and media if it has not been possible to include these in full in the main section. It also provides acquisition credit lines and information about loans in and out, as well as copyright and photographic credits for each painting. Finally, there is an index of artists' surnames.

Key to Painting Information

Almost all paintings are reproduced in the catalogue. Where this is not the case they are listed in the Paintings Without Reproductions section. Where paintings are missing or have been stolen, the best possible photograph on record has been reproduced. In some cases this may be black and white. Paintings that have been stolen are highlighted with a red border. Some paintings are shown with conservation tissue attached to parts of the painting surface.

Adam, Patrick William 1854–1929
Interior, Rutland Lodge: Vista through Open Doors 1920
oil on canvas 67.3 × 45.7
LEEAG.PA.1925.0671.LACF ✳

Artist name This is shown as surname first. Where the artist is listed on the Getty Union List of Artist Names (ULAN), ULAN's preferred presentation of the name is always given. In a number of cases the name may not be a firm attribution and this is made clear. Where the artist name is not known, a school may be given instead. Where the school is not known, the painter name is listed as *unknown artist*. If the artist name is too long for the space, as much of the name is given as possible followed by (…). This indicates the full name is given at the rear of the catalogue in the Further Information section.

Painting title A painting followed by *(?)* indicates that the title is in doubt. Where the alternative title to the painting is considered to be better known than the original, the alternative title is given in parentheses. Where the collection has not given a painting a title, the publisher does so instead and marks this with an asterisk. If the title is too long for the space, as much of the title is given as possible followed by *(…)* and the full title is given in the Further Information section.

Medium and support Where the precise material used in the support is known, this is given.

Artist dates Where known, the years of birth and death of the artist are given. In some cases one or both dates may not be known with certainty, and this is marked. No date indicates that even an approximate date is not known. Where only the period in which the artist was active is known, these dates are given and preceded with the word *active*.

Execution date In some cases the precise year of execution may not be known for certain. Instead an approximate date will be given or no date at all.

Dimensions All measurements refer to the unframed painting and are given in cm with up to one decimal point. In all cases the height is shown before the width. Where the painting has been measured in its frame, the dimensions are estimates and are marked with (E). If the painting is circular, the single dimension is the diameter. If the painting is oval, the dimensions are height and width.

Collection inventory number In the case of paintings owned by museums, this number will always be the accession number. In all other cases it will be a unique inventory number of the owner institution. (P) indicates that a painting is a private loan. Details can be found in the Further Information section. The ✳ symbol indicates that the reproduction is based on a Bridgeman Art Library transparency (go to www.bridgeman.co.uk) or that the Bridgeman administers the copyright for that artist.

Facing page: Leighton, Edmund Blair, 1853 –1922, *A Flaw in the Title* (detail), 1878, Royal Holloway, University of London, (p. 51)

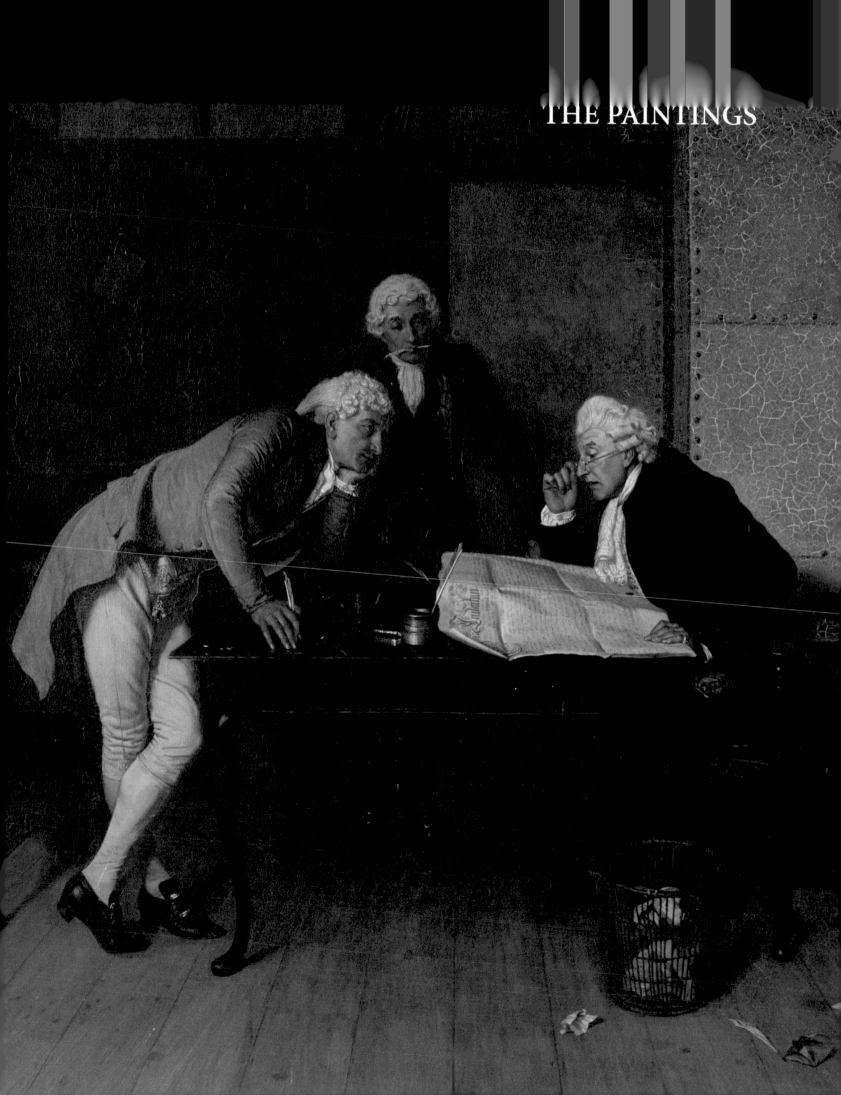

Ash Museum

Miles, John James active c.1906–c.1920
St Peter's Church, Ash c.1906
oil on cardboard 19.5 x 26.1
210

Miles, John James active c.1906–c.1920
Battleship c.1920
oil on cardboard 13.3 x 22.9
302

The Army Medical Services Museum

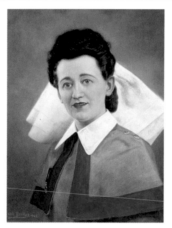

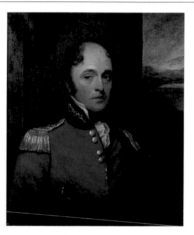

Bentos, Achille b.1882
Queen Alexandra's Imperial Military Nursing Service (QAIMNS) Sister, Second World War 1945
oil on canvas 60 x 40
Aldms A04

Brown, Mather 1761–1831
Purveyor, Army Medical Department 1800s
oil on canvas 29 x 24
448

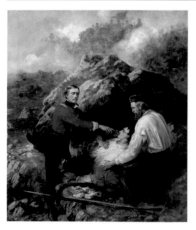

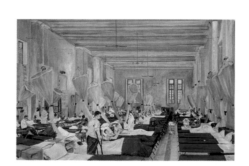

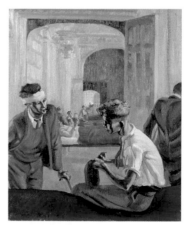

Desanges, Louis William 1822–c.1887
Assistant Surgeon H. Sylvester 1856
oil on canvas 47 x 39
725

Frankewitz, Bruno 1897–1982
B Ward, 64th British General Hospital, Second World War 1942
oil on canvas 78 x 118
Aldms A06

Newman, Beryl 1906–1991
Soldiers in Morton Hampstead Hospital, Second World War 1946
oil on canvas 75 x 62
2674

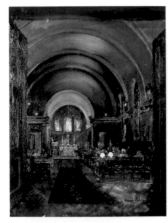

Robinson active 20th C
Queen Alexandra Military Hospital Chapel
oil on canvas 68 x 50
Aldms A05

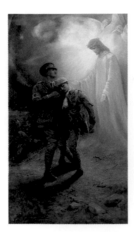

Swinstead, George Hillyard 1860–1926
White Comrade 1916
oil on canvas 74 x 41
Aldms A01

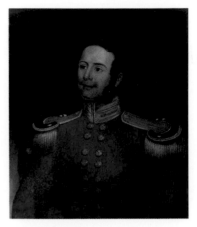

unknown artist
Hampton Massey mid-1800s
oil on canvas 29 x 24
1129

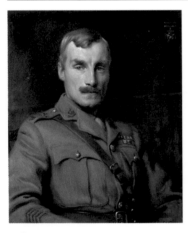

unknown artist
Arthur Martin Leake, VC 1920
oil on canvas 25 x 21
Aldms A02

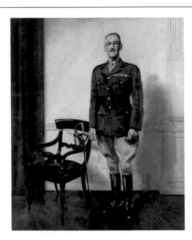

unknown artist
Colonel Alfred L. Robertson 1920s
oil on canvas 60 x 50
Aldms A03

Byfleet Heritage Society

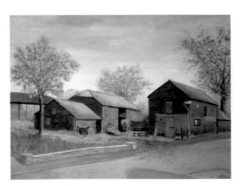

Bridgman, Marjorie
Foxlake Farm 1970
oil on hardboard 58 x 75.6
BHS742P

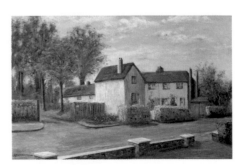

Henderson, H. B.
Stream Cottages 1970s
oil on hardboard 50 x 76.2
BHS743P

Byfleet Village Hall

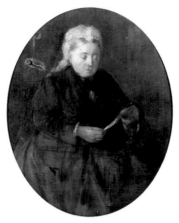

Lockhart, William Ewart 1846–1900
*Sketch of Queen Victoria Attending Her
Diamond Jubilee* 1897
oil on canvas 109 x 84
1

Surrey Heath Borough Council

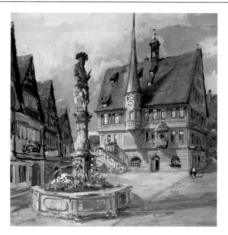

unknown artist
Bietigheim, the Rathaus 1970s
acrylic 61.5 x 61.5
SHBC 2

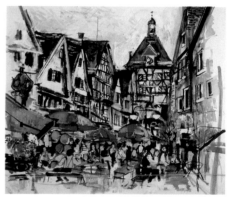

unknown artist
Bietigheim, Old Town Gate 1982
acrylic 59.5 x 71.3
SHBC 1

Surrey Heath Museum

As with many local museums, the art collection at Surrey Heath has developed in phases. Until 1985 there was a tradition of passive collecting, although some important watercolours and local architectural drawings were acquired during that period. Since that time, the approach has been more structured, targeting specific subjects, artists and, to a lesser extent, techniques. The Collection has also been enhanced immeasurably by the acquisition of a body of works by Percy Harland Fisher.

Born in 1867, 'Harley', as he was known to his family, grew up in Herne Hill, the youngest son of an artist-craftsman. Like his elder brothers Melton and Horace, who also became artists, Fisher was educated at Dulwich College and later attended the Royal Academy Schools. He then followed his brothers to the Continent, spending some years in Italy before moving to France, where he taught. This spell on the Continent had a clear influence on the development of his romantic style.

At the end of 1903, Fisher returned to England, due to ill health. He is thought to have chosen Camberley because its clean pine-laden air would relieve the bronchitis from which he increasingly suffered. Establishing himself in a studio in Plantation Row, Yorktown, he quickly developed a reputation as a portrait painter, finding a ready-made clientele amongst the many army officers in the area. His pictures of children were especially sought after. However, like any artist, he also painted for pleasure. Favourite subjects were the Romany families living on the local common, and the heathland landscape features as the background to a number of paintings. Fisher also produced many animal studies, particularly of dogs and horses.

Besides being a practising artist, Fisher gave painting classes in summer, and in 1911 married Catherine Hudson, one of his pupils. A tall, dark, rather taciturn man, he was a well-known figure in Camberley, still remembered by some older residents, since he occasionally recruited models through local schools. Children often found him rather intimidating, whereas his wife is remembered as more approachable.

Fisher exhibited regularly at the Royal Academy and other centres of excellence such as the Walker Art Gallery and the Royal Society of Artists. He never abandoned the romantic, painterly style of his early career, but during the 1920s and 1930s came to work increasingly in pastel. He died in 1944.

The Fisher works in the collection were acquired over several years with generous assistance from the Friends of Surrey Heath Museum, Lilly Research Ltd, the David Messum Gallery and, in two cases, the Victoria & Albert Museum Purchase Grant Fund. They include a number of oil sketches which provide an insight into the artist's working techniques, and a few pastels.

The Blue Veil portrays Catherine Fisher in a Romney-esque pose, smiling beguilingly at the viewer from under the cloudy blue veiling which swathes her dark hair. It was painted in Étaples during their honeymoon in 1911. Fisher's skill as a portraitist is illustrated by the contrast between this picture and the uncompromising picture of *Mrs Hudson*, the artist's mother-in-law, whose formidable personality is clearly captured. The lively *Washing on the Line*, arguably the most popular painting in the Collection, shows the view from the

artist's studio window in Plantation Row, while the more contemplative *Temptation* is apparently a study of a young Romany. However, when this acquisition was publicised, a local lady contacted the Museum to explain that the model was actually her sister, a Camberley schoolgirl, whose striking looks had caught the artist's eye. It appears that the child became so bored while posing that she surreptitiously began to pick at the apple in her hands, and Mrs Fisher's story-telling skills were called upon to distract her! Further invaluable insights into the Fisher household have been supplied by Fisher's grandson, Alan.

The remaining oils and acrylics in the Collection vary greatly in quality, from works by art-class beginners to paintings by professional artists of standing. One such, *King's Head Bridge*, was commissioned by the Council as a record of the Basingstoke Canal, an important historic feature which is also a leisure and environmental resource. Research still continues into both the copy of Gainsborough's *Mrs Siddons* and the large painting *of Frimley Heath*, presented to the Borough Council by the Wheen family of Chobham. This convincingly conveys the desolate nature of a landscape described by Defoe as 'a waste and barren land… a mark of the just resentment shown by heaven upon the Englshman's pride.'

In the 1970s, the Museum and local art society shared premises and a number of student works seem to have been collected when the building was vacated prior to demolition. An earlier naïve painting, *Old Pear Tree Cottage*, has great value as a social history document, showing one of the now long-vanished typical heathland cottages with red-ware pots and bunches of herbs by the door. The two pub signs were acquired at the time of demolition or refurbishment, primarily for their local historic associations.

The distinguished artist Roy Perry, an official war artist for the Falklands War, lived in this area in the 1960s and 1970s, and the collection holds several of his works. Apart from their spare yet atmospheric style, his pictures are a valuable record of views which have since been lost or undergone significant change.

Since the 1980s works like *Olive Grove with Goats, Crete* (by local artist-tutor Graham Scandrett), *Chobham Common* and *Elmhurst Ballet School* have been specifically acquired to fill gaps of subject, artist or style, and despite limitations of space, this process of development continues. In recent years, the Collection has been used as an educational resource for younger children, who have produced their own fascinating versions of the paintings. Bringing the material to a wider audience in this way is a fundamental part of the Museum's work and we welcome the opportunity afforded by the Public Catalogue Foundation's project to do so.

Sharon Cross, Curator

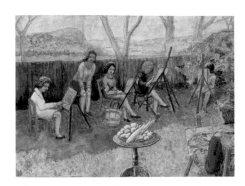

Biggs, R. Henry active c.1960–1970
Outdoor Studio 1965
oil on board 28.5 x 38.8
CN 433

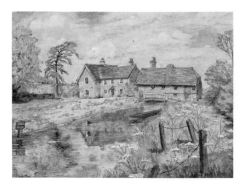

Biggs, R. Henry active c.1960–1970
Mill
oil on board 33.5 x 43.9
CN 434

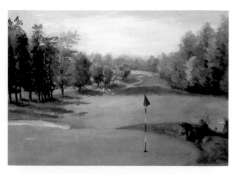

Billington, Neville active 1990s
Camberley Heath Golf Club
oil on board 33 x 44
RC57

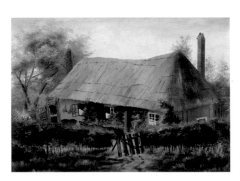

Cooper, A. L.
Old Pear Tree Cottage c.1904
oil on panel 24.5 x 34.5
RC328

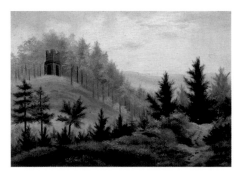

Cooper, A. L.
The Obelisk c.1904
oil on panel 24.5 x 34.5
RC 327

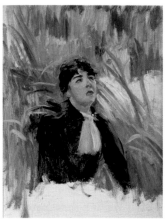

Fisher, Percy Harland 1867–1944
Amongst the Reeds 1903–1944
oil on canvas 25.3 x 19.6
SHM/1996.34/8

Fisher, Percy Harland 1867–1944
Barossa Common 1903–1944
oil on board 28 x 38.8
SHM/1992.9

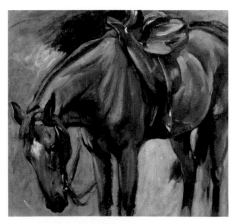

Fisher, Percy Harland 1867–1944
Chestnut Horse (Cookie the Hunter) (recto)
1903–1944
oil on board 41.4 x 44.2
SHM/1996.34/10

Fisher, Percy Harland 1867–1944
Chestnut Horse (verso) 1903–1944
oil on board 35.2 x 38
SHM/1996.34/10/b

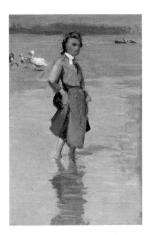

Fisher, Percy Harland 1867–1944
Paddling 1903–1944
oil on board 28.5 x 18.3
SHM/1996.34/3

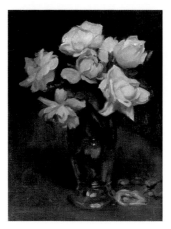

Fisher, Percy Harland 1867–1944
Roses in a Vase 1903–1944
oil on canvas 44.4 x 33
SHM/1992.43

Fisher, Percy Harland 1867–1944
The Chestnut Hunter 1903–1944
oil on board 28 x 34.9
SHM/1996.34/4

Fisher, Percy Harland 1867–1944
The Grey Horse (recto) 1903–1944
oil on board 31.2 x 37.8
SHM/1996.34/9

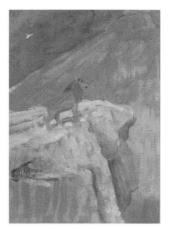

Fisher, Percy Harland 1867–1944
Lion Standing on Rock (verso)
oil or tempera on board 30.4 x 22
SHM/1996.34/1/b

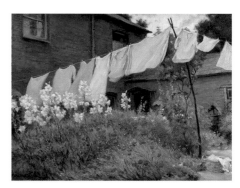

Fisher, Percy Harland 1867–1944
Washing on the Line 1903–1944
oil on canvas 49 x 65.8
SHM/1991.6

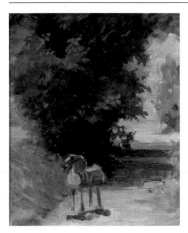

Fisher, Percy Harland 1867–1944
Dobbin on the Path (The Wooden Horse)
1910–1920
oil on panel 27.9 x 23.2
SHM/1996.34/66

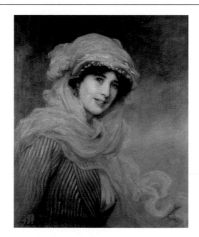

Fisher, Percy Harland 1867–1944
The Blue Veil 1911
oil on canvas 75 x 62.5
SHM/2000.24/2

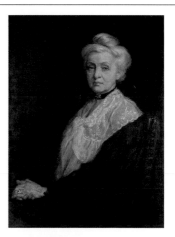

Fisher, Percy Harland 1867–1944
Mrs Hudson c.1911
oil on canvas 96 x 70.5
SHM/2000.24/1

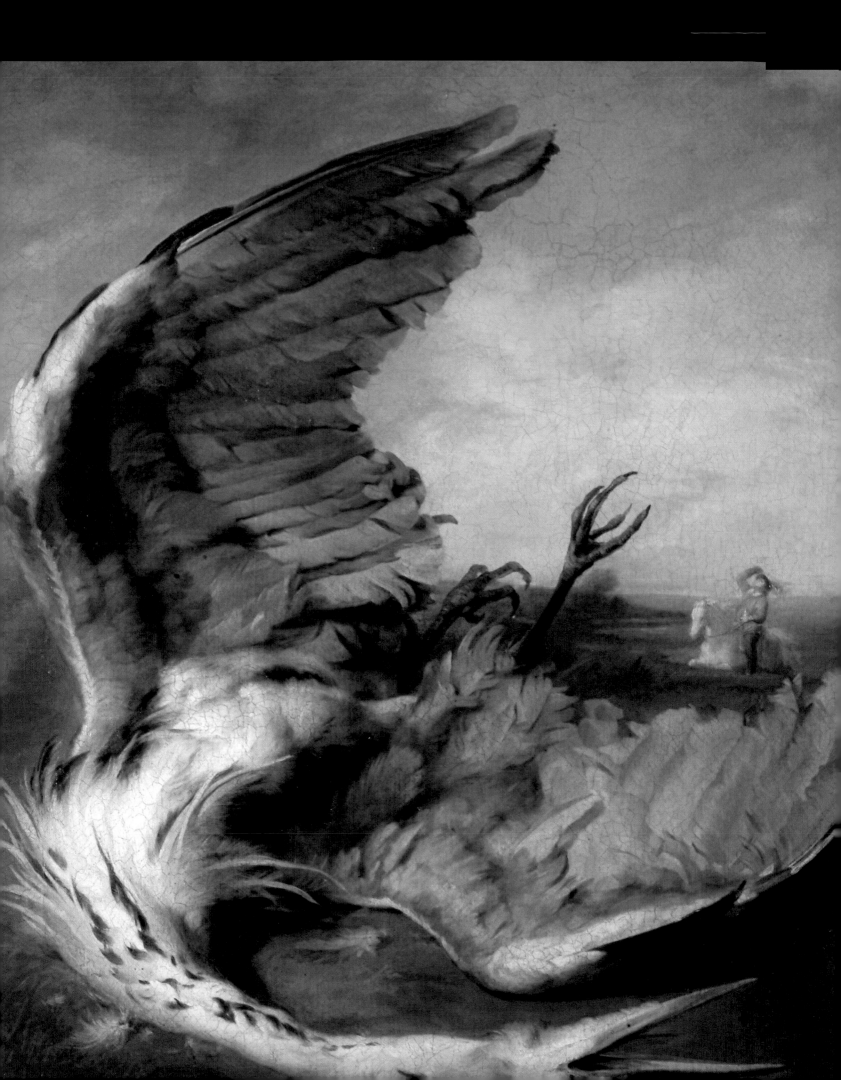

Royal Holloway, University of London

The spectacular facade of Royal Holloway is a familiar sight to motorists on the A30 between Egham and Sunningdale. Financed by the patent medicine millionaire, Thomas Holloway, it was designed by William Henry Crossland, who took the sixteenth-century Château de Chambord as his model, and opened as a college for women in 1886. No expense was spared. Solid, extravagant and richly decorated with sculpture, it stands as a monument to the wealth, optimism and spirit of philanthropy which so characterized the Victorian age. More famous even than the unique building is the collection of paintings which hangs in the College gallery in authentic High Victorian style, almost frame to frame and regardless of subject. It was assembled by Holloway in the last two years of his life, as the final educative touch to his generous endowment.

Heedless of cost, Holloway spent the equivalent, in today's terms, of several million on his collection. The importance he placed on it illustrates the Victorians' belief in art as the ultimate civilizing influence. Like literature, art could teach; not only in the obvious sense of portraying a moral lesson or illustrating an edifying text; but, in its own unique and inimitable way, through the medium of visual beauty. A picture collection of the first quality would provide the ultimate refining influence in Holloway's College for young ladies.

Virtually all the paintings were bought at Christie's, and the vast majority were modern. Holloway made his choice from the catalogues in consultation with his brother-in-law, George Martin, who did the bidding on his behalf. Amongst Holloway's purchases were some of the most important paintings of the period, including William Powell Frith's *The Railway Station* (1862), a panoramic view of the busy crowd at Paddington with the artist and his family in the centre-foreground. It is the most potent and revealing image ever painted of Victorian urban life; and no painting has been more admired or vilified. For the modernist critic Roger Fry, its mundane realism marked the lowest point to which Victorian art ever sunk: 'an artistic Sodom and Gomorrah', he called it. Frith, who expressed a healthy disdain for aesthetes, would have scorned such criticism. He knew that he was painting history in the making, and posterity has proved him right. As a visual social document and a repository of contemporary ideas, *The Railway Station* has few equals. It provides a stark contrast with another significant portrayal of contemporary life: Luke Fildes's *Casual Ward* (1874) – the toughest pictorial statement ever made on Victorian urban poverty and homelessness. It caused a sensation at the Royal Academy of 1874 and was voted picture of the year by popular assent. Fildes was the acknowledged leader of a group of artists who emerged independently in the 1870s, and whose direct engagement with the problems of the day earned them the title of the Social Realists. Frank Holl's *Newgate* (1878) is another masterpiece in this category. Painted from studies made in Newgate itself, it demonstrates the tenuous hold of the poor on respectability and the means of survival, both of which are instantly under threat when the breadwinner turns to crime.

Most Victorians preferred historical subjects to portrayals of their own time. Supreme amongst those at Royal Holloway is John Millais's *Princes in the*

Tower (1878); a masterly exercise in psychological drama which once adorned every child's history book. Daniel Maclise's *Peter the Great at Deptford Dockyard* (1857) is far more elaborate. It was based on contemporary accounts, and depends on an accumulation of historical detail to illustrate an episode from the period when the Russian Emperor visited England in order to learn how to construct his own navy. The contrast between the energetic figure of Peter, engaged in carpentry, and the refined and elegant form of William III, is the dramatic point of the picture. The largest painting in the Collection – Edwin Long's *Babylonian Marriage Market* (1875) is a meticulous archaeological reconstruction of the ancient world. Every detail was supplied by the Assyrian Galleries at the British Museum, and by published books by Austen Henry Layard and others on the excavations at Nineveh and other sites. The subject – young girls being auctioned in the market place, in order of beauty – may seem an odd choice for a college for well-bred young ladies; but critics agreed that the artist had handled the subject with irreproachable delicacy.

Holloway also secured two of the most celebrated animal paintings of the period. Briton Riviere unashamedly played to the gallery with *Sympathy* (1877); which shows his woeful little daughter being comforted by her pet bull terrier. Landseer, on the other hand, courted controversy with *Man Proposes - God Disposes* (1864) – a bleak portrayal of polar bears tearing at the remnants of an abandoned ship: a scarcely veiled reference to Sir John Franklin's ill-fated expedition to the Northern Arctic some 20 years previously. It may also be read as an image of the helplessness of man, and the ultimate decline and wreckage of all civilizations.

The cherished notion of an unspoiled countryside, and the continuity of traditional peasant and Highland life, is celebrated in landscape and figurative works by artists as distinguished as John Brett, Thomas Creswick, Thomas Faed, Benjamin W. Leader, John Linnell and John McWhirter. The much travelled Holloway, whose patent medicines reached the remotest corners of the world, also acquired scenes of favourite Continental destinations including Cairo, Venice, the Austrian Alps, Switzerland, the Pyrenees and Turkey. James Holland's view of Verona (1844), William J. Muller's *Tomb in the Water, Telmessus, Lycia* and Ludwig Munthe's Norwegian *Snow Scene* (1873) are particularly fine examples in this category.

Pride in Britain's naval and trading prowess is evident in numerous depictions of ships, harbours and dockyards; and the more negative aspect of native bull-dog pugnacity is celebrated in George Morland's portrayal of a press-gang in action. Clarkson Stanfield, whose contributions to the collection include a battle scene from the Napoleonic Wars, was himself press-ganged into the Royal Navy in 1812. Stanfield's ability to cover huge canvases at speed was aided by his time as a scene painter at Drury Lane Theatre – a task he shared with another great artist, David Roberts, whose *Pilgrims Approaching Jerusalem* (1841) is among Holloway's most inspired purchases.

The College also has a distinguished and varied secondary collection. This includes a large and impressive landscape by Sir David Murray, *Spring in the Alps*, which was exhibited as *Spring Blossoms to the Mountain Snows* at the RA in 1910. There is also a small number of paintings in tempera, dating from the turn of the twentieth century when the medium underwent a major revival in England. Most are high quality copies of early Renaissance paintings by Lady

Christiana Herringham, an expert in the field, and founder member of the Tempera Society in 1901. Another of her copies, in oils, of Gherardo di Giovanni's *Battle of Love and Chastity* (circa late fifteenth century, National Gallery, London), is perhaps the finest of all. *The Garden of the Slothful* (c.1901) by Margaret Gere, who was also active in the tempera revival, is a highly personal and charming interpretation of two verses from Proverbs.

The Herringham Collection, some portraits and other artworks, came with the merger of Bedford College with Royal Holloway in 1985. The College owns a number of outstanding portraits, including two by one of the most celebrated of all early-twentieth-century portrait painters, Philip De Laszlo. There are other major examples by Sir William Orpen, Sir Hubert von Herkomer (renowned as a Social Realist as well as a portrait painter), Sir James Shannon, David Jagger and Sir Herbert James Gunn. The tradition of commissioning portraits continues, and more recent examples include works by Sir Lawrence Gowing, Peter Greenham, Paul Brason and Louise Riley-Smith.

In 2001 the College was the recipient of an anonymous donation of ten contemporary paintings dating from the 1980s. These hang in the award-winning International Building, which was completed in 1999. They include John Bratby's *Washline, Little Bridge* (1989), Jon Groom's *Moorish House V*, and abstracts by Jeremy Annear, Fred Pollock and Gary Wragg. Other benefactors have enabled the College to acquire contemporary works which range from the representational to installations and other conceptual works. The former include particularly fine examples by Louise Courtnell, Steven Hubbard and Clive Wilkins.

In current values, Holloway spent at least £50,000,000 on the building and the collection. He appreciated the civilizing effects of art and architecture and their role in education, and through them he created a fitting memorial to himself and his wife. Holloway died rightly confident that his generous gift would inspire generations of students and teachers; and that inspiration has also been shared by the numerous visitors who have flocked to the College since it first opened. Holloway would have approved that the College buildings – and the contemporary art collection – continue to expand; for the enterprising spirit and generosity which make this possible are very much in the tradition of the College's original founder.

Mary Cowling, Curator & Lecturer in History of Art

Annear, Jeremy b.1949
Untitled Abstract in Blue and Grey
oil on canvas 76.3 x 91.5
P1675

Ansdell, Richard 1815–1885
The Drover's Halt, Island of Mull in the Distance 1845
oil on canvas 96 x 181.5
THC001

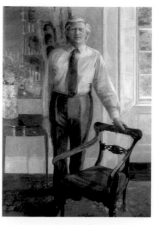

Atherton, Linda b.1952
Professor Drummond Bone 2002
oil on canvas 137.1 x 96
P1694

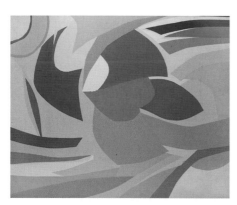

Atroshenko, Viacheslav 1935–1994
Musical Moment 1972
acrylic on canvas 152.4 x 182.8
P1695

Atroshenko, Viacheslav 1935–1994
New York I (of a series of six) 1978
acrylic on canvas 182.8 x 243.8
P1696

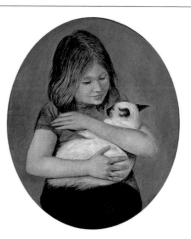

Backer
Girl with Siamese Cat c.1970
oil on canvas 58.5 x 48.3
P0443

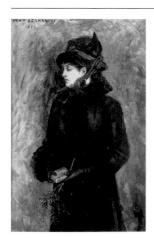

Bernhardt, Sarah 1844–1923
Le retour de l'église 1879
oil on board 38 x 22.8
P0492

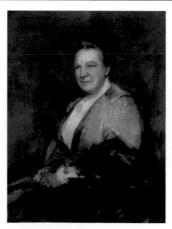

Bigland, Percy 1858–1926
Henrietta Busk 1884?
oil on canvas 101.6 x 76.2
P0459

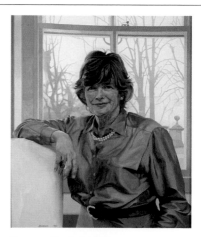

Brason, Paul b.1952
Professor Dorothy Wedderburn 1991
oil on canvas 91.5 x 76.2
P1551

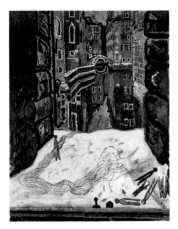

Bratby, John Randall 1928–1992
Washline, Little Bridge 1989
oil on canvas 122 x 91.5
P1672

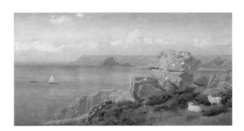

Brett, John 1830–1902
Carthillon Cliffs 1878
oil on canvas 45.7 x 91.4
THC002

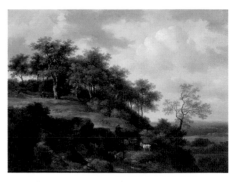

British School early 19th C
Wooded Landscape with Goat and Figures
oil on panel 35.5 x 47.8
P1010

British School 19th C
Thomas Holloway Senior (d.1836)
oil on canvas 81.3 x 63.5
P0460

British School late 19th C
Dame Emily Penrose (1858–1942)
oil on canvas 111.2 x 86.5
P0471

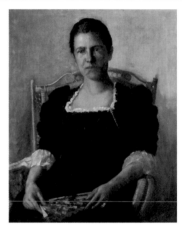

British School late 19th C
Mrs Louise d'Este Oliver (1850–1919)
oil on canvas 91.5 x 76.2
P0078

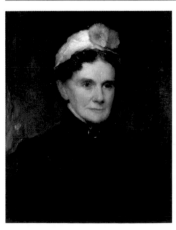

British School late 19th C
Mrs Maria Louisa Carlile (1826–1908)
oil on canvas 61.1 x 52
P0023

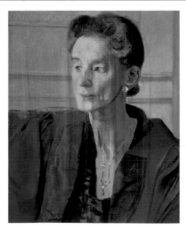

British School
Dr Nora L. Penston c.1964
oil on canvas 61 x 50.8
P1608

British School
Abstract Composition 1970s
acrylic on canvas 202.5 x 202.5
P1640

British School 20th C
Dame Margaret Janson Tuke (1862–1947)
oil on canvas 75.5 x 62.5
P0019

British School 20th C
Dame Margaret Janson Tuke (1862–1947)
oil on canvas 122 x 78
P0019A

British School late 20th C
Harbour
oil on canvas 50.8 x 40.6
P0405

British School late 20th C
Winter Landscape with Lake
oil on canvas 45 x 35
P1684

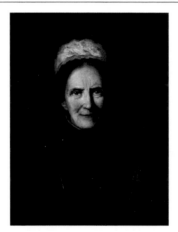

Bruce, H. A.
Miss Anna Swanwick (1813–1899)
oil on canvas 59.5 x 50
P0064

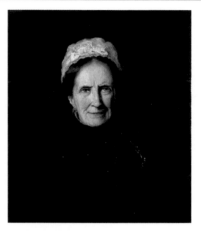

Bruce, H. A.
Miss Anna Swanwick (1813–1899)
oil on canvas 59.5 x 50 (E)
P1626

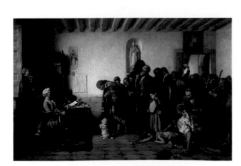

Burgess, John Bagnold 1830–1897
Licensing the Beggars in Spain 1877
oil on canvas 121.8 x 192.9
THC003

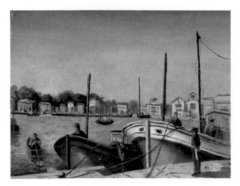

Butler, H. C.
Boats
oil on board 35 x 45
P0194

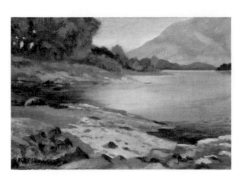

Butler, H. C.
Lakeside Landscape
oil on canvas 33 x 47
P0206

Facing page: Swedish School, *The Three Kings and the Wise and Foolish Virgins* (detail), c.1801–1828, Haslemere Educational Museum, (p. 171)

Carey, Charles William 1862–1943
Farm House, Mount Lee 1886
oil on canvas 34.2 x 44.4
P0210

Carey, Charles William 1862–1943
South East Corner of Royal Holloway College
1890
oil on canvas 22.8 x 35.5
P0787

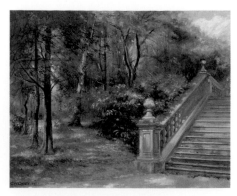

Carey, Charles William 1862–1943
*South West Terrace Steps, Royal
Holloway* 1896
oil on canvas 50.8 x 61
P0205

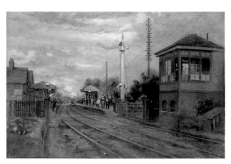

Carey, Charles William 1862–1943
Egham Station
oil on canvas 89 x 130
P0401 (P)

Chamberlain, Brenda 1912–1971
Seascape in Red 1959
oil on canvas 30.5 x 35.5
P1561

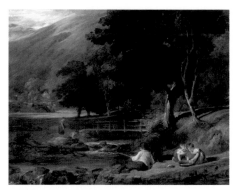

Collins, William 1788–1847
*Borrowdale, Cumberland, with Children
Playing by the Banks of a Brook* 1823
oil on canvas 86.3 x 111.7
THC004

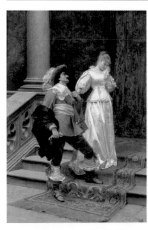

Conti, Tito 1842–1924
Goodbye 1877
oil on canvas 63.4 x 45.7
THC007

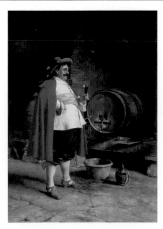

Conti, Tito 1842–1924
Approved
oil on panel 38 x 27.9
THC006

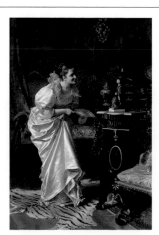

Conti, Tito 1842–1924
Paying Her Respects to His High Mightiness
oil on panel 44.4 x 31.7
THC005

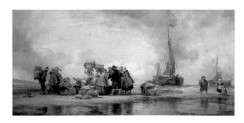

Cooke, Edward William 1811–1880
Scheveningen Beach 1839
oil on canvas 45.7 x 91.4
THC008

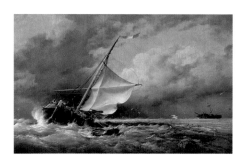

Cooke, Edward William 1811–1880
*A Dutch Beurtman Aground on the
Terschelling Sands, in the North Sea after a
Snowstorm* 1865
oil on canvas 106.6 x 167.5
THC009

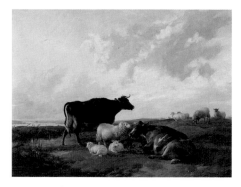

Cooper, Thomas Sidney 1803–1902
Landscape with Cows and Sheep 1850
oil on canvas 63.4 x 81.2
THC0010

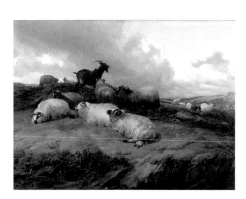

Cooper, Thomas Sidney 1803–1902
Landscape with Sheep and Goats 1856
oil on canvas 96.4 x 126.9
THC0011

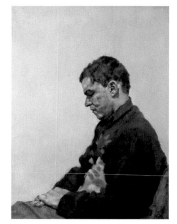

Courtnell, Louise b.1963
Mr Shoa the Younger 1992
oil on canvas 68.5 x 53.3
P1622

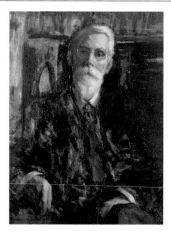

Covey, Molly Sale 1880–1917
Portrait of an Elderly Gentleman
oil on canvas 50.8 x 35.5
P0457

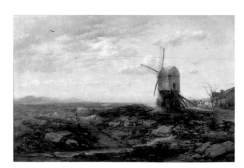

Creswick, Thomas 1811–1869
The First Glimpse of the Sea 1850
oil on canvas 101.5 x 152.3
THC0012

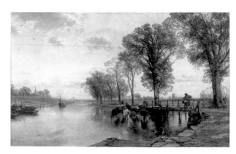

Creswick, Thomas 1811–1869
Trentside 1861
oil on canvas 114.2 x 182.8
THC0013

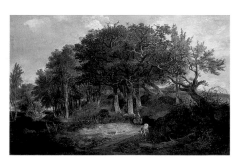

Crome, John (follower of) 1768–1821
A Woodland Scene 1813
oil on panel 78.7 x 121.9
THC0014

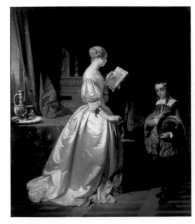

Daele, Charles van den d.1873
The Letter 1850
oil on panel 50.8 x 43.3
P1577

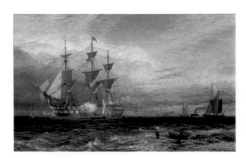

Dawson, Henry 1811–1878
Sheerness, Guardship Saluting 1875
oil on canvas 81.2 x 126.9
THC0015

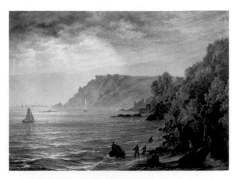

Dawson, Henry Thomas
1841/1842–after 1896
Salcombe Estuary, South Devon 1882
oil on canvas 76.1 x 106.6
THC0016

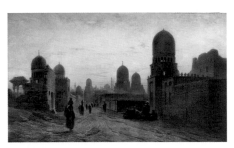

Dillon, Frank 1823–1909
Tombs of the Khedives in Old Cairo
oil on canvas 66 x 112
P0456

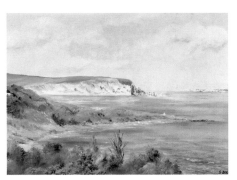

Dixon, G.
Seascape with Cliffs 1971
oil on board 28.5 x 39.5
P1688

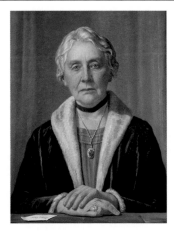

Dodd, Francis 1874–1949
*Dame Margaret Janson Tuke
(1862–1947)* 1934
oil on canvas 63.5 x 50.8
P0020

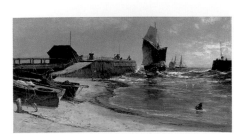

Ellis, Edwin 1841–1895
The Harbour Bar
oil on canvas 40.6 x 76.1
THC0017

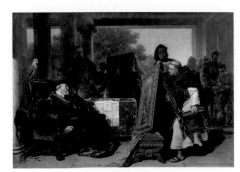

Elmore, Alfred 1815–1881
*The Emperor Charles V at the Convent of St
Yuste* 1856
oil on canvas 121.8 x 167.5
THC0018

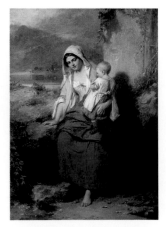

Faed, Thomas 1826–1900
Taking Rest 1858
oil on canvas 83.7 x 63.4
THC0019

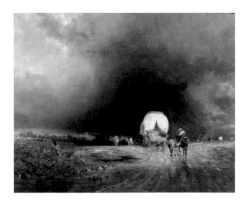

Fielding, Anthony V. C. 1787–1855
Travellers in a Storm, Approach to Winchester
1829
oil on canvas 101.5 x 126.9
THC0020

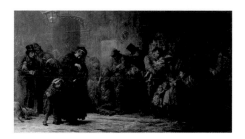

Fildes, Luke 1844–1927
Applicants for Admission to a Casual Ward
1874
oil on canvas 137.1 x 243.7
THC0021

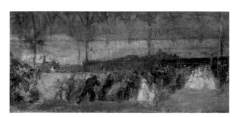

Frith, William Powell 1819–1909
Sketch for 'The Railway Station' c.1860
oil on canvas 17.7 x 25.4
P0068

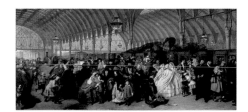

Frith, William Powell 1819–1909
The Railway Station 1862
oil on canvas 116.7 x 256.4
THC0022

Gere, Margaret 1878–1965
The Garden of the Slothful c.1901
tempera on silk mounted on panel 26 x 26
P1280

Girardot, Ernest Gustave 1840–1904
Jane Holloway (posthumous) 1882
oil on canvas 213.5 x 152.5
P1602

Girardot, Ernest Gustave 1840–1904
Thomas Holloway 1882
oil on canvas 213.5 x 152.5
P1601

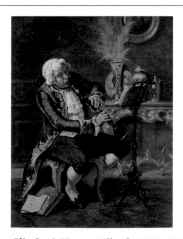

Glindoni, Henry Gillard 1852–1913
The Musician 1876
oil on panel 45.8 x 35.8
P1578

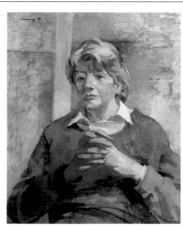

Gowing, Lawrence 1918–1991
Mrs E. M. Chilvers 1984
oil on canvas 76.2 x 63.5
P1606

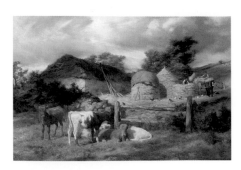

Graham, Peter 1836–1921
A Highland Croft 1873
oil on canvas 121.8 x 182.8
THC0023

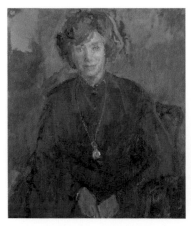

Greenham, Peter 1909–1992
Professor Dorothy Wedderburn 1985
oil on canvas 76.2 x 63.5
P0063 ❈

Groom, Jon b.1953
The Moorish House, V
oil on canvas 157.5 x 152.5
P1678

Gunn, Herbert James 1893–1964
Miss Geraldine E. M. Jebb, CBE 1952
oil on canvas 111.8 x 91.5
P1604

Gunn, Herbert James 1893–1964
*Sir Wilmot Herringham KCMG, CB, MD
(1855–1936)*
oil on canvas 132.1 x 91.5
P0079

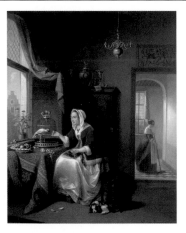

Hamme, Alexis van 1818–1875
Feeding the Parrot 1860
oil on panel 53.3 x 44.4
P1579

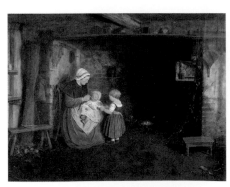

Hardy, Frederick Daniel 1826–1911
*Expectation: Interior of Cottage with Mother
and Children* 1854
oil on panel 22.8 x 30.4
THC0024

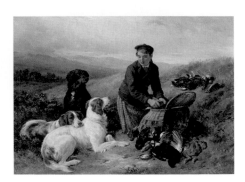

Hardy, James II 1832–1889
A Young Gillie, with Setters and Dead Game
1877
oil on canvas 71 x 99
THC0025

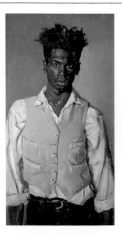

Haughton, Desmond b.1968
Self Portrait in a Yellow Waistcoat 1993
oil on canvas 81.3 x 45.7
P1620

Hazelwood, David B. 1932–1994
Fluttering 1966
oil on canvas 83.5 x 22
P1697

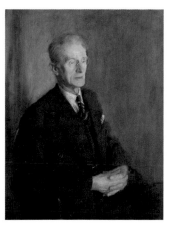

Hepple, Norman 1908–1994
Sir Charles Tennyson, 1954
oil on canvas 101.6 x 76.2
P0080 🐝

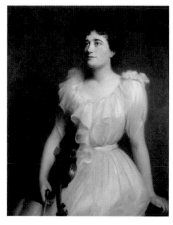

Herkomer, Hubert von 1849–1914
Marie Douglas (Mrs Arthur Stothert)
oil on canvas 111.8 x 86.5
P0824

Herringham, Christiana Jane 1852–1929
Asphodel
oil on canvas 91.5 x 61
P0453

Herringham, Christiana Jane 1852–1929
Battle of Love and Chastity (after Gherardo di Giovanni del Fora)
oil on canvas 45.8 x 38
P1279

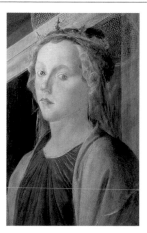

Herringham, Christiana Jane 1852–1929
Head of St Catherine (after Sandro Botticelli)
tempera on panel 45 x 28.5
P0145

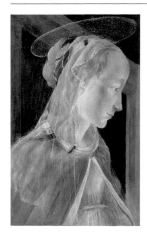

Herringham, Christiana Jane 1852–1929
Head of the Magdalene (after Sandro Botticelli)
tempera on panel 45 x 28.5
P0746

Herringham, Christiana Jane 1852–1929
Landscape with Farm
tempera on card 25 x 76.5
P15633

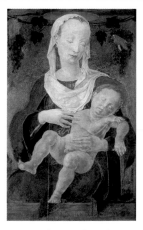

Herringham, Christiana Jane 1852–1929
Madonna and Child (after Cosmè Tura)
tempera on panel 62.5 x 42.5
P069A

Herringham, Christiana Jane 1852–1929
Pink Aquilegia, Yellow Foxgloves, Cow Parsley
oil on canvas 78.8 x 68.5
P1267

Herringham, Christiana Jane 1852–1929
Red Lilies on Blue Ground
oil on canvas 50.8 x 76.2
P1250

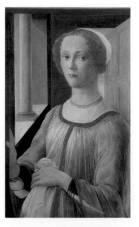

Herringham, Christiana Jane 1852–1929
Smeralda Bandinelli (after Sandro Botticelli)
tempera on panel 64.3 x 40.8
P0451

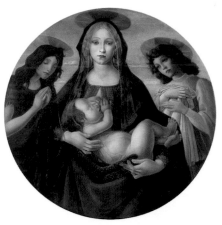

Herringham, Christiana Jane 1852–1929
Virgin and Child (after Sandro Botticelli)
oil on canvas 76.2
P1104

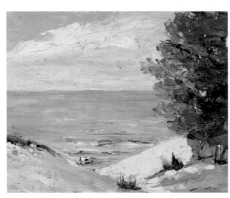

Heydorn, S.
Seascape
oil on card 20.3 x 24.8
P1687

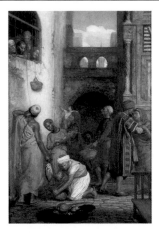

Hodgson, John Evan 1831–1895
Relatives in Bond 1877
oil on panel 93.9 x 66
THC0026

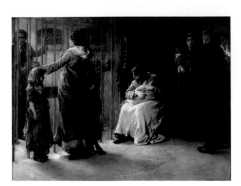

Holl, Frank 1845–1888
Newgate: Committed for Trial 1878
oil on canvas 152.3 x 210.7
THC0027

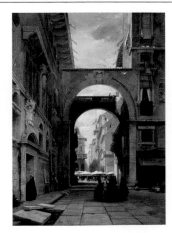

Holland, James 1800–1870
Piazza dei Signori, Verona, with the Market Place 1844
oil on canvas 101.5 x 76.1
THC0028

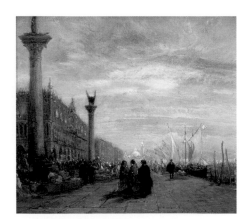

Holland, James 1800–1870
Venice, Piazza di San Marco 1850
oil on panel 22.8 x 27.9
THC0029

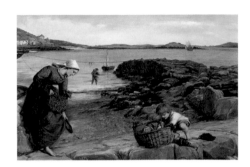

Hook, James Clarke 1819–1907
Leaving at Low Water 1863
oil on canvas 68.5 x 106.6
THC0030

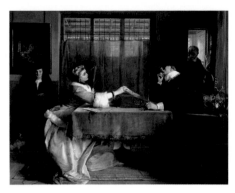

Horsley, John Callcott 1817–1903
*The Banker's Private Room, Negotiating a
Loan* 1870
oil on canvas 101.5 x 126.9
THC0031

Hubbard, Steven b.1954
Self Portrait with Objects 1993
oil on canvas 91.5 x 61
P1623

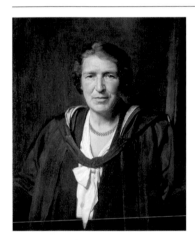

Jagger, David 1891–1958
Miss Janet Ruth Bacon 1946
oil on canvas 76.2 x 63.5
P1612

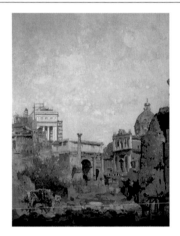

Kerr-Lawson, James 1865–1939
*The Forum with the Arch of Constantine,
Rome*
oil on canvas 122 x 91.5
P0996

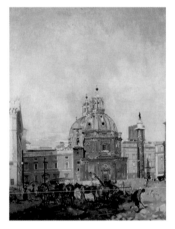

Kerr-Lawson, James 1865–1939
The Forum with Trajan's Column, Rome
oil on canvas 122 x 91.5
P0995

Koike, Masahiro
La fontaine 2003
oil on canvas 59 x 45.3
P1693

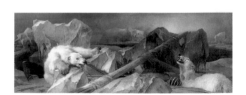

Landseer, Edwin Henry 1802–1873
Man Proposes, God Disposes 1864
oil on canvas 91.4 x 243.7
THC0032

László, Philip Alexius de 1869–1937
Dame Emily Penrose (1858–1942) 1907
oil on canvas 116.8 x 91.5
P0471 🐝

László, Philip Alexius de 1869–1937
Sketch for 'Dame Emily Penrose (1858–1942)'
1907
oil on canvas 34 x 24.3
P1683 🐝

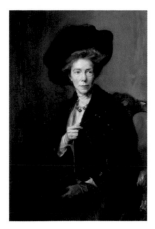

László, Philip Alexius de 1869–1937
Elizabeth Maude Guinness 1910
oil on canvas 101.6 x 76.2
P1600 🐝

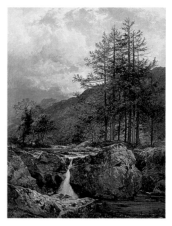

Leader, Benjamin Williams 1831–1923
The Rocky Bed of a Welsh River 1874
oil on canvas 121.8 x 91.4
THC0033

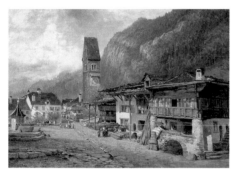

Leader, Benjamin Williams 1831–1923
Unterseen, Interlaken, Autumn in Switzerland
1878
oil on canvas 86.3 x 121.8
THC0034

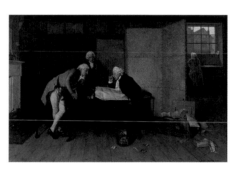

Leighton, Edmund Blair 1853–1922
A Flaw in the Title 1878
oil on canvas 60.9 x 91.4
THC0035

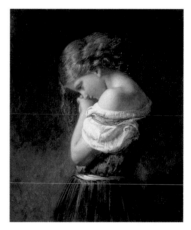

Lejeune, Henry 1820–1904
Early Sorrow 1869
oil on panel 30.4 x 25.3
THC0036

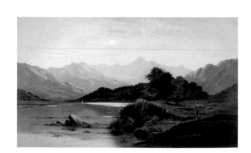

Leslie, Charles 1835–1890
Loch Katrine, Ellen's Isle 1879
oil on canvas 76.2 x 125.7
P1615

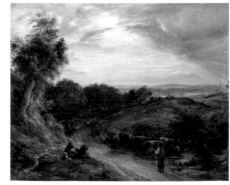

Linnell, John 1792–1882
Wayfarers 1849 & 1866
oil on canvas 71 x 91.4
THC0037

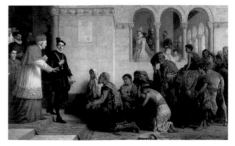

Long, Edwin 1829–1891
*The Suppliants: Expulsion of the Gypsies from
Spain* 1872
oil on canvas 182.8 x 286.9
THC0038

Facing page: Muszynski, Leszek, b.1923, *Sunrise (triptych)* (detail), 1989, University of Surrey, (p. 123)

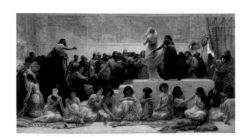

Long, Edwin 1829–1891
The Babylonian Marriage Market 1875
oil on canvas 172.6 x 304.6
THC0039

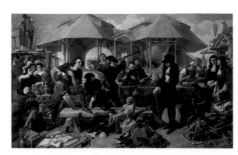

Maclise, Daniel 1806–1870
Peter the Great at Deptford Dockyard 1857
oil on canvas 152.3 x 243.7
THC0040

MacWhirter, John 1839–1911
'Night, most glorious night, thou wert not made for slumber' 1874
oil on canvas 99 x 165
THC0041

MacWhirter, John 1839–1911
Spindrift 1876
oil on canvas 81.2 x 142.1
THC0042

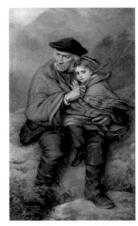

Mann, Joshua Hargrave Sams
active 1849–1884
The Cauld Blast 1876
oil on canvas 91.4 x 60.9
THC0043

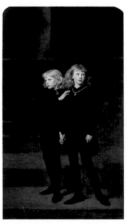

Millais, John Everett 1829–1896
The Princes in the Tower 1878
oil on canvas 147.2 x 91.4
THC0044

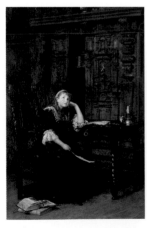

Millais, John Everett 1829–1896
Princess Elizabeth in Prison at St James's 1879
oil on canvas 144.7 x 101.5
THC0045

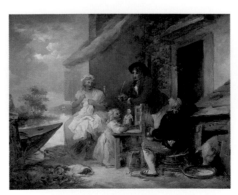

Morland, George 1763–1804
The Cottage Door 1790
oil on panel 35.5 x 45.7
THC0046

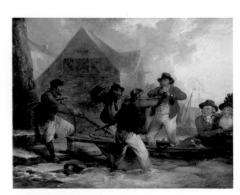

Morland, George 1763–1804
The Press-Gang 1790
oil on panel 35.5 x 45.7
THC0047

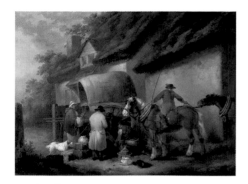

Morland, George 1763–1804
The Carrier Preparing to Set Out 1793
oil on canvas 86.3 x 116.7
THC0048

Morpurgo, Simonetta
Senigallia
oil on canvas 35.5 x 57
P0435

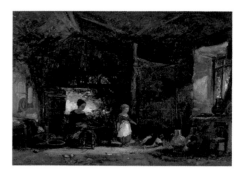

Müller, William James 1812–1845
Interior of a Cottage in Wales 1841
oil on panel 25.3 x 35.5
THC0049

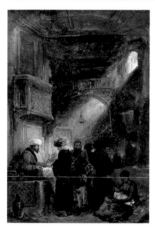

Müller, William James 1812–1845
Opium Stall 1841
oil on panel 40.6 x 27.9
THC0050

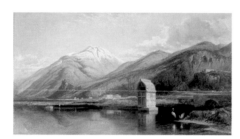

Müller, William James 1812–1845
Tomb in the Water, Telmessos, Lycia 1845
oil on canvas 76.1 x 137.1
THC0051

Munthe, Ludwig 1841–1896
Snow Scene 1873
oil on canvas 126.9 x 205.6
THC0052

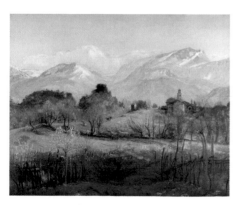

Murray, David 1849–1933
Spring in the Alps (Spring Blossoms to the Mountain Snows) 1910
oil on canvas 137.1 x 167.8
P1614

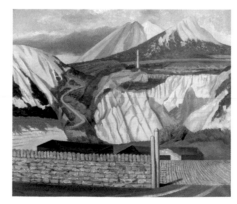

Nash, John Northcote 1893–1977
Mountain Landscape with Distant Lake 1939
oil on canvas 61 x 76.2
P1029

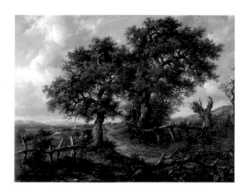

Nasmyth, Patrick 1787–1831
Landscape with Trees and Figures in the Foreground, a Church in the Distance 1830
oil on panel 30.4 x 40.6
THC0053

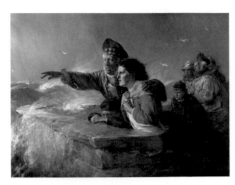

Nicol, Erskine 1825–1904
The Missing Boat 1876
oil on canvas 86.3 x 116.7
THC0054

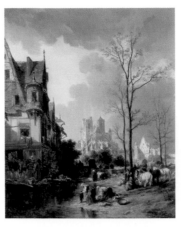

Noël, Jules Achille 1815–1881
Abbeville, with Peasants and Horses in the Foreground 1857
oil on panel 53.3 x 45.7
THC0055

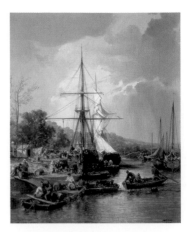

Noël, Jules Achille 1815–1881
The Quay, Hennebont, with Boats and Figures 1857
oil on panel 53.3 x 45.7
THC0056

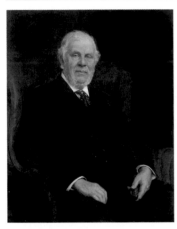

Olivier, Herbert Arnold 1861–1952
William James Russell (1830–1909)
oil on canvas 101.6 x 81.2
P0081

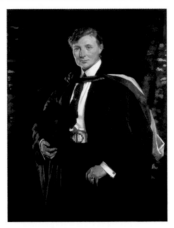

Orpen, William 1878–1931
Miss Ellen Charlotte Higgins 1926
oil on canvas 125.7 x 101.6
P1610

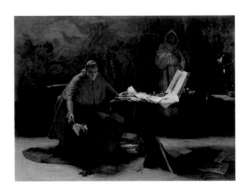

Pettie, John 1839–1893
A State Secret 1874
oil on panel 121.8 x 162.4
THC0057

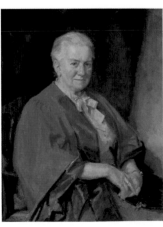

Phillips, Patrick Edward 1907–1976
Dr Edith Batho 1961
oil on canvas 91.5 x 71
P1611

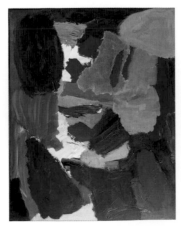

Pollock, Fred b.1937
Trossachs Blossom 1996
oil on canvas 205 x 160
P1674

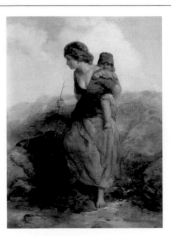

Poole, Paul Falconer 1807–1879
Crossing the Stream 1844
oil on panel 49.5 x 38
THC0058

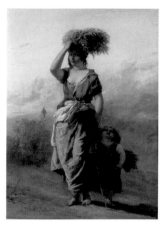

Poole, Paul Falconer 1807–1879
The Gleaner 1845
oil on canvas 48.2 x 38
THC0059

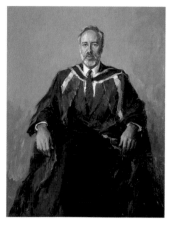

Poole, R. F.
Dr Roy Frank Miller c.1985
oil on canvas 122 x 91.5
P1553

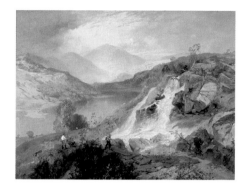

Pyne, James Baker 1800–1870
Haweswater from Waller Gill Force 1850
oil on canvas 83.7 x 111.7
THC0060

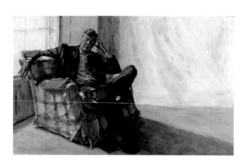

Riley-Smith, Louise b.1946
Norman Gowar 1999
oil on canvas 101.6 x 162.6
P1616

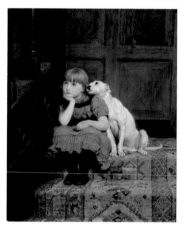

Riviere, Briton 1840–1920
Sympathy 1877
oil on canvas 121.8 x 101.5
THC0061

Riviere, Briton 1840–1920
An Anxious Moment 1878
oil on canvas 66 x 101.5
THC0062

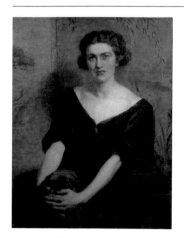

Riviere, Hugh Goldwin 1869–1956
Miss Peggy Wood 1935
oil on canvas 76.2 x 63.5
P1619

Roberts, David 1796–1864
Pilgrims Approaching Jerusalem 1841
oil on canvas 119.3 x 210.7
THC0063

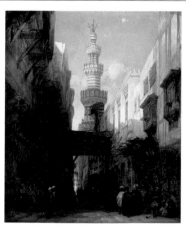

Roberts, David 1796–1864
A Street in Cairo 1846
oil on canvas 76.1 x 63.4
THC0064

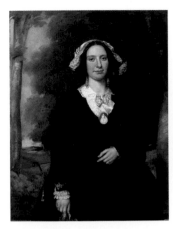

Scott, William Wallace 1795–1883
Jane Holloway 1845
oil on canvas 113 x 86.4
THC0066

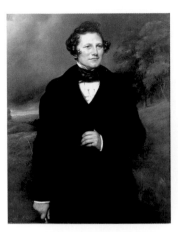

Scott, William Wallace 1795–1883
Thomas Holloway 1845
oil on canvas 115.6 x 83.8
THC0065

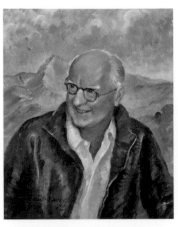

Scott-Moore, Elizabeth 1904–1993
Sir John Cameron (1903–1968) 1971
oil on canvas 76.2 x 61
P0065

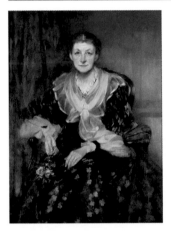

Shannon, James Jebusa 1862–1923
Miss Matilda Ellen Bishop 1897
oil on canvas 125.7 x 101.6
P1609

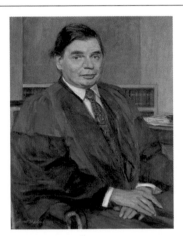

Shephard, Rupert 1909–1992
Professor Lionel Butler 1983
oil on canvas 91.5 x 71
P1552

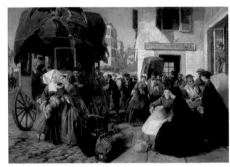

Solomon, Abraham 1824–1862
Departure of the Diligence 'Biarritz' 1862
oil on canvas 88.8 x 126.9
THC0067

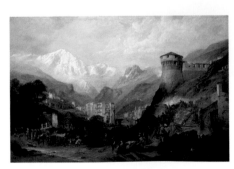

Stanfield, Clarkson 1793–1867
The Battle of Roveredo, 1796 1846
oil on canvas 182.8 x 274.2
THC0069

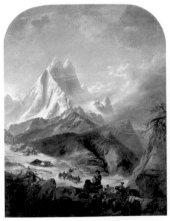

Stanfield, Clarkson 1793–1867
View of the Pic du Midi d'Ossau in the Pyrenees, with Brigands 1854
oil on canvas 213.2 x 152.3
THC0070

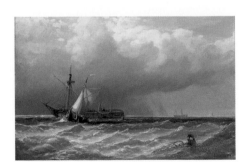

Stanfield, Clarkson 1793–1867
After a Storm
oil on millboard 21.5 x 33
THC0068

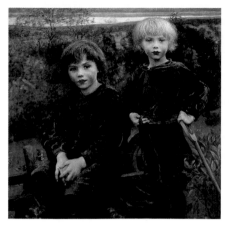

Swynnerton, Annie Louisa 1844–1933
Geoffrey and Christopher Herringham 1889
oil on canvas 91.5 x 91.5
P1367

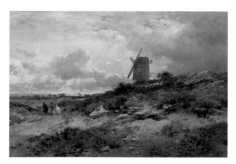

Syer, John 1815–1885
The Windmill 1878
oil on canvas 54.5 x 81.2
THC0071

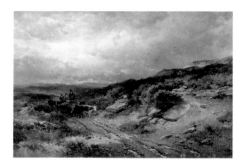

Syer, John 1815–1885
Welsh Drovers 1878
oil on canvas 81.2 x 121.8
THC0072

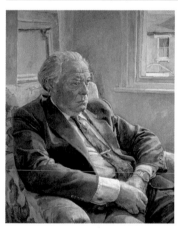

Todd, Daphne b.1947
Dr John Nicholson Black
oil on canvas 76.2 x 63.5
P1607

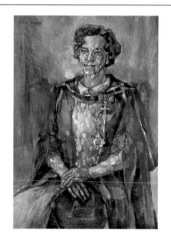

Tolansky, Ottilie 1912–1977
Dame Marjorie Williamson 1973
oil on canvas 106.8 x 76.2
P1613

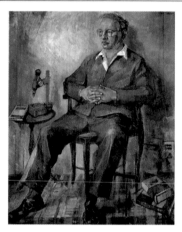

Tolansky, Ottilie 1912–1977
Professor Samuel Tolansky (d.1973)
oil on canvas 137.1 x 111.8
P1268

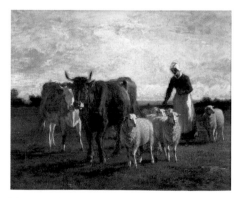

Troyon, Constant 1810–1865
Evening, Driving Cattle 1859
oil on canvas 66 x 88
THC0073

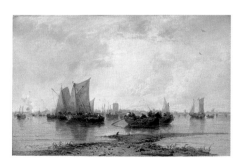

Webb, James c.1825–1895
Dordrecht before 1865
oil on canvas 22.8 x 35.5
THC0074

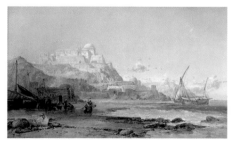

Webb, James c.1825–1895
Cartagena, Spain 1874
oil on canvas 76.1 x 126.9
THC0075

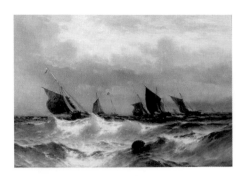

Weber, Theodor Alexander 1838–1907
Dover Pilot and Fishing Boats before 1882
oil on canvas 60 x 91.4
THC0076

Wells, Henry Tanworth 1828–1903
William Shaen 1877
oil on canvas 125.7 x 101.6
P0077

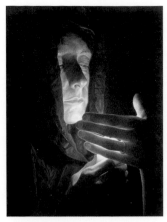

Wilkins, Clive
Woman with a Shielded Candle 1993
oil on board 20.3 x 17.7
P1621

Wragg, Gary b.1946
Medusa 1982
oil on canvas 253.5 x 176
P1671

Wragg, Gary b.1946
Blue Dragon 1984
oil on canvas 68.5 x 99
P1670

Epsom & Ewell
Borough Council

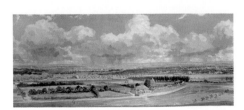

Birch, William Henry David 1895–1968
Epsom and Ewell from the Grandstand 1954
oil on canvas 54 x 125
2

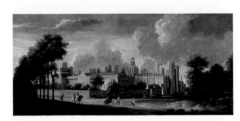

Danckerts, Hendrick (attributed to) 1625–1680
Nonsuch Palace from the North East c.1666–1679
oil on canvas 50 x 105
1

Royal Holloway, University of London

The spectacular facade of Royal Holloway is a familiar sight to motorists on the A30 between Egham and Sunningdale. Financed by the patent medicine millionaire, Thomas Holloway, it was designed by William Henry Crossland, who took the sixteenth-century Château de Chambord as his model, and opened as a college for women in 1886. No expense was spared. Solid, extravagant and richly decorated with sculpture, it stands as a monument to the wealth, optimism and spirit of philanthropy which so characterized the Victorian age. More famous even than the unique building is the collection of paintings which hangs in the College gallery in authentic High Victorian style, almost frame to frame and regardless of subject. It was assembled by Holloway in the last two years of his life, as the final educative touch to his generous endowment.

Heedless of cost, Holloway spent the equivalent, in today's terms, of several million on his collection. The importance he placed on it illustrates the Victorians' belief in art as the ultimate civilizing influence. Like literature, art could teach; not only in the obvious sense of portraying a moral lesson or illustrating an edifying text; but, in its own unique and inimitable way, through the medium of visual beauty. A picture collection of the first quality would provide the ultimate refining influence in Holloway's College for young ladies.

Virtually all the paintings were bought at Christie's, and the vast majority were modern. Holloway made his choice from the catalogues in consultation with his brother-in-law, George Martin, who did the bidding on his behalf. Amongst Holloway's purchases were some of the most important paintings of the period, including William Powell Frith's *The Railway Station* (1862), a panoramic view of the busy crowd at Paddington with the artist and his family in the centre-foreground. It is the most potent and revealing image ever painted of Victorian urban life; and no painting has been more admired or vilified. For the modernist critic Roger Fry, its mundane realism marked the lowest point to which Victorian art ever sunk: 'an artistic Sodom and Gomorrah', he called it. Frith, who expressed a healthy disdain for aesthetes, would have scorned such criticism. He knew that he was painting history in the making, and posterity has proved him right. As a visual social document and a repository of contemporary ideas, *The Railway Station* has few equals. It provides a stark contrast with another significant portrayal of contemporary life: Luke Fildes's *Casual Ward* (1874) – the toughest pictorial statement ever made on Victorian urban poverty and homelessness. It caused a sensation at the Royal Academy of 1874 and was voted picture of the year by popular assent. Fildes was the acknowledged leader of a group of artists who emerged independently in the 1870s, and whose direct engagement with the problems of the day earned them the title of the Social Realists. Frank Holl's *Newgate* (1878) is another masterpiece in this category. Painted from studies made in Newgate itself, it demonstrates the tenuous hold of the poor on respectability and the means of survival, both of which are instantly under threat when the breadwinner turns to crime.

Most Victorians preferred historical subjects to portrayals of their own time. Supreme amongst those at Royal Holloway is John Millais's *Princes in the*

Tower (1878); a masterly exercise in psychological drama which once adorned every child's history book. Daniel Maclise's *Peter the Great at Deptford Dockyard* (1857) is far more elaborate. It was based on contemporary accounts, and depends on an accumulation of historical detail to illustrate an episode from the period when the Russian Emperor visited England in order to learn how to construct his own navy. The contrast between the energetic figure of Peter, engaged in carpentry, and the refined and elegant form of William III, is the dramatic point of the picture. The largest painting in the Collection – Edwin Long's *Babylonian Marriage Market* (1875) is a meticulous archaeological reconstruction of the ancient world. Every detail was supplied by the Assyrian Galleries at the British Museum, and by published books by Austen Henry Layard and others on the excavations at Nineveh and other sites. The subject – young girls being auctioned in the market place, in order of beauty – may seem an odd choice for a college for well-bred young ladies; but critics agreed that the artist had handled the subject with irreproachable delicacy.

Holloway also secured two of the most celebrated animal paintings of the period. Briton Riviere unashamedly played to the gallery with *Sympathy* (1877); which shows his woeful little daughter being comforted by her pet bull terrier. Landseer, on the other hand, courted controversy with *Man Proposes - God Disposes* (1864) – a bleak portrayal of polar bears tearing at the remnants of an abandoned ship: a scarcely veiled reference to Sir John Franklin's ill-fated expedition to the Northern Arctic some 20 years previously. It may also be read as an image of the helplessness of man, and the ultimate decline and wreckage of all civilizations.

The cherished notion of an unspoiled countryside, and the continuity of traditional peasant and Highland life, is celebrated in landscape and figurative works by artists as distinguished as John Brett, Thomas Creswick, Thomas Faed, Benjamin W. Leader, John Linnell and John McWhirter. The much travelled Holloway, whose patent medicines reached the remotest corners of the world, also acquired scenes of favourite Continental destinations including Cairo, Venice, the Austrian Alps, Switzerland, the Pyrenees and Turkey. James Holland's view of Verona (1844), William J. Muller's *Tomb in the Water, Telmessus, Lycia* and Ludwig Munthe's Norwegian *Snow Scene* (1873) are particularly fine examples in this category.

Pride in Britain's naval and trading prowess is evident in numerous depictions of ships, harbours and dockyards; and the more negative aspect of native bull-dog pugnacity is celebrated in George Morland's portrayal of a press-gang in action. Clarkson Stanfield, whose contributions to the collection include a battle scene from the Napoleonic Wars, was himself press-ganged into the Royal Navy in 1812. Stanfield's ability to cover huge canvases at speed was aided by his time as a scene painter at Drury Lane Theatre – a task he shared with another great artist, David Roberts, whose *Pilgrims Approaching Jerusalem* (1841) is among Holloway's most inspired purchases.

The College also has a distinguished and varied secondary collection. This includes a large and impressive landscape by Sir David Murray, *Spring in the Alps*, which was exhibited as *Spring Blossoms to the Mountain Snows* at the RA in 1910. There is also a small number of paintings in tempera, dating from the turn of the twentieth century when the medium underwent a major revival in England. Most are high quality copies of early Renaissance paintings by Lady

Christiana Herringham, an expert in the field, and founder member of the Tempera Society in 1901. Another of her copies, in oils, of Gherardo di Giovanni's *Battle of Love and Chastity* (circa late fifteenth century, National Gallery, London), is perhaps the finest of all. *The Garden of the Slothful* (c.1901) by Margaret Gere, who was also active in the tempera revival, is a highly personal and charming interpretation of two verses from Proverbs.

The Herringham Collection, some portraits and other artworks, came with the merger of Bedford College with Royal Holloway in 1985. The College owns a number of outstanding portraits, including two by one of the most celebrated of all early-twentieth-century portrait painters, Philip De Laszlo. There are other major examples by Sir William Orpen, Sir Hubert von Herkomer (renowned as a Social Realist as well as a portrait painter), Sir James Shannon, David Jagger and Sir Herbert James Gunn. The tradition of commissioning portraits continues, and more recent examples include works by Sir Lawrence Gowing, Peter Greenham, Paul Brason and Louise Riley-Smith.

In 2001 the College was the recipient of an anonymous donation of ten contemporary paintings dating from the 1980s. These hang in the award-winning International Building, which was completed in 1999. They include John Bratby's *Washline, Little Bridge* (1989), Jon Groom's *Moorish House V*, and abstracts by Jeremy Annear, Fred Pollock and Gary Wragg. Other benefactors have enabled the College to acquire contemporary works which range from the representational to installations and other conceptual works. The former include particularly fine examples by Louise Courtnell, Steven Hubbard and Clive Wilkins.

In current values, Holloway spent at least £50,000,000 on the building and the collection. He appreciated the civilizing effects of art and architecture and their role in education, and through them he created a fitting memorial to himself and his wife. Holloway died rightly confident that his generous gift would inspire generations of students and teachers; and that inspiration has also been shared by the numerous visitors who have flocked to the College since it first opened. Holloway would have approved that the College buildings – and the contemporary art collection – continue to expand; for the enterprising spirit and generosity which make this possible are very much in the tradition of the College's original founder.

Mary Cowling, Curator & Lecturer in History of Art

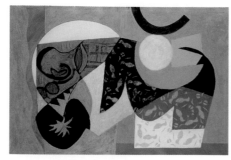

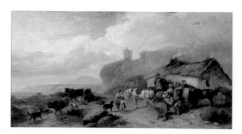

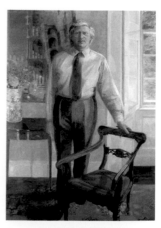

Annear, Jeremy b.1949
Untitled Abstract in Blue and Grey
oil on canvas 76.3 x 91.5
P1675

Ansdell, Richard 1815–1885
*The Drover's Halt, Island of Mull in the
Distance* 1845
oil on canvas 96 x 181.5
THC001

Atherton, Linda b.1952
Professor Drummond Bone 2002
oil on canvas 137.1 x 96
P1694

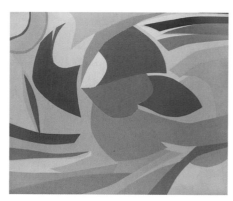

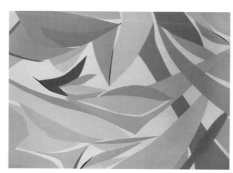

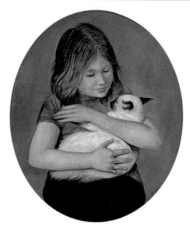

Atroshenko, Viacheslav 1935–1994
Musical Moment 1972
acrylic on canvas 152.4 x 182.8
P1695

Atroshenko, Viacheslav 1935–1994
New York I (of a series of six) 1978
acrylic on canvas 182.8 x 243.8
P1696

Backer
Girl with Siamese Cat c.1970
oil on canvas 58.5 x 48.3
P0443

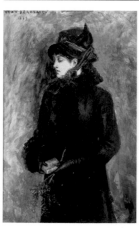

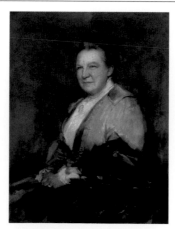

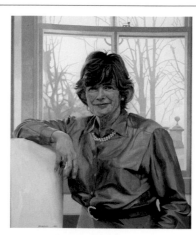

Bernhardt, Sarah 1844–1923
Le retour de l'église 1879
oil on board 38 x 22.8
P0492

Bigland, Percy 1858–1926
Henrietta Busk 1884?
oil on canvas 101.6 x 76.2
P0459

Brason, Paul b.1952
Professor Dorothy Wedderburn 1991
oil on canvas 91.5 x 76.2
P1551

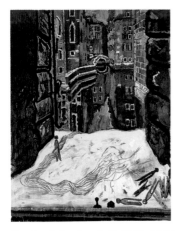

Bratby, John Randall 1928–1992
Washline, Little Bridge 1989
oil on canvas 122 x 91.5
P1672

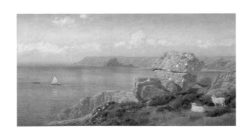

Brett, John 1830–1902
Carthillon Cliffs 1878
oil on canvas 45.7 x 91.4
THC002

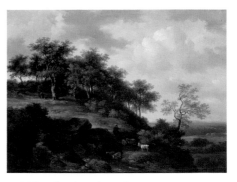

British School early 19th C
Wooded Landscape with Goat and Figures
oil on panel 35.5 x 47.8
P1010

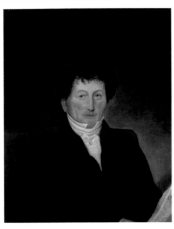

British School 19th C
Thomas Holloway Senior (d.1836)
oil on canvas 81.3 x 63.5
P0460

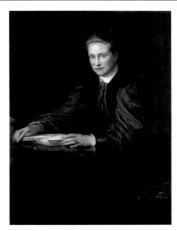

British School late 19th C
Dame Emily Penrose (1858–1942)
oil on canvas 111.2 x 86.5
P0471

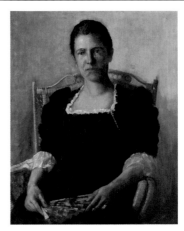

British School late 19th C
Mrs Louise d'Este Oliver (1850–1919)
oil on canvas 91.5 x 76.2
P0078

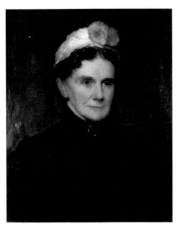

British School late 19th C
Mrs Maria Louisa Carlile (1826–1908)
oil on canvas 61.1 x 52
P0023

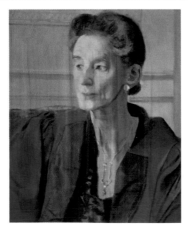

British School
Dr Nora L. Penston c.1964
oil on canvas 61 x 50.8
P1608

British School
Abstract Composition 1970s
acrylic on canvas 202.5 x 202.5
P1640

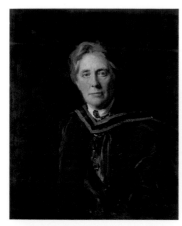

British School 20th C
Dame Margaret Janson Tuke (1862–1947)
oil on canvas 75.5 x 62.5
P0019

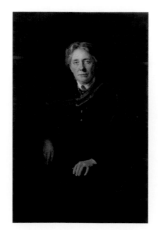

British School 20th C
Dame Margaret Janson Tuke (1862–1947)
oil on canvas 122 x 78
P0019A

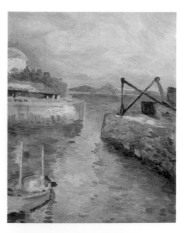

British School late 20th C
Harbour
oil on canvas 50.8 x 40.6
P0405

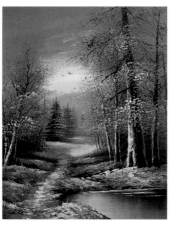

British School late 20th C
Winter Landscape with Lake
oil on canvas 45 x 35
P1684

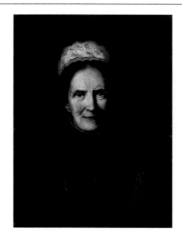

Bruce, H. A.
Miss Anna Swanwick (1813–1899)
oil on canvas 59.5 x 50
P0064

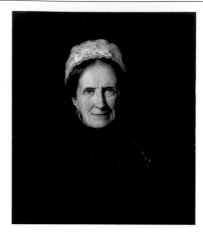

Bruce, H. A.
Miss Anna Swanwick (1813–1899)
oil on canvas 59.5 x 50 (E)
P1626

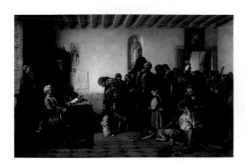

Burgess, John Bagnold 1830–1897
Licensing the Beggars in Spain 1877
oil on canvas 121.8 x 192.9
THC003

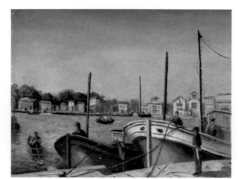

Butler, H. C.
Boats
oil on board 35 x 45
P0194

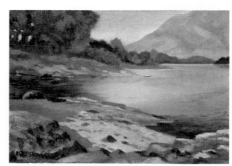

Butler, H. C.
Lakeside Landscape
oil on canvas 33 x 47
P0206

Facing page: Swedish School, *The Three Kings and the Wise and Foolish Virgins* (detail), c.1801–1828, Haslemere Educational Museum, (p. 171)

Carey, Charles William 1862–1943
Farm House, Mount Lee 1886
oil on canvas 34.2 x 44.4
P0210

Carey, Charles William 1862–1943
South East Corner of Royal Holloway College
1890
oil on canvas 22.8 x 35.5
P0787

Carey, Charles William 1862–1943
*South West Terrace Steps, Royal
Holloway* 1896
oil on canvas 50.8 x 61
P0205

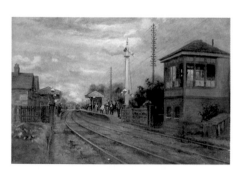

Carey, Charles William 1862–1943
Egham Station
oil on canvas 89 x 130
P0401 (P)

Chamberlain, Brenda 1912–1971
Seascape in Red 1959
oil on canvas 30.5 x 35.5
P1561

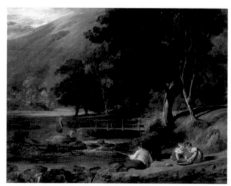

Collins, William 1788–1847
*Borrowdale, Cumberland, with Children
Playing by the Banks of a Brook* 1823
oil on canvas 86.3 x 111.7
THC004

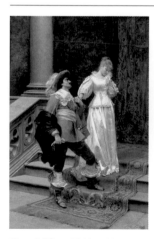

Conti, Tito 1842–1924
Goodbye 1877
oil on canvas 63.4 x 45.7
THC007

Conti, Tito 1842–1924
Approved
oil on panel 38 x 27.9
THC006

Conti, Tito 1842–1924
Paying Her Respects to His High Mightiness
oil on panel 44.4 x 31.7
THC005

Cooke, Edward William 1811–1880
Scheveningen Beach 1839
oil on canvas 45.7 x 91.4
THC008

Cooke, Edward William 1811–1880
*A Dutch Beurtman Aground on the
Terschelling Sands, in the North Sea after a
Snowstorm* 1865
oil on canvas 106.6 x 167.5
THC009

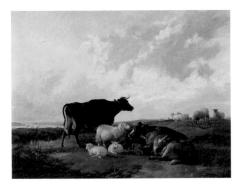

Cooper, Thomas Sidney 1803–1902
Landscape with Cows and Sheep 1850
oil on canvas 63.4 x 81.2
THC0010

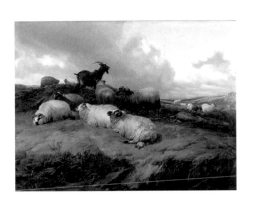

Cooper, Thomas Sidney 1803–1902
Landscape with Sheep and Goats 1856
oil on canvas 96.4 x 126.9
THC0011

Courtnell, Louise b.1963
Mr Shoa the Younger 1992
oil on canvas 68.5 x 53.3
P1622

Covey, Molly Sale 1880–1917
Portrait of an Elderly Gentleman
oil on canvas 50.8 x 35.5
P0457

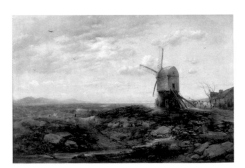

Creswick, Thomas 1811–1869
The First Glimpse of the Sea 1850
oil on canvas 101.5 x 152.3
THC0012

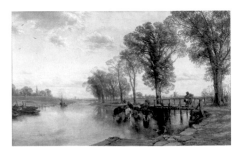

Creswick, Thomas 1811–1869
Trentside 1861
oil on canvas 114.2 x 182.8
THC0013

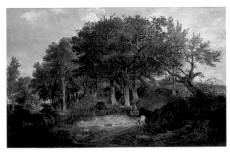

Crome, John (follower of) 1768–1821
A Woodland Scene 1813
oil on panel 78.7 x 121.9
THC0014

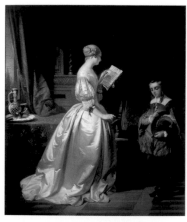

Daele, Charles van den d.1873
The Letter 1850
oil on panel 50.8 x 43.3
P1577

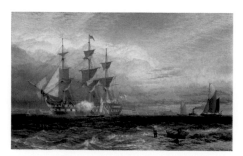

Dawson, Henry 1811–1878
Sheerness, Guardship Saluting 1875
oil on canvas 81.2 x 126.9
THC0015

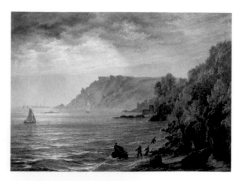

Dawson, Henry Thomas
1841/1842–after 1896
Salcombe Estuary, South Devon 1882
oil on canvas 76.1 x 106.6
THC0016

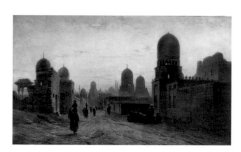

Dillon, Frank 1823–1909
Tombs of the Khedives in Old Cairo
oil on canvas 66 x 112
P0456

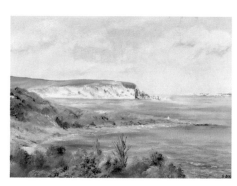

Dixon, G.
Seascape with Cliffs 1971
oil on board 28.5 x 39.5
P1688

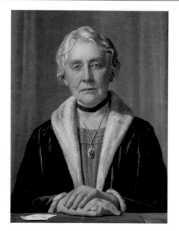

Dodd, Francis 1874–1949
*Dame Margaret Janson Tuke
(1862–1947)* 1934
oil on canvas 63.5 x 50.8
P0020

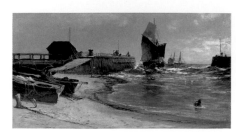

Ellis, Edwin 1841–1895
The Harbour Bar
oil on canvas 40.6 x 76.1
THC0017

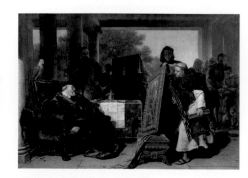

Elmore, Alfred 1815–1881
*The Emperor Charles V at the Convent of St
Yuste* 1856
oil on canvas 121.8 x 167.5
THC0018

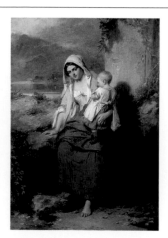

Faed, Thomas 1826–1900
Taking Rest 1858
oil on canvas 83.7 x 63.4
THC0019

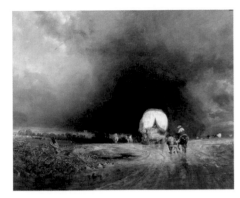

Fielding, Anthony V. C. 1787–1855
Travellers in a Storm, Approach to Winchester
1829
oil on canvas 101.5 x 126.9
THC0020

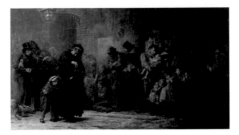

Fildes, Luke 1844–1927
Applicants for Admission to a Casual Ward
1874
oil on canvas 137.1 x 243.7
THC0021

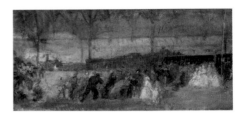

Frith, William Powell 1819–1909
Sketch for 'The Railway Station' c.1860
oil on canvas 17.7 x 25.4
P0068

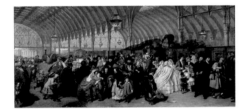

Frith, William Powell 1819–1909
The Railway Station 1862
oil on canvas 116.7 x 256.4
THC0022

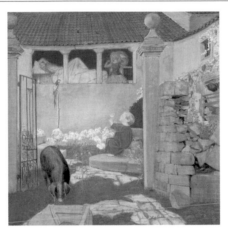

Gere, Margaret 1878–1965
The Garden of the Slothful c.1901
tempera on silk mounted on panel 26 x 26
P1280

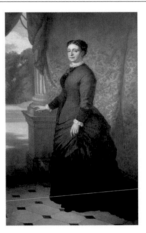

Girardot, Ernest Gustave 1840–1904
Jane Holloway (posthumous) 1882
oil on canvas 213.5 x 152.5
P1602

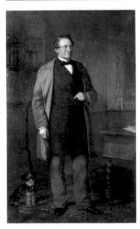

Girardot, Ernest Gustave 1840–1904
Thomas Holloway 1882
oil on canvas 213.5 x 152.5
P1601

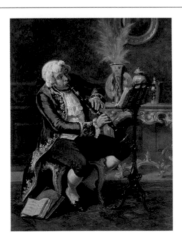

Glindoni, Henry Gillard 1852–1913
The Musician 1876
oil on panel 45.8 x 35.8
P1578

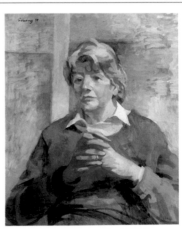

Gowing, Lawrence 1918–1991
Mrs E. M. Chilvers 1984
oil on canvas 76.2 x 63.5
P1606

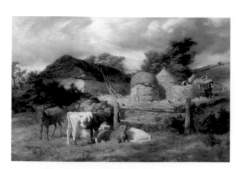

Graham, Peter 1836–1921
A Highland Croft 1873
oil on canvas 121.8 x 182.8
THC0023

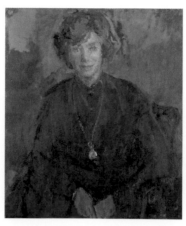

Greenham, Peter 1909–1992
Professor Dorothy Wedderburn 1985
oil on canvas 76.2 x 63.5
P0063 🐝

Groom, Jon b.1953
The Moorish House, V
oil on canvas 157.5 x 152.5
P1678

Gunn, Herbert James 1893–1964
Miss Geraldine E. M. Jebb, CBE 1952
oil on canvas 111.8 x 91.5
P1604

Gunn, Herbert James 1893–1964
*Sir Wilmot Herringham KCMG, CB, MD
(1855–1936)*
oil on canvas 132.1 x 91.5
P0079

Hamme, Alexis van 1818–1875
Feeding the Parrot 1860
oil on panel 53.3 x 44.4
P1579

Hardy, Frederick Daniel 1826–1911
*Expectation: Interior of Cottage with Mother
and Children* 1854
oil on panel 22.8 x 30.4
THC0024

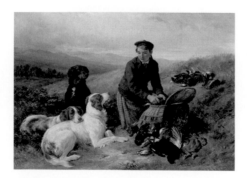

Hardy, James II 1832–1889
A Young Gillie, with Setters and Dead Game
1877
oil on canvas 71 x 99
THC0025

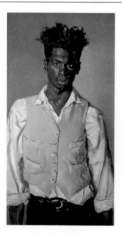

Haughton, Desmond b.1968
Self Portrait in a Yellow Waistcoat 1993
oil on canvas 81.3 x 45.7
P1620

Hazelwood, David B. 1932–1994
Fluttering 1966
oil on canvas 83.5 x 22
P1697

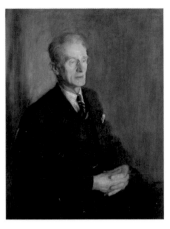

Hepple, Norman 1908–1994
Sir Charles Tennyson, 1954
oil on canvas 101.6 x 76.2
P0080 🐝

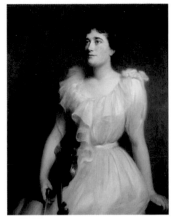

Herkomer, Hubert von 1849–1914
Marie Douglas (Mrs Arthur Stothert)
oil on canvas 111.8 x 86.5
P0824

Herringham, Christiana Jane 1852–1929
Asphodel
oil on canvas 91.5 x 61
P0453

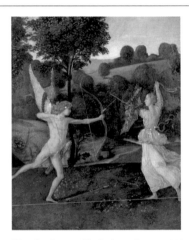

Herringham, Christiana Jane 1852–1929
Battle of Love and Chastity (after Gherardo di Giovanni del Fora)
oil on canvas 45.8 x 38
P1279

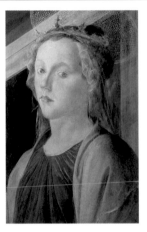

Herringham, Christiana Jane 1852–1929
Head of St Catherine (after Sandro Botticelli)
tempera on panel 45 x 28.5
P0145

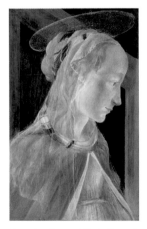

Herringham, Christiana Jane 1852–1929
Head of the Magdalene (after Sandro Botticelli)
tempera on panel 45 x 28.5
P0746

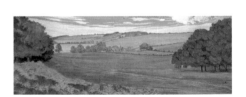

Herringham, Christiana Jane 1852–1929
Landscape with Farm
tempera on card 25 x 76.5
P15633

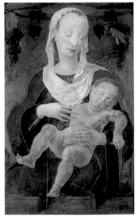

Herringham, Christiana Jane 1852–1929
Madonna and Child (after Cosmè Tura)
tempera on panel 62.5 x 42.5
P069A

Herringham, Christiana Jane 1852–1929
Pink Aquilegia, Yellow Foxgloves, Cow Parsley
oil on canvas 78.8 x 68.5
P1267

Herringham, Christiana Jane 1852–1929
Red Lilies on Blue Ground
oil on canvas 50.8 x 76.2
P1250

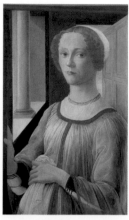

Herringham, Christiana Jane 1852–1929
Smeralda Bandinelli (after Sandro Botticelli)
tempera on panel 64.3 x 40.8
P0451

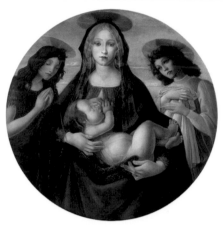

Herringham, Christiana Jane 1852–1929
Virgin and Child (after Sandro Botticelli)
oil on canvas 76.2
P1104

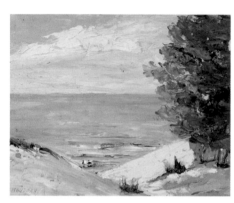

Heydorn, S.
Seascape
oil on card 20.3 x 24.8
P1687

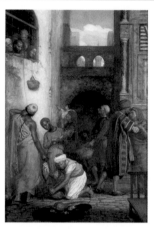

Hodgson, John Evan 1831–1895
Relatives in Bond 1877
oil on panel 93.9 x 66
THC0026

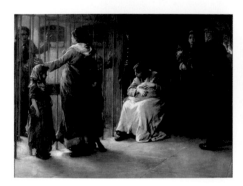

Holl, Frank 1845–1888
Newgate: Committed for Trial 1878
oil on canvas 152.3 x 210.7
THC0027

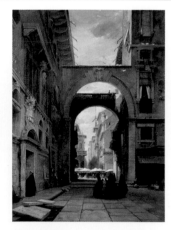

Holland, James 1800–1870
Piazza dei Signori, Verona, with the Market Place 1844
oil on canvas 101.5 x 76.1
THC0028

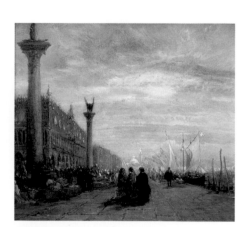

Holland, James 1800–1870
Venice, Piazza di San Marco 1850
oil on panel 22.8 x 27.9
THC0029

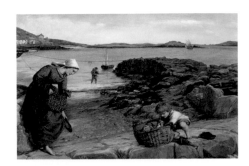

Hook, James Clarke 1819–1907
Leaving at Low Water 1863
oil on canvas 68.5 x 106.6
THC0030

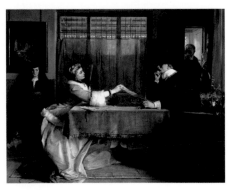

Horsley, John Callcott 1817–1903
The Banker's Private Room, Negotiating a Loan 1870
oil on canvas 101.5 x 126.9
THC0031

Hubbard, Steven b.1954
Self Portrait with Objects 1993
oil on canvas 91.5 x 61
P1623

Jagger, David 1891–1958
Miss Janet Ruth Bacon 1946
oil on canvas 76.2 x 63.5
P1612

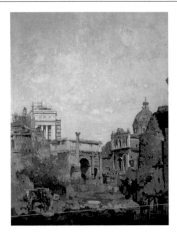

Kerr-Lawson, James 1865–1939
The Forum with the Arch of Constantine, Rome
oil on canvas 122 x 91.5
P0996

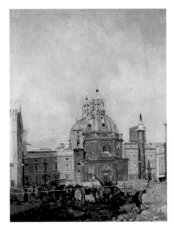

Kerr-Lawson, James 1865–1939
The Forum with Trajan's Column, Rome
oil on canvas 122 x 91.5
P0995

Koike, Masahiro
La fontaine 2003
oil on canvas 59 x 45.3
P1693

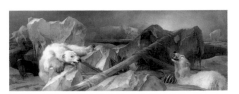

Landseer, Edwin Henry 1802–1873
Man Proposes, God Disposes 1864
oil on canvas 91.4 x 243.7
THC0032

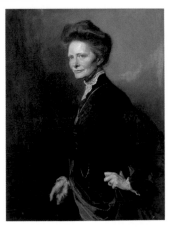

László, Philip Alexius de 1869–1937
Dame Emily Penrose (1858–1942) 1907
oil on canvas 116.8 x 91.5
P0471 ✷

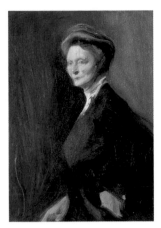

László, Philip Alexius de 1869–1937
Sketch for 'Dame Emily Penrose (1858–1942)'
1907
oil on canvas 34 x 24.3
P1683

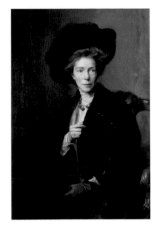

László, Philip Alexius de 1869–1937
Elizabeth Maude Guinness 1910
oil on canvas 101.6 x 76.2
P1600

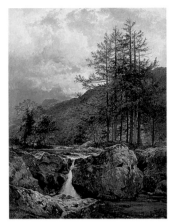

Leader, Benjamin Williams 1831–1923
The Rocky Bed of a Welsh River 1874
oil on canvas 121.8 x 91.4
THC0033

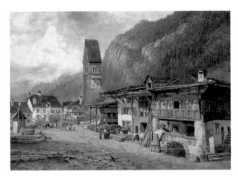

Leader, Benjamin Williams 1831–1923
Unterseen, Interlaken, Autumn in Switzerland
1878
oil on canvas 86.3 x 121.8
THC0034

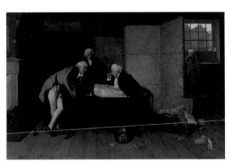

Leighton, Edmund Blair 1853–1922
A Flaw in the Title 1878
oil on canvas 60.9 x 91.4
THC0035

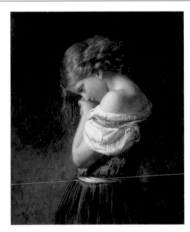

Lejeune, Henry 1820–1904
Early Sorrow 1869
oil on panel 30.4 x 25.3
THC0036

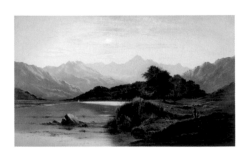

Leslie, Charles 1835–1890
Loch Katrine, Ellen's Isle 1879
oil on canvas 76.2 x 125.7
P1615

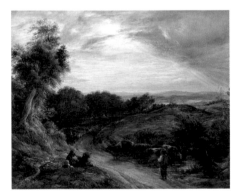

Linnell, John 1792–1882
Wayfarers 1849 & 1866
oil on canvas 71 x 91.4
THC0037

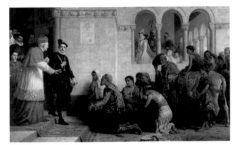

Long, Edwin 1829–1891
The Suppliants: Expulsion of the Gypsies from Spain 1872
oil on canvas 182.8 x 286.9
THC0038

Facing page: Muszynski, Leszek, b.1923, *Sunrise (triptych)* (detail), 1989, University of Surrey, (p. 123)

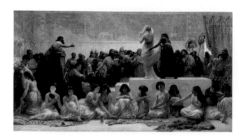

Long, Edwin 1829–1891
The Babylonian Marriage Market 1875
oil on canvas 172.6 x 304.6
THC0039

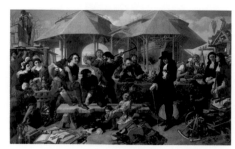

Maclise, Daniel 1806–1870
Peter the Great at Deptford Dockyard 1857
oil on canvas 152.3 x 243.7
THC0040

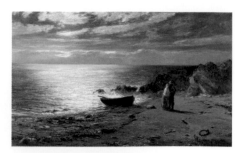

MacWhirter, John 1839–1911
*'Night, most glorious night, thou wert not
made for slumber'* 1874
oil on canvas 99 x 165
THC0041

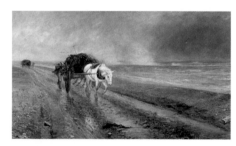

MacWhirter, John 1839–1911
Spindrift 1876
oil on canvas 81.2 x 142.1
THC0042

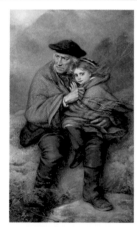

Mann, Joshua Hargrave Sams
active 1849–1884
The Cauld Blast 1876
oil on canvas 91.4 x 60.9
THC0043

Millais, John Everett 1829–1896
The Princes in the Tower 1878
oil on canvas 147.2 x 91.4
THC0044

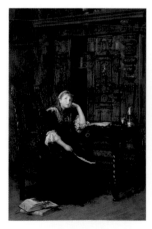

Millais, John Everett 1829–1896
Princess Elizabeth in Prison at St James's 1879
oil on canvas 144.7 x 101.5
THC0045

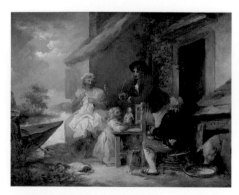

Morland, George 1763–1804
The Cottage Door 1790
oil on panel 35.5 x 45.7
THC0046

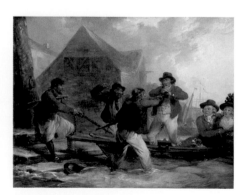

Morland, George 1763–1804
The Press-Gang 1790
oil on panel 35.5 x 45.7
THC0047

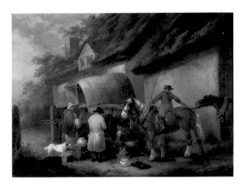

Morland, George 1763–1804
The Carrier Preparing to Set Out 1793
oil on canvas 86.3 x 116.7
THC0048

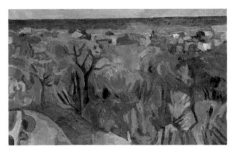

Morpurgo, Simonetta
Senigallia
oil on canvas 35.5 x 57
P0435

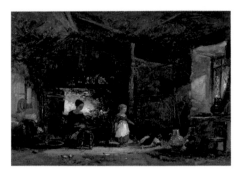

Müller, William James 1812–1845
Interior of a Cottage in Wales 1841
oil on panel 25.3 x 35.5
THC0049

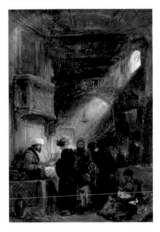

Müller, William James 1812–1845
Opium Stall 1841
oil on panel 40.6 x 27.9
THC0050

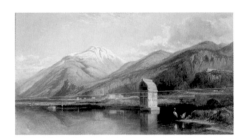

Müller, William James 1812–1845
Tomb in the Water, Telmessos, Lycia 1845
oil on canvas 76.1 x 137.1
THC0051

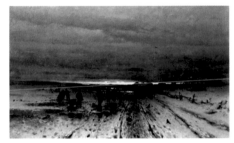

Munthe, Ludwig 1841–1896
Snow Scene 1873
oil on canvas 126.9 x 205.6
THC0052

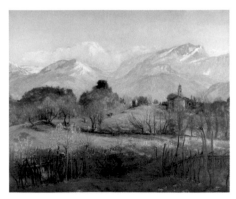

Murray, David 1849–1933
Spring in the Alps (Spring Blossoms to the Mountain Snows) 1910
oil on canvas 137.1 x 167.8
P1614

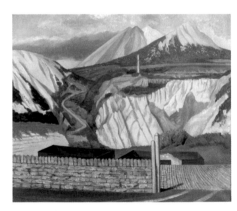

Nash, John Northcote 1893–1977
Mountain Landscape with Distant Lake 1939
oil on canvas 61 x 76.2
P1029

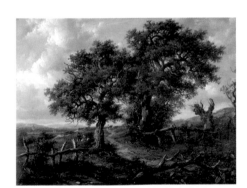

Nasmyth, Patrick 1787–1831
Landscape with Trees and Figures in the Foreground, a Church in the Distance 1830
oil on panel 30.4 x 40.6
THC0053

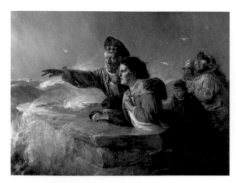

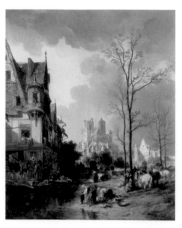

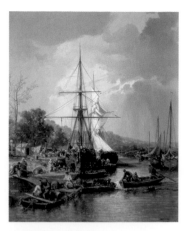

Nicol, Erskine 1825–1904
The Missing Boat 1876
oil on canvas 86.3 x 116.7
THC0054

Noël, Jules Achille 1815–1881
Abbeville, with Peasants and Horses in the Foreground 1857
oil on panel 53.3 x 45.7
THC0055

Noël, Jules Achille 1815–1881
The Quay, Hennebont, with Boats and Figures 1857
oil on panel 53.3 x 45.7
THC0056

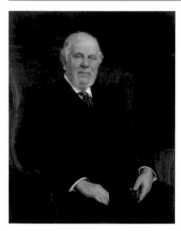

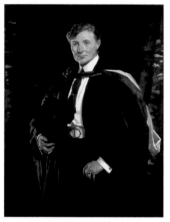

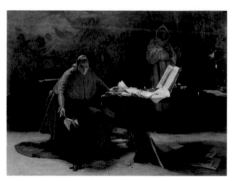

Olivier, Herbert Arnold 1861–1952
William James Russell (1830–1909)
oil on canvas 101.6 x 81.2
P0081

Orpen, William 1878–1931
Miss Ellen Charlotte Higgins 1926
oil on canvas 125.7 x 101.6
P1610

Pettie, John 1839–1893
A State Secret 1874
oil on panel 121.8 x 162.4
THC0057

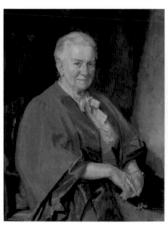

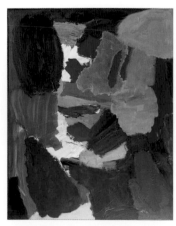

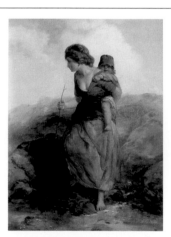

Phillips, Patrick Edward 1907–1976
Dr Edith Batho 1961
oil on canvas 91.5 x 71
P1611

Pollock, Fred b.1937
Trossachs Blossom 1996
oil on canvas 205 x 160
P1674

Poole, Paul Falconer 1807–1879
Crossing the Stream 1844
oil on panel 49.5 x 38
THC0058

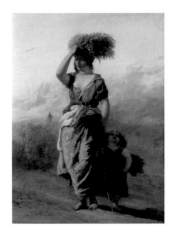

Poole, Paul Falconer 1807–1879
The Gleaner 1845
oil on canvas 48.2 x 38
THC0059

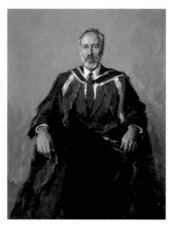

Poole, R. F.
Dr Roy Frank Miller c.1985
oil on canvas 122 x 91.5
P1553

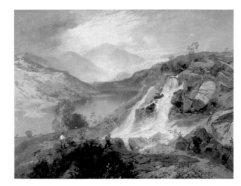

Pyne, James Baker 1800–1870
Haweswater from Waller Gill Force 1850
oil on canvas 83.7 x 111.7
THC0060

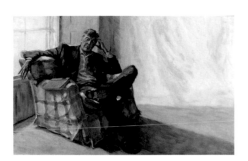

Riley-Smith, Louise b.1946
Norman Gowar 1999
oil on canvas 101.6 x 162.6
P1616

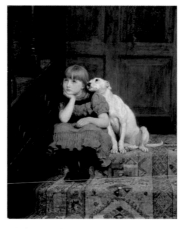

Riviere, Briton 1840–1920
Sympathy 1877
oil on canvas 121.8 x 101.5
THC0061

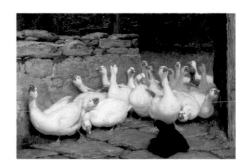

Riviere, Briton 1840–1920
An Anxious Moment 1878
oil on canvas 66 x 101.5
THC0062

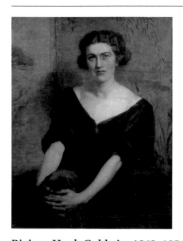

Riviere, Hugh Goldwin 1869–1956
Miss Peggy Wood 1935
oil on canvas 76.2 x 63.5
P1619

Roberts, David 1796–1864
Pilgrims Approaching Jerusalem 1841
oil on canvas 119.3 x 210.7
THC0063

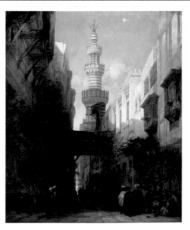

Roberts, David 1796–1864
A Street in Cairo 1846
oil on canvas 76.1 x 63.4
THC0064

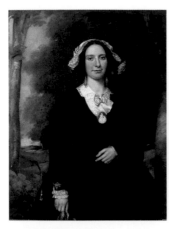

Scott, William Wallace 1795–1883
Jane Holloway 1845
oil on canvas 113 x 86.4
THC0066

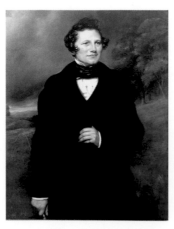

Scott, William Wallace 1795–1883
Thomas Holloway 1845
oil on canvas 115.6 x 83.8
THC0065

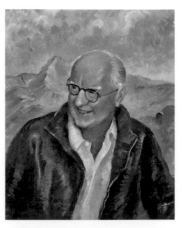

Scott-Moore, Elizabeth 1904–1993
Sir John Cameron (1903–1968) 1971
oil on canvas 76.2 x 61
P0065

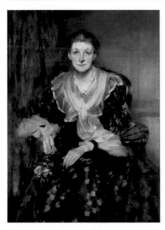

Shannon, James Jebusa 1862–1923
Miss Matilda Ellen Bishop 1897
oil on canvas 125.7 x 101.6
P1609

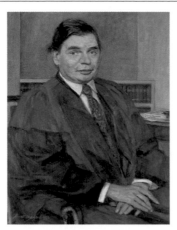

Shephard, Rupert 1909–1992
Professor Lionel Butler 1983
oil on canvas 91.5 x 71
P1552

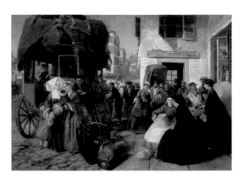

Solomon, Abraham 1824–1862
Departure of the Diligence 'Biarritz' 1862
oil on canvas 88.8 x 126.9
THC0067

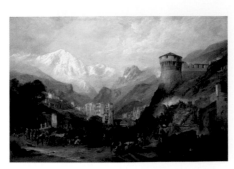

Stanfield, Clarkson 1793–1867
The Battle of Roveredo, 1796 1846
oil on canvas 182.8 x 274.2
THC0069

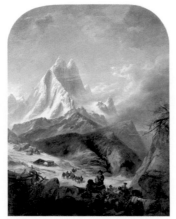

Stanfield, Clarkson 1793–1867
*View of the Pic du Midi d'Ossau in the
Pyrenees, with Brigands* 1854
oil on canvas 213.2 x 152.3
THC0070

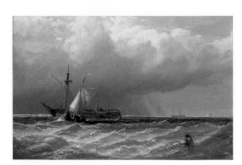

Stanfield, Clarkson 1793–1867
After a Storm
oil on millboard 21.5 x 33
THC0068

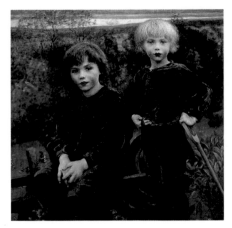

Swynnerton, Annie Louisa 1844–1933
Geoffrey and Christopher Herringham 1889
oil on canvas 91.5 x 91.5
P1367

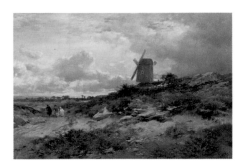

Syer, John 1815–1885
The Windmill 1878
oil on canvas 54.5 x 81.2
THC0071

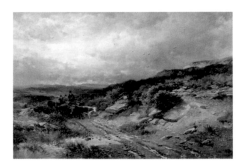

Syer, John 1815–1885
Welsh Drovers 1878
oil on canvas 81.2 x 121.8
THC0072

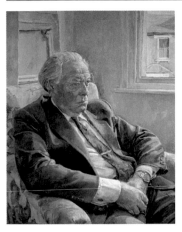

Todd, Daphne b.1947
Dr John Nicholson Black
oil on canvas 76.2 x 63.5
P1607

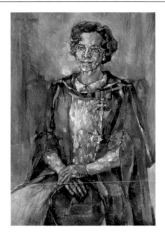

Tolansky, Ottilie 1912–1977
Dame Marjorie Williamson 1973
oil on canvas 106.8 x 76.2
P1613

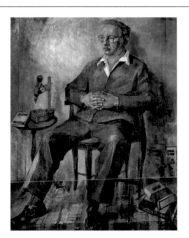

Tolansky, Ottilie 1912–1977
Professor Samuel Tolansky (d.1973)
oil on canvas 137.1 x 111.8
P1268

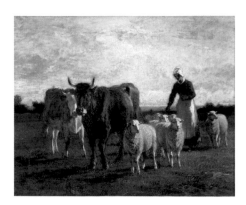

Troyon, Constant 1810–1865
Evening, Driving Cattle 1859
oil on canvas 66 x 88
THC0073

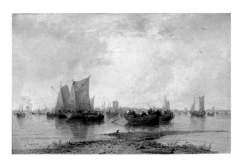

Webb, James c.1825–1895
Dordrecht before 1865
oil on canvas 22.8 x 35.5
THC0074

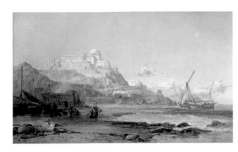

Webb, James c.1825–1895
Cartagena, Spain 1874
oil on canvas 76.1 x 126.9
THC0075

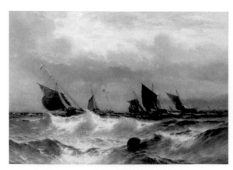

Weber, Theodor Alexander 1838–1907
Dover Pilot and Fishing Boats before 1882
oil on canvas 60 x 91.4
THC0076

Wells, Henry Tanworth 1828–1903
William Shaen 1877
oil on canvas 125.7 x 101.6
P0077

Wilkins, Clive
Woman with a Shielded Candle 1993
oil on board 20.3 x 17.7
P1621

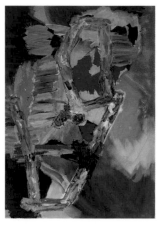

Wragg, Gary b.1946
Medusa 1982
oil on canvas 253.5 x 176
P1671

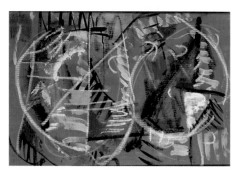

Wragg, Gary b.1946
Blue Dragon 1984
oil on canvas 68.5 x 99
P1670

Epsom & Ewell Borough Council

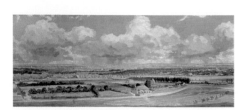

Birch, William Henry David 1895–1968
Epsom and Ewell from the Grandstand 1954
oil on canvas 54 x 125
2

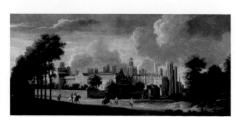

Danckerts, Hendrick (attributed to) 1625–1680
Nonsuch Palace from the North East c.1666–1679
oil on canvas 50 x 105
1

Esher Library

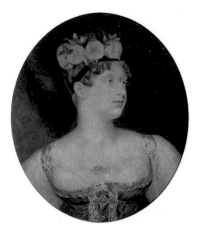

Dawe, George (copy of) 1781–1829
*Princess Charlotte Augusta of Wales
(1796–1817)* after 1816
oil on card 21 x 18
3

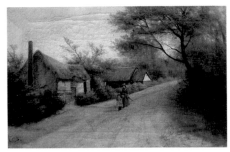

L. E. S.
Ember Lane, with a Woman and a Child
1890–1900
oil on canvas 29 x 44
1

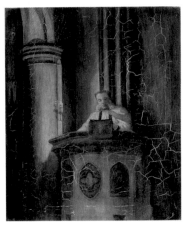

H. W.
Preacher at Christchurch, Esher, Surrey
oil on canvas 30 x 25
2

Bourne Hall
Museum

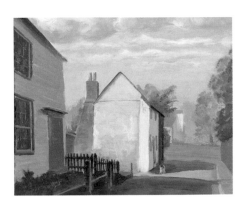

Cullerne, Rennie
Mill Lane, Ewell 1960s
oil on wood 30 x 36 (E)
1998.105

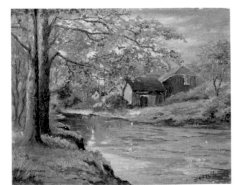

Pettit, D.
Lower Mill 1930s
oil on board 20 x 26
1990.140

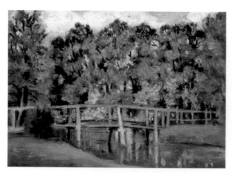

Stone, Helen C. 1884–1947
Bridge over the Hogsmill River, West Ewell
oil on canvas 27 x 36 (E)
1970.005

Stone, Helen C. 1884–1947
Old Cottages in West Ewell, Ewell
oil on canvas 40 x 26 (E)
1970.006

unknown artist
Mary Williams 1880s
oil on canvas 92 x 78 (E)
2002.017/002

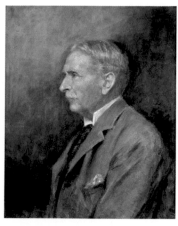 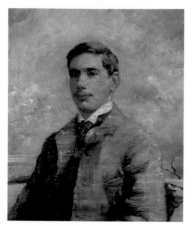

unknown artist
Sir Arthur Glyn 1880s
oil on canvas 82 x 72 (E)
2002.017/001

unknown artist
The Amato Inn c.1880s
oil on canvas 21 x 28
2005.040/014

unknown artist
Gervas Powell Glyn 1890s
oil on canvas 77 x 65 (E)
1990.135/005

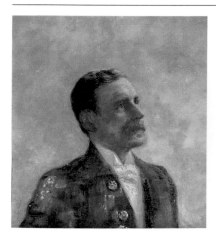 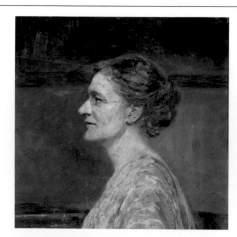

unknown artist
Gervas Powell Glyn 1900s
oil on canvas 57 x 53
1990.135/004

unknown artist
Margaret Glyn 1900s
oil on canvas 85 x 65
1990.135/006

unknown artist
Arthur Glyn 1910s
oil on canvas 60 x 46
1990.135/007

Facing page: Sime, Sidney Herbert, 1867–1941, *Woods and Dark Animals* (detail), Sidney H. Sime Memorial Gallery, (p. 233)

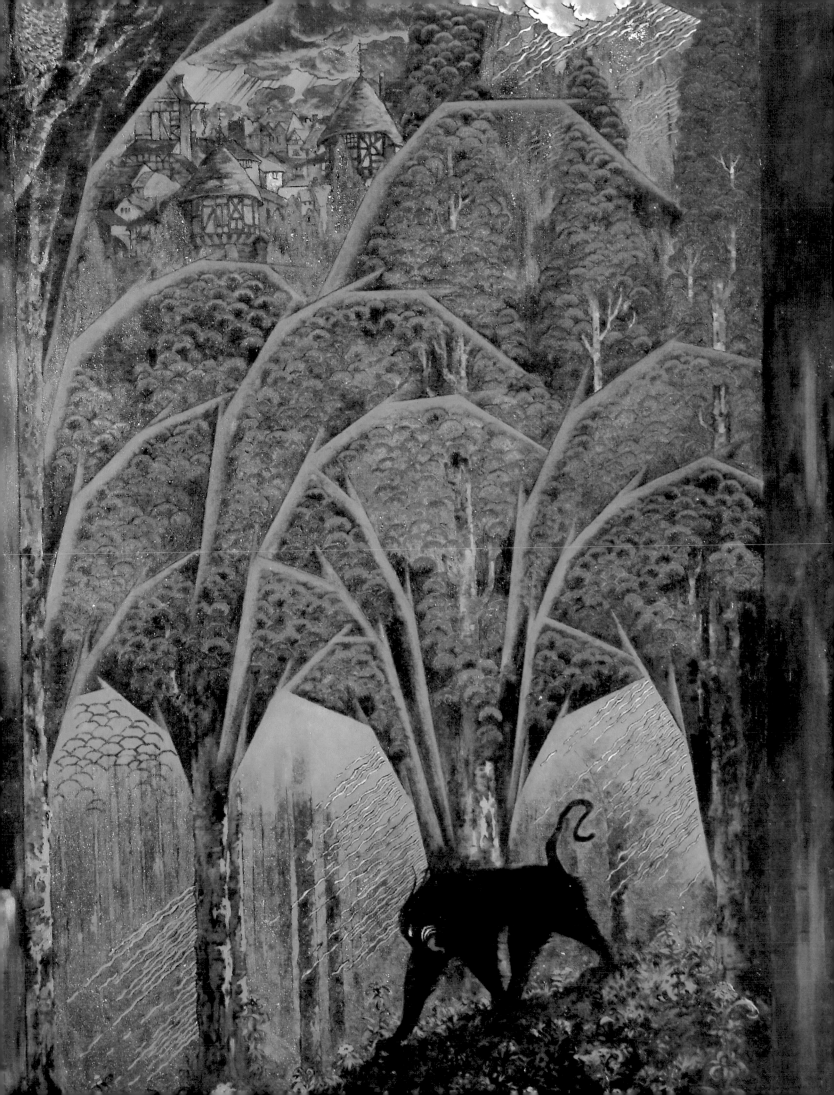

Ewell Court Library

Langer, D.
As I Remembered, Ewell Court Grounds 1980s
oil on board 47 x 60
1

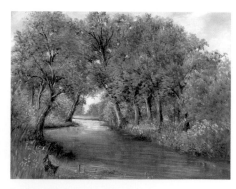

Langer, D.
As I Remembered, Hogsmill River 1980s
oil on board 49 x 60 (E)
2

Crafts Study Centre, University College for the Creative Arts

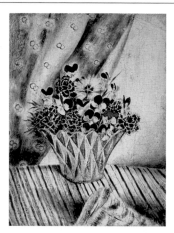

Larcher, Dorothy 1884–1952
Black Prince and Jackanapes c.1920–1930
oil on artboard 38 x 28
CSC.2006.19

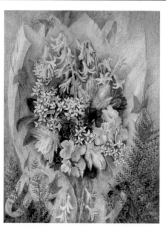

Larcher, Dorothy 1884–1952
Bunch for a Birthday 1945
tempera on gesso ground 40 x 29
CSC.2003.44

Farnham Maltings Association Limited

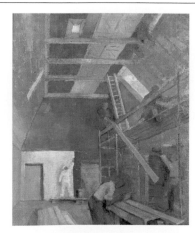

Anderson, Will
Kiln Conversion by DIY 1995
oil on board 59 x 49
FM3

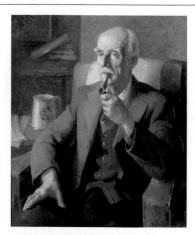

Bryson, Frank
Mr C. Biles 1950
oil on board 75 x 66
FM1

Krish, Raymond
The Philospher 1999
oil on board 91 x 34
FM2

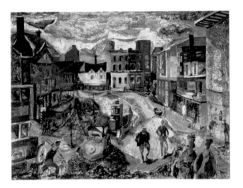

Verney, John 1913–1993
Castle Street, Farnham
oil on board 85 x 110
FM6

Verney, John 1913–1993
Pictures of Farnham
oil on board 43 x 73
FM4

Verney, John 1913–1993
Pictures of Farnham
oil on board 50 x 59
FM5

Museum of Farnham

The fine art Collection at the Museum of Farnham was started in 1961, when the Museum was first established. The Collection reflects the artistic heritage of Farnham, and its surrounding villages.

The fine art Collection contains works by prominent local artists, such as the eighteenth-century painter Stephen Elmer (c.1714–1796) who owned the building now occupied by the museum, but who lived and had his studio at a neighbouring property. Elmer was renowned in the eighteenth century for his skilful depiction of dead game. He was an Associate of the Royal Academy and exhibited there regularly from 1772 until his death. One contemporary critic favourably compared him with Stubbs, and his work adorned the walls of aristocratic homes throughout the country. The Museum of Farnham is thought to have one of the largest and finest collections of works by Elmer.

Another key figure in the artistic life of Farnham was William Herbert Allen (1863–1943). For many years he was Director of Farnham Art School, the forerunner of the University College for the Creative Arts at the Farnham Campus, which today enjoys an international reputation. Allen was strongly influenced by William Morris and was saddened by the rapid urbanisation at the turn of the twentieth century that was changing the face and character of the local landscape. He did his best to preserve the traditional local crafts and farming methods on paper and canvas, and he left a rich legacy of paintings, drawings and watercolours depicting the landscape of the Surrey and North Hampshire borders.

More recent works include a collection of paintings by John Verney (1913–1993). Born in London, Verney spent part of his childhood in India and served abroad with the SAS during the Second World War. He and his family settled in Farnham after the war, and for 30 years he was a familiar figure, tirelessly defending the town's heritage. Although he considered himself to be primarily an artist, Verney was also an accomplished author and illustrator. The Museum has been fortunate to acquire a number of his watercolours in recent years, most of which are on permanent display.

The Museum also owns four large murals by the New Zealand artist John Hutton (1906–1978) depicting women carrying out war work at the Crosby factory in Farnham. Hutton is probably better known for his engraved glass Great West Screen at Coventry Cathedral, but during the Second World War he was head of the Army School of Camouflage that was based at Farnham Castle. Hutton became friends with Basil Crosby who was in charge of the local bomb disposal squad and was invited to sketch the war work in progress at Crosby's factory. These sketches led Hutton to paint four heroic murals of the mainly female workforce making ammunition boxes, radio vans for use during the invasion of France and components for detonator boxes. The paintings were presented to Crosby's by the artist in 1946 and hung there in the staff canteen until the factory's closure in 1991. In that year, the owners of Crosby Sarek Ltd gave the paintings to the Museum in order to safeguard their long-term safety and ensure that they stay within the community. Because of the size of the murals the Museum was unable to display them, so they are on public display at the nearby Farnham Public Library.

Anne Jones, Curator

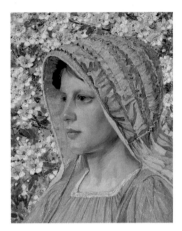

Allen, William Herbert 1863–1943
Bertha Clapshaw c.1900
oil on canvas 34 x 25.5
A980.5285

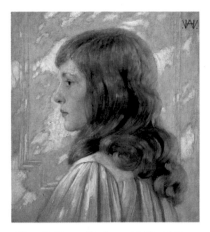

Allen, William Herbert 1863–1943
Winifred Clapshaw c.1900
oil on canvas 40 x 35
A980.5066

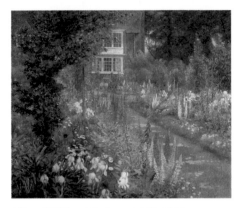

Allen, William Herbert 1863–1943
Stranger's Corner 1903
oil on canvas 102 x 120
A980.5158

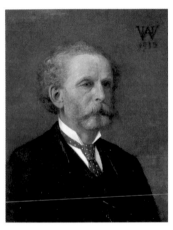

Allen, William Herbert 1863–1943
James Sydney Longhurst (d.1921) 1915
oil on canvas 57 x 44
609.2

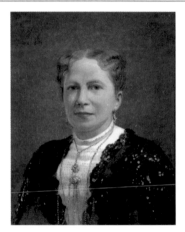

Allen, William Herbert 1863–1943
Phoebe Ellen Longhurst (d.1914) 1915
oil on canvas 58 x 44
609.1

Allen, William Herbert 1863–1943
Harvest Field with Elms
oil on canvas 26.5 x 36.5
A979.710

Allen, William Herbert 1863–1943
Italian Lake Scene
oil on canvas 35 x 52.5
A979.718

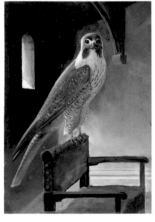

Booth, Ashton b.c.1925
Hawk 1971
oil on hardboard 34.5 x 23.5
A987.32

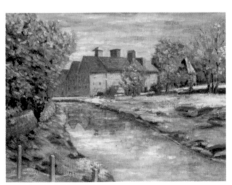

Brockman, Dale
The Maltings 1974
oil on hardboard 39.5 x 49.5
A991.29

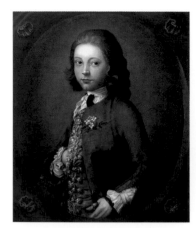

Elmer, Stephen c.1714–1796
Thomas Ashburne, Aged 11 Years 1735
oil on canvas 75 x 62.5
A996.25

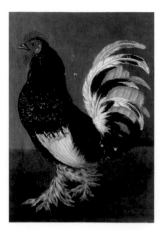

Elmer, Stephen c.1714–1796
A Cockerel Facing Left
oil on canvas 35 x 25
229-61

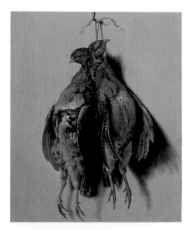

Elmer, Stephen c.1714–1796
Brace of Pheasant
oil on canvas 42 x 36
230-61

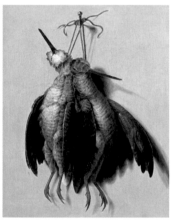

Elmer, Stephen c.1714–1796
Brace of Woodcock
oil on canvas 43 x 36
A979.2171

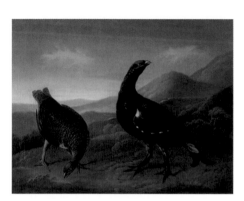

Elmer, Stephen c.1714–1796
Cock and Hen Black Grouse in Landscape
oil on canvas 61 x 74.5
A979.2111

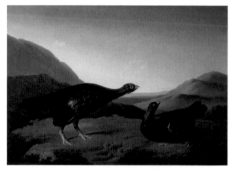

Elmer, Stephen c.1714–1796
Cock and Hen Red Grouse in Landscape
oil on canvas 62 x 75.5
A979.2115

Elmer, Stephen c.1714–1796
Dead Cock Pheasant
oil on canvas 80 x 61 (E)
227-61

Elmer, Stephen c.1714–1796
Dead Game with Pheasant
oil on canvas 62 x 74
A979.2175

Elmer, Stephen c.1714–1796
Dead Hare and Wild Fowl
oil on canvas 69.5 x 91
A980.5065

Elmer, Stephen c.1714–1796
Still Life with Pineapple and Other Fruit
oil on canvas 37 x 119
A979.2073

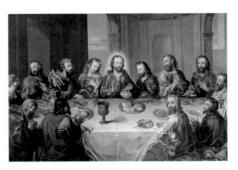

Elmer, Stephen c.1714–1796
The Last Supper
oil on canvas 150 x 191 (E)
A980.5619

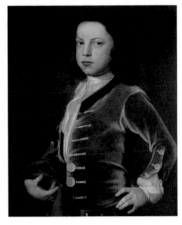

Elmer, Stephen c.1714–1796
William Elmer, Nephew of Artist
oil on canvas 64 x 52.5
A980.5063

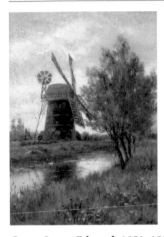

Grace, James Edward 1851–1908
Windmill
oil on canvas 34 x 24.5
A979.716

Harris, William E. 1860–1930
Cows Grazing in a Meadow 1891
oil on canvas 30 x 60.5
A979.616

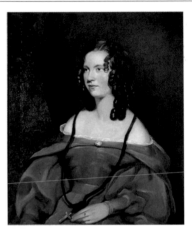

Hunter, Thomas Sr b.1771
Harriet Harding (d.1880) c.1835
oil on canvas 76 x 64
A002.29

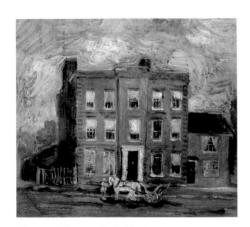

Hunter, Thomas Jr b.1821
Willmer House, Farnham c.1855
oil on board 16.5 x 18.7
A979.694

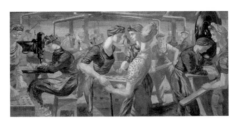

Hutton, John Campbell 1906–1978
Making Ammunition Boxes 1946
oil on panel 90 x 181
A991.41

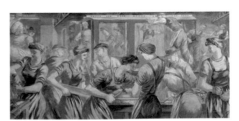

Hutton, John Campbell 1906–1978
Railway Carriages 1946
oil on panel 90 x 181
A991.41

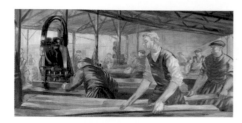

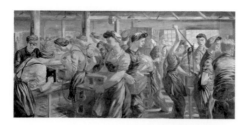

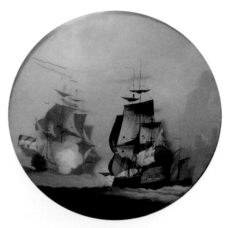

Hutton, John Campbell 1906–1978
Wartime Wood Machining 1946
oil on panel 90 x 181
A991.41

Hutton, John Campbell 1906–1978
Women Making Munitions Boxes 1946
oil on panel 90 x 181
A991.41

Loutherbourg, Philip James de 1740–1812
Sea Battle c.1790
oil on glass 12 x 12
A980.5369.1

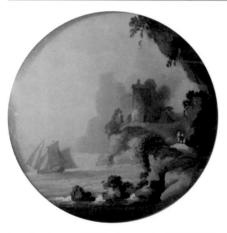

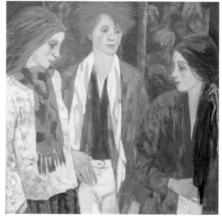

Loutherbourg, Philip James de 1740–1812
Seascape
oil on glass 12 x 12
A980.5369.2

McCannell, Ursula Vivian b.1923
'We don't know' c.1998
oil on hardboard 75 x 75
674

McCannell, William Otway 1883–1969
Colour 1966
oil on canvas 54 x 77
A980.5479

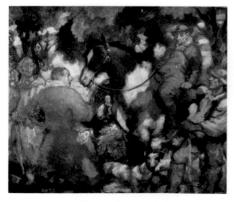

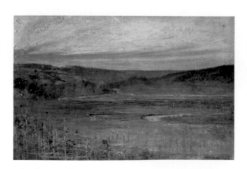

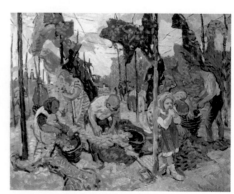

McCannell, William Otway 1883–1969
The Farmers
oil on canvas 53.5 x 64
A980.5480

Morley, Robert 1857–1941
River at Twilight
oil on canvas 50 x 76
A980.5616

Murphy, Clara Joan 1900–1986
*The Last Hop-Picking in the Chantries,
Farnham* c.1970
oil on canvas 61.5 x 74.5
A980.5326P

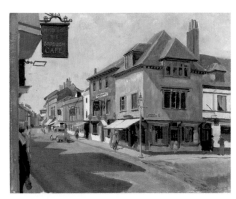

Newyin, R. Graham
View Looking from Mr Borelli's Courtyard
1949
oil on board 39 x 46
A991.28.88

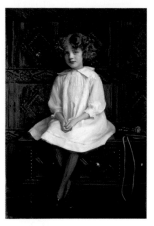

Peacock, Ralph 1868–1946
Eileen Fox 1908
oil on canvas 136 x 89.5
A979.2119

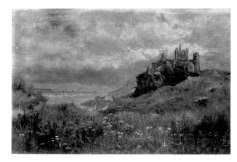

Ransom, George 1843–1935
Coastal Landscape with Castle 1892
oil on canvas 40 x 60.5
A979.1089

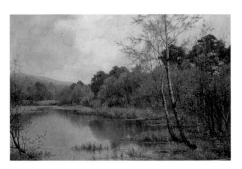

Ransom, George 1843–1935
Black Lake, Waverley
oil on canvas 59.5 x 90.5
3-74

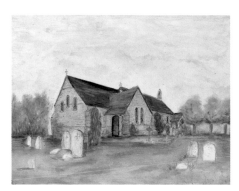

Reeves, Sidney b.c.1925
Old Bourne Church 1970s
oil on hardboard 26 x 34
A979.682

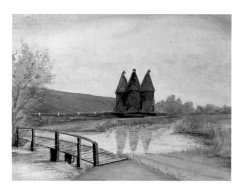

Reeves, Sidney b.c.1925
Landscape with Oasthouses
oil on hardboard 29 x 40.5
A979.684

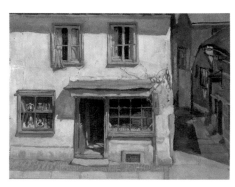

Russell, H. M. active mid-20th C
The Old Book Shop
oil on canvas 29 x 39
A979.714

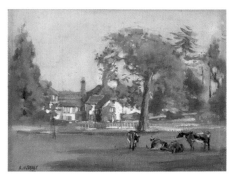

Seaby, Allan William 1867–1953
The Wakes from the Park 1912
oil on canvas 20 x 25 (E)
A979.634

Turk, W.
Farnham Castle c.1920
oil on hardboard 23.5 x 14.5
A996.17

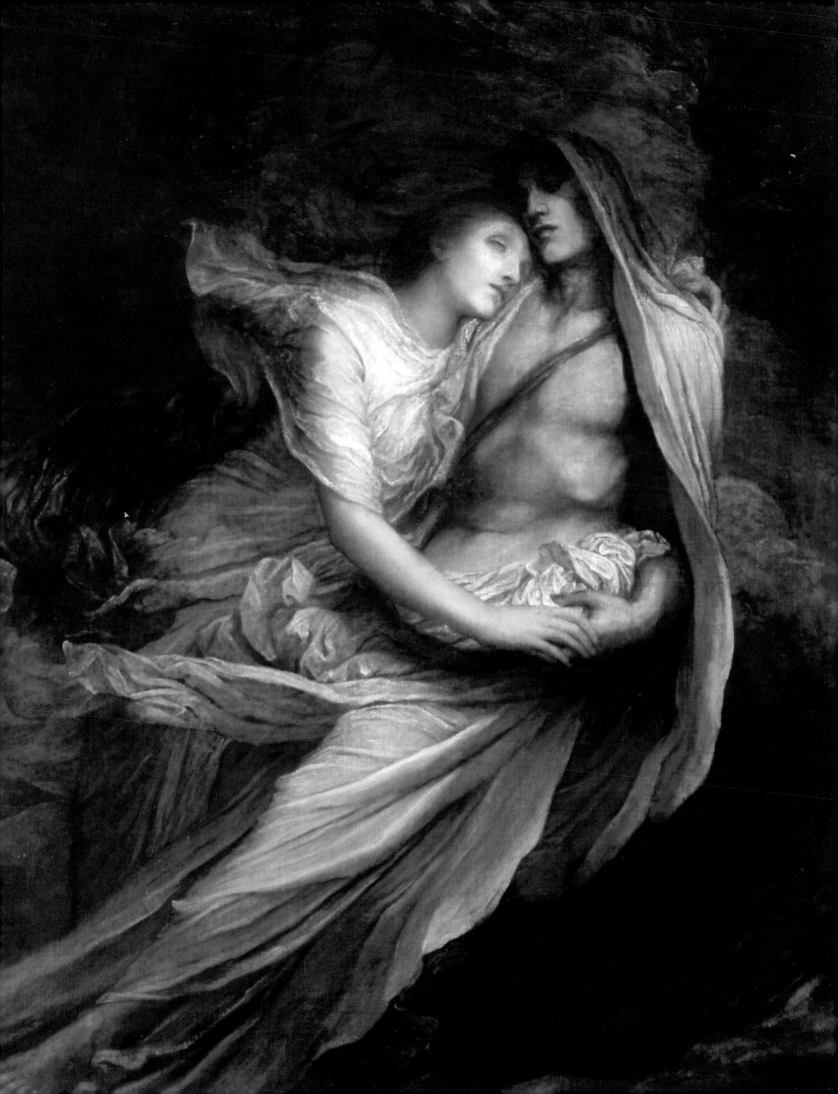

Turk, W.
Farnham Park Castle Approach c.1920
oil on hardboard 23.5 x 14.5
A996.16

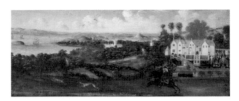

unknown artist
View over Bridgewater Bay c.1678
oil on wooden panel 57 x 142
A980.5522

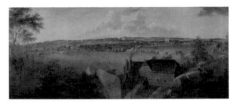

unknown artist
Panorama of Farnham c.1770
oil on canvas 56 x 148
A980.5280

unknown artist 18th C
Mr Cranston
oil on board 27 x 21
A979.2683

unknown artist 18th C
Portrait of a Lady
oil on canvas 34 x 25.5
A979.2313

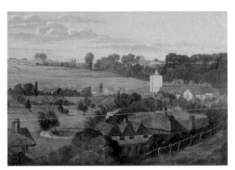

unknown artist
View of Farnham c.1830
oil on canvas 23 x 33
A991.27

unknown artist early 19th C
Portrait of a Member of the Duncan Family
oil on board 9.5 x 7.5
A979.5010.CAT.NO.68

unknown artist early 19th C
Sir David Ochterlony (1758–1825)
oil on board 9.5 x 8
A979.5010

unknown artist 19th C
Blacksmith Pulling Teeth
oil on wooden panel 28 x 20.5
A980.5053

Facing page: Watts, George Frederick, 1817–1904, *Paolo and Francesca* (detail), 1872–1875, Watts Gallery (see p.147)

unknown artist 19th C
Landscape at Night
oil on board 14 x 22.5
A979.696

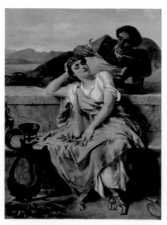

unknown artist 19th C
Poet Reading to a Seated Muse
oil on glass 21.5 x 16
A979.4406

unknown artist 19th C
Riverscape with Windmill and Fishermen
oil on glass 15 x 20
A980.5366.2

unknown artist 19th C
Seascape with Castle and Fisherman
oil on glass 15 x 20
A980.5366.1

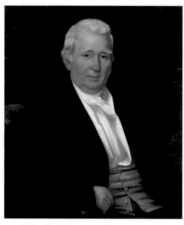

unknown artist 19th C
William Cobbett (1763–1835)
oil on canvas 74 x 61
A980.5185 (P)

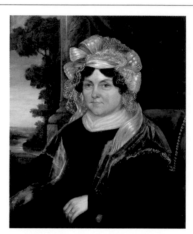

unknown artist 19th C
Mrs William Cobbett (1774–1848)
oil on canvas 74.5 x 62
A980.5186 (P)

unknown artist late 19th C
Angel
oil on wood 12 x 8.5
A979.4489

unknown artist
The Maltings c.1960
oil on hardboard 39 x 49
A994.23

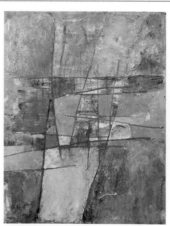

unknown artist
Abstract c.1970
oil on hardboard 86.5 x 66.5
0670

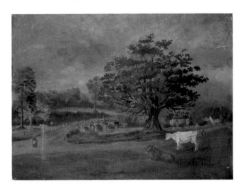

unknown artist early 20th C
Tilford Green and Cobbett's Oak
oil on canvas 101 x 130
A979.2121

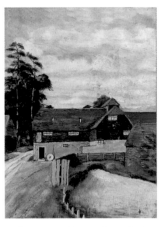

unknown artist early 20th C
Weydon Mill
oil on board 20.5 x 15
A982.59.2

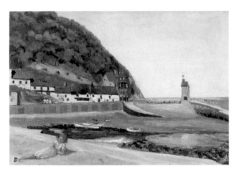

unknown artist 20th C
Shore Scene with Lighthouse
oil on card 25 x 35
A986.45

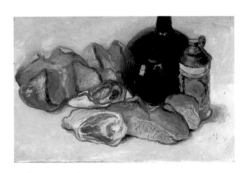

unknown artist
Still Life with Bread and Meat
oil on canvas 30 x 45.5
A979.608

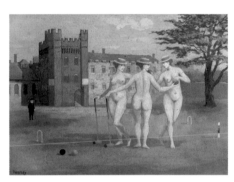

Verney, John 1913–1993
The Three Graces c.1965
oil on wood 25 x 34
A999.17

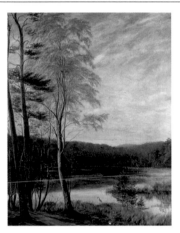

Wonnacott, Thomas 1835–1918
Black Lake, Waverley 1882
oil on canvas 90 x 69.5
A987.53

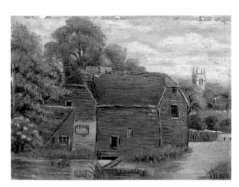

Wonnacott, Thomas 1835–1918
Weydon Mill 1910
oil on hardboard 14.5 x 19.5
A982.59.1

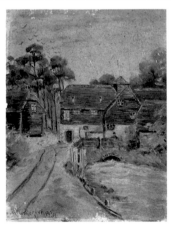

Wooderson, J.
Evening at Weydon Mill 1934
oil on hardboard 20.5 x 15.5
A979.2053

University College for the Creative Arts at the Farnham Campus

Ball, Robin 1910–1979
The Lovers
oil & collage 128 x 122.5
9

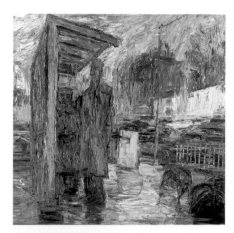

Butler, Paul b.1947
Bus Stop 1995
oil on board 120 x 120
1

Butler, Paul b.1947
City Night II 1999
oil on board 69.5 x 137
8

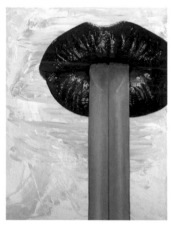

Clamp, Laura b.1980
Lips and Blue Straw
acrylic on canvas 66 x 51.5
11

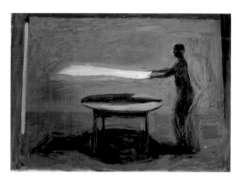

Edmonds, Frances b.1953
Blue Room 1993
oil on paper 93 x 130
2

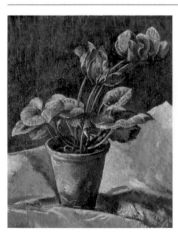

Hockey, James 1904–1990
A Cyclamen 1930
oil on board 39 x 30
5

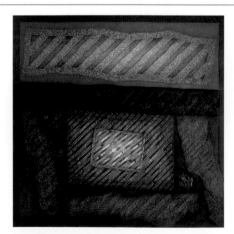

Hossain, Zahura Sultana
Where Am I? 2001
oil on board 140 x 140
6

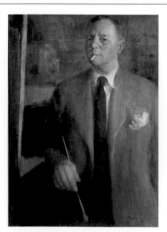

Muszynski, Leszek b.1923
James Hockey, RBA (1904–1990) 1954
oil on canvas 65 x 52
3

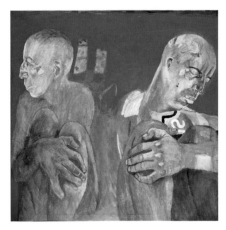

Northwood, Sally b.1935
Two Figures 1994
oil on canvas 105.5 x 105.5
4

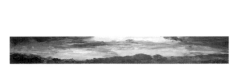

unknown artist late 20th C
Untitled
oil on canvas 16 x 117
10

Whamond, Andrew b.1947
Leaning Figure 2002–2004
oil on linen 85 x 110
7

Godalming
Library

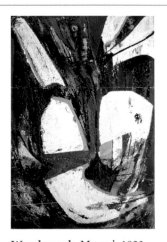

Wondrausch, Mary b.1923
Dead Magpie c.1956
mixed media on board 180 x 120.4
1

Godalming Museum

Godalming Museum was established in 1920 to preserve and share the story of the town and the surrounding area. Founded by the Town Council, it has always benefited from volunteer involvement and is now run in partnership by an independent charitable trust, Godalming Museum Trust, and Waverley Borough Council.

Originally set up in the Old Town Hall, the Museum is a friendly, welcoming place housed in a fascinating medieval building on the High Street. As well as displays on the geology, archaeology and history of the area, there is a gallery dedicated to the work of Gertrude Jekyll and Sir Edwin Lutyens and an exhibition space which shows the work of local artists and craftworkers. The garden, which is a living exhibit, is a copy of a border designed by Gertrude Jekyll for a house at Bramley. The Museum's local studies library offers access to published works on Godalming and the surrounding area, as well as photographs, ephemera and documents. The collections include many works about and by Gertrude Jekyll, as well as her planting notebooks and copies of her garden plans (the originals of which are held by the University of California).

The Museum collects art primarily for its local history interest. The Collection includes local views, portraits of individuals associated with the area and the work of local artists, both amateur and professional.

The more significant oil paintings in the Collection include *Thomas in the Character of Puss in Boots* (1869) and *The Sun of Venice Going to Sea (after Joseph Mallord William Turner)* (c.1870), both by Gertrude Jekyll.

Born in 1843, Gertrude Jekyll spent her childhood in Bramley. In later life, she was to become famous as a garden designer, especially for the commissions on which she worked with Arts and Crafts architect Sir Edwin Lutyens, but she originally trained as an artist. Always fond of cats, she was 26 when she painted her cat Thomas as Puss in Boots. She is thought to have painted the copy of Turner's *The Sun of Venice* at around the same time. She is known to have admired the artist's work and to have spent time at the National Gallery copying his paintings. In the early 1880s, Jekyll commissioned a house, Munstead Wood, just outside Godalming, from Lutyens. Here she created a garden which is still greatly admired, and established a nursery to supply plants for the gardens she designed. She was fascinated by the traditional life of the countryside, which she recorded in her book *South West Surrey* (1904). In Godalming she campaigned to preserve the Old Town Hall and the Museum archive includes correspondence between her and the curator. Jekyll died in 1932 and is buried in Busbridge churchyard, where her memorial stone, designed by Lutyens, simply states 'Artist, Gardener, Craftswoman'.

Another painting of note is *Jack Phillips* (1912) by Ellis Martin. John George 'Jack' Phillips would never have expected to have his portrait painted. Born in 1887 above the drapers' shop which his parents managed, his first job was in the Post Office in Godalming High Street. Here he learned Morse code and began a career which was to lead to a prestigious posting as Chief Telegraphist on the 'Titanic'. As the great liner went down, Jack stayed at his post, sending the messages which guided the 'Carpathia' to rescue the survivors. He lost his

life in the disaster and became a national hero. This portrait, painted from a photograph after his death, was commissioned by the students of Godalming Grammar School, where Jack had been a pupil.

Ellis Martin was to become well known as the Ordnance Survey artist between the wars, designing many evocative map covers. Born in Plymouth in 1881, he was educated at King's College, Wimbledon and later studied art at the Slade. Two years before this portrait was painted he had married Mabel Verstage of Godalming. The couple lived in Southampton but maintained links with the Godalming area and Martin produced many attractive watercolours of the local countryside.

T. H. Huxley's portrait, painted by his artist son-in-law John Collier in 1883, is in the National Portrait Gallery. Thomas Henry Huxley, the great Victorian scientist and supporter of Darwin, began the family's connection with the Godalming area when he rented a house in Milford for the summer of 1883. His son Leonard was appointed a master at Charterhouse two years later, a post which gave him the means to get married. His wife, Julia Arnold, granddaughter of the headmaster of Rugby, went on to establish her own school in Godalming, Priors Field, which celebrated its centenary in 2002. Their son Aldous was one of its first pupils and indeed is believed to be the only boy ever to attend the school.

Towards the end of his life, Collier, by then living in Egypt, told the *Egyptian Gazette* that he was making a series of replicas of his most important pictures and it may well be that he painted this small version of the work in the National Portrait Gallery at this time. It is not known how the portrait entered the Museum Collections. It is described in the 1950s catalogue as 'colour picture of an unknown man'. The Museum is indebted to conservator Sarah Cove who recognised the subject and to Jill Springall of the National Portrait Gallery who confirmed the identification and found the newspaper reference to Collier's plan to produce replicas of his paintings.

Alison Pattison, Curator

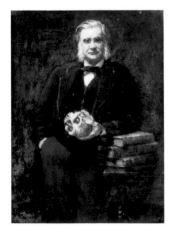

Collier, John 1850–1934
Thomas Henry Huxley (1825–1895)
oil on board 24.4 x 18.4
2195

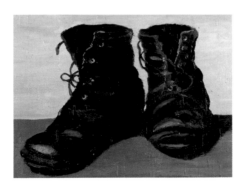

Duff, Pamela b.1920
Miss Jekyll's Boots (after William Nicholson)
1991
oil on canvas 31 x 40
B991.50

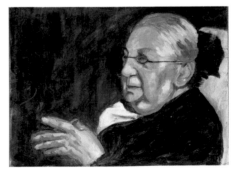

Duff, Pamela b.1920
Gertrude Jekyll (after William Nicholson)
1999
oil on canvas 30 x 40.4
B999.67

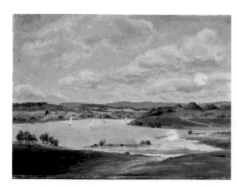

Harwood Eve
Great Pond, Frensham
oil on board 26.5 x 35.5
B980.783

Jekyll, Gertrude 1843–1932
Thomas in the Character of Puss in Boots 1869
oil on canvas 76.2 x 63.5
B999.60

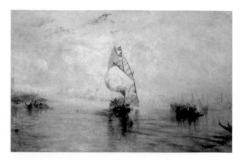

Jekyll, Gertrude 1843–1932
The Sun of Venice Going to Sea (after Joseph Mallord William Turner) c.1870
oil on canvas 150.1 x 227.8
B989.32

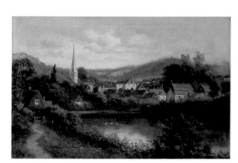

Lewis, J. active early 20th C
Godalming: A Bit of the Old Town
oil on canvas 50.7 x 76
B006.6

Martin, Ellis 1881–1977
Jack Phillips (1887–1912) 1912
oil on canvas 85 x 61
B004.34

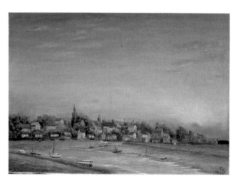

O'Brian, Henry active 1950s
Low Tide at Maldon, Essex 1953
oil on canvas 40.5 x 54.5
B980.623

O'Brian, Henry active 1950s
Berkshire Downs
oil on board 41 x 62
B980.775

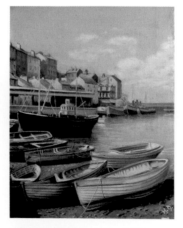

O'Brian, Henry active 1950s
Brixham Harbour
oil on canvas 47 x 36
B986.22

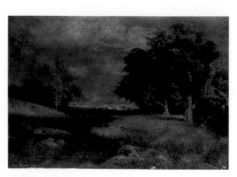

O'Brian, Henry active 1950s
Country Scene
oil on canvas 36 x 51
B980.627

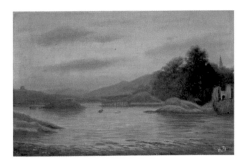

O'Brian, Henry active 1950s
Glengarriff, Kerry
oil on board 41 x 61
B980.625

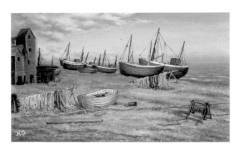

O'Brian, Henry active 1950s
Hastings Beach
oil on board 30.6 x 50.7
B980.626

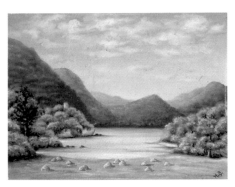

O'Brian, Henry active 1950s
Killarney from Muckross House Terrace, Co. Kerry
oil on board 30 x 39.5
B980.780

O'Brian, Henry active 1950s
Lake Geneva, Montreux
oil on board 32 x 51.5
B980.620

O'Brian, Henry active 1950s
Lakeside
oil on board 49.5 x 28.5
B980.621

O'Brian, Henry active 1950s
Nocturne
oil on board 44.5 x 59.5
B980.624

O'Brian, Henry active 1950s
River Glaslyn, Wales
oil on board 30.5 x 40.5
B980.629

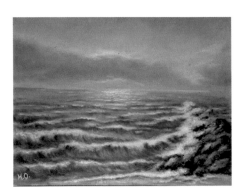

O'Brian, Henry active 1950s
Rolling Breakers at Evening
oil on board 35 x 46
B980.630

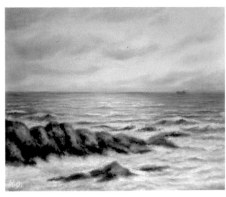

O'Brian, Henry active 1950s
Sea View with a Boat
oil on board 37 x 44
B980.631

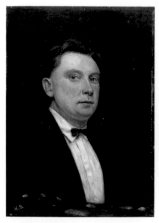

O'Brian, Henry active 1950s
Self Portrait
oil on canvas 35.7 x 25.5
B986.21

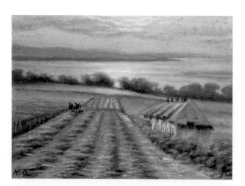

O'Brian, Henry active 1950s
Studland Bay, Dorset
oil on board 30 x 40.5
B980.628

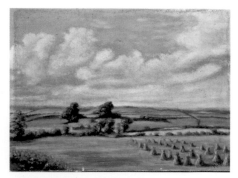

O'Brian, Henry active 1950s
Sussex Harvest
oil on board 32 x 43
B980.632

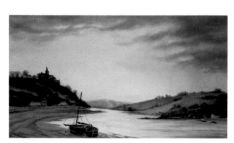

O'Brian, Henry active 1950s
The Church on the Hill
oil on board 38 x 68.3
B980.778

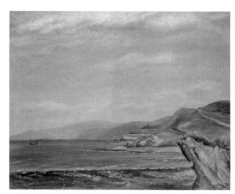

O'Brian, Henry active 1950s
Welsh Coast
oil on board 51 x 61.6
B980.622

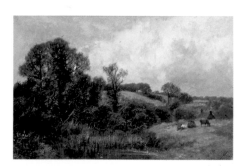

Peel, James 1811–1906
Roke Farm, Witley, Surrey
oil on canvas 20.5 x 31
B986.9

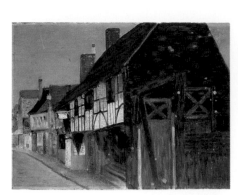

Smallman-Tew, F. active 20th C
Church Street, Godalming
oil on board 24 x 32
B980.758

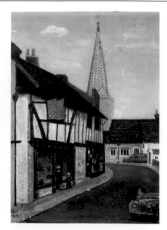

Smallman-Tew, F. active 20th C
Church Street, Godalming
oil on canvas board 35.5 x 25.3
2133

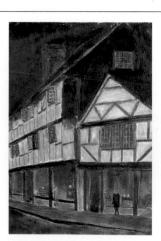

Smallman-Tew, F. active 20th C
Old Godalming by Moonlight
oil on canvas, laid onto board 35.2 x 24.5
B980.15

Facing page: Watts, George Frederick, 1817 –1904, *Time, Death and Judgement* (detail), 1884, Watts Gallery, (p. 151)

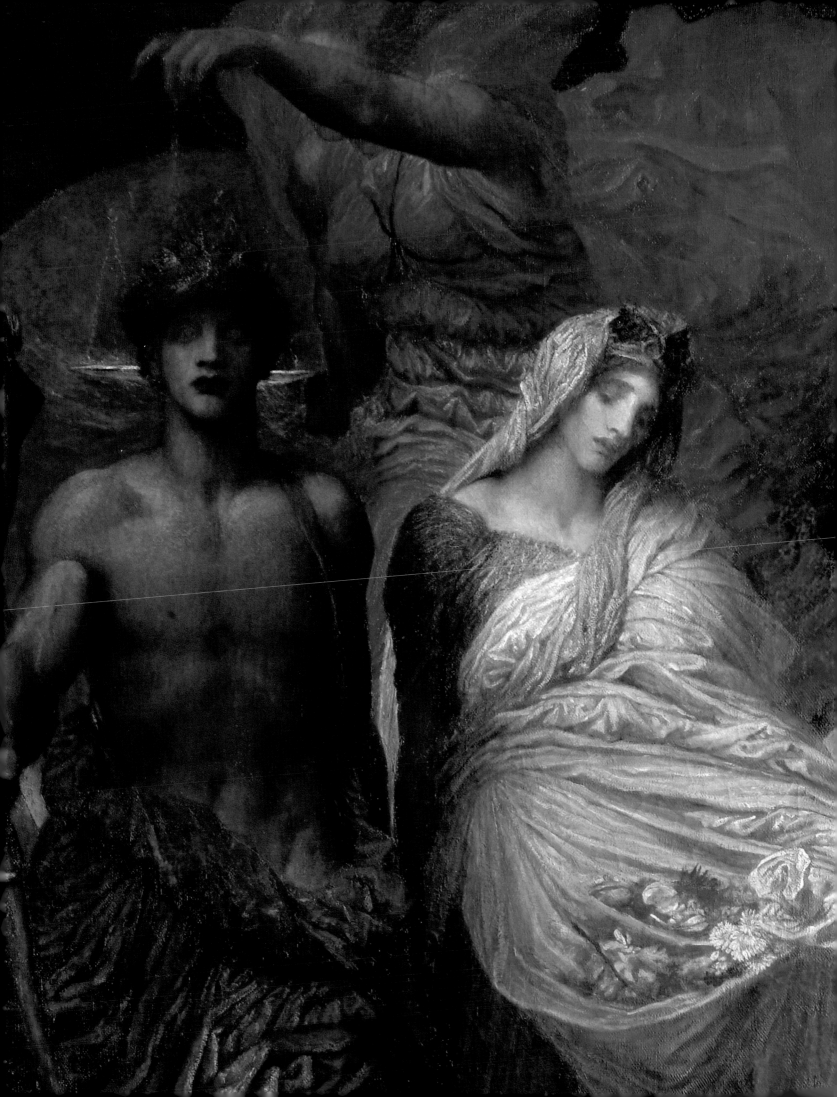

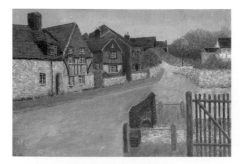

Smallman-Tew, F. active 20th C
The Millstream at Godalming
oil on board 25.5 x 35.5
2131

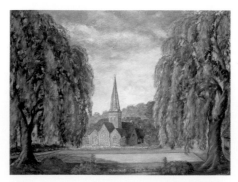

Smart, W. H. active mid-20th C
Godalming Church
oil on board 47 x 60.5
B000.18

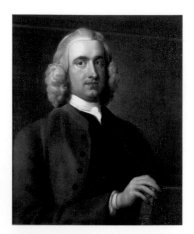

unknown artist
Dr Owen Manning 1758
oil on canvas 76.5 x 63.5
NN217

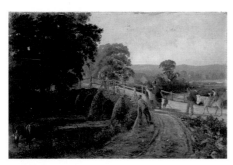

unknown artist 19th C
Ironstone Bridge, Tilthams Green
oil on canvas 30.8 x 45.8
NN097

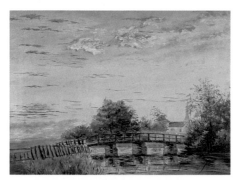

unknown artist 20th C
Old Borden Bridge
oil on canvas 25.4 x 35.5
B980.600

Godalming Town Council

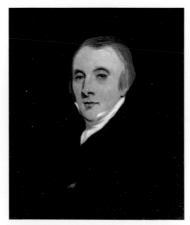

British (English) School mid-19th C
Sir Richard Balchin, Surgeon, Mayor of Godalming
oil on canvas 61 x 50.8
5

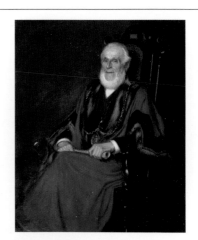

Donne, Walter J. 1867–1930
Alderman Thomas Rea 1907
oil on canvas 127 x 101.6
7

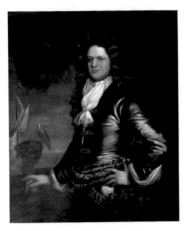

Kneller, Godfrey (style of) 1646–1723
Vice Admiral Sir John Balchin
oil on canvas 114.3 x 88.9
6

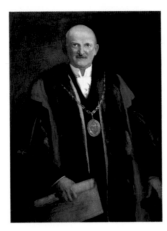

Schumacher, Vera active 1911–1913
*Joseph E. Sparkes, Mayor of Godalming
(1890–1892)* 1911
oil on canvas 129.5 x 94
1

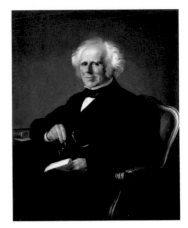

unknown artist 19th C
*Henry Marshall, First Mayor of Godalming,
1836*
oil on canvas 114.3 x 88.9
8

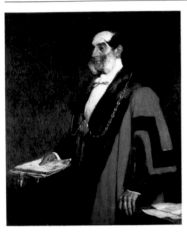

Watson, D.
John Simmonds, Mayor (1871 & 1875) 1876
oil on canvas 127 x 99.1
4

Waverley Borough
Council

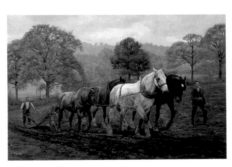

Hollams, F. Mabel 1877–1963
Horses Ploughing a Field 1904
oil on canvas 79 x 120
1

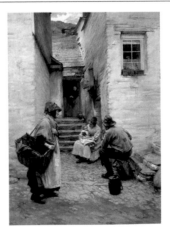

Langley, Walter 1852–1922
Cornish Village Scene
oil on canvas 135 x 98
2

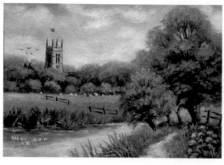

unknown artist
Farnham Church from the Meadows c.1869
oil on canvas 13.5 x 19
A979.2005

The White Hart Barn, Godstone Village Hall

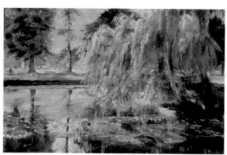

Burford, Eva active 1970–1985
Godstone Pond c.1980
oil on board 29.5 x 44
2

Butcher, Fred
Godstone High Street with the Clayton Arms
1902
oil on paper with board support 59.5 x 87.5
4

Hayner, D. (attributed to)
The Bay Pond, Godstone c.1980
oil on canvas 34 x 44.6
3

unknown artist
Ivy Mill Pond, Godstone c.1932
oil on canvas 24.5 x 30.5
1

Guildford House Gallery

Guildford Borough's Art Collection contains many fascinating artworks, despite its relatively compact size. Its home is Guildford House Gallery, an intriguing seventeenth-century townhouse in Guildford High Street. The Borough Council acquired the gallery building in 1957, and after restoration to much of its original appearance, the building opened as Guildford Borough Art Gallery in 1959. Today, Guildford House Gallery is well-known in Surrey and beyond for the Borough Collection and its exciting programme of temporary exhibitions. In 2005/2006, annual visitor numbers exceeded 120,000, which makes it one of the most popular cultural destinations in Surrey.

The Gallery was built as a private house for John Child, a London attorney and three times Mayor of Guildford, in about 1660. Built in an early Neo-Classical style, it contains many fine original architectural period features, including wooden wall-panelling, fine seventeenth-century plaster ceilings, rare espagnolette iron window bolts and an ornately carved Restoration staircase with fruit, flower and acanthus-leaf carving. The fine fittings of the house often surprise visitors and serve as a backdrop to the Borough Collection.

Guildford Borough's Collection comprises more than 550 pieces and small collections; many objects consist of multiple parts so the number of works comes close to 800. They span over 250 years and include a plethora of media – oil paintings, watercolours, pastels, etchings, engravings, prints, textiles, ceramics, sculpture and glass. In addition, there are interesting period furniture pieces on display within the Gallery, including a seventeenth-century court cupboard and a number of seventeenth- and eighteenth-century vernacular sideboards and chests-of-drawers. Guildford Borough's oil paintings thus form only one facet of this exciting and varied collection.

The Borough Collection has been built up through gifts, bequests and purchases over the past 50 years, and many of its historically most significant works have been acquired with assistance from national and local grant aid. New works are added to the Collection every year. Most of the Collection is not on continuous display; instead, the works are integrated carefully into the Gallery's varied exhibition programme. This temporary gallery display aids the preservation of the Collection and allows the Gallery to show as many objects as possible every year.

Many of the works in the Collection are by local artists and those with a strong Guildford connection; other pieces have associations with the Guildford area and Surrey. Guildford House Gallery is thus particularly well-known for the many works it owns by Guildford's most famous son, John Russell RA (1745–1806), who was pastel painter to King George III and his son, the Prince of Wales (later George IV). Guildford Borough's Collection of paintings by the artist is one of the largest in the country; as well as the three oil paintings depicted in this catalogue, the Russell Collection comprises 27 pastel portraits and numerous pen drawings, engravings and prints.

One of the most interesting and famous works is the oil painting of *Micoc and Tootac*. Micoc and her son Tootac were Inuit Indians from Labrador and were brought to England in the 1760s by Admiral Sir Hugh Palliser, Governor of Newfoundland between 1764 and 1766. Micoc and her son caused a

sensation in London and were presented at court, where George III presented Micoc with the medal she is depicted wearing in Russell's portrait. Interestingly, and fascinating from a historical perspective, the portrait was the first of 322 portraits Russell was to exhibit at the Royal Academy between 1769 and his death in 1806, and Robert Walpole described this picture as 'very natural'.

Graeme Highet (1905–1966), Edward Wesson (1910–1983) and Ronald Smoothey (1914–1996) are among many twentieth-century and contemporary painters represented in the Collection. Visitors enjoy their highly individual paintings and the eclectic mixture of pictorial and abstract works.

Currently, the Gallery is in the process of making all of its Collection available on its website on the Internet. Photographs of the works and short descriptions will become a valuable resource for study and enjoyment for those unable to visit the Gallery in person. The project will help overcome the access limitations of Guildford House Gallery's grade I listed gallery premises and will make the Gallery and its collections accessible for everyone for the first time in its history.

Now in its 47th year at Guildford House, the Gallery and the Borough Art Collection are flourishing; their future will, no doubt, be a vibrant and exciting one.

Christian Dettlaff, Gallery and Exhibitions Manager

Allison, Jane b.1959
Rose Cottage, Pockford Road, Chiddingfold
2004
oil on canvas 31 x 36
1113

Allison, Jane b.1959
View from the Chantries with Hawthorn Tree
2004
oil on canvas 50 x 59.5
1112

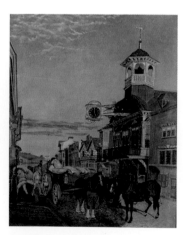

Boughton, Thomas 1812–1893
Guildford High Street c.1856–1858
oil on canvas 53.5 x 43.2
895

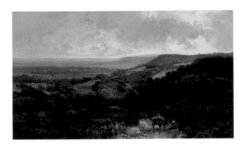

Caffyn, Walter Wallor 1845–1898
The Weald of Surrey 1887
oil on canvas 76.2 x 127
894

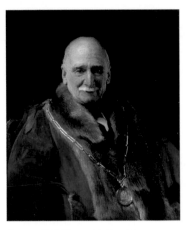

Carter, William 1863–1939
Mayor Ferdinand Smallpeice 1905
oil on canvas 74.5 x 61.5
730

Charlton, Mervyn b.1945
Moon Glow 1983
oil on board 90 x 95
780

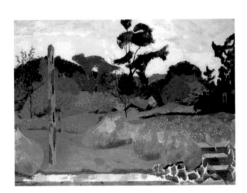

Cheesman, Harold 1915–1983
Landscape 1948
oil on canvas 71 x 90
927

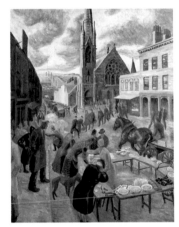

Collins, Helen 1921–1990
North Street, Guildford 1940s
oil on canvas 91.5 x 71.2
923

Collins, Helen 1921–1990
George Edward Collins
oil on canvas 35.8 x 30.6
972

Cracknell, Jennifer active 1960s–1970s
Rockfall 1971
oil on board 50.8 x 61
435

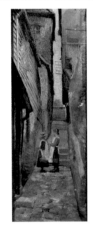

Cripps, Clara
Narrow Lane, Guildford c.1910
oil on canvas 40.7 x 15.2
1010

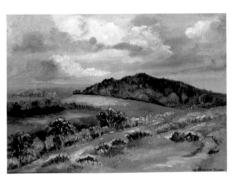

Dunn, John Selwyn 1895–1978
St Martha's c.1960
oil on board 58.5 x 74
1033

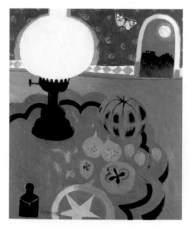

Fedden, Mary b.1915
The Lamp 1988
oil on canvas 64 x 51
798

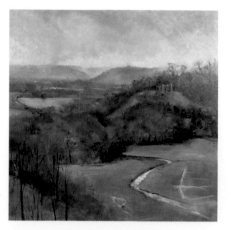

Harris Hughes, Susanna b.1947
St Catherine's, February 1997
oil on canvas 92 x 92
999

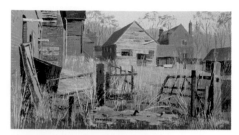

Harrison, Christopher b.1935
Below Coldharbour 1971
oil on canvas 51 x 91.5
363

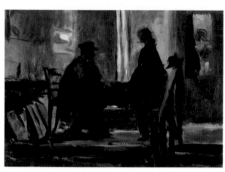

Harwood Eve
Old Guildford House c.1962
oil on canvas board 25.2 x 34
231

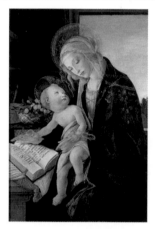

Herringham, Christiana Jane 1852–1929
Madonna and Child (after Sandro Botticelli)
c.1900
tempera on board 58 x 39
480

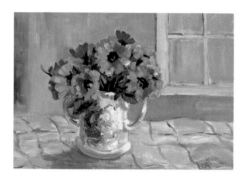

Hoyt Desmond, Charlotte d.1971
Pot of Marigolds c.1970
oil on board 30.8 x 40.4
617

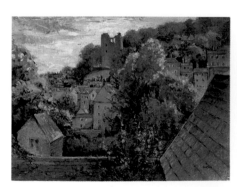

Huston active mid-20th C
View of Guildford Castle
oil on canvas 30 x 40.5
1058

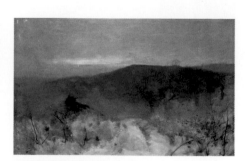

Hyde, William 1859–1925
Landscape towards Peaslake c.1900
oil on canvas 71.2 x 107
648

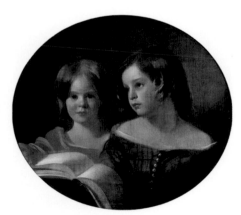

Laurence, Samuel 1812–1884
The Fletcher Children c.1850
oil on canvas 71 x 83
865

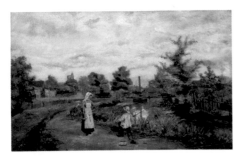

Le Mare, Frederick b.1846
Landscape Millmead 1890
oil on canvas 50 x 76
738

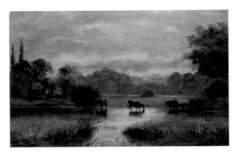

Lee, Ada
Cows and Boy in Landscape 1890
oil on canvas 35.7 x 53.6
755

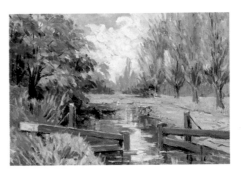

Marsham, Cara
Millmead Lock 1953
oil on board 28 x 38
116

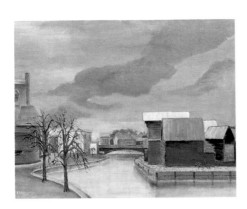

May, F. T. active c.1957–1968
River Wey in Winter 1959
oil on board 41 x 51
751

McCannell, Ursula Vivian b.1923
Birches and Hollies 1979
oil on canvas 35.5 x 25.5
913

Morris, Mali b.1945
In Apple Blossom Time c.1985
acrylic on canvas 58 x 181
767

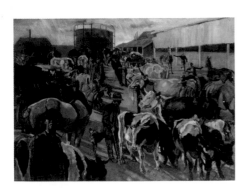

Morshead, Arminell 1889–1966
Guildford Cattle Market 1920
oil on canvas 90 x 119
746

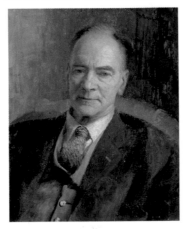

Narraway, William Edward 1915–1979
Alderman Lawrence Powell 1967
oil on canvas 61 x 51
692

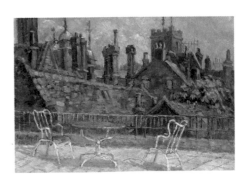

Parfitt, Ida 1910–1977
Guildford Old and New 1962
oil on board 30.5 x 40.7
241

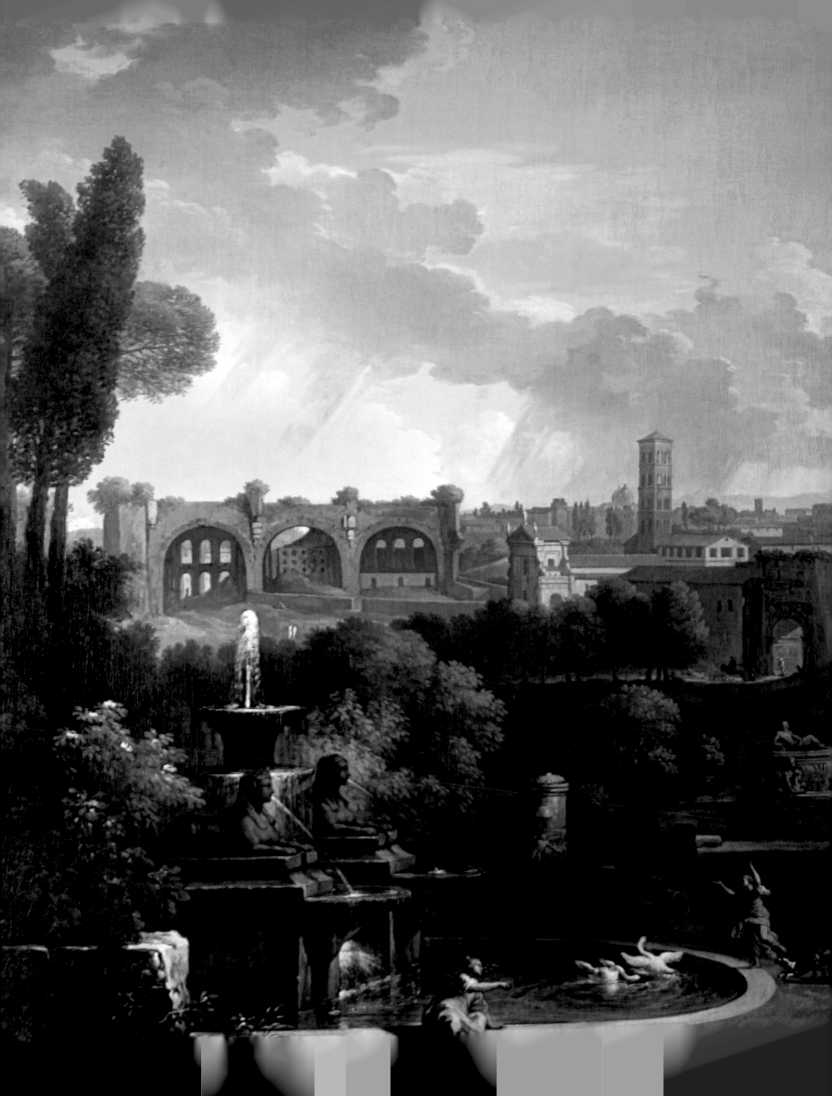

Passey, Charles Henry active 1870–c.1894
A Lane at Albury, Surrey c.1880
oil on canvas 60.5 x 50
896

Penycate, Dorothy 1910–1969
Roses c.1962
oil on canvas 34.3 x 44.5
969

Perraudin, Wilfrid b.1912
Black Forest Landscape and Farm Buildings
1989
oil on canvas 75 x 100
897

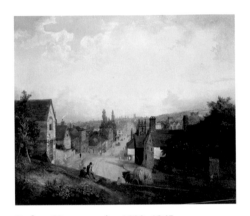

Pether, Henry active 1828–1865
Old Guildford 1849
oil on canvas 90 x 105
658

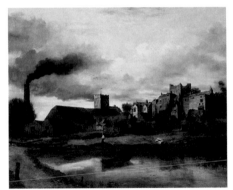

Pether, Henry (circle of) active 1828–1865
St Mary's, Guildford
oil on canvas 62.8 x 76.5
966

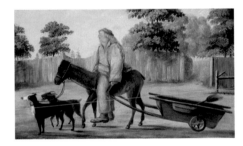

Randoll, F.
The Eccentric Billy Hicks, Shere 1854
oil on canvas 32.2 x 51.8
744

Ranken, Marguerite 1897–1973
The Estuary c.1960
oil & gouache on canvas board 39.2 x 29.2
589

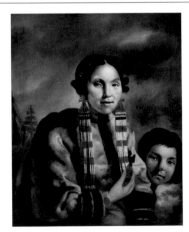

Russell, John 1745–1806
Micoc and Tootac 1769
oil on canvas 75 x 60
1003

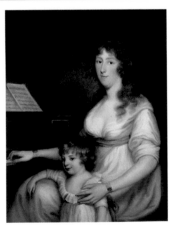

Russell, John 1745–1806
Portrait of a Lady with Her Child 1798
oil on canvas 99 x 76
915

Facing page: Bloemen, Jan Frans van, 1662 –1749, *View of Rome from the Baberini Palace* (detail), Surrey County Council, (p. 175)

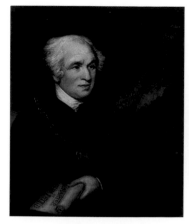

Russell, William 1780–1870
Samuel Russell, Mayor of Guildford 1805
oil on board 93.5 x 76
863

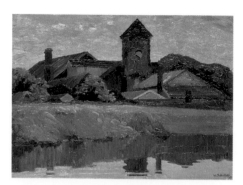

Schofield, Winifred d.2000
The Oil Mills, Thames Lock 1928–1929
oil on canvas 31 x 41.2
757

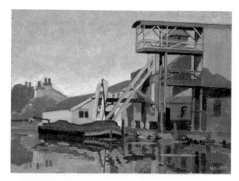

Schofield, Winifred d.2000
The Oil Mills, Weybridge, Surrey 1930s
oil on canvas 30.8 x 40.8
739

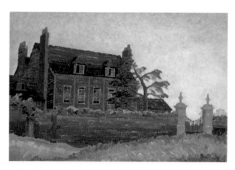

Schofield, Winifred d.2000
The Lone Manor House 1975
oil on canvas 32 x 44.8
742

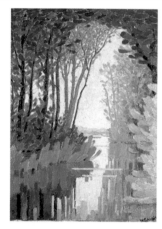

Scholfield, Margaret active 1922–1932
Impression: Wey Navigation Canal 1922
oil on canvas 38 x 27
694

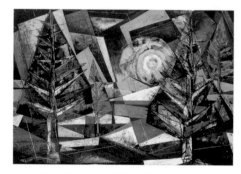

Smoothey, Ronald 1913–1996
Winter Landscape 1960
oil on board 50.5 x 70.8
818

Smoothey, Ronald 1913–1996
Headlamps c.1970
oil on board 39.5 x 57
916

Smoothey, Ronald 1913–1996
Mutation c.1970
oil on board 56 x 76.6
1109

Smoothey, Ronald 1913–1996
Stress Forms c.1970
acrylic on board 81 x 53
335

Smoothey, Ronald 1913–1996
Volcanic Creation c.1970
acrylic on board 45.8 x 30.5
912

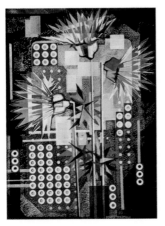

Smoothey, Ronald 1913–1996
Shadows of a Sculpture early 1980s
oil & collage on board 47 x 34.5
988

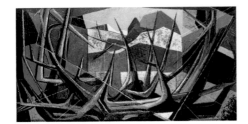

Smoothey, Ronald 1913–1996
The Hawthorn Tree mid-1980s
oil on board 48.4 x 91.6
819

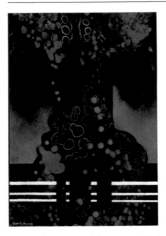

Smoothey, Ronald 1913–1996
Space Horizons 1988
oil on board 38 x 28
985

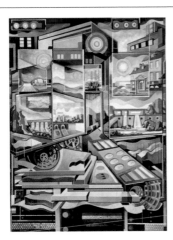

Smoothey, Ronald 1913–1996
Howard Humphreys and Partners c.1989
oil on board 74 x 54.6
986

Smoothey, Ronald 1913–1996
Howard Humphreys and Partners c.1989
oil on board 73 x 55
987

Smoothey, Ronald 1913–1996
Skyscrapers 2 early 1990s
oil & collage on board 63.5 x 47.5
989

Spurrier, Lanta c.1910–c.1980
Floods early 1970s
oil on canvas 51 x 66.2
651

Stedman, Roy b.1933
Frosty Morning, Albury Park mid-1990s
oil on board 18.2 x 28.2
968

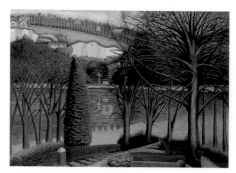

Stoneham, Olive d.1966
Great Quarry, Warwick's Bench mid-1960s
oil on board 43.8 x 61
752

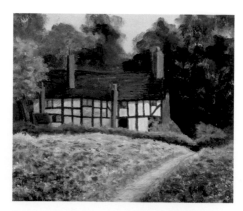

Stuart, Margaret active 1924–1988
The Pest House, Pilgrim's Way, Shalford 1924
oil on canvas board 25.4 x 30.5
792

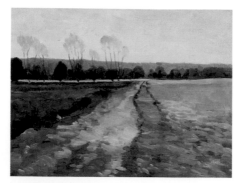

Ta'Bois, Zweena
Through the Fields to Farnham early 1980s
oil on board 40 x 50
653

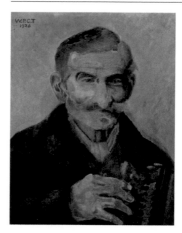

Tenison, W. R. C. active 1926–1929
Domenico 1926
oil on canvas 43.7 x 36.4
1008

Tenison, W. R. C. active 1926–1929
Souvenir de l'orient 1929
oil on canvas 35.7 x 41.7
1009

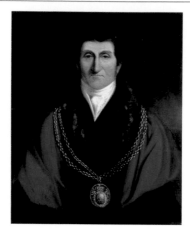

unknown artist
Portrait of an Unknown Mayor (1810–1820)
c.1810
oil on canvas 71.5 x 58
731

unknown artist
Abbot's Hospital, High Street c.1840
oil on canvas 66 x 85
844

unknown artist
Guildford Castle from the River Wey 1886
oil on canvas 27 x 37
1110

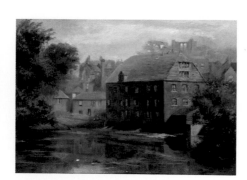

unknown artist
The Mill, Guildford 1886
oil on canvas 27 x 37
1111

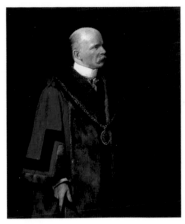

unknown artist late 19th C
Mayor Henry Neville
oil on canvas 75 x 62
728

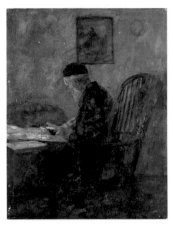

unknown artist early 20th C
Richard Heath
oil on canvas 46 x 35
733

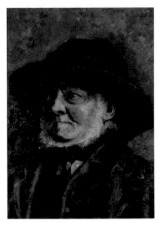

Unwin, Ida M. 1869–1953
Charles Baker 1890
oil on cardboard 43 x 30.3
735

Waite, Edward Wilkins 1854–1924
The Time of Wild Roses c.1900
oil on canvas 44.5 x 60
778

Wesson, Edward 1910–1983
River Meadow Landscape c.1970
oil on canvas 50 x 74
1014

Widdes, C. A.
Richard Sparkes c.1900
oil on canvas 75 x 62
729

Wilkie, Mary b.1915
Farley Heath Wood late 1960s
oil on canvas board 39 x 29
334

Guildford
Museum

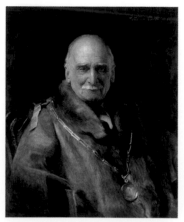

Carter, William 1863–1939
Mayor Ferdinand Smallpeice
oil on canvas 75 x 61
LG 3927

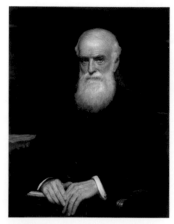

Eddis, Eden Upton 1812–1901
Henry Sharp Taylor after 1878
oil on canvas 90 x 70
LG 3928

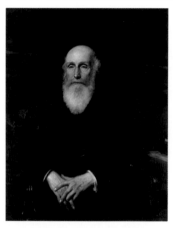

Eddis, Eden Upton 1812–1901
R. J. Shepherd after 1884
oil on canvas 101 x 85
LG 3932

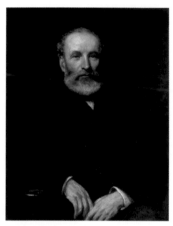

Eddis, Eden Upton 1812–1901
Lieutenant Colonel Hankin after 1885
oil on canvas 90 x 70
LG 3931

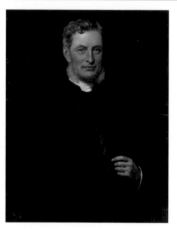

Eddis, Eden Upton 1812–1901
George Chilton after 1893
oil on canvas 90 x 70
LG 3930

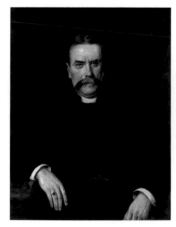

Eddis, Eden Upton 1812–1901
Reverend Robson after 1895
oil on canvas 90 x 70
LG 3929

Lintott, (Miss)
View of Park Street before 1957
oil on canvas 30 x 49.5
TG1340

May, F. T. active c.1957–1968
View of South Hill c.1957
oil on hardboard 27.5 x 38
TG 324

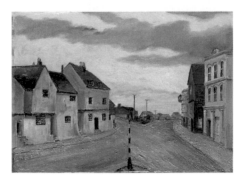

May, F. T. active c.1957–1968
View of Park Street
oil on canvas laid on board 30.1 x 40.3
TG 323

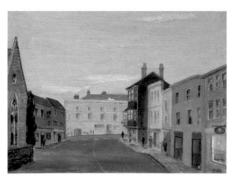

May, F. T. active c.1957–1968
View of 'The Old White Lion'
oil on canvas laid on board 30.1 x 40.3
TG 322

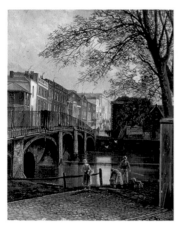

unknown artist
View of Guildford Town Bridge c.1850?
oil? on wood panel 30.3 x 24.6
G 3804

Van Jones active 1917–1941
Artwork for Friary Ales Poster c.1939
oil on hardboard 81 x 58
RB 2431

Queen's Royal Surrey Regimental Museum

Bennett, John active 20th C
Salerno 43
oil on canvas 55 x 70.5
HH45

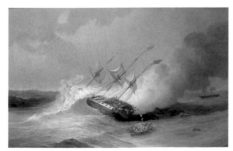

Daniell, William 1769–1837
Burning of 'The Kent' 1st March 1825 c.1827
oil on canvas 47 x 71
DS45

Davidson, Thomas
The Queen's (Second) Royal Regiment of Foot,
c.1830 c.1830
oil on canvas 25 x 15
DS27

Deayton-Groom, (Major) active 20th C
The East Surrey Regiment Passing through
Cassino, 18th May 1944
oil on canvas 25 x 38
DS116

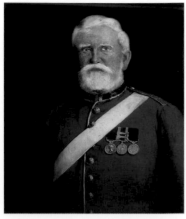

Grant, Henry active 1950–1980
Sergeant Major Lynch (d.1917)
oil on canvas 38 x 25
DS34

Rocke, R. Hill (Major)
The Queen's (Second) Royal Regiment of Foot
in South Africa c.1853
oil on canvas 20 x 30
DS29

Surrey Archaeological Society

The Surrey Archaeological Society was founded in 1854, and since the early years of the twentieth century has had its headquarters in Guildford. Its library has been in existence since the Society's earliest days, and as well as purchasing material of local archaeological and historical interest, has, over the years, received a number of bequests and donations from members and friends. This means that it now represents probably the finest source of material on Surrey history and archaeology. Although the library is maintained primarily for the benefit of members of the Society, it is open by appointment to the general public, and the catalogue can be viewed on the Society's website.

The Collection includes books, drawings, prints, journals, photographs, scrapbooks and maps. Apart from two items – *Study of a Castle on a Hill* by an unknown artist, and a copy of a portrait of John Evelyn, after Godfrey Kneller, donated by Mr C. J. A. Evelyn in 1948 – the collection of oil paintings is a series of 59 views, mainly of East Surrey buildings and landscapes, by Ernest C. Christie.

Ernest Christie was born in Redhill in 1863 into an artistic family and lived his life in East Surrey. He began painting at the age of six, and won a prize at the age of ten for a painting of Brays Farm in Nutfield. He studied under Linnell in Reigate, and Charles Davidson at Reigate Grammar School, both very competent local artists. He spent two and a half years at South Kensington School of Art, but was not to make painting his main career, as he joined his father's firm, the Commercial Assurance Company Country Department.

In the 1920s Christie exhibited at the Royal Academy. As well as art, he had a lifelong interest in archaeology and local history, which is why the Surrey Archaeological Society was fortunate enough to receive some of his paintings. He produced wash drawings and sketches in addition to oil paintings. Like the paintings, the sketches detail the exterior and interior of buildings in Limpsfield, Oxted, Godstone, Bletchingley, Dorking and, Ockley and a few further afield, providing an invaluable record of architectural detail and bygones such as firebacks, hearths and pumps. There are views of gardens, and landscapes from War Coppice Hill, Whitehill and Leith Hill, among others, and studies of separate parts of buildings and machinery.

Christie took enormous care over his work, and would go back many times to make sure that he had left nothing out of his pictures. The story is told of how an admirer criticised the colouring in his painting of Brewer Street Farm. 'Would you have seen it at five o'clock this morning?', Christie asked, and on being told no, he replied, 'Then you had better go then.' He displayed a sensitive eye for reflected light and stone texture, a love for trees, which figure largely in his paintings, and a genuine affection for the Surrey buildings he portrayed.

He appears to have been a rather withdrawn, private person who never married. His niece remembered how, as a child, she was not allowed in his studio while he was working, and when they went for walks, he would often be thinking, during which time she was not supposed to talk!

He remained a very competent amateur artist until his death, with a tremendous love for his corner of Surrey. 'He had the usual look of the Christies – they were thinking and working it out, but they all had nice manners, and shook hands very warmly.'

Gillian Drew, Honorary Librarian

Christie, Ernest C. 1863–1937
Interior View of Unidentified Cottage in East Surrey 1897
oil on board 35.6 x 53.3
RR PD1 / 30 / 30

Christie, Ernest C. 1863–1937
Interior of Room in a Cottage at Chaldon, with Fireplace c.1900
oil on board 30.5 x 45.7
RR PD1 / 30 / 51

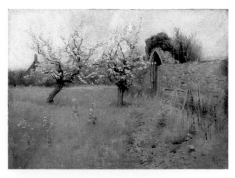

Christie, Ernest C. 1863–1937
Wall with Arched Gateway Opening on to a Field with Trees, Identified as the Entrance to Oxted Church 1906
oil on board 30.5 x 40.6
RR PD1 / 30 / 49

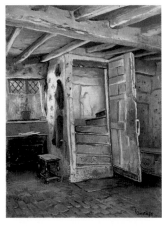

Christie, Ernest C. 1863–1937
Staircase in Cottage at Limpsfield 1911
oil on board 40.6 x 30.5
RR PD1 / 30 / 15

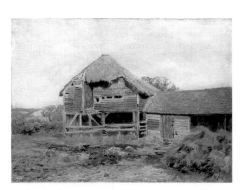

Christie, Ernest C. 1863–1937
Barn at Godstone 1912
oil on board 30.5 x 40.6
RR PD1 / 30 / 10

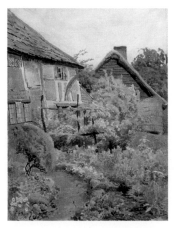

Christie, Ernest C. 1863–1937
Exterior of Cottage near Oxted 1914
oil on board 40.6 x 30.5
RR PD1 / 30 / 22

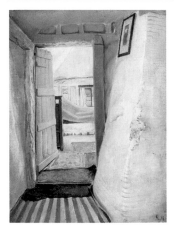

Christie, Ernest C. 1863–1937
Doorway between Two Rooms in Cottage at Godstone 1916
oil on board 40.6 x 30.5
RR PD1 / 30 / 5

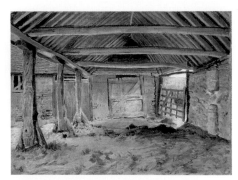

Christie, Ernest C. 1863–1937
Interior View of a Cart Shed in East Surrey 1916
oil on board 30.5 x 40.6
RR PD1 / 30 / 53

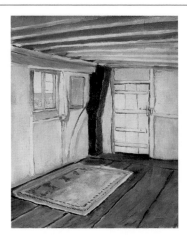

Christie, Ernest C. 1863–1937
Room in Cottage at Godstone c.1916
oil on board 38.1 x 30.5
RR PD1 / 30 / 7

Facing page: Russell, John, 1745–1806, *Micoc and Tootac* (detail), 1769, Guildford House Gallery, (p. 91)

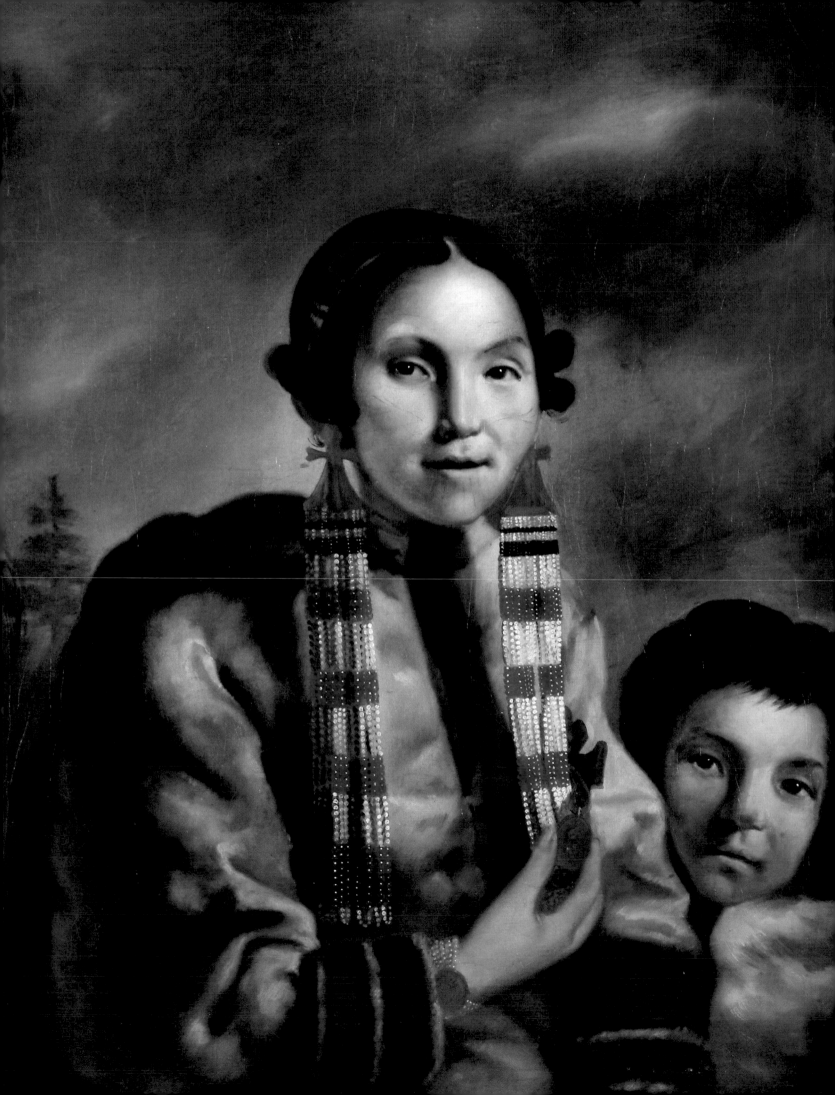

Christie, Ernest C. 1863–1937
High Street, Bletchingley 1917
oil on board 40.6 x 30.5
RR PD1 / 30 / 27

Christie, Ernest C. 1863–1937
*Kitchen Range at the Hare and Hounds,
Godstone* 1917
oil on board 30.5 x 40.6
RR PD1 / 30 / 9

Christie, Ernest C. 1863–1937
Staircase in Cottage at Godstone 1917
oil on board 40.6 x 30.5
RR PD1 / 30 / 8

Christie, Ernest C. 1863–1937
*Exterior View of Unidentified Barn at
Bletchingley or Godstone* 1918
oil on board 40.6 x 30.5
RR PD1 / 30 / 29

Christie, Ernest C. 1863–1937
1 and 2 Needles Bank, Godstone 1919
oil on board 40.6 x 30.5
RR PD1 / 30 / 12

Christie, Ernest C. 1863–1937
*Exterior View of Unidentified Cottage in East
Surrey* 1919
oil on board 40.6 x 30.5
RR PD1 / 30 / 25

Christie, Ernest C. 1863–1937
*Exterior View of Unidentified Cottage near
Bletchingley* 1919
oil on board 40.6 x 30.5
RR PD1 / 30 / 28

Christie, Ernest C. 1863–1937
*Fireplace and Post in Centre of Room in
Cottage at Godstone* 1919
oil on board 40.6 x 30.5
RR PD1 / 30 / 6

Christie, Ernest C. 1863–1937
*Rear of Cottage at Godstone (probably Forge
Cottage)* 1919
oil on board 45.7 x 30.5
RR PD1 / 30 / 14

Christie, Ernest C. 1863–1937
Staircase in Cottage at Godstone 1919
oil on board 40.6 x 30.5
RR PD1 / 30 / 13

Christie, Ernest C. 1863–1937
*Streeters, Terrace and Huddle Cottages, High
Street, Oxted* 1919
oil on board 30.5 x 35.6
RR PD1 / 30 / 21

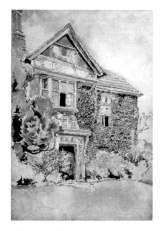

Christie, Ernest C. 1863–1937
Bonet's Farm, Capel c.1919
oil on board 45.7 x 30.5
RR PD1 / 30 / 36

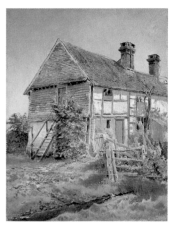

Christie, Ernest C. 1863–1937
Exterior View of Cottage at Oakwood c.1919
oil on board 40.6 x 30.5
RR PD1 / 30 / 38

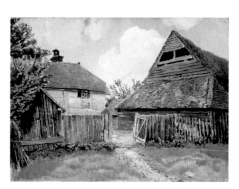

Christie, Ernest C. 1863–1937
Exterior View of Cottage at Ockley c.1919
oil on board 30.5 x 40.6
RR PD1 / 30 / 39

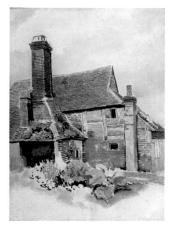

Christie, Ernest C. 1863–1937
Exterior View of Cottage at Outwood c.1919
oil on board 40.6 x 30.5
RR PD1 / 30 / 33

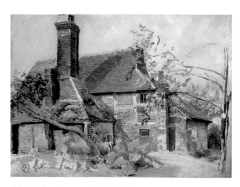

Christie, Ernest C. 1863–1937
Exterior View of Cottage at Outwood c.1919
oil on board 30.5 x 40.6
RR PD1 / 30 / 44

Christie, Ernest C. 1863–1937
Exterior View of Cottages at Ockley c.1919
oil on board 30.5 x 40.6
RR PD1 / 30 / 46

Christie, Ernest C. 1863–1937
*Exterior View of Unidentified Cottage in East
Surrey, with Prominent Chimney and Porch*
c.1919
oil on board 40.6 x 30.5
RR PD1 / 30 / 31

Christie, Ernest C. 1863–1937
Exterior View of Unidentified House in East Surrey c.1919
oil on board 40.6 x 30.5
RR PD1 / 30 / 41

Christie, Ernest C. 1863–1937
Exterior View of West End of Unidentified Church in East Surrey c.1919
oil on board 40.6 x 30.5
RR PD1 / 30 / 37

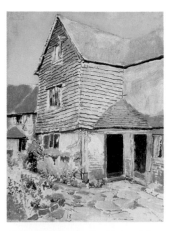

Christie, Ernest C. 1863–1937
Part of 'The Barracks', Oakwood Hill, Ockley, near Dorking c.1919
oil on board 40.6 x 30.5
RR PD1 / 30 / 40

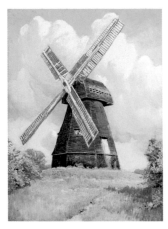

Christie, Ernest C. 1863–1937
Shiremark Windmill, Capel c.1919
oil on board 40.6 x 30.5
RR PD1 / 30 / 34

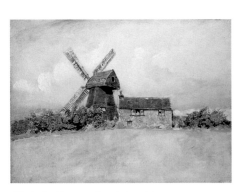

Christie, Ernest C. 1863–1937
Shiremark Windmill, with Mill Cottage on Bonet's Farm, Capel c.1919
oil on board 30.5 x 40.6
RR PD1 / 30 / 35

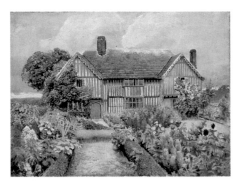

Christie, Ernest C. 1863–1937
Brewer Street Farm, Bletchingley c.1920
oil on board 30.5 x 40.6
RR PD1 / 30 / 48

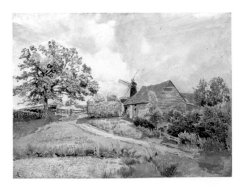

Christie, Ernest C. 1863–1937
Ockley Windmill c.1920
oil on board 30.5 x 40.6
RR PD1 / 30 / 43

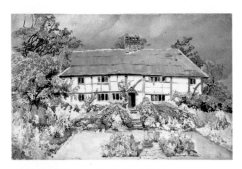

Christie, Ernest C. 1863–1937
Pollingfold, Abinger (front view) c.1920
oil on board 30.5 x 45.7
RR PD1 / 30 / 56

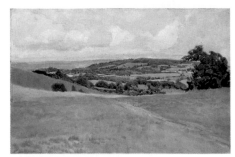

Christie, Ernest C. 1863–1937
View of North Downs in East Surrey c.1920
oil on board 30.5 x 45.7
RR PD1 / 30 / 50

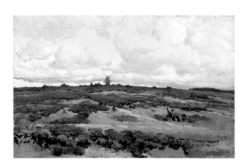

Christie, Ernest C. 1863–1937
Walton Heath Windmill c.1920
oil on board 30.5 x 45.7
RR PD1 / 30 / 45

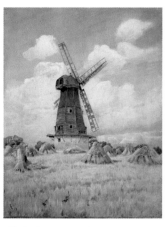

Christie, Ernest C. 1863–1937
Ockley Windmill 1923
oil on board 40.6 x 30.5
RR PD1 / 30 / 47

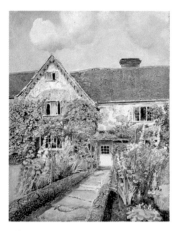

Christie, Ernest C. 1863–1937
School House, Ockley 1923
oil on board 40.6 x 30.5
RR PD1 / 30 / 24

Christie, Ernest C. 1863–1937
Interior of Cottage, Ockley 1924
oil on board 40.6 x 30.5
RR PD1 / 30 / 23

Christie, Ernest C. 1863–1937
*St John the Baptist Church, Okewood, near
Ockley* 1924
oil on board 30.5 x 40.6
RR PD1 / 30 / 32

Christie, Ernest C. 1863–1937
Exterior of Cottage at Forest Green 1925
oil on board 40.6 x 30.5
RR PD1 / 30 / 4

Christie, Ernest C. 1863–1937
Exterior of House at Dorking 1925
oil on board 40.6 x 30.5
RR PD1 / 30 / 2

Christie, Ernest C. 1863–1937
Pinkhurst, Oakwood Hill 1925
oil on board 40.6 x 30.5
RR PD1 / 30 / 3

Christie, Ernest C. 1863–1937
Distant View of Leith Hill, with Tower c.1925
oil on board 30.5 x 45.7
RR PD1 / 30 / 54

Christie, Ernest C. 1863–1937
Farm Buildings at Dorking 1926
oil on board 30.5 x 45.7
RR PD1 / 30 / 1

Christie, Ernest C. 1863–1937
Gosterwood Manor, Forest Green 1926
oil on board 30.5 x 45.7
RR PD1 / 30 / 26

Christie, Ernest C. 1863–1937
Pollingfold, Abinger (rear view) 1926
oil on board 30.5 x 45.7
RR PD1 / 30 / 57

Christie, Ernest C. 1863–1937
Tudor Barn at Standen Farm, Ockley 1926
oil on board 30.5 x 40.6
RR PD1 / 30 / 20

Christie, Ernest C. 1863–1937
Gosterwood Manor Farm, Forest Green c.1926
oil on board 30.5 x 40.6
RR PD1 / 30 / 52

Christie, Ernest C. 1863–1937
Pollingfold, Abinger (view towards a landing)
1927
oil on board 40.6 x 30.5
RR PD1 / 30 / 58

Christie, Ernest C. 1863–1937
Volvens Farm, Forest Green 1927
oil on board 30.5 x 40.6
RR PD1 / 30 / 55

Christie, Ernest C. 1863–1937
Pollingfold, Abinger (view of a landing) c.1927
oil on board 40.6 x 30.5
RR PD1 / 30 / 59

Christie, Ernest C. 1863–1937
Exterior Chimney of Cottage at Mayes Green
1928
oil on board 40.6 x 30.5
RR PD1 / 30 / 17

Christie, Ernest C. 1863–1937
Exterior Chimney of Cottage at Mayes Green
1928
oil on board 45.7 x 30.5
RR PD1 / 30 / 18

Christie, Ernest C. 1863–1937
Exterior Chimney of Cottage at Mayes Green
1928
oil on board 38.1 x 30.5
RR PD1 / 30 / 19

Christie, Ernest C. 1863–1937
Fireplace in Cottage at Mayes Green 1928
oil on board 30.5 x 40.6
RR PD1 / 30 / 16

Christie, Ernest C. 1863–1937
Interior of Olde Bell Inn, Oxted 1928
oil on board 40.6 x 30.5
RR PD1 / 30 / 11

Christie, Ernest C. 1863–1937
Exterior View of Cottage at Mayes Green
c.1928
oil on board 40.6 x 30.5
RR PD1 / 30 / 42

Kneller, Godfrey (after) 1646–1723
John Evelyn, 1687
oil on canvas 76.2 x 66
PD/EV

unknown artist
Study of a Castle on a Hill
oil on canvas 48.9 x 35.6
RR PD1 / 30 / 63

The Guildford Institute of the University of Surrey

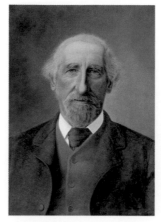

Harris, W. J.
George William Downes (1831–1915) 1916
oil on canvas board 50 x 35.5
G.I. 5

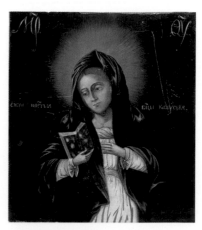

Russian School
Three-Quarter Length Portrait of a Female Saint
oil on panel 35.5 x 30.7
G.I. 6

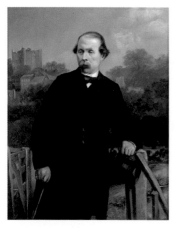

unknown artist
James Macnab by the River Wey, with a View of Guildford Castle c.1866
oil on panel 47 x 37
G.I. 1

Willis-Pryce, George 1866–1949
High Street, Guildford, Looking West, with a View of Holy Trinity Church c.1892
oil on canvas board 52 x 87
G.I. 4

The Guildhall

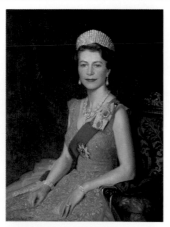

Halliday, Edward Irvine 1902–1984
Elizabeth II (b.1926) 1957
oil on canvas 99.1 x 73.7
584

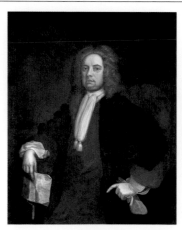

Highmore, Joseph (circle of) 1692–1780
Portrait of a Gentleman, Wearing a Brown Coat, White Glove and an Academic Gown, Holding a Letter
oil on canvas 124.5 x 99.1
582

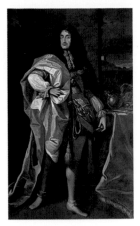

Lely, Peter (circle of) 1618–1680
Charles II (1630–1685)
oil on canvas 259.1 x 134.6
575

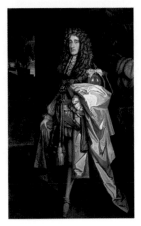

Lely, Peter (circle of) 1618–1680
James II (1633–1701)
oil on canvas 259.1 x 137.2
576

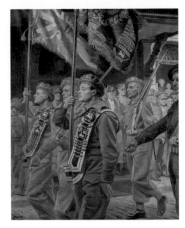

Lewis
Queen's Regiment Parade before the Mayor of Guildford
oil on canvas 125 x 99
574

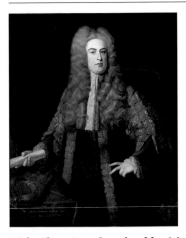

Richardson, Jonathan the elder (circle of) 1665–1745
The Right Honourable Arthur Onslow (1691–1768)
oil on canvas 124.5 x 99.1
579

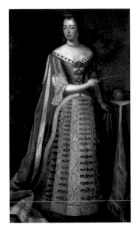

Riley, John (studio of) 1646–1691
Mary II (1662–1694)
oil on canvas 177.8 x 104.1

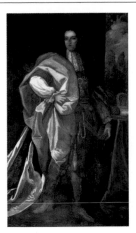

Riley, John (studio of) 1646–1691
William III (1650–1702)
oil on canvas 177.8 x 104.1

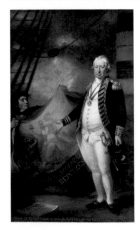

Russell, John 1745–1806
Sir Richard Onslow, Bt (1741–1817)
oil on canvas 231.1 x 142.2
580

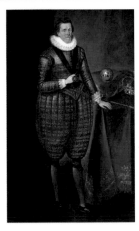

Somer, Paulus van I (circle of) 1576–1621
James I (1566–1625)
oil on canvas 205.7 x 137.2
583

University of Surrey

The University of Surrey was granted its Charter on the 9th September 1966. It had its origins in Battersea College of Technology, which, by the early 1960s, was a potential university in search of a campus, just as Guildford was beginning to be a town in search of a university. The College had been primarily a teaching institution, albeit with increasingly strong research in some disciplines. The University's Charter defined its objectives as, 'The pursuit of learning, the advancement and dissemination of knowledge in Science and Technology and all that pertains to a fuller understanding of humanity, in close co-operation with the industrial life of the country and with commerce and the professions.'

The designated site was on Stag Hill, below the recently completed Cathedral, and building was concentrated on three bands of activity – residential, social and academic – and the move from Battersea to Guildford was completed by 1970. A wide range of cultural activities was planned to draw the local community on to the campus.

The first Vice-Chancellor, Dr Peter Leggett, placed a high value on the arts and humanities, and the college had been starting to develop degree courses in these areas and to offer General Studies courses to all students. Today there is a School of Arts which comprises Dance Studies; Law; Culture, Media and Communication Studies; Translation Studies; Music and Sound Recording; and Political, International and Policy Studies.

At Battersea, Professor Lewis Elton (who had arrived in England in 1939 as a refugee from Prague) had started a project in 1963 to show real art in the Physics Department, of which he was Head. In 1978 Lewis suggested an exhibition *Then and Now* to show the work of some artists who had exhibited, contrasting what they were doing at that time with current work. Those represented included local artists Charles Bone, Brian Dunce, Sir George Pollock, Ronald Smoothey, James Winterbottom and even David Hockney. The exhibitions continue to this date, at first they were located in the Library Gallery, and since 1997 they have been displayed in the Lewis Elton Gallery.

The Gallery continues to flourish and there is a queue of people waiting to exhibit. The policy is to show the work of artists of international and national repute, local professional artists, student work from affiliated institutions and sculpture, ceramics, photography and jewellery.

Apart from Professor Elton's exhibitions in the corridors, there was not much art in the new buildings at Guildford. The Library received the portraits of the Principals of Battersea Polytechnic and in 1983 a number of pictures in the General Studies Department were discovered, of which the provenance and in many cases the names of the artists, were unknown. There had been two artists-in-residence, Oleg Prokofiev (son of the composer) and Andrzej Jackowski, some of whose pictures now adorn our walls.

Over the last 23 years the collection has steadily grown, over and above those works which fall within the scope of this catalogue, particularly pastels and watercolours. Eilean Pearcey, a friend of Professor Elton, donated a collection of drawings she had made of the great Indian dancer Uday Shankar, (brother of Ravi Shankar) now housed in the National Resource Dance Centre.

Facing page: Watts, George Frederick, 1817 –1904, *Sower of the Systems* (detail), 1902, Watts Gallery, (p. 157)

Professor Carola Grindea offered us a selection of paintings by her brother-in-law, Arnold Daghani, a survivor of the holocaust, many of them in unusual media, on sacking, cupboard doors and the like. There is also a collection of his work at the University of Sussex, under the care of the Centre for Anglo-Jewish Studies. An artist called Wendy Spooner (also known as Sparks), donated a number of large pieces to the University before moving abroad, but sadly we have lost touch with her (can anybody help?). There have of course been portraits of Chancellors and Vice-Chancellors by distinguished artists, and even pictures donated by our very eminent late Pro-Chancellor, Sir George Edwards OM, CBE, FRS, DL, who was a talented painter himself.

In 1966–1967 Professor Elton had received £50 for the purchase of works from the exhibitions, this was increased to £500 in the early 1980s and subsequently money was used from the unspent surplus from the arts budget. Now there is a 'Per Cent for Art' budget, as a result of which 1% of the contract price for new buildings and .1% for refurbishments can be used to purchase works of art. This has resulted in some major sculpture commissions, again alas outside the present remit. Another source has been the yearly Vice-Chancellor's Prize for a final year student at Wimbledon School of Art, and the opportunity has been seized to buy other works from their degree shows, also from the Department of Fine Art at the former Roehampton Institute, now Roehampton University, whose students created a mural inspired by the 1987 hurricane for the vegetarian restaurant.

When Professor Dowling – a great supporter of the arts and a discerning collector himself – became Vice-Chancellor in 1994, he moved into a new official residence, Blackwell House, created from an old farmhouse with the addition of a similar-sized new block with an atrium in between. It became a showcase for the University's Collection and acquisitions from exhibitions often found their way there. Professor Christopher Snowden, who became Vice-Chancellor on the 1st July 2005, paints himself and is keen to maintain the tradition of support for the visual arts.

Another source was tapped by the European Institute of Health and Medical Sciences, which entered into an agreement with a comprehensive school in Farnham to acquire paintings by their sixth form pupils. This has been a great success.

The Collection is displayed around the campus for the benefit of staff and students. It has become widely known that pictures can be borrowed from the Arts Office, and lack of storage space means that all are actually on view, and of course are adequately insured!

Patricia Grayburn, Curator

Allen, Michael b.1976
Barriers 1999
oil on canvas 150 x 292 (E)
306

Allison, Jane b.1959
Lord Nugent 1989
oil on canvas 76.2 x 61
148

Allison, Jane b.1959
Lord Robens of Woldingham 1989
oil on canvas 100 x 74.6
294

Allison, Jane b.1959
Sir George Edwards 1989
oil on canvas 76.2 x 61
149

Allison, Jane b.1959
Sir William Mullens 1989
oil on canvas 76.2 x 61
151

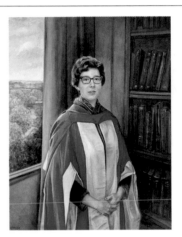

Allison, Jane b.1959
Daphne Jackson (1936–1991) 2001
oil on canvas 89.5 x 69.5
276

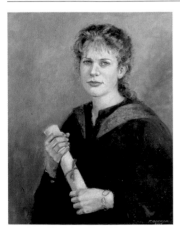

Anderson, Freda b.1942
Emma Jerman 2005
oil on canvas 48 x 38.5
316

Bachba, Emma & Powell, Alex
The Storm, October 1987 1987
acrylic on board 137.5 x 122
202a

Bachba, Emma & Powell, Alex
The Storm, October 1987 1987
acrylic on board 234 x 122
202b

Bachba, Emma & Powell, Alex
The Storm, October 1987 1987
acrylic on board 234 x 86.5
202c

Bachba, Emma & Powell, Alex
The Storm, October 1987 1987
acrylic on board 234 x 86.5
202d

Bachba, Emma & Powell, Alex
The Storm, October 1987 1987
acrylic on board 234 x 96
202e

Bachba, Emma & Powell, Alex
The Storm, October 1987 1987
acrylic on board 234 x 121.5
202f

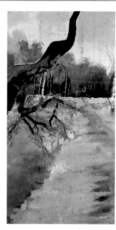

Bachba, Emma & Powell, Alex
The Storm, October 1987 1987
acrylic on board 234 x 122
202g

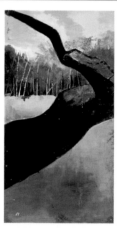

Bachba, Emma & Powell, Alex
The Storm, October 1987 1987
acrylic on board 234 x 122
202h

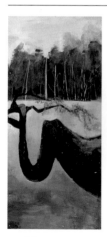

Bachba, Emma & Powell, Alex
The Storm, October 1987 1987
acrylic on board 234 x 105
202i

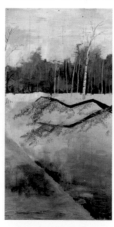

Bachba, Emma & Powell, Alex
The Storm, October 1987 1987
acrylic on board 234 x 122
202j

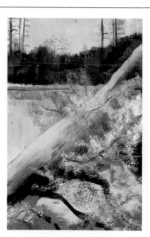

Bachba, Emma & Powell, Alex
The Storm, October 1987 1987
acrylic on board 137.5 x 86
202k

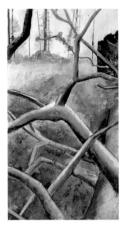

Bachba, Emma & Powell, Alex
The Storm, October 1987 1987
acrylic on board 234 x 122
202l

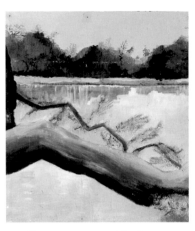

Bachba, Emma & Powell, Alex
The Storm, October 1987 1987
acrylic on board 137.5 x 122
202m

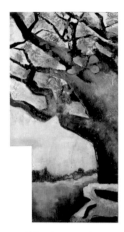

Bachba, Emma & Powell, Alex
The Storm, October 1987 1987
acrylic on board 234 x 122.4
202n

Bachba, Emma & Powell, Alex
The Storm, October 1987 1987
acrylic on board 137.5 x 122
202o

Bachba, Emma & Powell, Alex
The Storm, October 1987 1987
acrylic on board 234 x 121.5
202p

Barratt, Krome 1924–1990
Cadmium and Compliments before 1983
oil on board behind ribbed glass 170 x 59.6
134

Barter, Paul b.1945
130204
mixed media on board 65 x 122
344

Cuthbert, Alan 1931–1995
Abstract: Yellow Series 3/13
oil on canvas 152 x 152
170

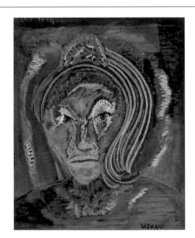

Daghani, Arnold 1909–1985
Abstract: Portrait 1956
acrylic on paper 35.5 x 28.8
326

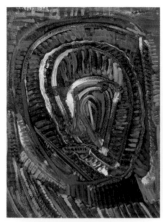

Daghani, Arnold 1909–1985
Abstract 1958
oil on paper 42.4 x 30.6
327

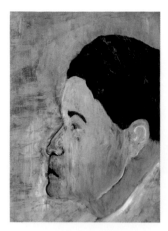

Daghani, Arnold 1909–1985
Portrait in Profile 1963
oil & gouache on paper 58.5 x 40.6
117

Daghani, Arnold 1909–1985
Musical Abstract No.2 1974–1977
acrylic on paper 59.8 x 49.5
225

Daghani, Arnold 1909–1985
*Décaméron: Studies of a Female in
Metamorphosis* 1979
oil on door panels 31 x 58.5
209

Daghani, Arnold 1909–1985
Abstract: House c.1970s
oil on paper 49.5 x 34.5
325

Daghani, Arnold 1909–1985
Abstract
acrylic? on canvas 37 x 32.7
229

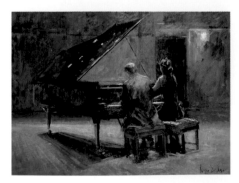

Dellar, Roger b.1949
*One Piano, Four Hands (Guildford
International Music Festival)* 2005
oil on canvas 95 x 120
318

Devitt, Margaret b.1944
Mirabib, Namibia 1995
oil on canvas 61 x 137
277

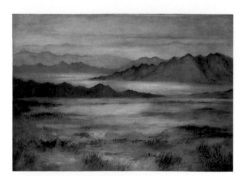

Devitt, Margaret b.1944
Red Desert 2004
oil on canvas 69.6 x 97.5
329

Di Duca, Adrian b.1966
Big Red 1997
gloss paint, acrylic, pigment on canvas
286 x 286
345

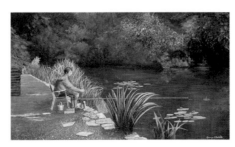

Edwards, George 1908–2003
Boy Fishing 1981
oil on board 29 x 48.5
281

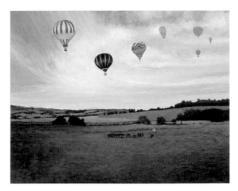

Edwards, George 1908–2003
Balloons over Longdown
oil on board 39.5 x 49.5
D280

Edwards, George 1908–2003
Newlands Corner
oil on board 62 x 60.3
278

Edwards, George 1908–2003
St Martha's Hill
oil on board 58.5 x 59.5
D354

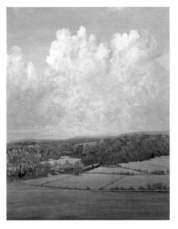

Edwards, George 1908–2003
Tyting Farm
oil on board 40.5 x 34.5
D279

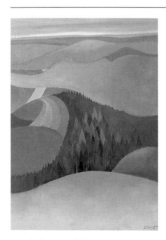

Enright, Madeleine
Mont Pilat
oil on canvas 70 x 49.5
193

Farthing, Stephen b.1950
The Eye of Information 1999–2000
oil on canvas 207.5 x 303.5
282

Fitzgerald, Paul b.1922
HRH the Duke of Kent 1999
oil on canvas 95 x 69.5
283

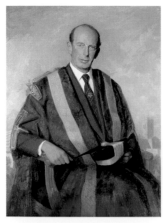

Fitzgerald, Paul b.1922
HRH the Duke of Kent 1999
oil on canvas 120 x 84 (E)
305

Ganley, Brogan b.1971
Cuenca Recollection 2002
oil on canvas 193 x 117
284

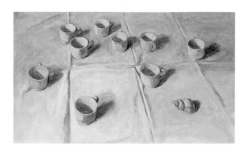

Gildea, Paul b.1956
White Cups and Shell
oil on canvas 55.3 x 90
110

Gotlib, Henryk 1890–1966
Sketch for 'Knossos'
mixed media on paper 96.5 x 59.8
119

Grant, Keith b.1930
*Launch of the Ariane Rocket Carrying
UOSAT* 1983–1984
oil on canvas 127 x 100.5; 127 x 100.5;
127 x 100.5
161a; 161b; 161c

Grant, Keith b.1930
*Design for a Mural on the Leggett Building of
UOSAT in the Night Sky* 1985
mixed media on paper 55.5 x 78.5 (E)
323a

Grant, Keith b.1930
*Design for a Mural on the Leggett Building of
UOSAT in the Night Sky* 1985
mixed media on paper 55.5 x 78.5 (E)
323b

Grant, Keith b.1930
*Design for a Mural on the Leggett Building of
UOSAT in the Night Sky* 1985
mixed media on paper 55.5 x 78.5 (E)
323c

Hardy, Anne
Blue Abstract c.2003
oil or acrylic on canvas 91.2 x 122
307

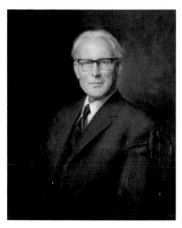

Hepple, Norman 1908–1994
Dr Peter Leggett 1973
oil on canvas 75 x 62
172 🐝

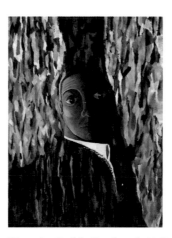

Hornsby-Smith, Stephen b.1969
Man outside a Nightclub in San Francisco
1991
oil on chipboard 89 x 66

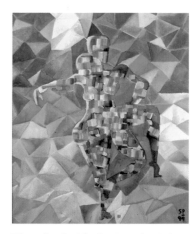

Hornsby-Smith, Stephen b.1969
Seascape II 1995
oil on canvas 59.5 x 49.5
D286

Jackowski, Andrzej b.1947
The Way (Falmouth): Lovers II 1973
mixed media on paper 19.7 x 21.6
235

Jackowski, Andrzej b.1947
Dinner Party for Four 1976
mixed media on paper 20.3 x 25.5
114

Jackowski, Andrzej b.1947
Room at Midday 1976
mixed media on paper 22 x 29
107

Jackowski, Andrzej b.1947
Room with Blinds 1976
mixed media on paper 23.3 x 28
105

Jackowski, Andrzej b.1947
Room with Surprised Guest 1976
mixed media on paper 23.5 x 28
106

Jackowski, Andrzej b.1947
Reclining Nude
oil on canvas 121 x 103 (E)
230

Jackowski, Andrzej b.1947
Room with a View of the Road
mixed media on paper 23 x 28
108

Jackowski, Andrzej b.1947
The Room (A Lady Seated at a Table)
oil on canvas 122 x 110.5 (E)
231

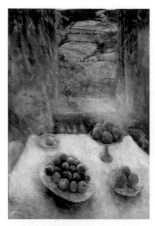

Jordan, Valerie
I Wish Bonnard Could Come to Tea c.2002
oil on canvas 152.5 x 122
287

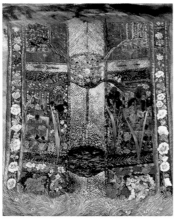

Jordan, Valerie
Kurdistan Garden c.2002
oil on canvas 153 x 122
353

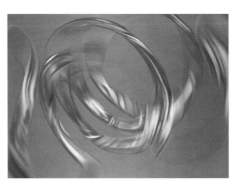

Kannreuther, Caroline b.1964
Movement in Four Colours: Large Pink (panel 1 of 4) 2005
oil & acrylic on canvas 150 x 200
317a

Kannreuther, Caroline b.1964
Movement in Four Colours: Red (panel 2 of 4) 2005
oil, enamel & alkyd on board 48 x 58.5
317b

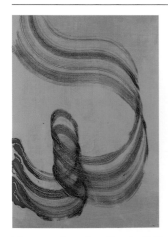

Kannreuther, Caroline b.1964
Movement in Four Colours: Green (panel 3 of 4) 2005
oil, enamel & alkyd on board 66.5 x 46
317c

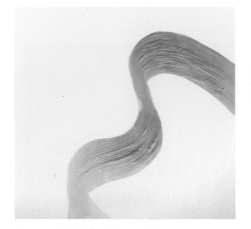

Kannreuther, Caroline b.1964
Movement in Four Colours: Yellow (panel 4 of 4) 2005
acrylic & alkyd on board 100 x 100
317d

Kilpatrick, Alan b.1963
Beijing Opera 1991
oil & acrylic on canvas 143.5 x 183
104

Facing page: Millais, John Everett, 1829 –1896, *The Princes in the Tower* (detail), 1878, Royal Holloway, University of London, (p. 52)

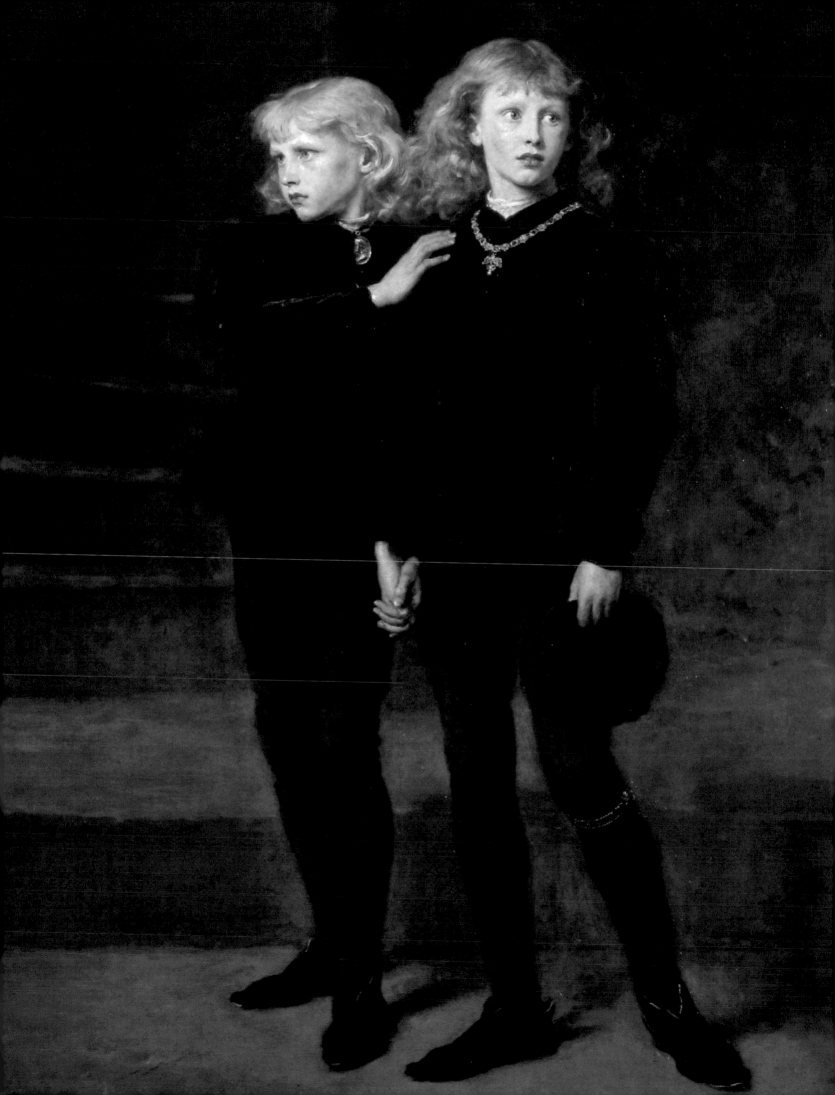

University of Surrey

Lang, Kathryn b.1979
Motion Pictures (panel 1 of 3) 2001
oil on canvas 90 x 240 (E)
288a

Lang, Kathryn b.1979
Motion Pictures (panel 2 of 3) 2001
oil on canvas 90 x 240 (E)
288b

Lang, Kathryn b.1979
Motion Pictures (panel 3 of 3) 2001
oil on canvas 90 x 240 (E)
288c

Lawrence, William b.1957
The Painting Studio c.1980
acrylic on canvas 55 x 76
347

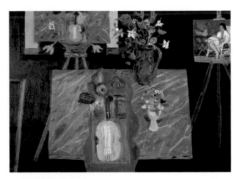

McClure, David 1926–1998
Between Two Easels 1965
oil on canvas 75 x 100
165

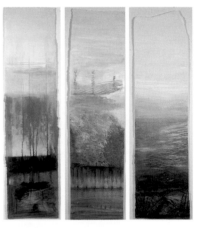

McLynn, Rebecca b.1966
Perspectives on the Wey (triptych) 2001
oil on paper 118 x 93
319a; 319b; 319c

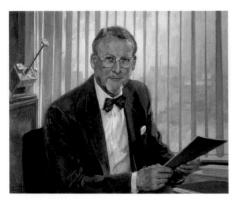

Mendoza, June active 1960–2006
Professor Anthony Kelly 1994
oil on canvas 62.3 x 75
171

Mendoza, June active 1960–2006
Professor Patrick Dowling 2005
oil on canvas 110 x 55
289

Mohanty, Michael
Abstract c.2000
mixed media on canvas 152 x 101
308

Mohanty, Michael
Abstract c.2000
mixed media on canvas 152 x 101
309

Muszynski, Leszek b.1923
Sunrise (triptych) 1989
oil on canvas 89 x 69
343a

Muszynski, Leszek b.1923
Heat of the Day (triptych) 1989
oil on canvas 89 x 69
343b

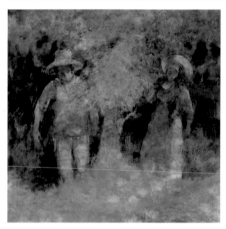

Muszynski, Leszek b.1923
Twilight (triptych) 1989
oil on canvas 89 x 89
343c

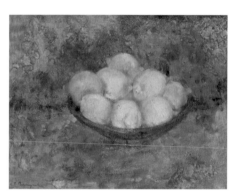

Muszynski, Leszek b.1923
Lemons
oil on canvas 39.5 x 49.5
348

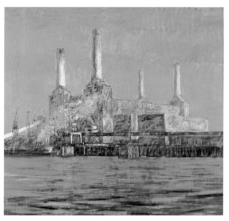

Newbolt, Thomas b.1951
Battersea Power Station 1980
oil on canvas 141 x 152.3
159

Oki, Yuji b.1949
Dancing Tree 1997
oil on canvas 86 x 111
290

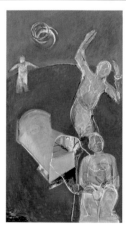

Paxson, Pat b.1939
The Broken Dream (triptych) 1998
oil on canvas 200 x 110.7 (E)
291a

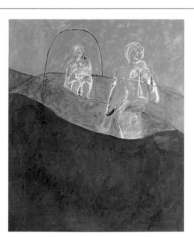

Paxson, Pat b.1939
The Broken Dream (triptych) 1998
oil on canvas 200 x 166 (E)
291b

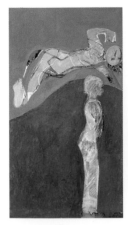

Paxson, Pat b.1939
The Broken Dream (triptych) 1998
oil on canvas 200 x 110 (E)
291c

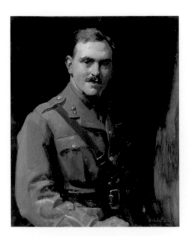

Penn, William Charles 1877–1968
Major F. H. Johnson, VC 1916
oil on canvas 71 x 58.4
167

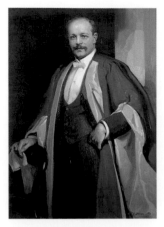

Penn, William Charles 1877–1968
*Sidney G. Rawson, DC, Principal of Battersea
Polytechnic (1907–1915)* 1916
oil on canvas 102.5 x 87.2
168

Prokofiev, Oleg 1928–1998
Belle-Ile 1975
oil on canvas 170 x 255 (E)
136

Prokofiev, Oleg 1928–1998
Bodies 1975
oil on canvas 173 x 272
292

Prokofiev, Oleg 1928–1998
The Tree of Life 1975
oil on canvas 200 x 178
135

Prokofiev, Oleg 1928–1998
Allegory of Calumny
oil on canvas 178 x 130
189

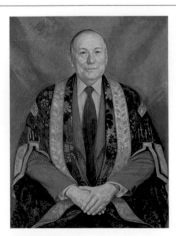

Ramos, Theodore b.1928
Lord Robens 1989
oil on canvas 100 x 74.6
294

Reason, Cyril b.1931
Salome
oil on canvas 213 x 166.5
156

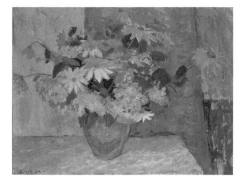

Sajó, Gyula 1918–1979
Yellow Flowers 1965
oil on board 48.2 x 63.5
166

Satchel, Hannah b.1980
South Africa (pair) 2003
oil on canvas 134 x 270
295a

Satchel, Hannah b.1980
South Africa III (pair) 2003
oil on canvas 134 x 270
295b

Spooner, Wendy
A New Moon and a Vortex (The Wave)
mixed media on board 105.5 x 122
267

Spooner, Wendy
Abstract Design: The Blue Tree
acrylic on board 98.5 x 109
270

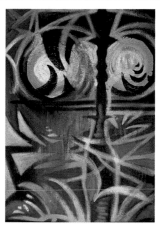

Spooner, Wendy
Abstract: Street Light
acrylic on board 102 x 72
269

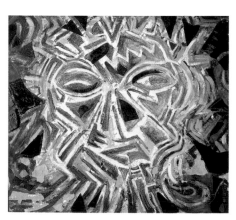

Spooner, Wendy
Christ in Gethsemane
mixed media on board 122 x 135.5
268

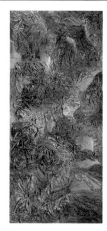

Spooner, Wendy
Flower Rocks
acrylic & textiles on board 122.2 x 54.3
275

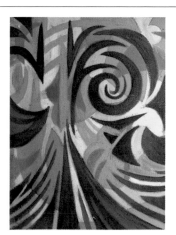

Spooner, Wendy
Summer Wind
acrylic on board 121.5 x 91.5
271

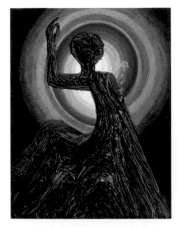

Spooner, Wendy
The Annunciation
mixed media on board 108.2 x 98.5
266

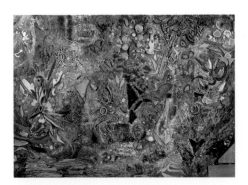

Spooner, Wendy
The Garden
mixed media on board 90 x 121
265

Spooner, Wendy
The Hand
mixed media on board 79 x 122
264

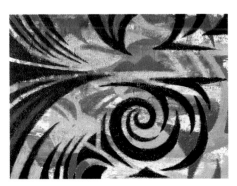

Spooner, Wendy
Winter Wind
acrylic on board 90 x 121.2
272

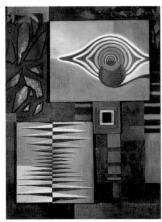

Spooner, Wendy
Wooden Collage
acrylic & wooden collage on board 150 x 102
273

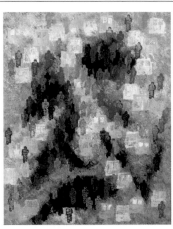

Stockbridge, Gill b.1938
Populoso 2004
oil on canvas 90.6 x 72
296

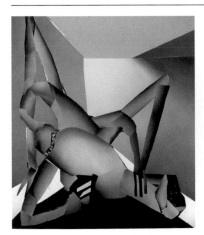

Stokoe, Jack b.1980
Two Figures 2003
oil on canvas 250 x 200 (E)
297

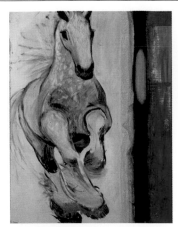

Swann, Marilyn b.1932
Galloping Horse
oil on canvas, laid on board 102.2 x 77
131

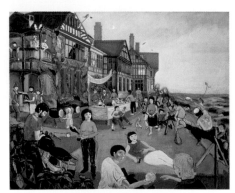

Swift, Richard b.1918
Manor House Hall of Residence 1983
oil on canvas 110.5 x 137
139

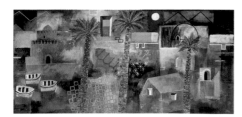

Taylor, Frank b.1946
Methoni, Greece 1999
acrylic & watercolour on paper 36.5 x 75.5
349

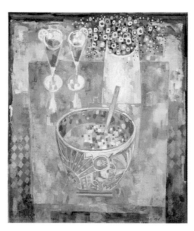

Taylor, Frank b.1946
Punch 1999
acrylic & watercolour on paper 28.5 x 24.5
328

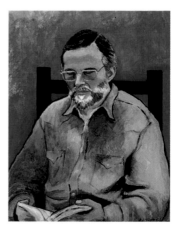

Tipton, Heather b.1941
Colin Tipton
oil or acrylic 50 x 39
D299

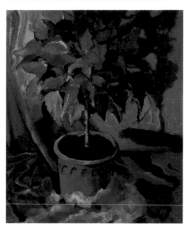

Tipton, Heather b.1941
Still Life: Plant
acrylic on paper? 49.5 x 42
D298

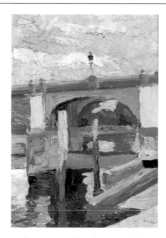

unknown artist late 20th C
View of a Bridge in Richmond
oil on board 34.5 x 24.5
303

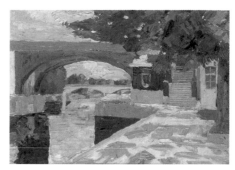

unknown artist late 20th C
View of a Bridge in Richmond
oil on board 24.5 x 34.5
304

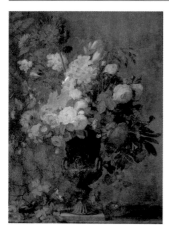

unknown artist
Jardinière of Flowers
oil on board 126.8 x 92
321

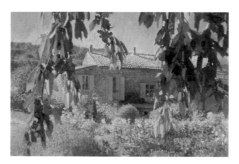

Verrall, Nicholas b.1945
Cerisiers dans le jardin
oil on canvas 62 x 94
352

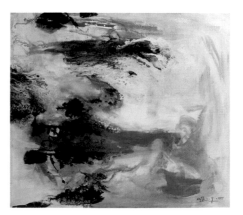

Wei, Feng
The Transfiguration of Landscape 1985
oil on canvas 79 x 90.2
111

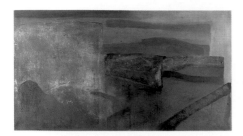

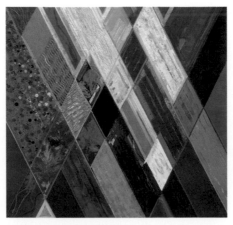

Whishaw, Anthony b.1930
Green Landscape c.1972
acrylic on canvas 175 x 305
L300 (P)

Windsor, Alan b.1931
Stars, Fields and Trees 1998–1999
acrylic on canvas 107 x 107
302

Windsor, Alan b.1931
Gem II 2002
acrylic on canvas 38 x 70.3
301

Wolf, Tim
Abstract
oil on canvas 122 x 90
350

Wright, Peter active 20th C
East Coast
oil on canvas 132 x 172.2
181

Wright, Steve b.1975
Bonsai 1 (panel 1 of 2) 1998
oil on canvas 95.5 x 79.5
351a

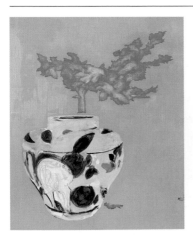

Wright, Steve b.1975
Bonsai 2 (panel 2 of 2) 1998
oil on canvas 95.5 x 79.5
351b

Watts Gallery

Watts Gallery in Compton (near Guildford) was the first purpose-built gallery dedicated to the work of a single artist in England, and opened on Good Friday, 1st April 1904, three months before George Frederick Watts's death.

In his day G. F. Watts (1817–1904) was one of the most famous and internationally renowned living artists. He was the first living artist to be invited to have a solo exhibition at the recently opened Metropolitan Museum of Art in New York. Due to public demand, the show was extended and culminated in Watts's controversial gift of his allegorical painting *Love and Life* to the American people. Watts was awarded two gold medals at the Paris Universal Exhibitions in 1878 and 1889 and won the high regard of the European avant-garde artistic community, including that of the Belgian Symbolist painter and art critic Fernand Khnopff. Watts was also greatly admired by some of the most original thinkers of his day, including Henry James and Oscar Wilde. Such recognition was due to Watts's strong artistic autonomy and deliberate independence of any of the schools or movements of the time. He not only rejected an invitation from the Pre-Raphaelites to decorate the Oxford Union walls with Arthurian murals, but was also reluctant to join the prestigious Royal Academy, despite Lord Leighton's encouragement (though he was eventually convinced in 1867, when the election procedure was especially reformed for him).

Watts had a deep belief in 'art for all' and considered himself a public artist aiming to 'stimulate the mind and awaken large thoughts' in the viewers. Consequently, he donated large parts of his prolific output to public collections and institutions across the UK. Watts was one of the four original founders of the Tate in 1897 (alongside Henry Tate, and two public transfers from the Royal Academy and the National Gallery), having donated 18 of his most accomplished symbolical paintings for the benefit of the nation. This generous gift was received with well-deserved appreciation and was prominently displayed in two dedicated Watts Rooms on the Gallery's opening (and subsequently transferred to a larger room where it remained on permanent display until Mary Seton Watts's death in 1938, when the Watts Room was converted into a special exhibition space).[1] 'The Hall of Fame', Watts's vital gift of over 50 portraits of his distinguished contemporaries to the National Portrait Gallery, still forms the core of its nineteenth-century collection. The series comprises likenesses of eminent Victorians from the world of culture, politics, religion and philosophy, including William Morris, Lord Alfred Tennyson, Josephine Butler, Thomas Carlyle, Cardinal Manning and John Stuart Mill. As a result of his philosophy, Watts is probably the best represented artist in national collections.

However, since its foundation in 1904, Watts Gallery has continued to be the chief repository of G. F. Watts's work. Its rural location might have been partly dictated by convenience, since the Wattses spent their winters at 'Limnerslease', their country house in Compton from the 1890s, where Mary moved permanently after her husband's death. However, it appears that Watts's decision to display the contents of his Kensington studio in the heart of Surrey stemmed primarily from his belief in 'art for all' and his urge to improve the

[1] Smith, A. (2004), 'Watts and the National Gallery of British Art', in C. Trodd and S. Brown (eds), *Representations of G. F. Watts. Art Making in Victorian Culture*, Ashgate.

lives of the working class.

When the Arts and Crafts Movement building designed by Christopher Turnor first opened it served a double purpose. It became an exhibition space for the display of Watts's studio collection, as well as a hostel for Mary Seton Watts's apprentice potters working for her Potters' Arts Guild, later known as the Compton Pottery. The Wattses transformed Compton into a model Arts and Crafts Movement village by involving the local community in a number of artistic undertakings, including clay-modelling classes at Limnerslease (launched in 1895), the building of the Mortuary Chapel (consecrated in 1898) and the foundation of the pottery (c.1900). Indeed, Mary's support for the building of the Compton Village Hall (completed in 1934) demonstrated her continuing dedication and devotion to the local people.

The Gallery houses over 1,000 diverse exhibits including oil paintings, drawings, sculptures and pottery. The artworks range from finished masterpieces (*Paolo and Francesca*, c.1872–1884, or the bronze bust *Clytie*, 1875) to sketches, studies, sculptural maquettes and purely experimental works never intended for public display. The nature and scope of the Watts Gallery collection makes it a fascinating resource for the study of Watts's working methods and techniques. It also demonstrates Watts's remarkable evolution as an artist in terms of style and subject matter over the seven decades of his active career, as well as his responses and contribution to the development of British and European art of the nineteenth and early twentieth century.

Throughout the reign of Queen Victoria, G. F. Watts's style moves from History Painting through Social Realism, Aestheticism and Symbolism to works anticipating Expressionism and Abstraction. The young Watts set out to emulate the achievement of Italian artists in the fresco technique and become England's most famous history painter. This early ambition is represented by two major oils on permanent display at Watts Gallery (*Echo*, 1844–1846 and *Guelphs and Ghibellines*,1846).

However, Watts's aspiration to 'invite reflection' through his art soon took different forms. In the late 1840s, on his return from a carefree four-year stay in Italy with Lord and Lady Holland, Watts was so moved by the miserable poverty of the working classes in England and Ireland that he produced a series of large-scale paintings representing the plight of the unprivileged in very sympathetic terms. These oppressive scenes of modern life (as opposed to grand history) were pioneering works of English Social Realism. Having been exhibited only once during Watts's lifetime at his solo exhibition at the avant-garde Grosvenor Gallery in 1881, *Found Drowned, Under the Dry Arch, Song of the Shirt* and *Irish Famine* (all 1848–1850) remain on permanent display at Watts Gallery.

Throughout his career, Watts innovated within Victorian art and unconsciously foreshadowed developments in the late nineteenth-and early twentieth-century European avant-garde. His Venetian classical paintings of the 1860s, such as *Rhodopis* (c.1868) and *Clytie* (late 1860s), reveal him as a pioneer of Aestheticism along with his friends Dante Gabriel Rossetti, Edward Burne-Jones and Frederic Leighton. [2] He helped re-introduce the depiction of the nude into Victorian art in the 1860s through works like *Thetis* (1866–1893) and later developed a heroic and deliberately non-sexual depiction of the nude in grand public works such as *Eve Repentant* (1868–1903). [3] His monumental allegories such as *Love and Death* (1871–1887) and *Mammon* (1885) were

[2] Underwood, H. (2004), 'Watts and the Symbolist Art in the Nineteenth Century', pp.30-31 in V. Franklin Gould (ed.), *The Vision of G.F. Watts*, Watts Gallery.
[3] Smith, A. (1996), *The Victorian Nude: Sexuality, Morality and Art*, Manchester University Press.

admired by the European Symbolists, as were his aesthetic portraits (*Violet Lindsay*, 1879) and symbolist landscapes (*After the Deluge*, 1885–1886).[4] Some of his paintings (*Sower of the Systems*, 1902) even seem to presage Abstraction.

In addition to diverse works by G. F. Watts, Watts Gallery also owns a number of works by other Victorian and early Edwardian artists, including Val Prinsep, Arthur Hughes, Charles Shannon, Lord Leighton, John Singer Sargent and Graham Robertson. These works come primarily from two major bequests made after Mary Seton Watts's death in 1938. The Graham Robertson Bequest (1951) consists of a collection of Victorian and Edwardian portraiture. The Cecil French Bequest (1954) comprises primarily imaginative works from the Aesthetic Movement and Pre-Raphaelite traditions. The nature of the two bequests reflects the main tendencies within Watts's oeuvre – subject pictures and portraits.

However, when Watts Gallery first opened, the Collection included 109 core works by G. F. Watts exclusively. These largely finished subject pictures comprised the original Memorial Collection listed in the Trust Deed signed by Mary Seton Watts and the executors and trustees of G. F. Watts's will on the 24th May 1905. Only 13 of these pictures were recorded as studies, sketches or unfinished works, and only four were drawings. The core Collection was subsequently enriched by gifts from Mary Seton Watts and Lilian Chapman (née Macintosh), Watts's adopted daughter, and has been expanding through other bequests and donations as well as acquisitions made with the generous support of the NACF and Heritage Lottery Fund (the significant portrait of the Ionides family, *Alexander Constantine Ionides and His Wife Euterpe*, c.1841–1842, being the most recent addition to the Collection purchased through Sotheby's in 2005).

There have been only four curators in the gallery's first century. Mr Thompson, the first, left the gallery in 1914 and Mrs Watts dispensed with an official curator until 1931, when Roland Alston was appointed and confirmed as curator in 1938. Wilfrid Blunt (artist, writer and, formerly, drawing and calligraphy master at Eton) took over in 1959 and wrote the first contemporary biography of G. F. Watts, *England's Michelangelo* (1975). Blunt's curatorship lasted for 26 years and, following his retirement in 1985, his assistant Richard Jefferies was appointed as his successor. At the beginning of his term of office, Richard was able to refurbish and reopen the Sculpture Gallery, which had been closed for over 40 years, and which remains one of the favourite aspects of our Collection. In 2004 Perdita Hunt joined Watts Gallery as its Director and launched the *Hope Appeal* – a restoration and education project aimed at rescuing the Gallery for future generations. Mark Bills was appointed the new curator following Richard's retirement earlier this year.

Watts Gallery is undergoing a dynamic period of development, which started with the Watts Centenary in 2004. The Centenary celebrations were marked with special temporary exhibitions and the publication of several significant books on Watts, including the most recent and comprehensive biography of the artist, *G. F. Watts: The Last Great Victorian* by Veronica Franklin Gould (2004). The reinstatement of Watts's reputation is underway and we are delighted to be able to promote Watts's output through the work of the Public Catalogue Foundation.

Julia Dudkiewicz, Assistant Curator

[4] For a comprehensive discussion of Watts's symbolist works see: A. Wilton and R. Upstone (eds) (1997). *The Age of Rossetti, Burne-Jones & Watts. Symbolism in Britain 1860-1910*, Tate Gallery Publishing.

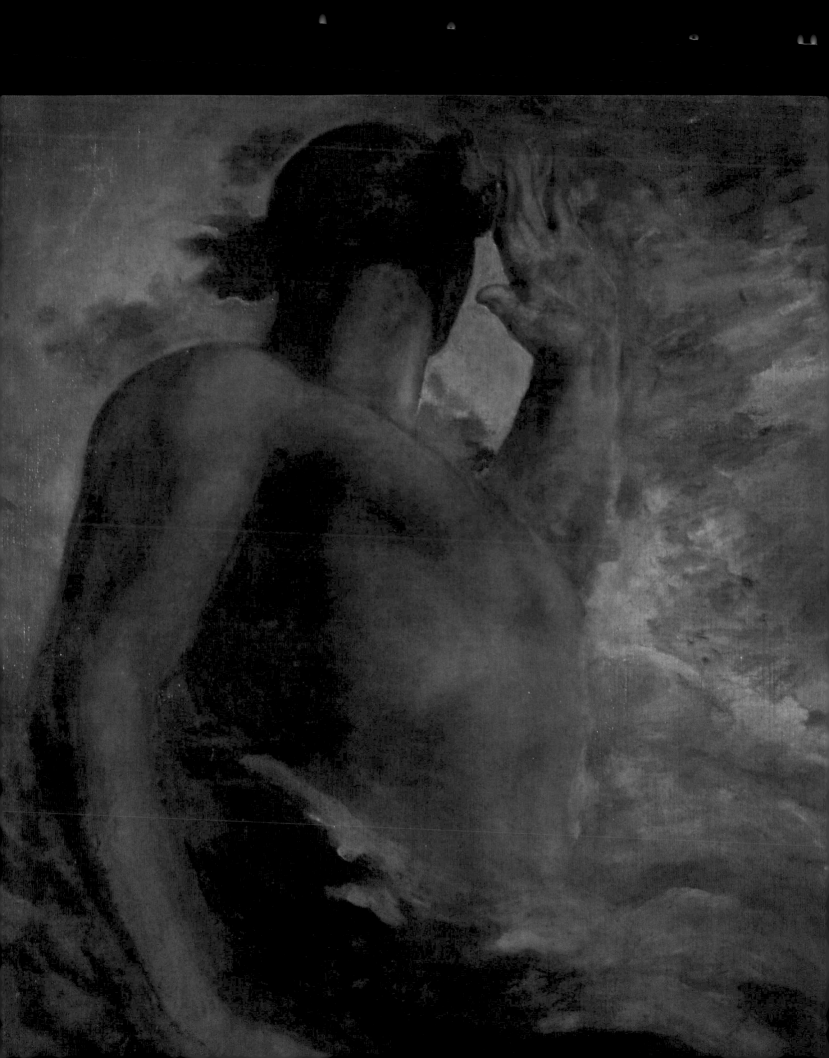

Alston, Rowland Wright 1895–1958
Lough Conn, Ireland 1935
oil on paper 21.5 x 31.8

Alston, Rowland Wright 1895–1958
Dead Bird (Sheldrake)
oil on canvas 45.7 x 30.5
COMWG 580

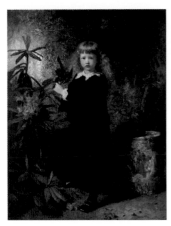

Bauerle, Karl Wilhelm Friedrich 1831–1912
Graham Robertson as a Boy 1871
oil on canvas 140.8 x 110
COMWG 572

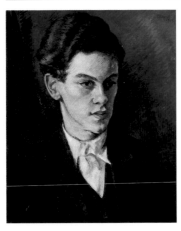

Blunt, Wilfrid 1901–1987
Michael Severne 1939
oil on canvas 49.6 x 39.5
COMWG NC 25

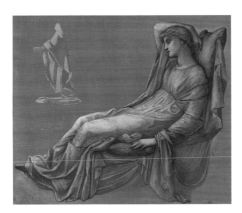

Burne-Jones, Edward 1833–1898
Laus Veneris c.1873
mixed media heightened with gold on board
34 x 40
COMWG 560

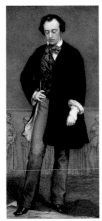

Couzens, Charles active 1838–1875
G. F. Watts 1849
oil on canvas 41 x 21.4
COMWG 501

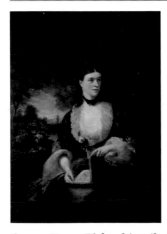

Graves, Henry Richard (attributed to)
1818–1882
Mrs Graham Robertson, in Her Youth 1873
oil on canvas 140.5 x 99.7
COMWG 573

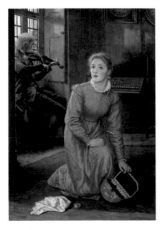

Hughes, Arthur 1832–1915
Memories c.1882–1883
oil on canvas 84 x 59.9
COMWG 579

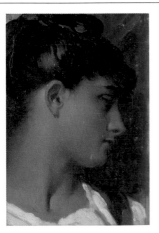

**Leighton, Frederic, 1st Baron Leighton of
Stretton** 1830–1896
Female Head
oil on canvas 18 x 13
COMWG 555

Facing page: Watts, George Frederick, 1817 –1904, *Satan* (detail), 1847, Watts Gallery, (p. 138)

Melville, Arthur 1855–1904
Mrs Graham Robertson 1900
oil on canvas 201 x 165
COMWG 571

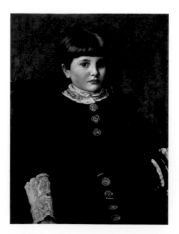

Prinsep, Valentine Cameron 1838–1904
Nancy Hitchens c.1880s
oil on canvas 65.2 x 50.3
COMWG 577

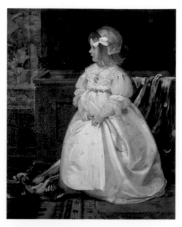

Robertson, Walford Graham 1866–1948
Binkie 1899
oil on canvas 124 x 100.1
COMWG 570

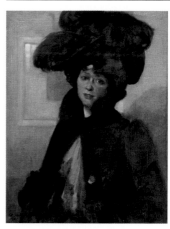

Robertson, Walford Graham 1866–1948
Olga Brandon 1901
oil on canvas 76.5 x 58.5
COMWG 569

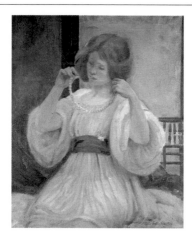

Robertson, Walford Graham 1866–1948
The Amber Necklace
oil on canvas 77.6 x 64.7
COMWG NC 7

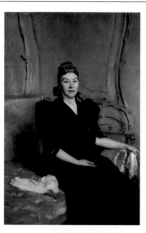

Sargent, John Singer 1856–1925
Mrs Graham Robertson 1880
oil on canvas 159 x 102.5
COMWG 568

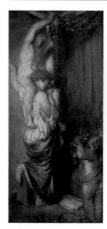

Shannon, Charles Haslewood 1863–1937
The Garland 1895–1902
oil on canvas 88.2 x 40.8
COMWG 575

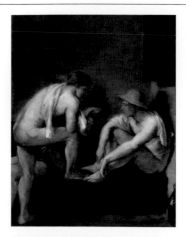

Shannon, Charles Haslewood 1863–1937
The Bathers 1900
oil on board 45.8 x 35.2
COMWG 563

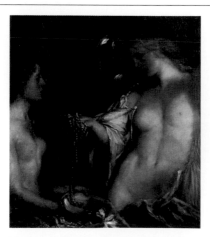

Shannon, Charles Haslewood 1863–1937
The Toilet 1903
oil on canvas 85 x 76.4
COMWG 553

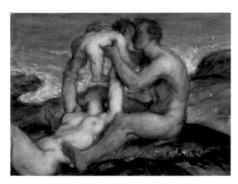

Shannon, Charles Haslewood 1863–1937
An Idyll 1904
oil on canvas 35.8 x 46.2
COMWG 564

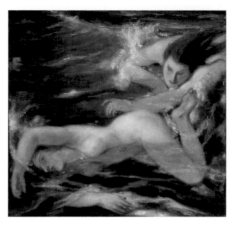

Shannon, Charles Haslewood 1863–1937
The Pursuit
oil on canvas 38.6 x 40.8
COMWG 554

Stott, William 1857–1900
Washing Day
oil on canvas 46.7 x 51.9
COMWG 550

unknown artist
Group Portrait
oil on board 33.8 x 53.5
COMWG NC36

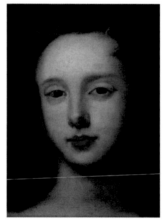

Watts, George Frederick 1817–1904
*Early Copy from an Unidentified Baroque
Portrait* c.1830
oil on canvas 29.8 x 21.6
COMWG 259

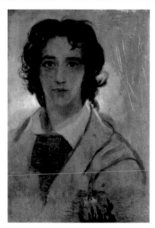

Watts, George Frederick 1817–1904
Self Portrait, Aged 17 1834
oil on canvas 53.3 x 38.1
COMWG 10

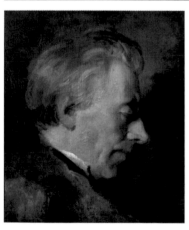

Watts, George Frederick 1817–1904
The Artist's Father 1834–1836
oil on canvas 38 x 32
COMWG 119

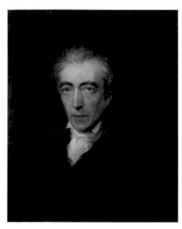

Watts, George Frederick 1817–1904
The Artist's Father, Half-Length 1834–1836
oil on canvas 61 x 51
COMWG 3

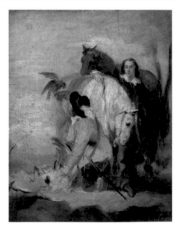

Watts, George Frederick 1817–1904
The Falconer c.1834–1836
oil on canvas 25.4 x 20.3
COMWG 236

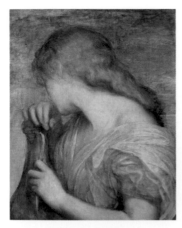

Watts, George Frederick 1817–1904
Undine 1835 & 1870
oil on canvas 61 x 48.3
COMWG 62

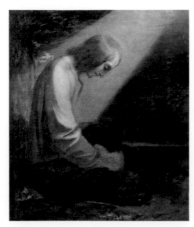

Watts, George Frederick 1817–1904
A Kneeling Figure (A Man of Sorrows)
c.1835–1836
oil on canvas 34.5 x 30.1
COMWG NC 23

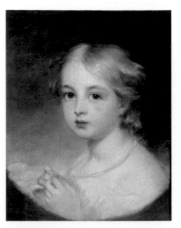

Watts, George Frederick 1817–1904
Little Miss Hopkins 1836
oil on canvas 25.4 x 20.3
COMWG 58

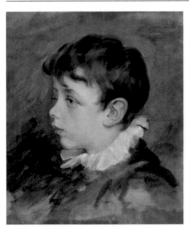

Watts, George Frederick 1817–1904
Portrait of a Boy's Head (Cornellius) 1836
oil on canvas 40.6 x 35.6
COMWG 173

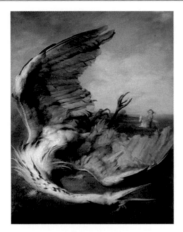

Watts, George Frederick 1817–1904
The Wounded Heron 1837
oil on canvas 91.4 x 71.1
COMWG 64

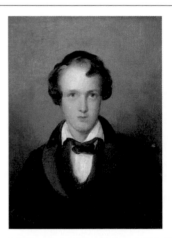

Watts, George Frederick 1817–1904
Reverend A. Wellsted 1838–1839
oil on canvas 25.4 x 20.3
COMWG 189

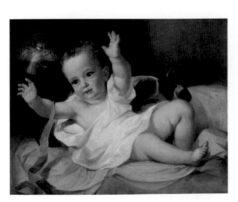

Watts, George Frederick 1817–1904
Gerald Hamilton as an Infant 1839
oil on canvas 50.8 x 63.5
COMWG NC 24

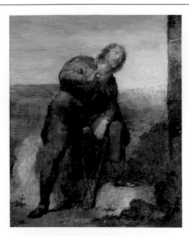

Watts, George Frederick 1817–1904
Blondel 1841
oil on canvas 29.7 x 24.7
COMWG NC 13

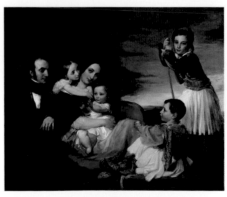

Watts, George Frederick 1817–1904
*Alexander Constantine Ionides and His Wife
Euterpe, with Their Children Constantine,
Alexander, Aglaia and Alecco* c.1841–1842
oil on canvas 150 x 183
COMWG NC 26

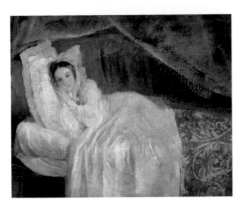

Watts, George Frederick 1817–1904
Lady Holland on Daybed 1844
oil on canvas 38.1 x 45.7
COMWG 16

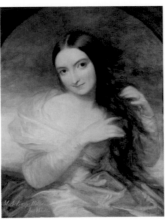

Watts, George Frederick 1817–1904
Lady Augusta Holland c.1844
oil on canvas 68.5 x 56
COMWG 55

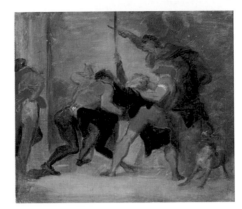

Watts, George Frederick 1817–1904
Drowning of the Doctor 1844–1845
oil on canvas 20.3 x 25.4
COMWG 253

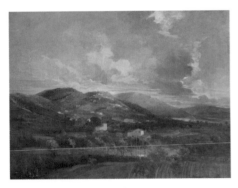

Watts, George Frederick 1817–1904
Fiesole, Tuscany 1844–1845
oil on canvas 66 x 86.4
COMWG 12

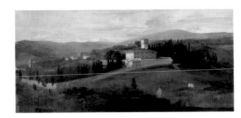

Watts, George Frederick 1817–1904
Villa Petraia 1844–1845
oil on canvas 30.5 x 63.3
COMWG NC 22

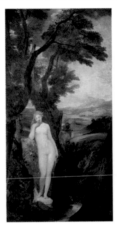

Watts, George Frederick 1817–1904
Echo 1844–1846
oil on canvas 388.6 x 198.1
COMWG LN 1

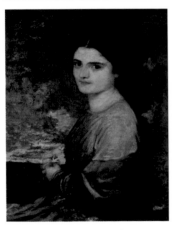

Watts, George Frederick 1817–1904
Miss Marietta Lockhart 1845
oil on canvas 76.2 x 63.5
COMWG NC 10

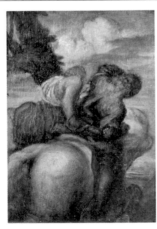

Watts, George Frederick 1817–1904
Orderic and the Witch 1845–1868
oil on panel 35.6 x 27.9
COMWG 24

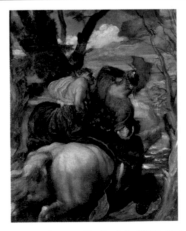

Watts, George Frederick 1817–1904
Orderic and the Witch (Large version in colour) 1845–1868
oil on canvas 71.1 x 58.4
COMWG 4

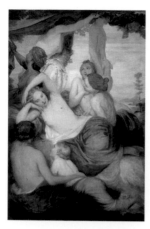

Watts, George Frederick 1817–1904
Diana's Nymphs 1846
oil on canvas 195.6 x 137.2
COMWG 32

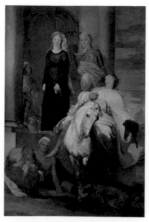

Watts, George Frederick 1817–1904
Guelphs and Ghibellines 1846
oil on canvas 320 x 259.1
COMWG 45

Watts, George Frederick 1817–1904
Satan 1847
oil on canvas 198.1 x 132.1
COMWG 117

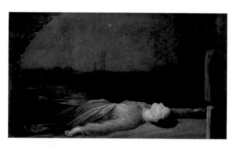

Watts, George Frederick 1817–1904
Found Drowned 1848–1850
oil on canvas 119.4 x 213.4
COMWG 161

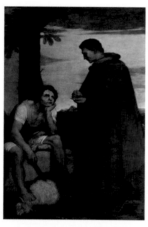

Watts, George Frederick 1817–1904
Aristides and the Shepherd 1848–1852
oil on canvas 305 x 213
COMWG 33

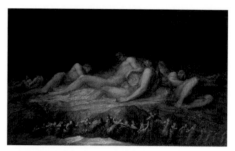

Watts, George Frederick 1817–1904
The Titans 1848–1873
oil on panel 71.1 x 111.8
COMWG 109

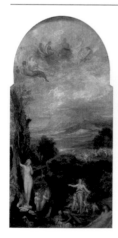

Watts, George Frederick 1817–1904
Olympus 1849
oil on canvas 129.5 x 53.5
COMWG 74

Watts, George Frederick 1817–1904
Under the Dry Arch 1849–1850
oil on canvas 137 x 101.5
COMWG 171

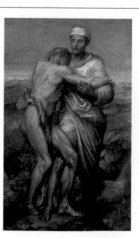

Watts, George Frederick 1817–1904
The Good Samaritan 1849–1904
oil on canvas 243.8 x 154.9
COMWG 140

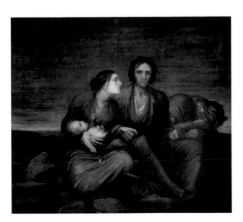

Watts, George Frederick 1817–1904
Irish Famine 1850
oil on canvas 180.3 x 198.1
COMWG 132

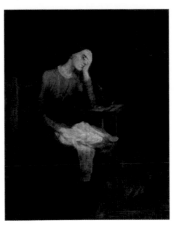

Watts, George Frederick 1817–1904
Song of the Shirt 1850
oil on canvas 144.8 x 127
COMWG 128

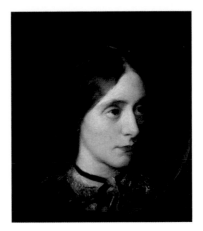

Watts, George Frederick 1817–1904
Mrs Morris 1850s
oil on panel 40.6 x 35.6
COMWG 181

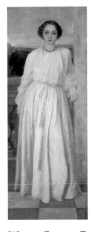

Watts, George Frederick 1817–1904
Lady Dalrymple c.1851–1853
oil on canvas 198 x 78.7
COMWG 200

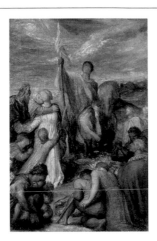

Watts, George Frederick 1817–1904
St George 1852
oil on canvas 55.9 x 38.1
COMWG 20

Watts, George Frederick 1817–1904
Study for Carlton House Terrace Frescoes
1853–1854
oil on canvas 14 x 61
COMWG NC 1

Watts, George Frederick 1817–1904
James Barr Mitchell 1855–1856
oil on canvas 46.6 x 56.2
COMWG NC 6

Watts, George Frederick 1817–1904
Miss Mildmay 1855–1856
oil on canvas 55.9 x 45.7
COMWG 65

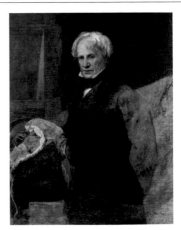

Watts, George Frederick 1817–1904
Admiral Lord Lyons 1856
oil on canvas 121.9 x 99.1
COMWG 170

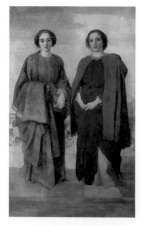

Watts, George Frederick 1817–1904
The Sisters 1856
oil on canvas 231.1 x 144.8
COMWG 137

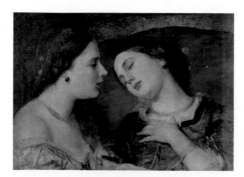

Watts, George Frederick 1817–1904
Georgina Treherne 1856–1858
oil on canvas 50.8 x 69.9
COMWG NC 19

Watts, George Frederick 1817–1904
Bodrum, Asia Minor 1857
oil on canvas 20.3 x 58.4
COMWG 174

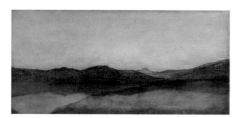

Watts, George Frederick 1817–1904
In Asia Minor 1857
oil on canvas 30.5 x 61
COMWG 85

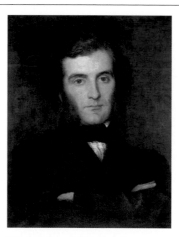

Watts, George Frederick 1817–1904
Dr Zambaco 1858
oil on panel 50.8 x 40.6
COMWG NC 20

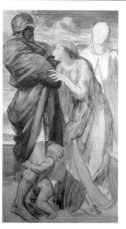

Watts, George Frederick 1817–1904
*Study for Fresco of Corialanus for Bowood
House* 1858–1860
mixed media on paper laid on canvas
134 x 109.5
COMWG NC 2

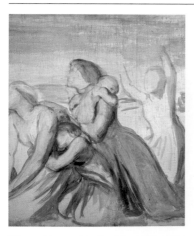

Watts, George Frederick 1817–1904
*Study for Fresco of Corialanus for Bowood
House* 1858–1860
mixed media on paper laid on canvas
134 x 105.5
COMWG NC 3

Watts, George Frederick 1817–1904
*Study for Fresco of Corialanus for Bowood
House* 1858–1860
mixed media on paper laid on canvas
134 x 77.5
COMWG NC 4

Watts, George Frederick 1817–1904
*Study for Fresco of Corialanus for Bowood
House* 1858–1860
mixed media on paper laid on canvas
98.5 x 86
COMWG NC 5

Facing page: Holland, James, 1800–1870, *Piazza dei Signori, Verona, with the Market Place* (detail), 1844,
Royal Holloway, University of London, (p. 48)

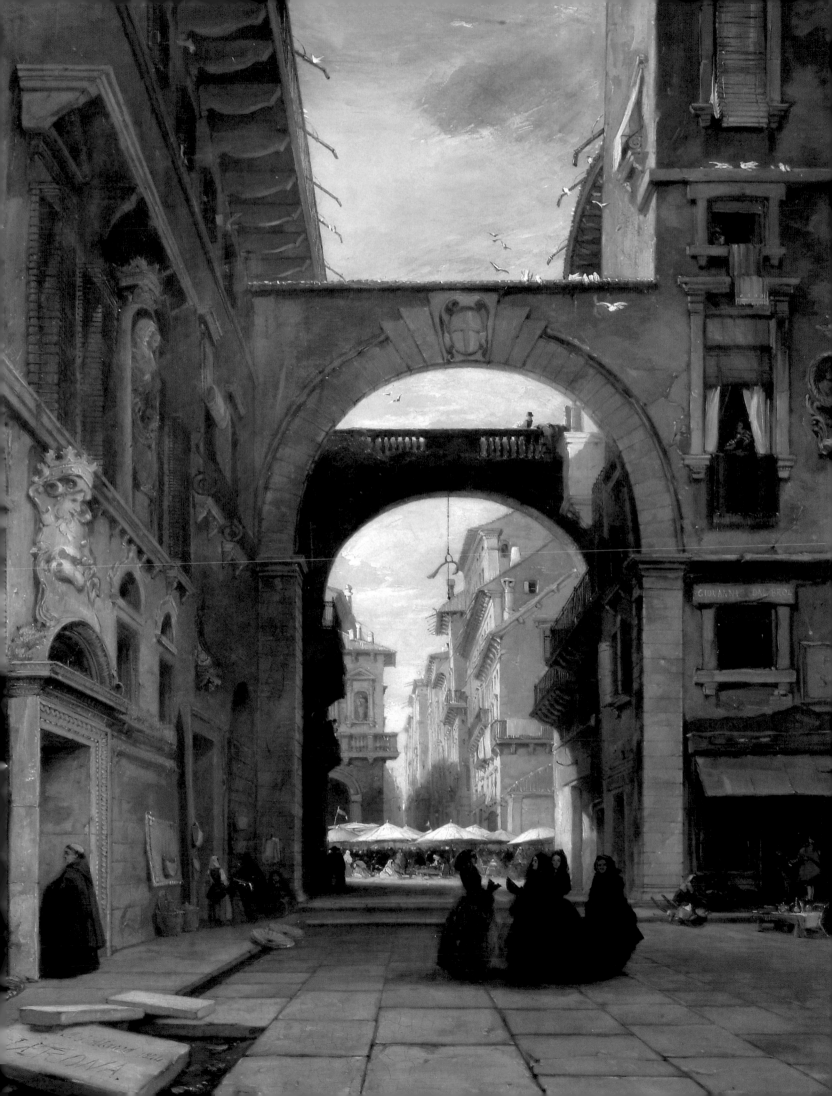

Watts, George Frederick 1817–1904
Achilles and Briseis c.1858–1860
fresco, mixed media & oil on plaster
122 x 518.5
COMWG 94

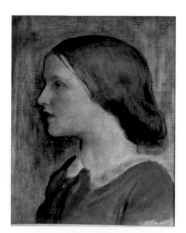

Watts, George Frederick 1817–1904
Aileen Spring-Rice 1859
oil on canvas 40.6 x 33
COMWG 27

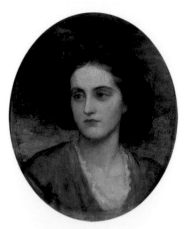

Watts, George Frederick 1817–1904
Lady Lilford 1860
oil on canvas 50.8 x 40.6
COMWG 31

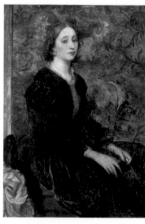

Watts, George Frederick 1817–1904
Lady Somers 1860
oil on panel 121.9 x 89
COMWG 71

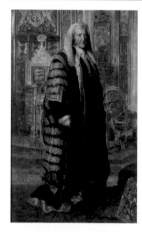

Watts, George Frederick 1817–1904
Lord Campbell 1860
oil on panel 63.5 x 38
COMWG 18

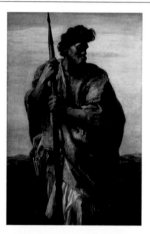

Watts, George Frederick 1817–1904
Esau 1860–1865
oil on canvas 165.1 x 111.8
COMWG 129

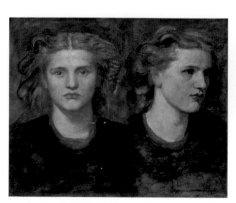

Watts, George Frederick 1817–1904
'Long Mary' c.1860
oil on panel 53.3 x 66
COMWG 180

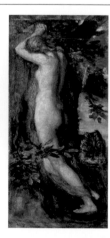

Watts, George Frederick 1817–1904
Eve Repentant 1860s
oil on canvas 61 x 28
COMWG 26

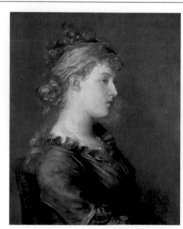

Watts, George Frederick 1817–1904
Lady Archibald Campbell 1860s
oil on canvas 66 x 53.3
COMWG 108

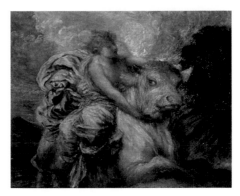

Watts, George Frederick 1817–1904
Europa 1860s & late 1890s
oil on canvas 53.3 x 66
COMWG 14

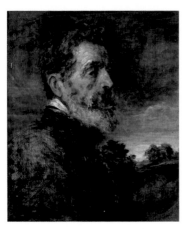

Watts, George Frederick 1817–1904
Earl of Shrewsbury 1862
oil on panel 61 x 53.3
COMWG 52

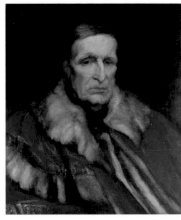

Watts, George Frederick 1817–1904
Lord Lyndhurst 1862
oil on canvas 61 x 50.8
COMWG 50

Watts, George Frederick 1817–1904
Head of an Ass 1862–1863
oil on panel 61 x 51
COMWG 155

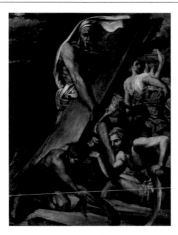

Watts, George Frederick 1817–1904
The Building of the Ark 1862–1863
oil on canvas 94 x 73.7
COMWG 111

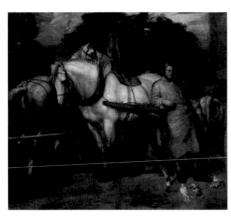

Watts, George Frederick 1817–1904
The Midday Rest (Dray Horses) 1862–1863
oil on canvas 137.2 x 154.9
COMWG 82

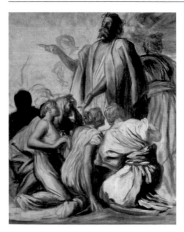

Watts, George Frederick 1817–1904
Preaching of Jonah (or Noah) c.1863
oil on canvas 70 x 58
COMWG 165

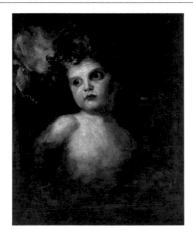

Watts, George Frederick 1817–1904
Ganymede (Son of Dr Zambaco and Miss Mary Cassavetti) 1864
oil on canvas 58.4 x 45.7
COMWG 110

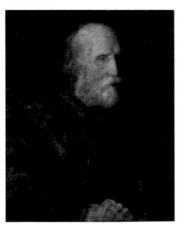

Watts, George Frederick 1817–1904
Giuseppe Garibaldi (1807–1882) 1864
oil on canvas 68.6 x 55.9
COMWG 51

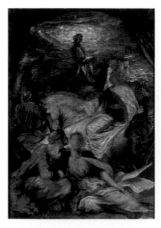

Watts, George Frederick 1817–1904
Britomart 1865
oil on canvas 56 x 38
COMWG 29

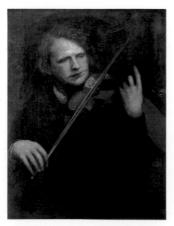

Watts, George Frederick 1817–1904
Dr J. Joachim 1865–1866
oil on canvas 91.4 x 66.6
COMWG 34

Watts, George Frederick 1817–1904
Sir Henry Taylor (unfinished) 1865–1870
oil on canvas 66 x 53.3
COMWG 96

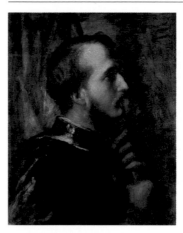

Watts, George Frederick 1817–1904
The Standard-Bearer 1866
oil on canvas 66 x 53.3
COMWG 19

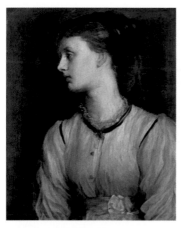

Watts, George Frederick 1817–1904
Miss May Prinsep 1867–1869
oil on canvas 66 x 53.3
COMWG 88

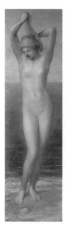

Watts, George Frederick 1817–1904
Thetis 1867–1869
oil on canvas 193 x 53.3
COMWG 42

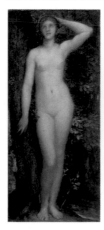

Watts, George Frederick 1817–1904
Thetis 1867–1869
oil on canvas 66.5 x 30.5
COMWG 93

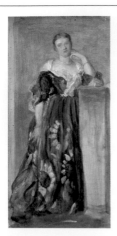

Watts, George Frederick 1817–1904
Mrs Percy Wyndham 1867–1871
oil on canvas 53.3 x 27.9
COMWG 56

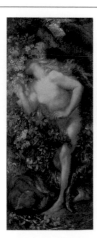

Watts, George Frederick 1817–1904
Eve Tempted 1868
oil on canvas 251.5 x 109.2
COMWG 142

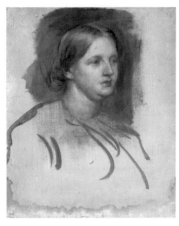

Watts, George Frederick 1817–1904
Florence Nightingale (1820–1910) 1868
oil on canvas 66 x 53.3
COMWG 152

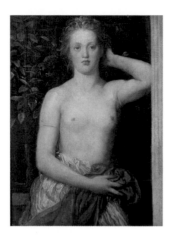

Watts, George Frederick 1817–1904
Rhodopis c.1868
oil on canvas 91.4 x 71.1
COMWG 114

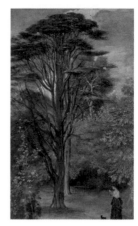

Watts, George Frederick 1817–1904
Cedar Tree 1868–1869
oil on panel 45.7 x 29.2
COMWG 160

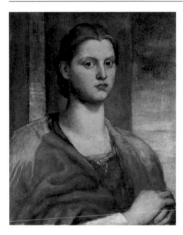

Watts, George Frederick 1817–1904
A Fair Saxon 1868–1870
oil on canvas 66 x 53.3
COMWG 91

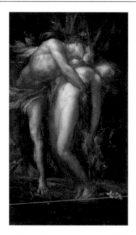

Watts, George Frederick 1817–1904
Orpheus and Euridice (small version)
1868–1872
oil on canvas 66 x 38.1
COMWG 79

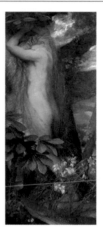

Watts, George Frederick 1817–1904
Eve Repentant 1868–1903
oil on canvas 251.5 x 114.3
COMWG 141

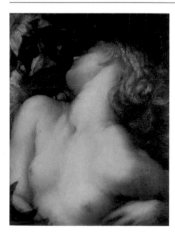

Watts, George Frederick 1817–1904
Clytie late 1860s
oil on panel 61 x 51
COMWG 73

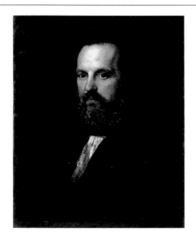

Watts, George Frederick 1817–1904
Donders Frans late 1860s
oil on canvas 66 x 53.3
COMWG 179

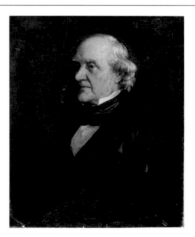

Watts, George Frederick 1817–1904
George Peabody late 1860s
oil on canvas 94 x 71.1
COMWG 121

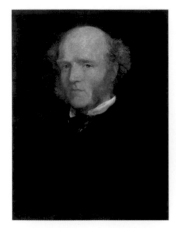

Watts, George Frederick 1817–1904
Thomas Hughes c.1870s
oil on canvas 66 x 48.3
COMWG 5

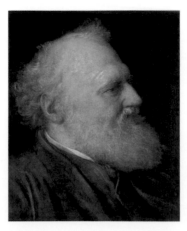

Watts, George Frederick 1817–1904
H. Toby Prinsep 1871
oil on canvas 50.8 x 40.6
COMWG 153

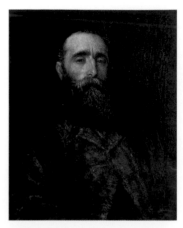

Watts, George Frederick 1817–1904
P. H. Calderon 1871
oil on canvas 63.5 x 51
COMWG 40

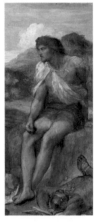

Watts, George Frederick 1817–1904
Samson 1871
oil on panel 55.9 x 25.4
COMWG 75

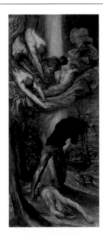

Watts, George Frederick 1817–1904
The Denunciation of Cain 1871–1872
oil on canvas 147 x 68.6
COMWG 76

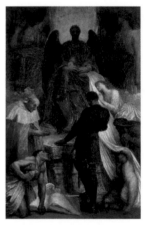

Watts, George Frederick 1817–1904
The Court of Death 1871–1902
oil on canvas 94 x 61
COMWG 81

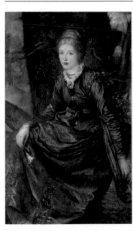

Watts, George Frederick 1817–1904
Miss Virginia Julian Dalrymple (Mrs Francis Champneys) 1872
oil on canvas 132 x 84
COMWG 200A

Watts, George Frederick 1817–1904
Rith H. Wallis-Dunlop 1872
oil on canvas 64.8 x 52.1
COMWG LN 2 (P)

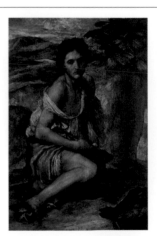

Watts, George Frederick 1817–1904
The Prodigal Son 1872–1873
oil on canvas 109.2 x 78.7
COMWG 192

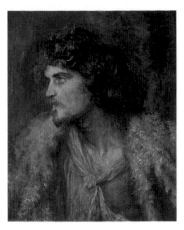

Watts, George Frederick 1817–1904
The Prodigal Son (bust-length figure)
1872–1873
oil on canvas 61 x 50.8
COMWG 44

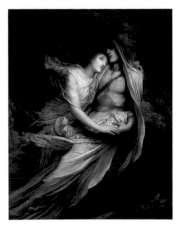

Watts, George Frederick 1817–1904
Paolo and Francesca 1872–1875
oil on canvas 152.4 x 129.5
COMWG 83

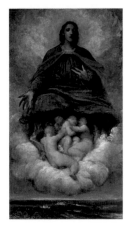

Watts, George Frederick 1817–1904
The Spirit of Christianity 1872–1875
oil on canvas 91.4 x 53.3
COMWG 122

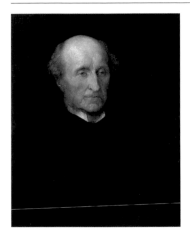

Watts, George Frederick 1817–1904
John Stuart Mill (1806–1873) 1873
oil on canvas 66 x 53.3
COMWG 86

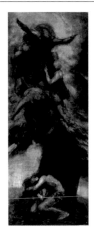

Watts, George Frederick 1817–1904
The Denunciation of Adam and Eve 1873
oil on panel 61 x 25.4
COMWG 59

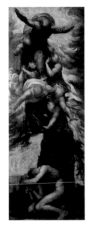

Watts, George Frederick 1817–1904
The Denunciation of Adam and Eve 1873
oil on canvas 117 x 44
COMWG 162

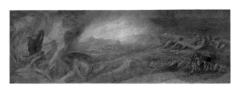

Watts, George Frederick 1817–1904
Chaos 1873–1875
oil on canvas 104 x 317.5
COMWG 143

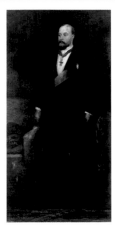

Watts, George Frederick 1817–1904
King Edward VII (1841–1910) 1874
oil on canvas 235 x 118.1
COMWG 138

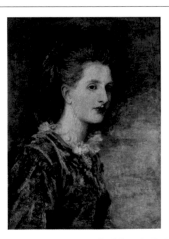

Watts, George Frederick 1817–1904
Lady Garvagh 1874
oil on canvas 66 x 48.3
COMWG 57

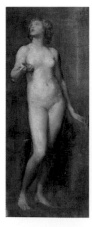

Watts, George Frederick 1817–1904
Study of Nude (Standing Figure) 1874
oil on canvas 52 x 21.5
COMWG 17

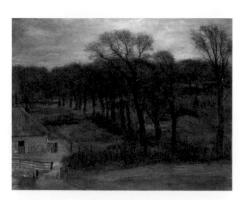

Watts, George Frederick 1817–1904
Freshwater, near Farringford 1874–1875
oil on canvas 53.3 x 66
COMWG 163

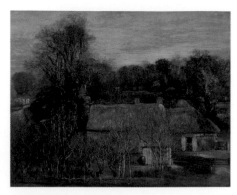

Watts, George Frederick 1817–1904
Freshwater Farm Buildings 1875
oil on canvas 53.3 x 66
COMWG 166

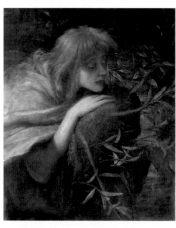

Watts, George Frederick 1817–1904
Ophelia 1875–1880
oil on canvas 76.2 x 63.5
COMWG 89

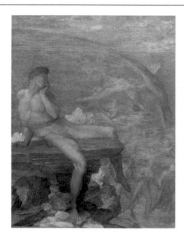

Watts, George Frederick 1817–1904
Genius of Greek Poetry 1878
oil on canvas 66 x 53.3
COMWG 22

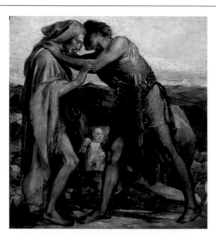

Watts, George Frederick 1817–1904
Jacob and Esau 1878
oil on canvas 106.7 x 99.1
COMWG 25

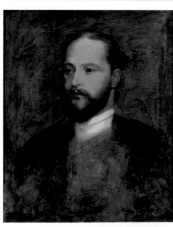

Watts, George Frederick 1817–1904
King Edward VII (1841–1910) 1878
oil on canvas 66 x 56
COMWG 154

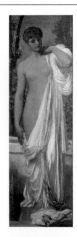

Watts, George Frederick 1817–1904
Arcadia 1878–1880
oil on canvas 193 x 61
COMWG 39

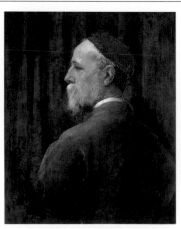

Watts, George Frederick 1817–1904
Self Portrait 1879
oil on canvas 66 x 53.3
COMWG 9

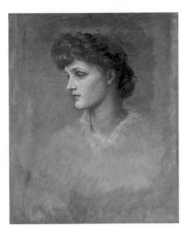

Watts, George Frederick 1817–1904
Violet Lindsay 1879
oil on canvas 66 x 53.3
COMWG 148

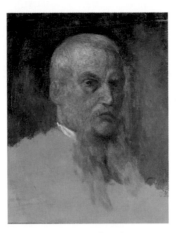

Watts, George Frederick 1817–1904
Sir Richard Burton 1879–1880
oil on canvas 66 x 53.3
COMWG 176

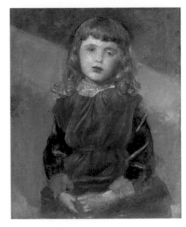

Watts, George Frederick 1817–1904
Lucy Bond 1880
oil on canvas 66 x 53.3
COMWG 177

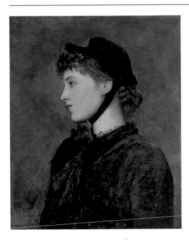

Watts, George Frederick 1817–1904
Mrs Lillie Langtry 1880
oil on canvas 66 x 53.3
COMWG 43

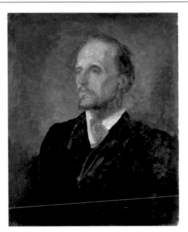

Watts, George Frederick 1817–1904
Sketch of Lord Dufferin 1880
oil on canvas 66.4 x 53.2
COMWG NC 11

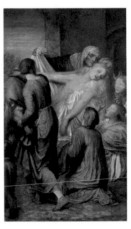

Watts, George Frederick 1817–1904
Lady Godiva 1880–1890
oil on canvas 185.4 x 109.2
COMWG 136

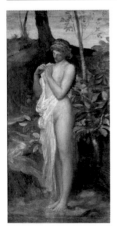

Watts, George Frederick 1817–1904
Daphne's Bath 1880s
oil on canvas 56 x 28
COMWG 77

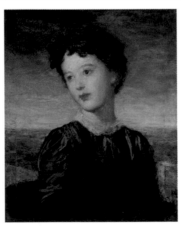

Watts, George Frederick 1817–1904
Laura Gurney (later Lady Troubridge) 1880s
oil on canvas 61 x 50.8
COMWG 54

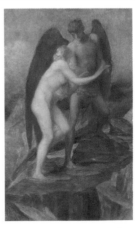

Watts, George Frederick 1817–1904
Love and Life 1880s
oil on canvas 66 x 43.2
COMWG 175

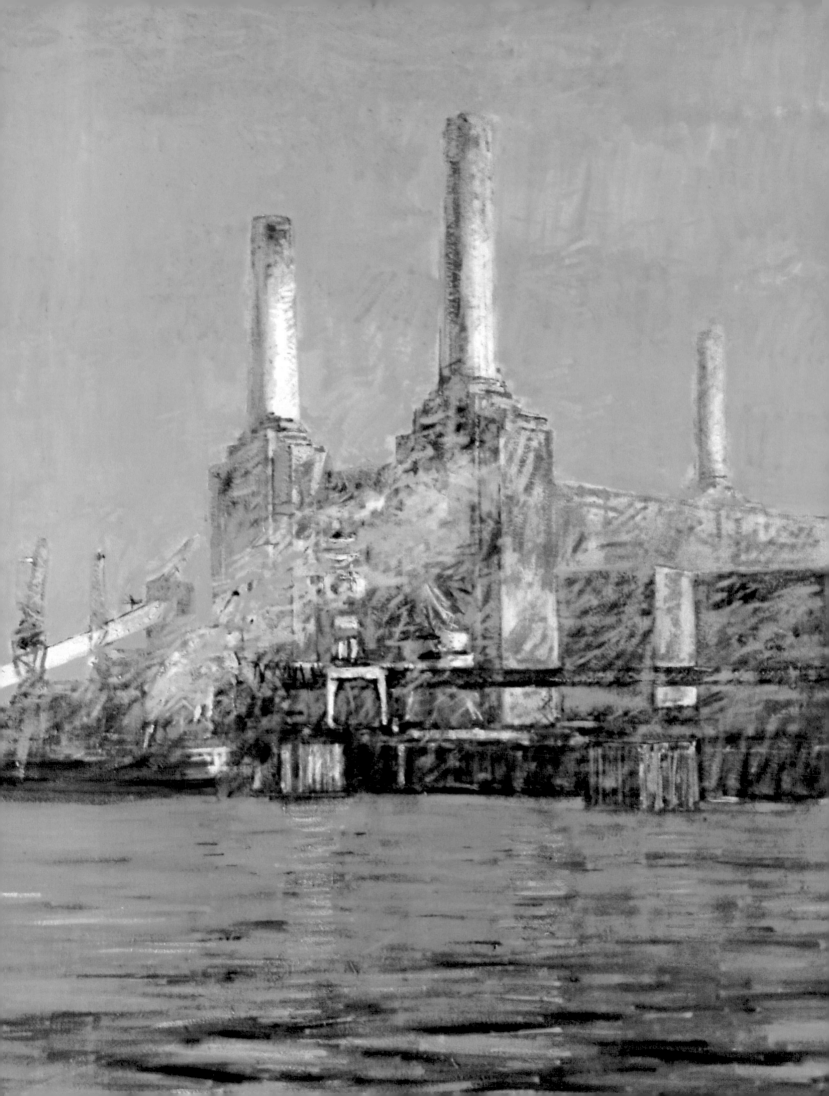

Watts, George Frederick 1817–1904
Miss Blanche Maynard 1881–1882
oil on canvas 63.5 x 53.3
COMWG 149

Watts, George Frederick 1817–1904
The Creation of Eve 1881–1882
oil on canvas 117 x 43.2
COMWG 11

Watts, George Frederick 1817–1904
The Creation of Eve (unfinished) 1881–1882
oil on canvas 117 x 43.2
COMWG 13

Watts, George Frederick 1817–1904
G. F. Watts 1882
oil on canvas 66 x 53.3
COMWG 105 (P)

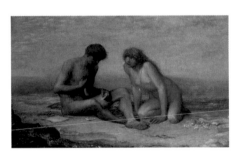

Watts, George Frederick 1817–1904
Tasting the First Oyster 1882–1883
oil on canvas 104.1 x 165.1
COMWG 92

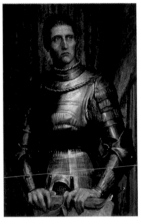

Watts, George Frederick 1817–1904
The Condottiere 1883
oil on canvas 99.1 x 61
COMWG 168

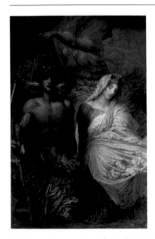

Watts, George Frederick 1817–1904
Time, Death and Judgement 1884
oil on canvas 243.8 x 168.9
COMWG LN 3

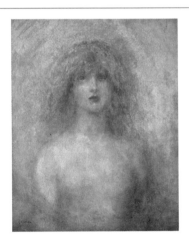

Watts, George Frederick 1817–1904
Uldra 1884
oil on canvas 66 x 53.3
COMWG NC 21

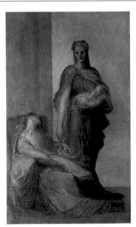

Watts, George Frederick 1817–1904
The Messenger 1884–1885
oil on canvas 111.8 x 66
COMWG 37

Facing page: Newbolt, Thomas, b.1951, *Battersea Power Station* (detail), 1980, University of Surrey, (p. 123)

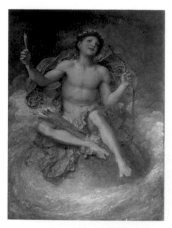

Watts, George Frederick 1817–1904
Idle Child of Fancy 1885
oil on canvas 147.3 x 106.7
COMWG 147

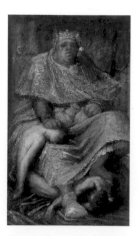

Watts, George Frederick 1817–1904
Mammon 1885
oil on canvas 53.3 x 30.5
COMWG 49

Watts, George Frederick 1817–1904
Near Brighton 1885
oil on canvas 50.8 x 61
COMWG 125

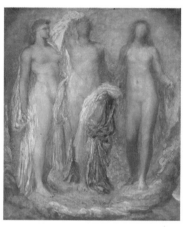

Watts, George Frederick 1817–1904
Olympus on Ida 1885
oil on canvas 66 x 55.9
COMWG 30

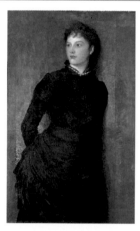

Watts, George Frederick 1817–1904
Rachel Gurney 1885
oil on canvas 111.8 x 66.6
COMWG 38

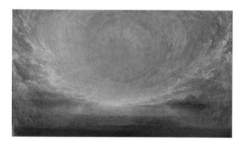

Watts, George Frederick 1817–1904
After the Deluge 1885–1886
oil on canvas 104 x 178
COMWG 145

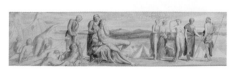

Watts, George Frederick 1817–1904
Study for 'Achilles and Briseis' 1885–1886
mixed media on paper 13 x 51
COMWG 258

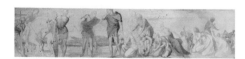

Watts, George Frederick 1817–1904
Study for 'Corialanus' 1885–1886
mixed media on paper 13 x 51
COMWG 258

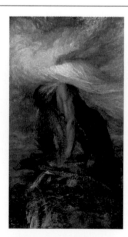

Watts, George Frederick 1817–1904
The Death of Cain 1885–1886
oil on canvas 63.5 x 35.6
COMWG 66

Watts, George Frederick 1817–1904
A Sea Ghost 1887
oil on canvas 45.7 x 71.1
COMWG 100

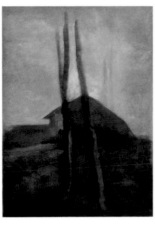

Watts, George Frederick 1817–1904
Egyptian Landscape 1887
oil on paper laid on canvas 78.7 x 55.9
COMWG 127

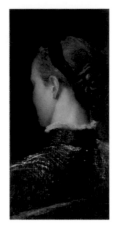

Watts, George Frederick 1817–1904
Mrs G. F. Watts 1887
oil on canvas 50.8 x 25.4
COMWG 1

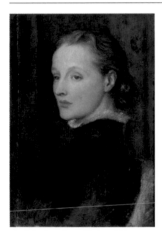

Watts, George Frederick 1817–1904
Mrs G. F. Watts 1887
oil on canvas 48.3 x 35.6
COMWG 7

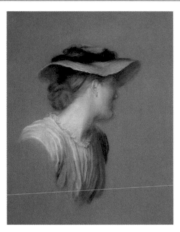

Watts, George Frederick 1817–1904
Mrs G. F. Watts in a Straw Hat 1887
oil on paper 64.6 x 51.8
COMWG NC 15

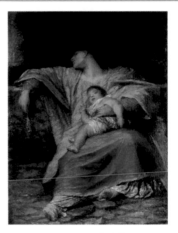

Watts, George Frederick 1817–1904
Peace and Goodwill 1887
oil on canvas 66 x 53.3
COMWG 2

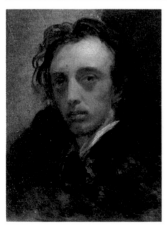

Watts, George Frederick 1817–1904
Self Portrait, Aged 24 1887
oil on copper 12.7 x 10.2
COMWG 184

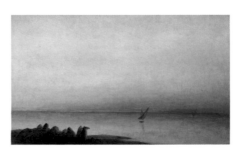

Watts, George Frederick 1817–1904
Sunset on the Nile 1887
oil on canvas 62.2 x 102
COMWG NC 16

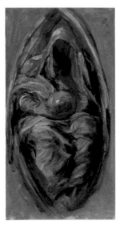

Watts, George Frederick 1817–1904
The All-Pervading 1887
oil on paper 26.5 x 16
COMWG NC 30

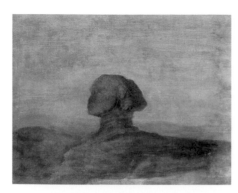

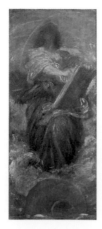

Watts, George Frederick 1817–1904
The Sphinx 1887
oil on canvas 40.6 x 50.8
COMWG 126

Watts, George Frederick 1817–1904
Recording Angel 1888
oil on canvas 58.4 x 25.4
COMWG 61

Watts, George Frederick 1817–1904
Sunset on the Alps 1888
oil on canvas 142.2 x 109.2
COMWG 113

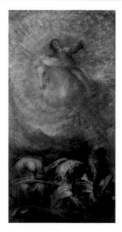

Watts, George Frederick 1817–1904
The Alps near Monnetier 1888
oil on canvas 48 x 107
COMWG 80

Watts, George Frederick 1817–1904
Progress 1888–1904
oil on canvas 281.9 x 142.2
COMWG 139

Watts, George Frederick 1817–1904
Naples 1889
oil on canvas 27.9 x 45.7
COMWG 172

Watts, George Frederick 1817–1904
The Bay of Naples 1889
oil on canvas 96.5 x 121.9
COMWG 124

Watts, George Frederick 1817–1904
Lila Prinsep 1890
oil on canvas 65 x 52.2
COMWG LN 4 (P)

Watts, George Frederick 1817–1904
Patient Life of Unrequited Toil 1890–1891
oil on canvas 182.9 x 167.6
COMWG 130

Watts, George Frederick 1817–1904
Evening Landscape 1890s
oil on canvas 40.6 x 30.5
COMWG 178

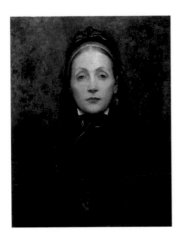

Watts, George Frederick 1817–1904
Sympathy 1892
oil on canvas 66 x 53.3
COMWG 95

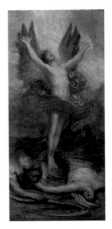

Watts, George Frederick 1817–1904
Love Triumphant 1893–1898
oil on canvas 132.1 x 50.8
COMWG 90

Watts, George Frederick 1817–1904
'For he had great possessions' 1894
oil on canvas 94 x 45.7
COMWG 36

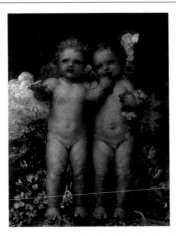

Watts, George Frederick 1817–1904
In the Land of Weissnichtwo 1894
oil on canvas 91.4 x 71.1
COMWG 46

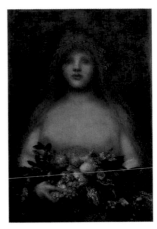

Watts, George Frederick 1817–1904
Earth 1894–1895
oil on canvas 86.4 x 61
COMWG 167

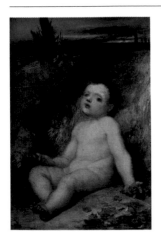

Watts, George Frederick 1817–1904
Outcast Goodwill 1895
oil on canvas 99.1 x 66
COMWG 118

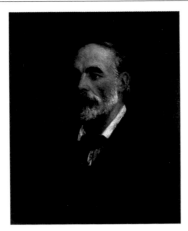

Watts, George Frederick 1817–1904
John Burns 1897
oil on canvas 66 x 53.3
COMWG 84

Watts, George Frederick 1817–1904
Can These Bones Live? 1897–1898
oil on canvas 152.4 x 190.5
COMWG 15

Watts, George Frederick 1817–1904
George Andrews 1898
oil on canvas 63.5 x 51
COMWG 103

Watts, George Frederick 1817–1904
A Dedication 1898–1899
oil on canvas 137.2 x 71
COMWG 157

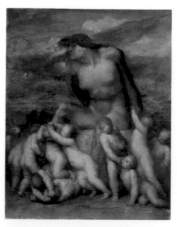

Watts, George Frederick 1817–1904
Evolution 1898–1904
oil on canvas 167.6 x 134.6
COMWG 35

Watts, George Frederick 1817–1904
Invernesshire Landscape (Loch Ruthven) 1899
oil on canvas 35.6 x 88.9
COMWG 21

Watts, George Frederick 1817–1904
Seen from the Train 1899
oil on canvas 39.5 x 76.3
COMWG 112

Watts, George Frederick 1817–1904
Study of Moorland, Invernesshire 1899
oil on canvas 20.3 x 45.7
COMWG NC 9

Watts, George Frederick 1817–1904
The Right Honourable Gerald Balfour 1899
oil on canvas 76.2 x 63.5
COMWG 120

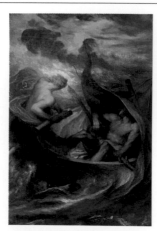

Watts, George Frederick 1817–1904
Love Steering the Boat of Humanity
1899–1901
oil on canvas 198.1 x 137.2
COMWG 131

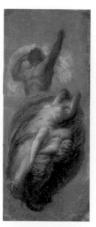

Watts, George Frederick 1817–1904
Sun, Earth and Their Daughter Moon
1899–1902
oil on canvas 61 x 25.4
COMWG 70

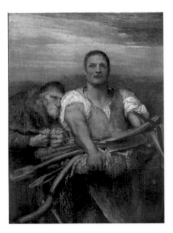

Watts, George Frederick 1817–1904
Industry and Greed 1900
oil on canvas 114.3 x 104.1
COMWG 159

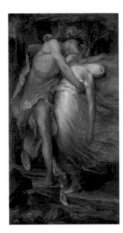

Watts, George Frederick 1817–1904
Orpheus and Euridice 1900–1903
oil on canvas 185.4 x 104.1
COMWG 134

Watts, George Frederick 1817–1904
Fugue 1900–1904
oil on canvas 198 x 106.7
COMWG 158

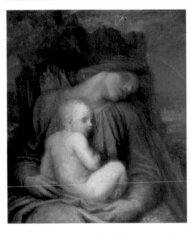

Watts, George Frederick 1817–1904
The Slumber of the Ages 1901
oil on canvas 106.7 x 94
COMWG 53

Watts, George Frederick 1817–1904
Autumn 1901–1903
oil on canvas 134.6 x 73.7
COMWG 78

Watts, George Frederick 1817–1904
Sower of the Systems 1902
oil on canvas 66 x 53.3
COMWG 101

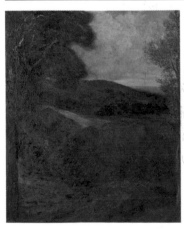

Watts, George Frederick 1817–1904
End of the Day (Surrey Woodland) 1902–1903
oil on canvas 76.2 x 63.5
COMWG 68A

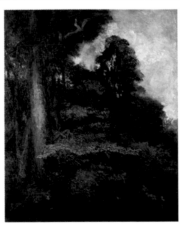

Watts, George Frederick 1817–1904
Surrey Woodland 1902–1903
oil on canvas 76.2 x 63.5
COMWG 68

Watts, George Frederick 1817–1904
A Parasite 1903
oil on canvas 198.1 x 106.7
COMWG 135

157

Watts, George Frederick 1817–1904
C. J. G. Montefiore 1903
oil on canvas 76.2 x 63.5
COMWG 98

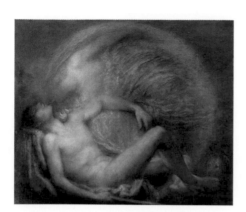

Watts, George Frederick 1817–1904
Endymion 1903
oil on canvas 104.1 x 121.9
COMWG 150

Watts, George Frederick 1817–1904
Green Summer 1903
oil on canvas 167.6 x 88.9
COMWG 47

Watts, George Frederick 1817–1904
Mother and Child 1903–1904
oil on canvas 76.2 x 63.5
COMWG 69

Watts, George Frederick 1817–1904
Self Portrait in Old Age 1903–1904
oil on canvas 63.5 x 45.7
COMWG 6

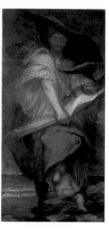

Watts, George Frederick 1817–1904
Destiny 1904
oil on canvas 213.4 x 104
COMWG 133

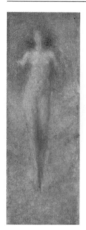

Watts, George Frederick 1817–1904
Iris 1904
oil on canvas 53.3 x 20.3
COMWG 48

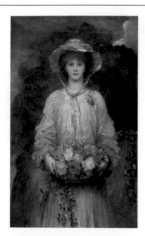

Watts, George Frederick 1817–1904
Lilian 1904
oil on canvas 152.4 x 101.6
COMWG 123

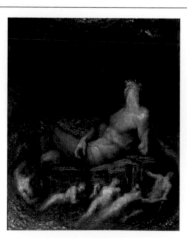

Watts, George Frederick 1817–1904
Prometheus 1904
oil on canvas 66 x 53.3
COMWG 28

Watts, George Frederick 1817–1904
A Fragment
oil on canvas 38.1 x 81.3
COMWG 164

Watts, George Frederick 1817–1904
Death with Two Angels
oil on paper 28 x 23
COMWG 254

Watts, George Frederick 1817–1904
Lady Halle
oil on canvas 73.7 x 61
COMWG 41

Watts, George Frederick 1817–1904
Magdalen
oil on canvas 36.2 x 30.5
COMWG 191

Watts, George Frederick 1817–1904
Malta
oil on paper 17 x 35
COMWG NC33

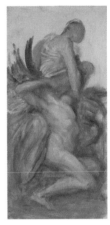

Watts, George Frederick 1817–1904
Monochrome Study
oil on canvas 41.2 x 19.8
COMWG NC35

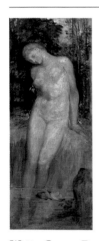

Watts, George Frederick 1817–1904
Nude Standing (The Pool)
oil on canvas 52 x 21
COMWG 107

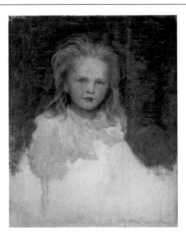

Watts, George Frederick 1817–1904
Portrait of a Small Girl with Fair Hair and Full Face
oil on canvas 66 x 53.5
COMWG 104

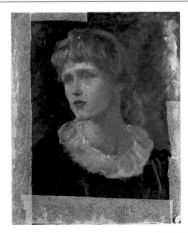

Watts, George Frederick 1817–1904
Portrait of an Unknown Lady (possibly Lilian Macintosh)
oil on canvas 51 x 41
COMWG 116

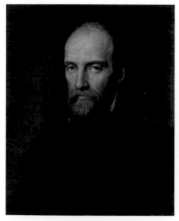

Watts, George Frederick 1817–1904
Prince de Joinville (1818–1900)
oil on panel 61 x 50.8
COMWG 67

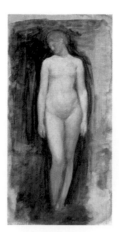

Watts, George Frederick 1817–1904
Psyche
oil on canvas 54.5 x 28.5
COMWG 182

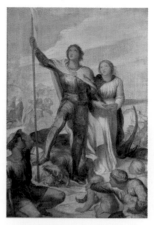

Watts, George Frederick 1817–1904
St George
oil on canvas 58.5 x 41
COMWG 20A

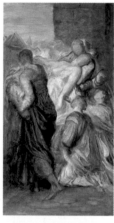

Watts, George Frederick 1817–1904
Study for 'Lady Godiva'
oil on canvas 66 x 53.3
COMWG 151

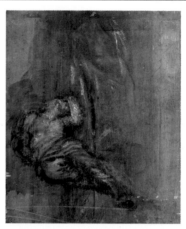

Watts, George Frederick 1817–1904
Study for 'The Messenger'
oil on panel 111 x 88
COMWG NC 14

Watts, George Frederick 1817–1904
Study of Armour
oil on canvas 48 x 35.6
COMWG 146

Watts, George Frederick 1817–1904
Study of Armour
oil on canvas 51 x 23
COMWG 156

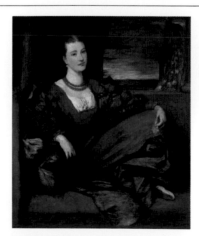

Watts, George Frederick 1817–1904
The Countess of Kenmare (My Lady Peacock)
oil on canvas 132.1 x 116.8
COMWG 97

Watts, George Frederick 1817–1904
The Wine-Bearer
oil on canvas 53.3 x 22.9
COMWG 63

Facing page: Sime, Sidney Herbert, 1867 –1941, *Illustrative* (detail), Sidney H. Sime Memorial Gallery, (p. 216)

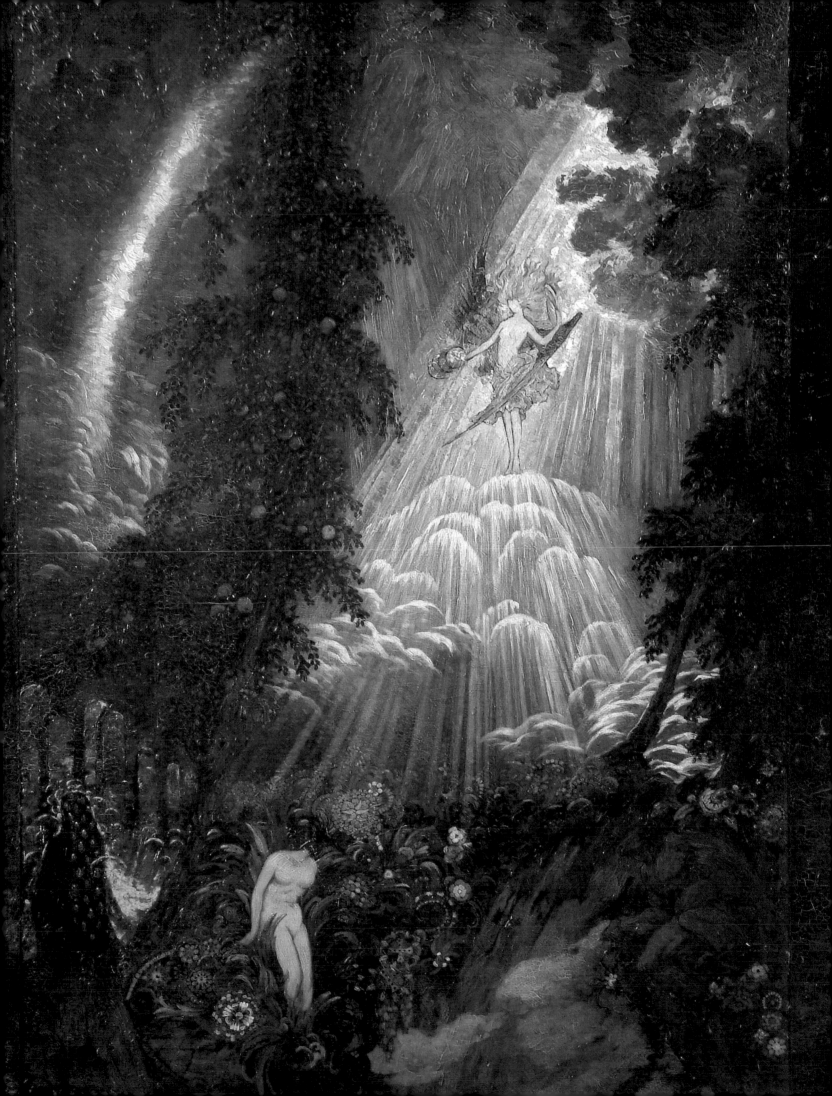

Watts, George Frederick 1817–1904
Unknown Landscape
oil on paper 17.5 x 25.2
COMWG NC32

Watts, George Frederick 1817–1904
Unknown Landscape, possibly Ireland
oil on paper 16.7 x 22.7
COMWG NC31

Watts, George Frederick 1817–1904
Unknown Portrait (possibly Lady Somers or Lady Lothian)
oil on canvas 72 x 53
COMWG 205

Watts, George Frederick 1817–1904
View from Monkshatch, Compton
oil on paper 17.1 x 35.5
COMWG NC29

Watts Mortuary Chapel

Watts, George Frederick 1817–1904
The All-Pervading 1904
oil on canvas 137.5 x 55.5
1

Yvonne Arnaud Theatre

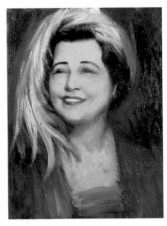

Charters, Cecil
Yvonne Arnaud (1890–1958) c.1958
oil on board 37.5 x 28
1

Haslemere Educational Museum

Haslemere Educational Museum was founded in 1888 by Sir Jonathan Hutchinson (1828–1913), an eminent surgeon whose practice was based in London. In the 1860s, Hutchinson built a country home in Haslemere, where he had the space to indulge his delight in collecting. This passion was based on his deep conviction that an education could be acquired through the study of objects. His original museum was opened in the grounds of his home until its success led to its establishment at larger premises in the town.

Early collecting was strongly biased towards natural history specimens and it is not clear when or how the first artworks were acquired by the Museum. The entire art Collection now numbers over 11,000 items and largely comprises paintings, prints and drawings. Most of the Collection dates from the eighteenth to the twentieth centuries and has predominantly been developed through donations and bequests. The acquisition of new artworks has focussed on subject matters of local significance or on pieces by local artists. Conversely, an eclectic range of other works has been acquired through general donations and this contributes a rich diversity to the Collection as a whole. The 70 pictures highlighted in this publication are primarily made up of landscapes and picturesque scenes, with only a few portraits that qualify for inclusion.

A significant number of the paintings are by Byron Cooper (1850–1933). Born and bred in Manchester, Cooper became known as the father of the Manchester School of Painters. He exhibited seven works at the Royal Academy between 1906–1929 and represented British Art at several international exhibitions. He travelled extensively throughout Britain and Europe in order to obtain his scenes and his works reflect his love of landscape, colour and light. He was also a great admirer of Lord Alfred Tennyson, who lived in Haslemere, and he endeavoured to relate through pictures the emotions aroused by Tennyson's poetical works. An exhibition of more than 100 of these paintings toured the country for many years. After the deaths of Cooper and his

donated these to Haslemere Museum.

Another interesting group of works are the four Swedish wall paintings on linen, which form part of the unique Peasant Art Collection at Haslemere Museum. Gathered from across Europe before the First World War, the Peasant Art Collection includes rare and ancient examples of peasant craftsmanship from the continent's remoter regions. At that time it seemed to many observers that the traditional skills of the European peasantry were on the verge of extinction. Inspired by the Arts and Crafts Movement, a number of local luminaries championed the preservation of those things 'made for love not money'. Examples of 'peasant arts' were collected from the extremities of Europe in order to inspire local artisans and keep traditional skills alive.

Museum records offer dates between c.1801 and 1828 for three of the four paintings. One of these works has suffered from fading, but the others remain bold and colourful. They tell the biblical stories of 'The Five Wise and the Five Foolish Virgins' and 'The Journey of the Three Wise Men'. These paintings are regarded as symbols of Swedish vernacular culture and are characterised by the flat, frieze-like depiction of their subjects. Such paintings were commissioned from itinerant painters and were displayed in village homes. The Haslemere paintings are believed to have come from the southern Halland region of Sweden, noted for its isolation even in the late nineteenth century.

Portraits form a small proportion of this selection of paintings, but two particular examples indicate that what they lack in quantity they make up for in interest value. Firstly, *Portrait of a Maori Woman* was painted by Vera Cummings (1891–1949). Cummings was born in New Zealand, to a family of Scottish and Northern Irish descent who were pioneer settlers on the goldfields. At the age of 11 her artistic talents earned her a scholarship to the Elam School of Fine Arts and later she studied under Charles Frederick Goldie, probably New Zealand's best-known artist. Goldie was famous for his portraits depicting elderly Maori with *moko* (Maori tattoos). Like Goldie, Cummings became well-known for her Maori portraits, though her work is not as highly regarded. During her lifetime her Maori studies were in great demand overseas and through the local tourist market.

The second example is Frank Dicksee's portrait of *Miss Edith Fitton*, which reflects his reputation as a painter of elegant portraits of fashionable society women, though he was also known for his scenes of a dramatic, historical and romantic nature. Dicksee (1853–1928) was a member of a noted artistic family and was first trained by his father, Thomas Francis Dicksee, before entering the Royal Academy Schools in 1870, where he excelled in his studies. Much of his early career was spent in book and magazine illustration, as well as some stained-glass window design. He exhibited at the Royal Academy from 1876, becoming ARA in 1881, RA in 1891 and finally President of the Royal Academy in 1924. During his lifetime he also held many other appointments and awards; he was knighted in 1925, became KCVO in 1927, and was a Trustee of the British Museum and the National Portrait Gallery.

Julia Tanner, Curator

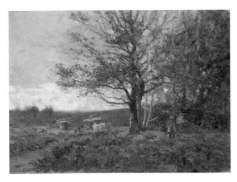

Aborn, John d.1915
Country Scene with Caravans and Peasants
oil on wooden board 25.5 x 35
FP.1992.1

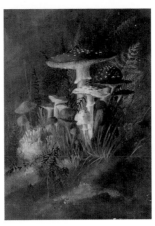

Ainsworth
Fungi
oil on canvas 43 x 30
FP.2.16

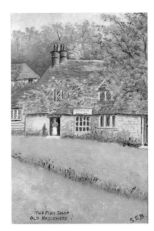

S. E. B.
The Fish Shop, Haslemere
oil on board 25 x 18
FP.2.6

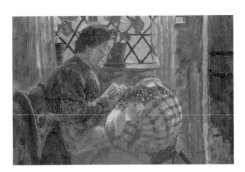

Chandler, Allen 1887–1969
Ann c.1912
oil on canvas 26.5 x 37
FP.2.8

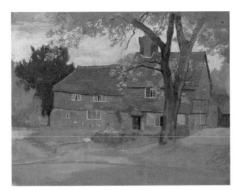

Chandler, Allen 1887–1969
Opposite Shottermill 1932
oil on board 25.5 x 32
FP.2.158

Chandler, Allen 1887–1969
A Woodland Industry (Glass Production)
oil on artboard 200 x 120
FP.8.82

Chandler, Allen 1887–1969
Early Old Stone Age
oil on board 45 x 60
FP.8.79

Chandler, Allen 1887–1969
Later Old Stone Age
oil on board 45 x 60
FP.8.80

Chandler, Allen 1887–1969
New Stone Age
oil on canvas/board 45 x 60
FP.8.81

Cooper, Byron 1850–1933
Blackdown from Hascombe 1887
oil on canvas 49 x 74
FP.2.122

Cooper, Byron 1850–1933
Aldworth 1890
oil on canvas 49 x 74
FP.2.129

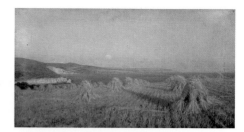

Cooper, Byron 1850–1933
Freshwater Bay, Summer Moonlight 1890
oil on canvas 51 x 92
FP.2.10

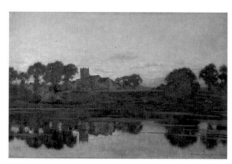

Cooper, Byron 1850–1933
Freshwater Church 1890
oil on canvas 49 x 74
FP.2.125

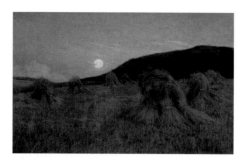

Cooper, Byron 1850–1933
Moonrise from the Downs 1891
oil on canvas 60 x 90
FP.2.28

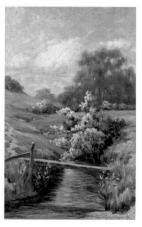

Cooper, Byron 1850–1933
Stream through Countryside 1891
oil on wooden board 33 x 20.5
FP.2.163

Cooper, Byron 1850–1933
Tennyson's Private Road from the Downs 1891
oil on canvas 50 x 76
FP.2.13

Cooper, Byron 1850–1933
The Brook 1891
oil on canvas 49 x 74
FP.2.123

Cooper, Byron 1850–1933
Moonrise on the Old Canal, Bude 1893
oil on canvas 50 x 75
FP.2.25

Cooper, Byron 1850–1933
Brook, May Morning 1895
oil on canvas 45 x 60.5
FP.2.2

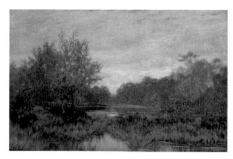

Cooper, Byron 1850–1933
A Quiet Pool, near Haslemere 1900
oil on canvas 60 x 90
FP.2.15

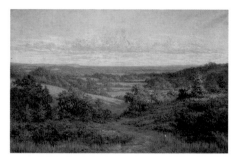

Cooper, Byron 1850–1933
Sussex Weald 1904
oil on canvas 100 x 149
FP.2.139

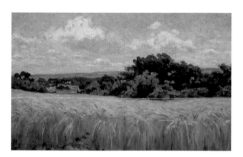

Cooper, Byron 1850–1933
Barley Field
oil on wooden board 22 x 35
FP.2.164

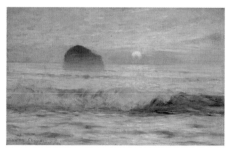

Cooper, Byron 1850–1933
Gull Rock, Tintagel
oil on wooden board 22 x 35
FP.2.22

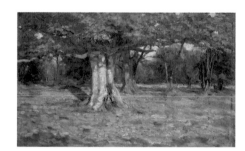

Cooper, Byron 1850–1933
In the Woods
oil on wooden board 22.5 x 35.5
FP.2.157

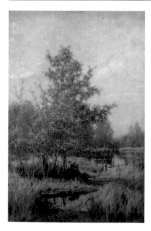

Cooper, Byron 1850–1933
Maple Tree
oil on canvas 90 x 60
FP.2.23

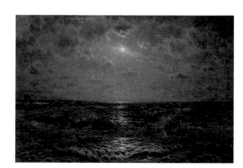

Cooper, Byron 1850–1933
Moonlit Atlantic from Tintagel
oil on canvas 101 x 153
FP.2.138

Cooper, Byron 1850–1933
Near Haslemere, Sunset
oil on canvas 102 x 153.5
FP.2.144

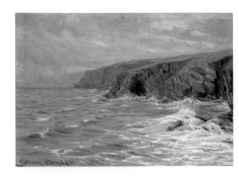

Cooper, Byron 1850–1933
On the Cliffs, Tintagel
oil on wooden board 25 x 35.5
FP.2.154

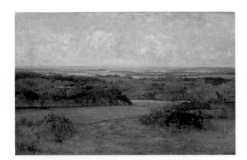

Cooper, Byron 1850–1933
Solent from Farringford
oil on canvas 60 x 91
FP.2.21

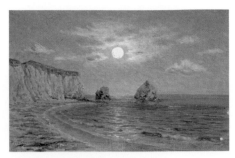

Cooper, Byron 1850–1933
Summer Moonlight
oil on wooden panel 24 x 34.5
FP.2.155

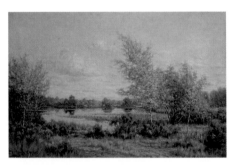

Cooper, Byron 1850–1933
The Birches
oil on canvas 61 x 91
FP.2.26

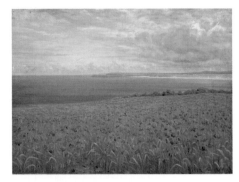

Cooper, Byron 1850–1933
The Poppy Field
oil on canvas 45.6 x 61
FP.2.3

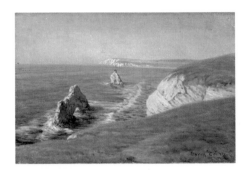

Cooper, Byron 1850–1933
Tintagel Coast
oil on canvas 33 x 48
FP.2.1

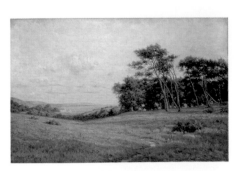

Cooper, Byron 1850–1933
View from Farringford
oil on canvas 60 x 91
FP.2.19

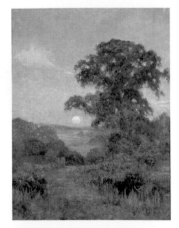

Cooper, Byron 1850–1933
View of a Sunset over Water by a Tree
oil on canvas 60 x 45
FP.2.7

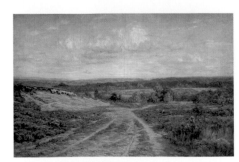

Cooper, Byron 1850–1933
View of Countryside Hills
oil on canvas 60 x 90
FP.2.20

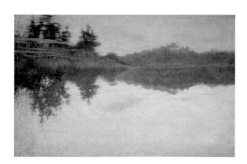

Cooper, Byron 1850–1933
View over a Pool
oil on canvas 60 x 90
FP.2.18

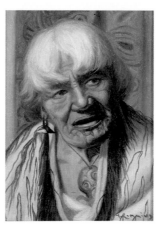

Cummings, Vera 1891–1949
Portrait of a Maori Woman
oil on canvas 19 x 14
FP.2.43

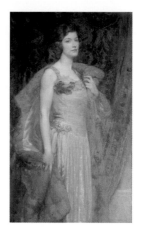

Dicksee, Frank 1853–1928
Miss Edith Fitton 1926
oil on canvas 140 x 85
FP.2.179

Dobie, Joan
Waggoners Wells
oil on canvas 46 x 62
FP.2005.2

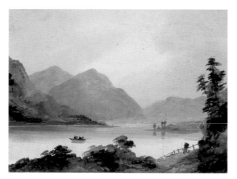

Ewbank, S.
Pass of Elsinore
oil on paper 11.5 x 15.5
FP.01.2.14

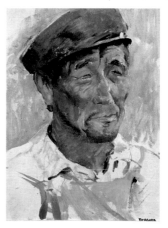

Gridnev, Valery b.1956
Fisherman
oil on hardboard 39 x 30
FP.2005.1

Hill, J. R.
View of Cottage Surrounded by Woodland
1929
oil on canvas 50.5 x 66
FP.2.5

Leizle, Eric
The Devil's Punchbowl
oil on canvas 57 x 155
FP.1998.1

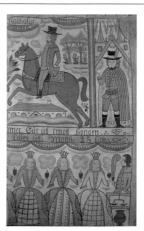

Nilsson, Johannes 1757–1827
*The Three Kings and the Wise and Foolish
Virgins* c.1801–1827
oil on canvas 124 x 80
FP.7.270

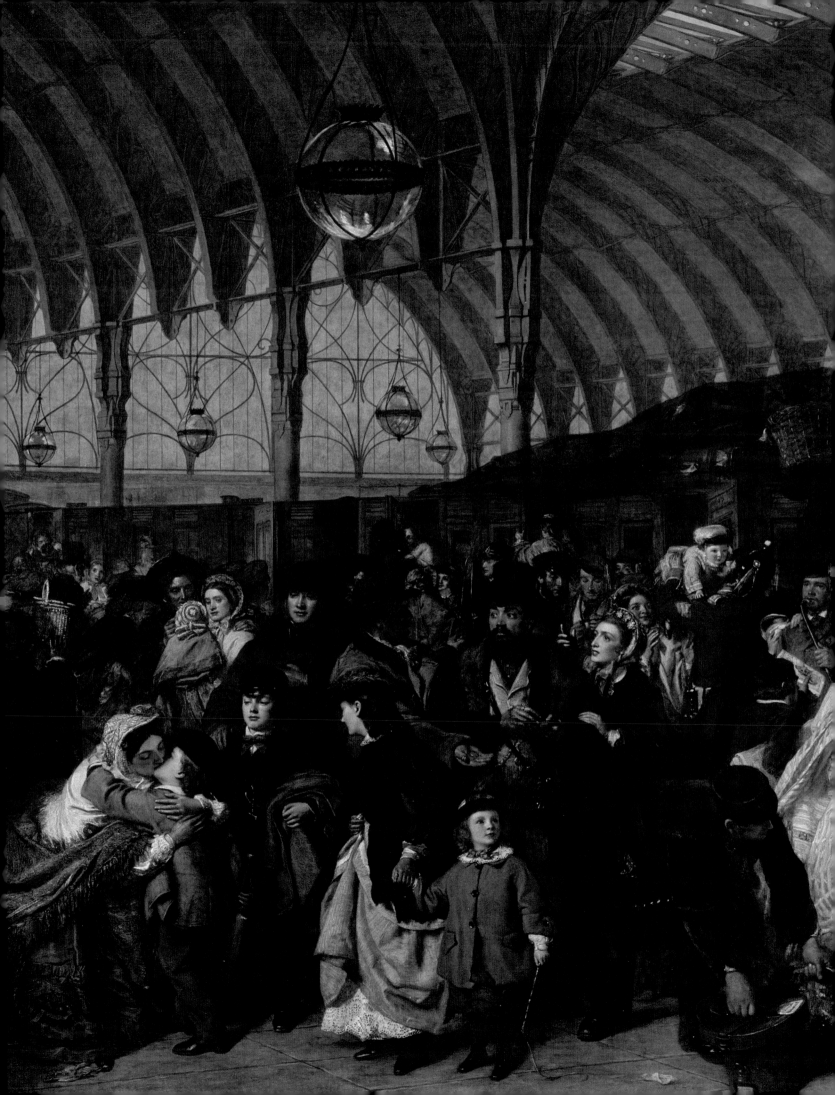

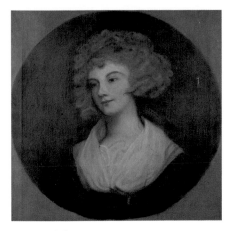

Potter, Violet
Potter (after George Romney)
oil on canvas 63 x 63
FP.1998.2

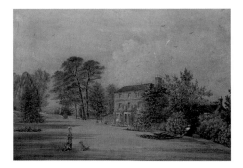

Prossen, Henry
Killinghurst, Haslemere 1878
oil on canvas 40 x 55
FP.2.11

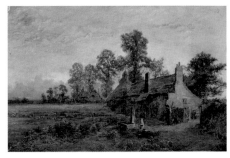

Storr, Milton active 1888–1891
Cottage with a Man, Woman and a Dog 1888
oil on canvas 60 x 91
FP.2.17

Swedish School
The Three Kings and the Wise and Foolish Virgins c.1801–1828
oil on canvas 123 x 276
FP.7.267

Swedish School
The Three Kings and the Wise and Foolish Virgins c.1801–1828
oil on canvas 114 x 200
FP.7.268

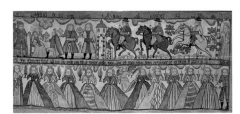

Swedish School
The Three Kings and the Wise and Foolish Virgins c.1801–1828
oil on canvas 95 x 207
FP.7.269

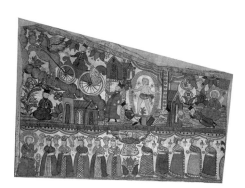

Swedish School
The Three Kings and the Wise and Foolish Virgins c.1801–1828
oil on canvas 116 x 160
FP.7.271

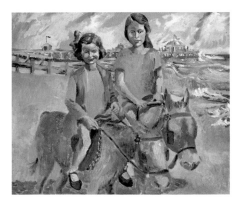

Tomes, Marjorie
On the Beach
oil on artboard 50 x 61
FP.2001.3.1

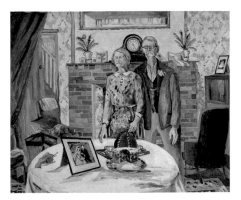

Tomes, Marjorie
The Anniversary
oil on artboard 63 x 76
FP.2001.3.2

Facing page: Frith, William Powell, 1819–1909, *The Railway Station* (detail), 1862, Royal Holloway, University of London, (p. 45)

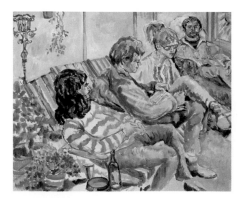

Tomes, Marjorie
*Two Men and Two Women Sitting in
Deckchairs*
oil on artboard 51 x 61
FP.2001.3.3

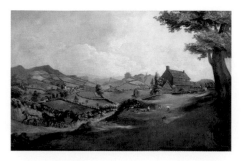

unknown artist
*The London to Chichester Coach on Shepherd's
Hill, Haslemere* c.1760–1826
oil on canvas 86 x 134
FP.6.444.1

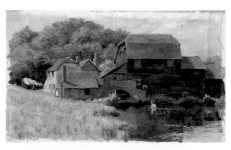

unknown artist
New Mill c.1890s
oil on canvas 26 x 42
FP.2.162

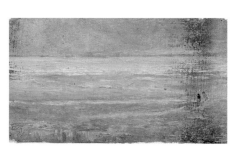

unknown artist late 19th C
Beach Scene
oil on paper 9.5 x 17
FP.01.2.5

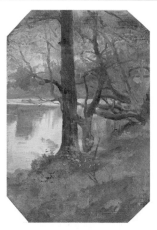

unknown artist late 19th C
Woodland Scene by a Lake
oil on paper 24 x 16
FP.01.2.6

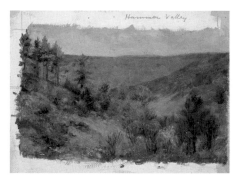

unknown artist
Hammer Valley
oil on cardboard 26.5 x 35.5
FP.2.153

unknown artist
*Haslemere Society of Artists Exhibition:
Landscape*
oil on canvas 68 x 45.5
FP.7.358

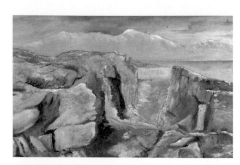

unknown artist
Landscape of Iceland
oil on wood 30 x 46
FP.06.3.1

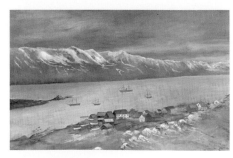

unknown artist
Landscape of Iceland
oil on wood 30 x 46
FP.06.3.2

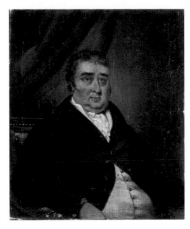

unknown artist
Portrait of a Man
oil on canvas on hardboard 29.5 x 24.5
FP.7.1

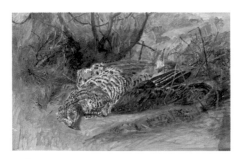

unknown artist
Study of Dead Game Bird
oil on artboard 43 x 68
FP.7.261

unknown artist
The Pigsties, Inval
oil on canvas 31 x 40
FP.2.161

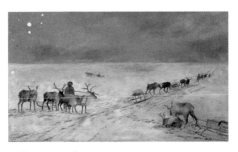

unknown artist
Winter Landscape with Reindeer and Sledges
oil on artboard 30 x 50
FP.8.3

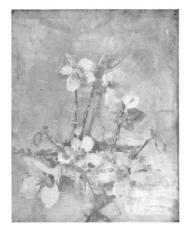

Whymper, Emily 1833–1886
Still Life
oil on canvas 45 x 36.5
FP.2.160

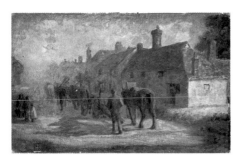

Williams, Juliet Nora d.1937
Winter Morning c.1900
oil on canvas 26 x 40
FP.2.4

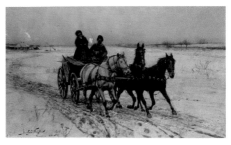

Wolski, Stanislaw Polian 1859–1894
Winter Landscape with Horse Drawn Carriage
1884
oil on canvas 54 x 89
FP.2.30

Surrey County Council

County Hall in Penrhyn Road, Kingston-upon-Thames is a fine 1893 Portland-stone construction of a scale which lends itself to the display of many full-length portraits, typical of nineteenth-and early twentieth-century commemoration of county dignitaries. Often gifts or works raised by public subscription, the paintings reflect the warmth in which local worthies were held, at a time when individuals who held office usually came from a relatively small number of families and were gentlemen of means who had the leisure time to represent the people of Surrey. These men (and apart from royalty there are no oil paintings of women in the Collection) were often in post for decades and had huge influence over the development of services in the county, directly affecting people's lives.

An excellent example is the portrait by the American artist Herman Herkomer of Edward Hugh Leycester Penrhyn, the first Chairman of the County Council. Although he served the usual three-year term, he had already led the county as Chairman of Quarter Sessions since 1862, so he gave a continuity to Surrey's government. As well as being remembered in the road name, he appears in this delightful, relaxed portrait as an approachable and lively man.

Of the later paintings, Michael Noakes' three-quarter length portrait *The Right Honourable James Chuter Ede*, painted in 1961, is worthy of note. James Chuter Ede of Epsom was an active member of the council (1914–1949), as well as being a Labour MP and Home Secretary (1945–1951). Remembered for his love for education, he was greatly involved in the 1944 Education Act. Noakes, the internationally famous portrait painter, was educated in Surrey at Reigate School of Art.

The earliest painting in the County Collection is probably that of Sir Richard Onslow, 1st Lord Onslow (1654–1717). A rather pinched face in a heavy wig, painted in the manner of Sir Godfrey Kneller, depicts one of the more contentious Speakers of the House of Commons, known for his lack of neutrality and pedantic demeanour. Quite a contrast from the other sitters!

The County Council is delighted that through the Public Catalogue Foundation a wider audience will be able to share our fondness for these local treasures.

Maggie Vaughan-Lewis, County Archivist

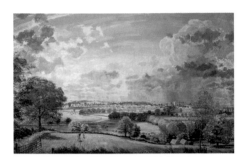

Birch, David 1895–1968
Morning in June, the Vale of Dedham
oil on canvas 129.5 x 203.2
10

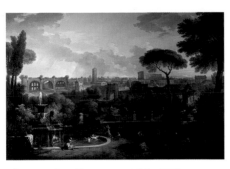

Bloemen, Jan Frans van 1662–1749
View of Rome from the Baberini Palace
oil on canvas 167.6 x 245.1
15b

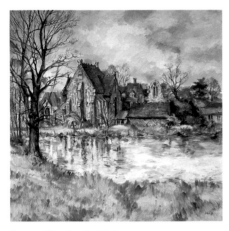

Bone, Charles b.1926
Oxenford Grange, Peper Harow
oil on canvas 90.2 x 90.2
G15 🐝

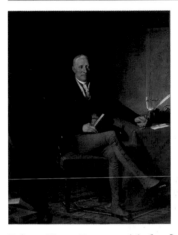

Briggs, Henry Perronet (circle of)
1791/1793–1844
John Leech
oil on canvas 198.1 x 137.2
23

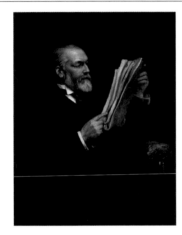

Brooks, Henry Jamyn 1865–1925
Sir William Vincent, Bt 1897
oil on canvas 111.8 x 86.4
24

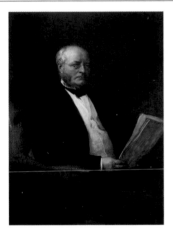

Carter, William 1863–1939
Henry Yool Esq. 1895
oil on canvas 127 x 101.6
17

Carter, William 1863–1939
Edward Joseph Halsey 1908
oil on canvas 215.9 x 128.3
13

Carter, William 1863–1939
*The Right Honourable St John Broderick, 9th
Viscount Midleton* 1908
oil on canvas 212.1 x 111.8
3

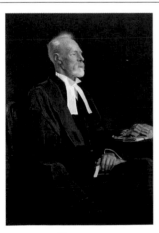

Carter, William 1863–1939
Thomas Weeding Weeding (1847–1929) 1928
oil on canvas 147.3 x 101.6
9

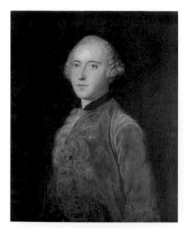

Chamberlin, Mason the elder (circle of) 1727–1787
Richard, 3rd Earl of Onslow
oil on canvas 71.8 x 56.5
21

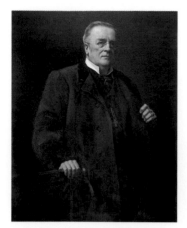

Clay, Arthur 1842–1928
Sir William Hardman, QC 1889
oil on canvas 127 x 101.6
19

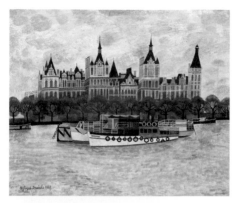

Daniels, Alfred b.1924
Boats Moored on the River Thames 1968
oil on canvas 61 x 71.1
2

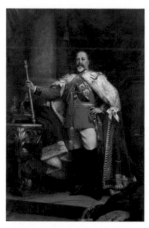

Fildes, Luke (after) 1844–1927
King Edward VII (1841–1910)
oil on canvas 269.2 x 177.8
6

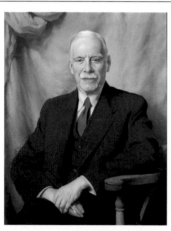

Gunn, Herbert James 1893–1964
Sir Lawrence Edward Halsey, KBE, JP 1945
oil on canvas 90.2 x 69.9
15a

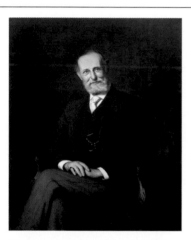

Herkomer, Herman 1863–1935
*Edward Hugh Leycester Penrhyn, First
Chairman of Surrey County Council
(1889–1893)* 1889
oil on canvas 127 x 101.6
18

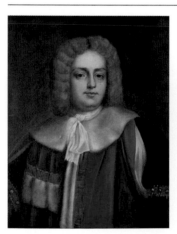

Jervas, Charles (style of) c.1675–1739
*Thomas Onslow, 2nd Lord Onslow
(1680–1740)*
oil on canvas 71.8 x 56.5
22

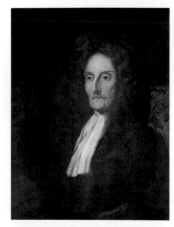

Kneller, Godfrey (style of) 1646–1723
*Sir Richard Onslow, 1st Lord Onslow
(1654–1717)*
oil on canvas 72.4 x 56.5
20

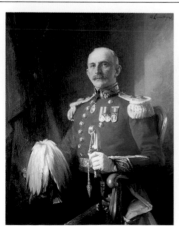

Llewellyn, William Samuel Henry
1854–1941
The Right Honourable Lord Ashcombe, CB, TD
c.1939
oil on canvas 124.5 x 97.8
12

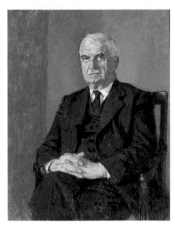

Noakes, Michael b.1933
The Right Honourable James Chuter Ede, CH, JP, DL 1961
oil on board 88.9 x 68.6
11

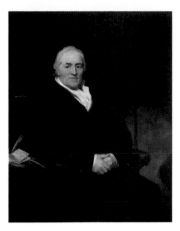

Phillips, Thomas 1770–1845
Florance Young Esq. 1824
oil on canvas 127 x 101.6
14

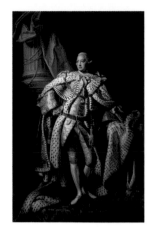

Ramsay, Allan (studio of) 1713–1784
King George III (1738–1820) c.1775
oil on canvas 254 x 157.5
7

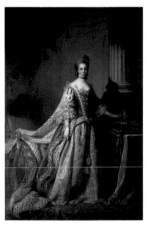

Ramsay, Allan (studio of) 1713–1784
Queen Charlotte (1744–1818) c.1775
oil on canvas 254 x 157.5
8

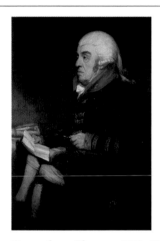

Stewardson, Thomas 1781–1859
The Right Honourable George, 4th Baron and 1st Earl of Onslow
oil on canvas 180.3 x 125.7
5

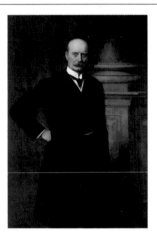

Symonds, William Robert 1851–1934
The Right Honourable George Viscount Cave, CC, MC 1911
oil on canvas 152.4 x 101.6
4

Leatherhead and District Local History Society

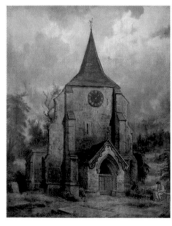

unknown artist
Mickleham Church
oil on canvas 74.6 x 61.7 (E)
LP 1082

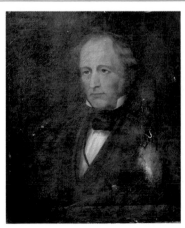

unknown artist
Mr S. Maw
oil on canvas 76.2 x 63.5 (E)
LP 1185

The Guest House, Lingfield Library

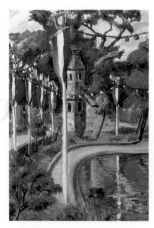

Akehurst, R. D.
Lingfield Coronation Decorations 1953
oil on board 35 x 24
2

Oxted Library

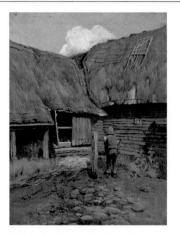

Christie, Ernest C. (attributed to)
1863–1937
Kentish Farm, E. Christie War Coppice
oil on canvas 39.5 x 30 (E)
2 (P)

Christie, Ernest C. (attributed to)
1863–1937
Prucks Works at Links Corner, Limpsfield (now demolished)
oil on canvas 30 x 44
1 (P)

Christie, Ernest C. (attributed to) 1863–1937
View of Pond Gate and Farm
oil on canvas 38 x 30 (E)
3 (P)

Tandridge District Council

Collier, John 1850–1934
Colonel Arthur Stuart Daniel, Chairman of Godstone Rural District Council (1900–1935) 1928
oil on board 122 x 91.4
5

Curzon-Price, Paddy
Councillor Mrs M. D. Wilks, First Lady Chair of Tandridge District Council (1977–1978) 1980
oil on canvas 91.4 x 76.2 (E)
3

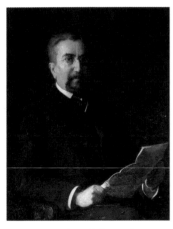

Grace, Harriet Edith active 1877–1909
William Garland Soper, First Chairman of Caterham & Warlingham Urban District Council (1899–1908) 1909
oil on board 91.4 x 76.2
4

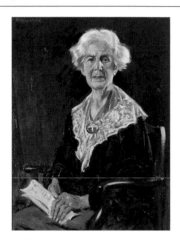

unknown artist
Marjory Pease, JP (1911–1947)
oil on canvas 91.4 x 76.2
1

unknown artist
Old Oxted
oil on board 61 x 91.4
2

East Surrey Hospital

Dorman, Ernest A. b.1928
Darkness on Face of the Deep 1999
oil on MDF board 78 x 122
11

Dorman, Ernest A. b.1928
Earth without Form and Void 1999
oil on MDF board 91 x 61
12

Dorman, Ernest A. b.1928
*Gathering of the Waters unto One Place and
Dry Land Appearing* 1999
oil on MDF board 91 x 61
15

Dorman, Ernest A. b.1928
*God Created Lights to Rule the Day and
Night* 1999
oil on MDF board 91 x 61
14

Dorman, Ernest A. b.1928
Let There Be Light 1999
oil on MDF board 91 x 61
13

Dorman, Ernest A. b.1928
*Produce of the Earth by Nature and Creation of
Every Living Creature* 1999
oil on MDF board 91 x 61
16

Dorman, Ernest A. b.1928
The Four Seasons, Winter 1999
oil on MDF board 102 x 91
10

Dorman, Ernest A. b.1928
The Four Seasons, Spring 1999
oil on MDF board 102 x 91
7

Dorman, Ernest A. b.1928
The Four Seasons, Summer 1999
oil on MDF board 102 x 91
8

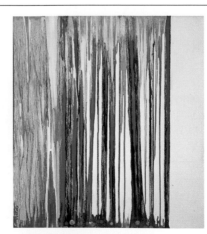

Dorman, Ernest A. b.1928
The Four Seasons, Autumn 1999
oil on MDF board 102 x 91
9

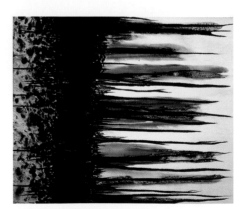

Dorman, Ernest A. b.1928
Winter Tree 1999
oil on MDF board 78 x 91
6

Facing page: Sargent, John Singer, 1856 –1925, *Mrs Graham Robertson* (detail), 1880, Watts Gallery, (p. 134)

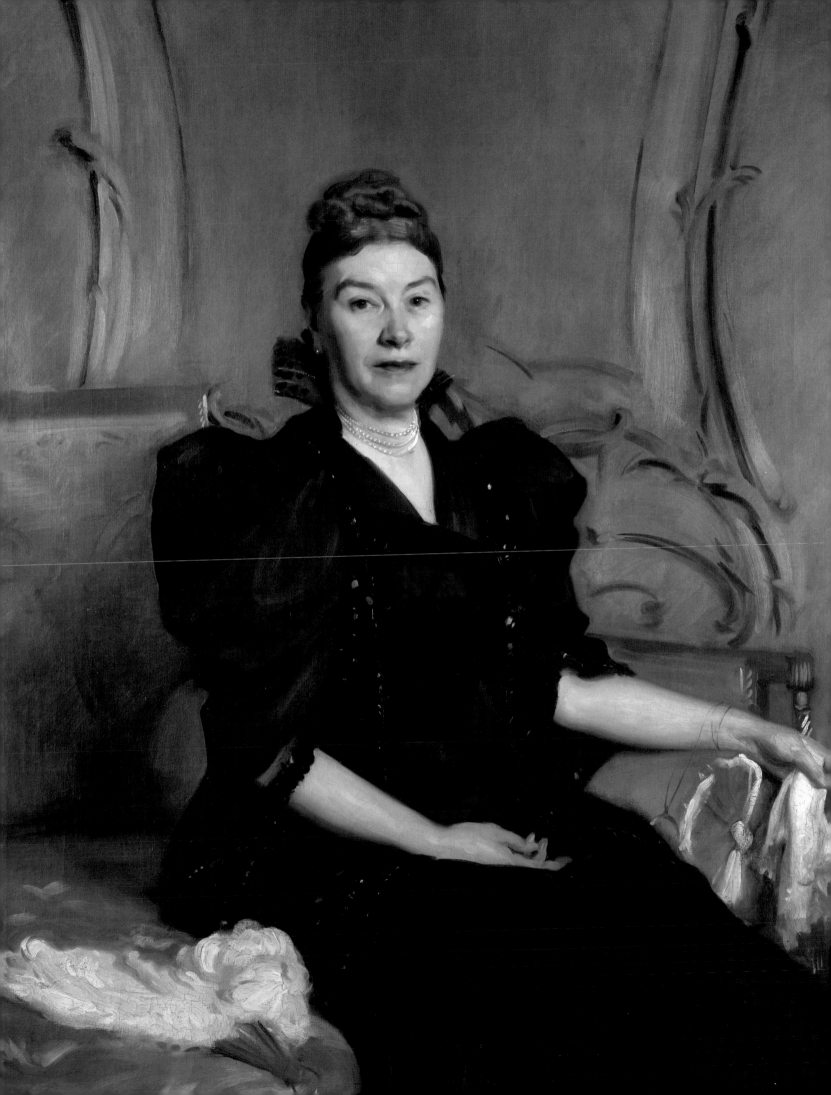

Moosajee, Mariya
A Not So Funny Bone 2004
oil on wood 120 x 80
3

Moosajee, Mariya
High Heels and Fashion Fractures 2004
oil on wood 120 x 80
2

Moosajee, Mariya
Rugby Kicks and Patella Nicks 2004
oil on wood 100 x 120
4

Shepherd, Frank
Pastoral Scene via Open Window 2003
oil on MDF board 107 x 122
5

Stevens active mid-20th C
Seascape
oil on canvas 61 x 122
1

Holmsdale Natural History Club

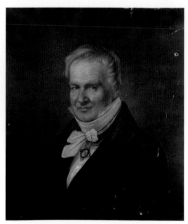

unknown artist early 19th C
Portrait of a Man (possibly Baron von Humbolt)
oil on canvas 71.2 x 60.6
2

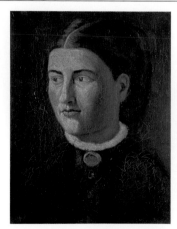

unknown artist 19th C
Portrait of an Unknown Victorian Lady
oil on canvas 49.5 x 38.3
1

Reigate & Banstead Borough Council

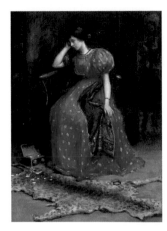

Gogin, Alma 1854–1948
Regrets
oil on canvas 89.5 x 64
2

Hooper, George 1910–1994
The Garden at Loxwood, Redhill
acrylic on board 60 x 55
6

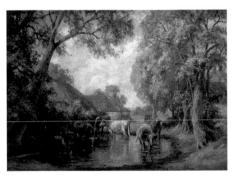

Little, George Leon 1862–1941
Cows in a Landscape
oil on canvas 87 x 118
4

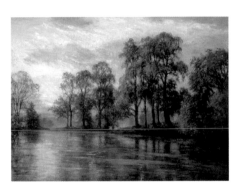

Little, George Leon 1862–1941
Evening Lake Scene
oil on canvas 89.5 x 120.5
1

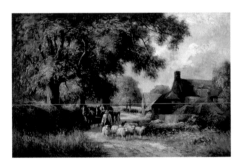

Little, George Leon 1862–1941
Sheep in a Landscape
oil on canvas 59 x 90
3

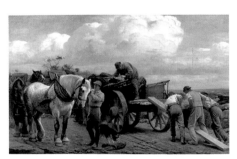

Wells, Henry Tanworth 1828–1903
Loading at the Quarry, Holmbury Hill
oil on canvas 134.5 x 211
5

Reigate Priory Museum

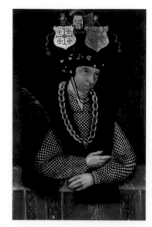

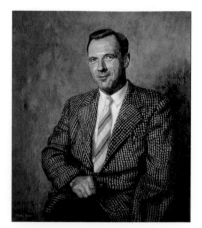

British (English) School early 16th C
*John Lymden (elected 1530, surrendered 1536),
the Last Prior of Reigate*
oil on wood panel 57 x 36
2

Noakes, Michael b.1933
F. E. Claytor, Headmaster (1948–1957) 1957
oil on canvas 75.5 x 62.5
1

Send and Ripley Museum

Baigent, R. active c.1920–c.1940
Newark Mill, Ripley, Surrey
oil on canvas 21 x 35
P2

Brown, Frank active 1950s–1970s
Ripley Village 1973
oil on canvas 51 x 62
P1

Spelthorne Borough Council

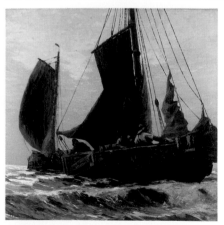

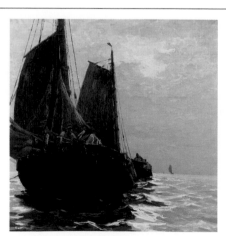

Marion
At Sea 1
oil on canvas 191.2 x 192.4 (E)
2005:01

Marion
At Sea 2
oil on canvas 191.2 x 192.4 (E)
2005:02

Spelthorne Museum

unknown artist
Cottages in Thames Street
oil on canvas 20 x 25
SMXSP:1995.289

Vasey, M.
A Mother's Rosary
oil on canvas 11 x 16
SMXSP:1980.239

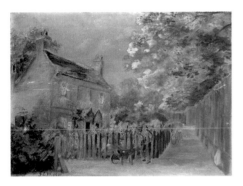

Winfield, G. E.
A Cottage on the Corner of Manygate Lane and Rope Walk, Shepperton 1901
oil on canvas 30 x 41
SMXSP:2006.106

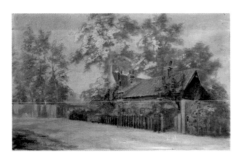

Winfield, G. E.
A Cottage on the Corner of Manygate Lane and Rope Walk, Shepperton 1901
oil on canvas 26 x 41
SMXSP:2006.107

Sunbury Library

The Sunbury Art Group
The Thames at Sunbury 1960s
oil on canvas 61 x 213.4
1

Dittons Library

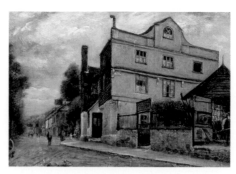

Freeman, William c.1838–1918
Thames Villa 1905
oil on canvas 30.5 x 40.6
3

Freeman, William c.1838–1918
'The Swan' at Claygate 1905
oil on board 21.6 x 29.2
7

Freeman, William c.1838–1918
'The White Lion', Esher 1905
oil on canvas 19.1 x 29.2
2

Freeman, William c.1838–1918
High Street, Thames Ditton?
oil on canvas 30.5 x 40.6
4

P. W. J.
'Ye Olde Swan', Thames Ditton? mid-20th C
oil on board 29.5 x 45
1

Stevens, Thomas active 1889–1893
Cottage at Weston Green 1889
oil on canvas 25.4 x 35.6
5

Stevens, Thomas active 1889–1893
Weston Green Pond 1890
oil on canvas 24.1 x 34.3
6

Warlingham Library, Lockton Collection

In All Saints' Church, Warlingham, there is a simple alabaster tablet inscribed to the memory of Charles Langton Lockton (1856–1932). Few remember him now, but some may know of the collection of his paintings of local scenes which he gave to the Parish, and which can be seen in the library. Many depict a rural community now long gone.

Charles Langton Lockton was born in Tasmania on the 2nd July 1856. He was the second son of the Reverend Philip Langton Lockton. In 1864 the family returned to England, and the eldest son, Philip, became a pupil at Merchant Taylors' School in London. Charles joined him there in 1866.

Charles did not achieve any exceptional scholastic success but did develop into a fine natural athlete, outstanding at school and in nationwide competition. In 1873 and again in 1875 he won the National Long Jump Championship, and at 16 he became the youngest English Champion on record. Charles retained his connection with sport by qualifying as an official starter, a position he filled at most athletic championships between 1890 and 1911, including the 1908 Olympic Games in London. From 1877 to 1881 he worked in the library of the India Office, moving on to a position as a Clerk in the House of Commons, where he remained until retirement in 1921.

He married Jane Emma Seale of Croydon and they had two children, Noel and Dorothy. In 1894 they moved to live in Warlingham, Surrey, then still a very rural village. Charles purchased a plot of land and a house was built to his requirements. Completed in 1898, he named it 'Teeton'.

Now settled in Warlingham, Charles built himself a studio in his garden. During the 30 years that followed, he passed many happy hours there painting, a hobby he found relaxing. His grandsons, Philip and Tom, recalled the studio as friendly and untidy, glass jam pots full of brushes, jars of turpentine and tubes of oil paints everywhere. They were allowed to sit and watch, enthralled. Charles did not sell his paintings but gave them away, either to local people or for village fundraising purposes. He was a prolific artist, and most of his works are on board as canvas was expensive. The Parish Collection, which since 1970 has been displayed in the local library, provides a glimpse of rural life long gone. These paintings are mostly of uniform size but larger paintings do exist. Few people appear in the paintings and any animals are usually sheep at a distance.

Charles soon became much involved in village activities, including sport, of course. He became a sidesman at All Saints' Church, and in 1901 was appointed Vicar's Warden, a position he held until his death. During the 1920s he served five years on the Parish Council, and due to his involvement in many local affairs he was very well-liked and respected in the village.

In 1921 his wife, Jane, died, and his son Noel and his wife came to live with him at 'Teeton'. Following his retirement later that year he was made a Justice of the Peace.

Charles was a sincere, straightforward man, always willing to help others with his kindness and generosity. In 1932 his health began to fail, and he was often unable to attend to his many duties and interests as diligently as he would have wished. He died peacefully on the 30th October 1932, aged 76.

Dorothy Tutt, Vice-President, The Bourne Society

Lockton, Charles Langton 1856–1932
All Saints' Church, North-West, before
Enlargement early 1890s
oil on card 15 x 23
6

Lockton, Charles Langton 1856–1932
All Saints' Church, South Side, before
Enlargement early 1890s
oil on wood 15.5 x 24
31

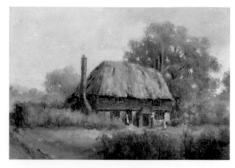

Lockton, Charles Langton 1856–1932
Cottage on the Corner of Westhall Road and
Ridley Road (demolished in 1898), Site of
'Teeton', the Artist's Home c.1895
oil on wood 17 x 24
9

Lockton, Charles Langton 1856–1932
Westhall Road, Corner of Workhouse Lane
(now Hillbury Road) c.1895
oil on wood 18.5 x 22
4

Lockton, Charles Langton 1856–1932
Cottage between 'The Leather Bottle' and Mill
House 1900
oil on wood 29 x 21.5
16

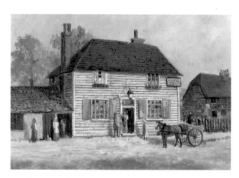

Lockton, Charles Langton 1856–1932
'The Leather Bottle', with Butcher's Shop on the
Left as it was in the 1880s 1900
oil on wood 17 x 25
21

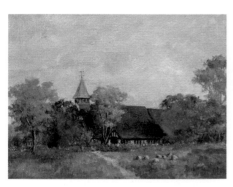

Lockton, Charles Langton 1856–1932
All Saints' Church c.1900
oil on card 9.5 x 15
30

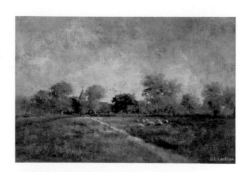

Lockton, Charles Langton 1856–1932
All Saints' Church, Footpath from Village
c.1900
oil on wood 20 x 30
26

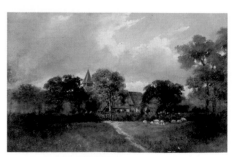

Lockton, Charles Langton 1856–1932
All Saints' Church, Footpath from Village
c.1900
oil on wood 27 x 41
27

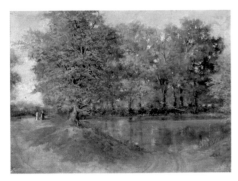

Lockton, Charles Langton 1856–1932
Hamsey Green Pond c.1900
oil on board 19 x 22
32

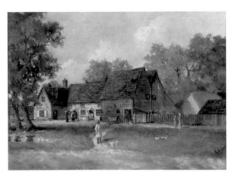

Lockton, Charles Langton 1856–1932
'The White Lion' as it was in the 1880s c.1900
oil on wood 24 x 33
10

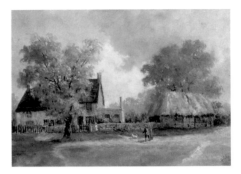

Lockton, Charles Langton 1856–1932
Village Green, South-East Corner c.1900
oil on wood 24 x 34
5

Lockton, Charles Langton 1856–1932
*Westhall Road, Warlingham (near Searchwood
Road)* 1901
oil on wood 24 x 30
19

Lockton, Charles Langton 1856–1932
Tydcombe Farm 1902
oil on wood 10 x 22
12

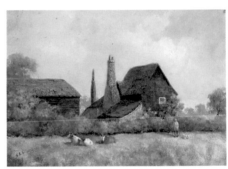

Lockton, Charles Langton 1856–1932
Blanchman's Farm from the South-East 1913
oil on wood 24 x 34
7

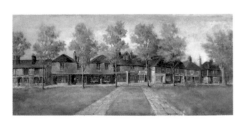

Lockton, Charles Langton 1856–1932
Shops on the Village Green early 1920s
oil on canvas 24 x 51
2

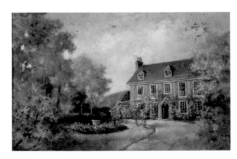

Lockton, Charles Langton 1856–1932
Warlingham Vicarage mid-1920s
oil on wood 22 x 33
35

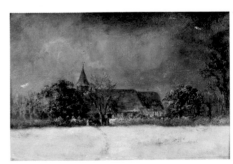

Lockton, Charles Langton 1856–1932
All Saints' Church
oil on card 15 x 22
28

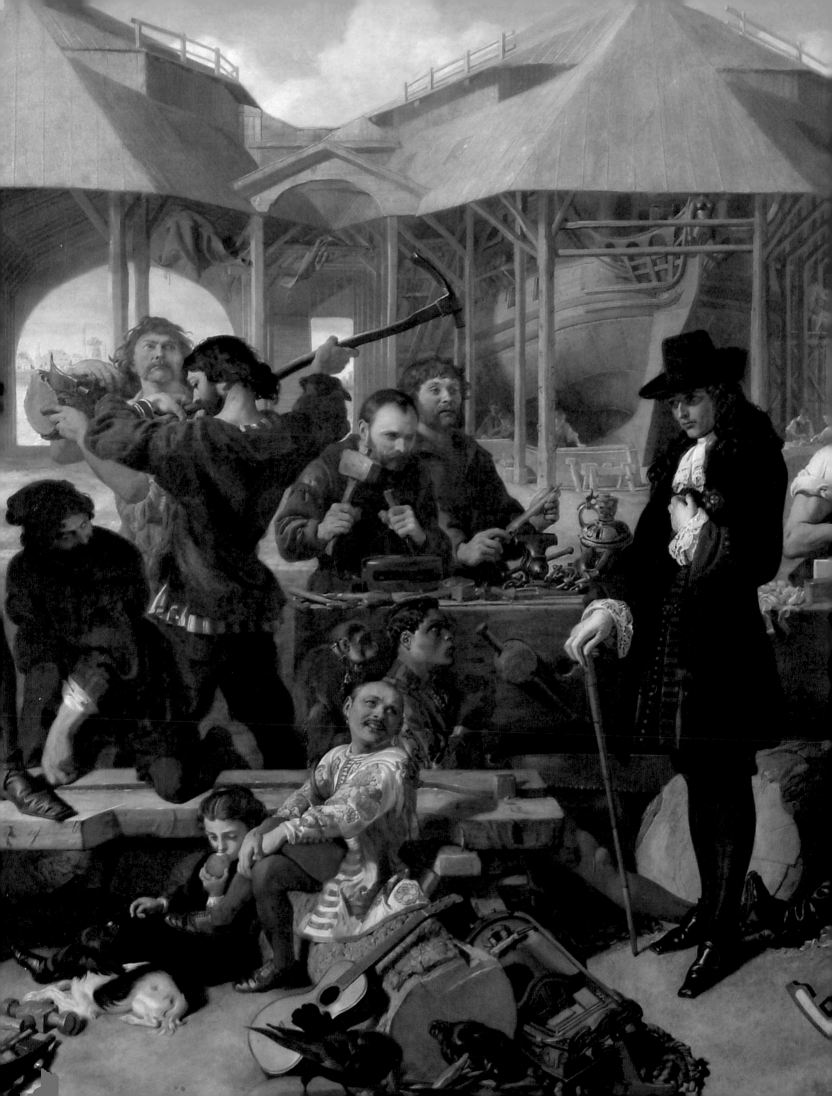

Lockton, Charles Langton 1856–1932
All Saints' Church, before Enlargement
oil on card 15 x 12.5
28

Lockton, Charles Langton 1856–1932
Alms Houses, Leas Road
oil on card 9.5 x 13
28

Lockton, Charles Langton 1856–1932
Baker's Wheelwrights Shop on Farleigh Road
oil on wood 10 x 22
13

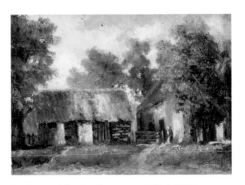

Lockton, Charles Langton 1856–1932
Barn and Post Office Cottage by 'The White Lion'
oil on card 9.5 x 13
28

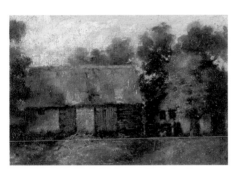

Lockton, Charles Langton 1856–1932
Barn between Glebe Road and 'The White Lion' (long since demolished)
oil on wood 13 x 20
20

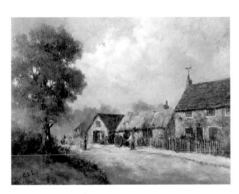

Lockton, Charles Langton 1856–1932
Blanchard's Smithy, Farleigh Road
oil on wood 18.5 x 22
3

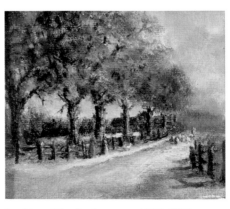

Lockton, Charles Langton 1856–1932
Bug Hill Road (Now Leas Road)
oil on card 10 x 11.5
28

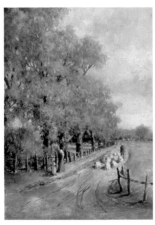

Lockton, Charles Langton 1856–1932
Bug Hill Road from the Village (Leas Road)
oil on wood 30.5 x 21
17

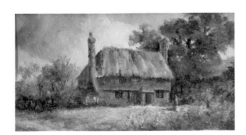

Lockton, Charles Langton 1856–1932
Cottage, Westhall Road, Demolished 1898 (The site of the artist's house 'Teeton')
oil on card 11.5 x 21
28

Facing page: Maclise, Daniel, 1806 –1870, *Peter the Great at Deptford Dockyard* (detail), 1857, Royal Holloway, University of London, (p. 52)

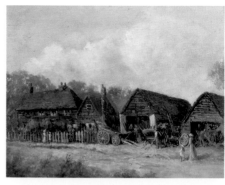

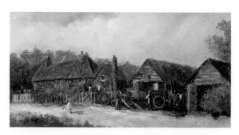

Lockton, Charles Langton 1856–1932
Cottages and Baker's Wheelwrights, Farleigh Road
oil on wood 24 x 31
22

Lockton, Charles Langton 1856–1932
Cottages and Baker's Wheelwrights, Farleigh Road
oil on card 11.5 x 21
28

Lockton, Charles Langton 1856–1932
Cottages between 'The Leather Bottle' and Mill House
oil on card 15 x 12
28

Lockton, Charles Langton 1856–1932
Court Cottage, North Side (front view), Hamsey Green
oil on wood 19.5 x 34
23

Lockton, Charles Langton 1856–1932
Court Cottage, South Side (rear view), Hamsey Green
oil on wood 19 x 34
18

Lockton, Charles Langton 1856–1932
Crewes Cottages, opposite 'The Leather Bottle'
oil on card 9 x 13
28

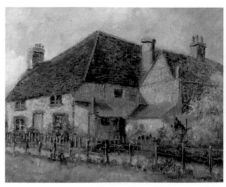

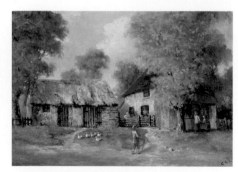

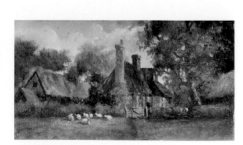

Lockton, Charles Langton 1856–1932
Horseshoe Cottages, Side/Rear View from Mint Walk, Farleigh Road
oil on board 16.5 x 20
34

Lockton, Charles Langton 1856–1932
Post Office on North-East Side of the Green next to 'The White Lion' Cottage
oil on wood 21 x 28
8

Lockton, Charles Langton 1856–1932
Side/Rear view of Horseshoe Cottages from Mint Walk
oil on card 9 x 12.5
28

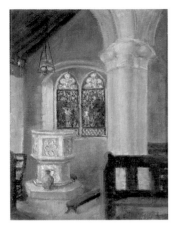

Lockton, Charles Langton 1856–1932
The Font, All Saints' Church
oil on board 20 x 15
29

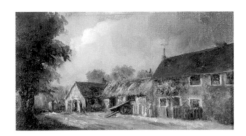

Lockton, Charles Langton 1856–1932
The Forge, Farleigh Road
oil on card 11.5 x 21
28

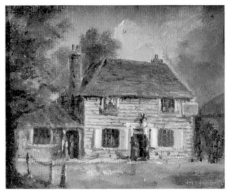

Lockton, Charles Langton 1856–1932
'The Leather Bottle' as it was in the 1880s
oil on card 10 x 12
28

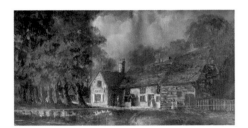

Lockton, Charles Langton 1856–1932
'The White Lion' as it was in the 1880s
oil on card 11.5 x 21
28

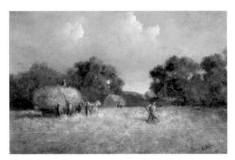

Lockton, Charles Langton 1856–1932
Tydcombe Farm
oil on wood 19 x 29
14

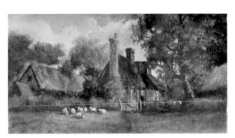

Lockton, Charles Langton 1856–1932
Tydcombe Farm
oil on card 11.5 x 21
28

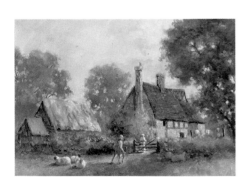

Lockton, Charles Langton 1856–1932
Tydcombe Farm from the North-West
oil on wood 22 x 30
15

Lockton, Charles Langton 1856–1932
Unidentified Farm Buildings (possibly Crewes Farm)
oil on wood 10 x 22
11

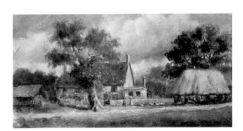

Lockton, Charles Langton 1856–1932
Village Green, South-East Corner
oil on card 11.5 x 21
28

Lockton, Charles Langton 1856–1932
Webbs Cottage, Farleigh Road
oil on card 10 x 12
28

Lockton, Charles Langton 1856–1932
Westhall Cottage
oil on board 19 x 23
33

Lockton, Charles Langton 1856–1932
Westhall Road (Narrow Lane to Right)
oil on card 10 x 12
28

Lockton, Charles Langton 1856–1932
Woodland Scene
oil on canvas 16 x 23
24

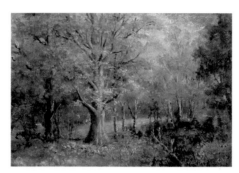

Lockton, Charles Langton 1856–1932
Woodland Scene
oil on canvas 16 x 23
25

Molesey Library

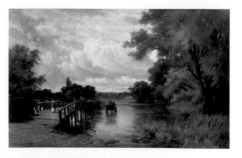

Helcke, Arnold active 1880–1911
The Bridge over the Mole 1905
oil on canvas 92 x 145

Brooklands Museum

Broomfield, Keith
Some Aircraft in which Weybridge Design Office Has Been Involved since 1948 c.1987
oil on board 99 x 142
D3410/1

Gaunt, David
Grindlay Peerless on Track 1995
oil on board 49 x 64
L459 (P)

Lovesey, Roderick b.1944
Incident in the Battle 1987
oil on canvas 49 x 65
D249

Brooklands Museum opened in 1991 on 30 acres of the original 1907 motor racing circuit near Weybridge, Surrey – the world's first purpose built motor racing track. Brooklands is not just the birthplace of British motor sport but of British aviation too, and the Museum tells the story of aviation at Brooklands throughout most of the twentieth century from A. V. Roe's first flight in 1908 to the design and production of Concorde in the 1970s.

Many original buildings survive, including the Edwardian motor racing clubhouse, paddock workshops, tuning sheds and petrol pagodas of the 1920s and 1930s. These have been restored and used to display a growing collection of racing cars, motorcycles and bicycles alongside photographs, costumes and memorabilia.

The collecting policy of the Brooklands Museum Trust is directed towards researching, identifying, acquiring, conserving and exhibiting items that directly help to interpret the history of Brooklands and the many people (racing drivers, pilots, engineers, designers, mechanics, spectators and staff) who gave the track, aerodrome and related factories their unique role in British history. Items must relate to the motoring, aviation, industrial or social history of Brooklands or to related activities, organisations and people locally, such as the landowning Locke King family that built the track. Items that demonstrate Brooklands' contribution to current motoring and aerospace technology are also considered, particularly where direct development can be demonstrated, such as in modern Grand Prix racing, from past design, engineering and testing work at Brooklands.

An important part of the collections and displays is the many paintings, drawings and prints that have been acquired over the years featuring the machines and the personalities that brought life to the track, including aircraft flown by Brooklands flying clubs or built at the Vickers, Sopwith and Hawker factories. The paintings, which currently include 47 oils and acrylics, are as varied as they are numerous, artists having been inspired by so many aspects of life at Brooklands. Racing on the Outer Circuit occurs frequently as a motoring subject with the first flights of prototype aircraft being particularly popular on the aviation side.

Pre-war motor sport magazines such as *The Autocar* and *The Motor* commissioned artists to express the pace and colour of motor racing that photography was still unlikely to capture, and among the most accomplished were names like F. Gordon Crosby and Roy Nockolds. One of the finest oil paintings in the Museum's permanent collection is probably the Nockolds painting of Kaye Don breaking the Brooklands Outer Circuit record in a Sunbeam from c.1929.

Aviation artists have shown equal accomplishment and Brooklands-built aircraft are often still the inspiration behind paintings by members of the Guild of Aviation Artists. As with motoring, it was often to artists rather than photographers that publishers looked to for the colour and glamour of flying, whether it be the early pioneers, the 1930s flying clubs or the machines that duelled in the skies in the Second World War. This latter subject is well represented in the Collection in works such as *'Defender of this Sceptred Isle'* by

Tootall, Ray
Sir Thomas Sopwith
oil on canvas 50 x 35 (E)
D551

Turner, Graham b.1964
A. V. Roe's First Flight 1993
oil on board 51 x 77
L665 (P)

unknown artist
Sir Thomas Gore-Brown 1873
oil on board 45 x 41
L500 (P)

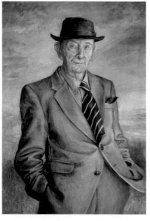

Allison, Jane b.1959
Sir George Edwards (1909–2003)
oil on canvas 66 x 46
D3268

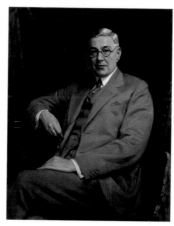

unknown artist
Sir Percival Perry, Founder, Ford of Britain
1931
oil on canvas 113 x 86
L550 (P)

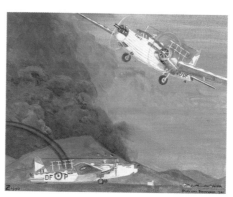

unknown artist
Storm over Benevenagh 1941
oil on canvas 46 x 53
D1643

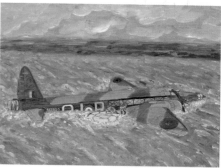

unknown artist
Wellington 'R' for 'Robert' Ditched in Loch Ness 1987
oil on canvas 31 x 41
D547

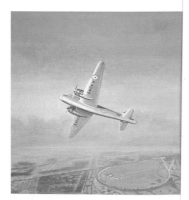

Boorer, Norman 1916–2004
Prototype Wellington 1986
oil on canvas 62 x 77
D247

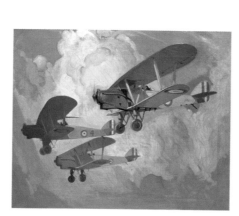

unknown artist 20th C
Hawker Horsley Biplanes in Flight
oil on canvas 64 x 77
D3415

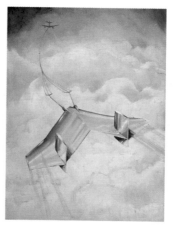

unknown artist
Tail Fin Section on Tow
oil on board 40 x 30
D3299

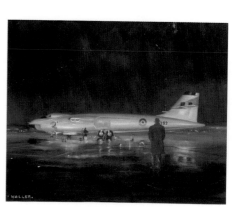

Waller, Claude b.c.1920
Vickers Valiant Night Scene 1965
oil on board 50 x 60
D3403

196

Facing page: Watts, George Frederick, 1817 –1904, *End of the Day (Surrey Woodland)* (detail), 1902–1903, Watts Gallery, (p. 157)

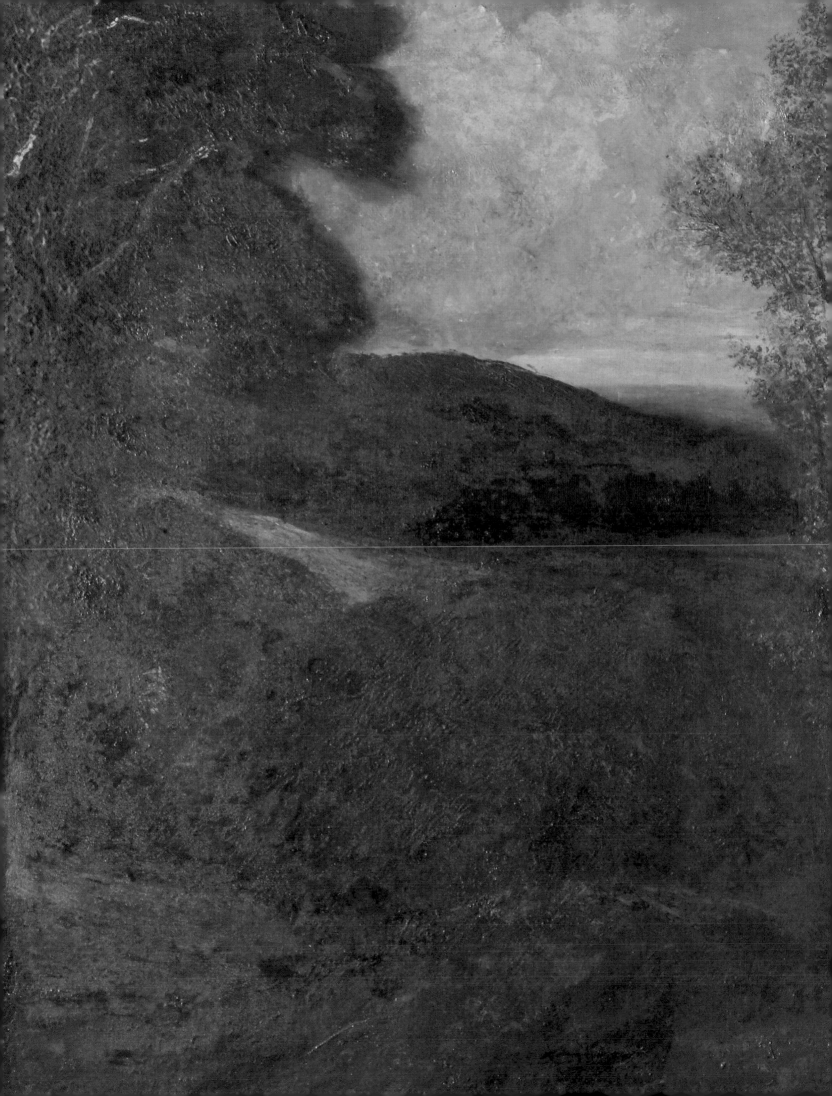

Waller, Claude b.c.1920
Tiger Moth over Brooklands c.1996
oil on canvas 51 x 77
D2273

Weekley, Barry active 1993–2006
Wellington 'R' for 'Robert' in Flight 1993
oil on canvas 51 x 71
D2562

Wells, Henry Tanworth 1828–1903
Peter Locke King 1874
oil on canvas 187 x 140
L512

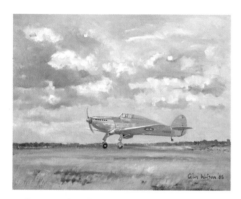

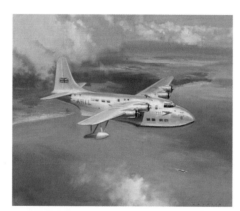

Wilson, Colin b.1949
Hurricane Landing 1985
oil on canvas 60 x 77
D248

Wootton, Frank 1914–1998
BOAC Shorts S45A Solent Seaplane, 'Salisbury'
oil on canvas 56 x 63
D1920

Elmbridge Museum

Elmbridge Museum, located in the heart of Weybridge, is a fascinating source of local knowledge which illustrates the rich history of our beautiful Borough in the North-West of Surrey.

Weybridge Museum opened on the 23rd June 1909, though there had been a long tradition of exhibitions of 'Art, Industries and Manufactures' in the town, going back to 1874. From the outset, the Museum was part of the local council but it was not until 1967, when it moved to its current location above Weybridge Library, that it had paid, rather than voluntary, staff. Following the Local Government reorganisation, the name changed to Elmbridge Museum, to show that it served the Borough as a whole.

As a service provided by Elmbridge Borough Council, the Museum is not just about the past, it also deals with contemporary issues and supports the

arts, community, health, youth and sports services provided by the Council. In addition to the permanent exhibitions, there is an exciting programme of temporary displays as well as workshops and children's activities. For more information visit the museum website at www.elmbridgemuseum.org.uk.

As a local history museum, the art collection is linked to the local area and communities. As a result, the collection contains landscapes of Elmbridge and the surrounding areas, as well as portraits of individuals connected with the Borough. Many paintings in the Collection are by local artists, and a number of oil paintings are on loan from various local individuals and organisations.

Due to space constraints, very few paintings are on display. One of the few is a large oil painting on a wooden board representing a group of people in eighteenth-century costume dancing around a maypole on Monument Green in Weybridge. It was found in 'Lavender Cottage' on Monument Green and is currently on display in the museum reception.

Amongst those paintings not on display are a number with interesting backgrounds. One of these, by an unknown artist from c.1895, represents Lady Louisa Egerton, the wife of Admiral Francis Egerton, in a black evening dress with large pink puff sleeves. Initially it was thought to depict the sitter's mother-in-law, the Countess of Ellesmere. The painting was found in an old air-raid shelter in 1970 in Walton-on-Thames (no one knows how it came to be there). Originally, it was substantially larger than it is today. However, after its discovery the damaged areas of the painting were removed and the painting was remounted. The picture eventually ended up in a jumble sale in 1972, where the donor purchased it for the princely sum of one penny.

Another painting with an interesting background is *HM Torpedo Boat 2015* by Charles David Cobb, which illustrates the long, and possibly surprising history connecting the Borough of Elmbridge and the Royal Navy, which dates back to the eighteenth century. During the Second World War different towns adopted various warships and Walton and Weybridge adopted 'HM Torpedo Boat 2015'. As a sign of gratitude, the crew of the ship presented a painting of their boat to the two towns during Thanksgiving Week in November 1945.

The Collection at Elmbridge Museum also includes contemporary paintings. To celebrate the millennium, the Museum organised the 'Painting for Prosperity' arts project (funded by the R. C. Sherriff Rosebriars Trust), in order to acquire contemporary landscapes by local artists. These included the three oil paintings, *Oxshott Station*, *The Wey Bridge* and *Cedar House, Cobham*.

Given its space constraints, Elmbridge Museum is dedicated to finding new and different ways to make its collections accessible to the public and is delighted to have had the opportunity to be involved with the Public Catalogue Foundation's exciting project.

Jason Finch, Temporary Assistant Manager

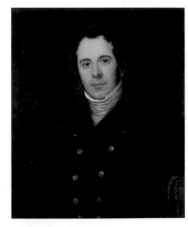

Bradley
Robert Gill, Railway Pioneer (1796–1871)
c.1805
oil on canvas 73 x 60
16.1986.44

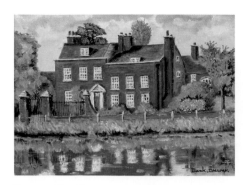

Brewer, Derek
Cedar House, Cobham 1999
oil on board 24 x 34.5
72.2000.4

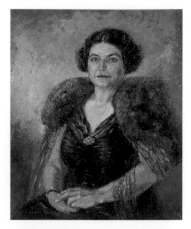

Butler, Villers
Amy Gentry, OBE 1952
oil on canvas 75 x 62
L.290.1976.41 (P)

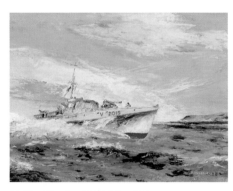

Cobb, Charles David b.1921
HM Torpedo Boat 2015 1945
oil on canvas 44.5 x 59
23.1985

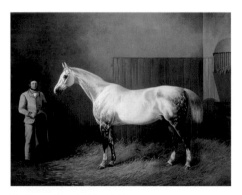

Dalby, John 1810–1865
*A White Horse with Dappled Legs Standing in
a Stable* 1849
oil on board 44 x 56
16.1986.48

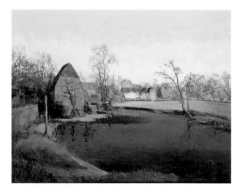

Dawson, M.
*Cobham Mill with Houses on Right Bank of a
River in the Distance* 1974
oil 39 x 49
366.1974

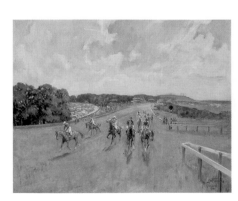

Edwards (attributed to)
Going to the Post, Goodwood 1955
oil 49 x 59.5
L.346.1989.5 (P)

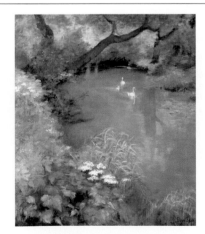

Ewan, Eileen
Swans on the River Wey
oil on canvas 104.5 x 90.5
317.1994

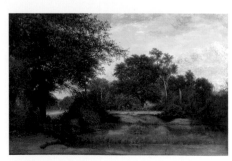

Godfrey, J.
*A View of St George's Hill, with Dead Man's
Pool in the Foreground* 1886
oil 49.5 x 75
270.1989 (P)

Gray, M.
Esher Road, Showing a Rustic Bridge (now demolished) 1950
oil 37.5 x 49
43.1982

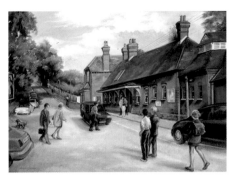

Grosvenor, Jennifer b.1931
Oxshott Station
oil 44.5 x 60
72.2000.7

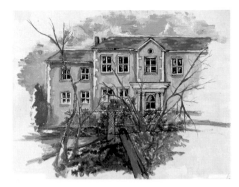

Hobbes, Ian b.1969
Cardinal Godfrey School, Sunbury
oil on canvas 39 x 49
318.1994

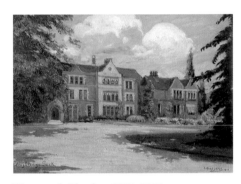

Houssard, Charles 1884–1958
Weybridge Park College 1915
oil 38 x 46 (E)
29.1996

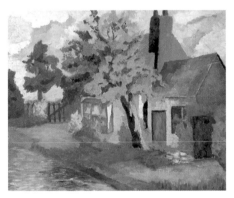

Lefevre, M.
The Lock-Keeper's Cottage by the Oil Mills on the River Wey 1959
oil 39 x 49
239.1969.1

Lock, Edwin active 1929–1961
The Duchess of York's Monument at Monument Green, Weybridge 1929
oil 16 x 20.5
L.30.1982.5 (P)

Lock, Edwin active 1929–1961
An Old Chestnut Tree, Which Stood near the 'Ship Inn', High Street, Weybridge 1960
oil on board 25 x 36
L.30.1982.7 (P)

Lock, Edwin active 1929–1961
Shops in the High Street: 'Sough & Son' 1960
oil on board 24 x 35
L.30.1982.1 (P)

Lock, Edwin active 1929–1961
The Entrance to Springfield Lane, Weybridge 1961
oil 29.5 x 39
L.30.1982.4 (P)

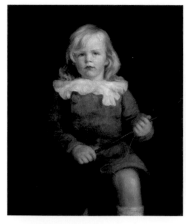

Outram, Lance
Robert John Brook Gill, Aged Two 1913
oil on canvas? 75.8 x 62.7
16.1986/47

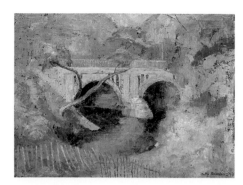

Saunders, Jutta
The Wey Bridge 1970
oil 48 x 65
218.1970.1

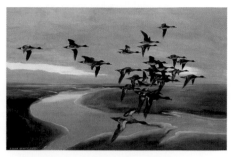

Scott, Peter Markham 1909–1989
Flying Geese 1935
oil 50 x 75
L.346.1989.6 (P)

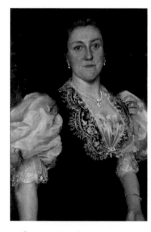

unknown artist
Lady Louisa Egerton, Wife of Admiral Francis Egerton c.1895
oil on canvas 74.5 x 49
203.1973

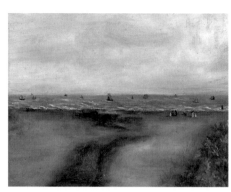

unknown artist
Beach and Seascape 1987
oil on canvas 18.5 x 24

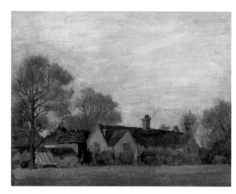

unknown artist
Hamm Court Farm, Weybridge
oil 20.5 x 25
L.254.1971 (P)

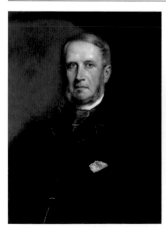

unknown artist
John Phillip Fletcher, Son of Sir Henry Fletcher, of Ashley House, Walton
oil on canvas 81 x 58.4
1.1936

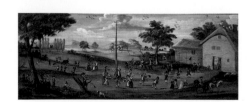

unknown artist
Maypole on Monument Green, with Figures in 18th Century Costume
oil on wooden board 87.6 x 188 (E)
6.1914

unknown artist
Portion of Fresco from East Wall of Old St James' Church
oil fresco 57 x 45
13.1910

unknown artist
Prince Charles (b.1948)
oil on canvas? 34.5 x 24.5
123.1980

unknown artist
Second Walton Bridge
oil on canvas 38.5 x 58.5
L.58.1969.2

unknown artist
'The Newcastle Arms'
oil on canvas 45.7 x 66
1.1938

unknown artist
Walton Bridge, with a Cottage on the Left,
(possibly 'The Angler's Rest') and a Boat
Drawn Up on a Bank of Pebbles
oil on canvas 29 x 37
26.1967

Wallis, Nancy
Baker Street, Weybridge in 1880s (taken from
a postcard)
oil on Daler board 25.5 x 30.5
63.1972

Wilcox, Doreen
The Ruined Temple
oil on Daler canvas panel 35.5 x 46
241.1989

Williams, F. S.
The Weir
oil on board 34 x 37.5
8.1955

Surrey History Centre

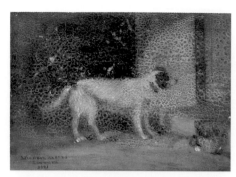

Lowther, Micheal Angelo
Dog 1821
oil on board 11.5 x 15.2
DFC/A/1/5 (P)

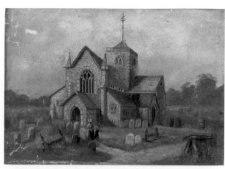

unknown artist
Dorking Church and Churchyard before 1837
oil on canvas 28 x 38
1867/box21 (P)

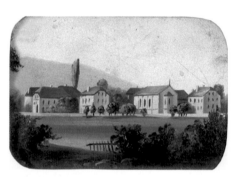

unknown artist
An Alpine Village before c.1857
oil set into leather book binding 7 x 10
6932/7/5/1

Sidney H. Sime Memorial Gallery

Sidney Herbert Sime was born in Manchester in 1867, the second of six children of Scottish parents. As soon as he was old enough, the young Sime went out to work, taking on a variety of jobs including that of a pit boy, when often during the day he would scratch drawings of demons and imps on the walls of the pit. The hours were long and spare time came only in the late evening, when he went out with paint box to find moonscapes. Having very little formal education, Sime took great pains to educate himself, so graduating to a post of sign writing, and at this point he was able to join the Liverpool School of Art, where he gained prizes and medals for his drawing.

His studies completed, Sime decided the best way for a young artist to start earning a profitable living was by illustrating for books and magazines. He contributed to many magazines, including *Pall Mall, The Idler, Pick-me-up* and *The Illustrated London News,* along with artists such as Lewis Baumer, Will Owen, Dudley Hardy, Maurice Greiffenhagen, Edgar Wilson and J. W. T. Manuel.

At one time, as a popular member of both the Langham Sketching Club and the Yorick Club in London, Sime interacted with musical friends Duncan Tovey and Joseph Holbrooke as well as the writer Lord Dunsany, for whose books he drew many illustrations. Sime's interest in the theatre led him to produce many fine caricatures of artists from the stage. A number of these may be seen in the Sime Memorial Gallery at Worplesdon.

It was said of Sime by Frank Emanuel, 'Mr Sime is as eloquent and vivacious in his speech as with his pencil, and modest though he be, he is markedly a man of great individuality and deep thought. A vast forehead dominates a face indicative of strength, while a certain appearance of grimness is frequently dispelled by a humorous twinkle of the eye and the most genial of smiles. In short he looks very much the author of his drawings, in equal part an irresistible humorist, an original thinker and a truly inventive artist.'

Although Sime earned his living as an 'illustrator', he still cherished ambitions of becoming a painter and so gained membership of the Royal Society of British Artists in 1896.

In 1898 Sime's deceased solicitor uncle left him comfortably well off with a residence in Perthshire. It was to this house that Sime brought his artist bride Mary Susan Pickett and here in Scotland he took the opportunity to develop his talent as a painter. The Worplesdon gallery houses several of his Scottish landscapes.

Sime also took a studio in Kings Road, Chelsea, and while enjoying the congenial stimulus of friends in London decided to sell his Scottish home and buy a house in Worplesdon (its location being more accessible to London) next to his friend Duncan Tovey. Here he became a regular visitor to the local inn, often staying until closing time, where he would sit and draw caricatures of local working men and tradesmen. Today many are on view at Worplesdon.

It is said that Sime was an avid reader with preferences for Poe, Heine, De Quincey and Meredith, and would return to his studio after country walks to read and paint long into the night. Holbrooke Jackson wrote of Sime, 'He is an art product of the nineties, along with Aubrey Beardsley, Charles Condor,

Charles Ricketts and Laurence Housman.' In 1922 Haldane Macfall writes, 'Sime ranges free and unfettered and wide – his flight is limitless. He leaps into the immensities and is reckless of the eternities… Sime is eternally young with the reckless inquisition of youth.'

It was when invalided out of the army in 1918 that Sime's passion for painting in oils was most prolific. He became obsessed with the visions of St John in the Book of Revelation and painted his own visions of the Apocalypse. Painting in oil and watercolour was very important to him, in fact more so than the reputation he gained as an illustrator, yet it was difficult to form an opinion of its merit, although the original version of *Wild Beast Wood* was rightly called his 'masterpiece'. It was in 1924 that Sime staged a well-received exhibition at St George's Gallery in London, and then another in 1927 with less acclaim.

Desmond Coke, visiting Sime at Worplesdon, writes in his *Confessions of an Incurable Collector*, 'Sime, more than most alleged 'geniuses' whom I have met, has something of the real spark in him… his shattering conversation, his knowledge of the paints that he himself mixes with the loving care of an Old Master, in his rustic cottage/studio, his recondite knowledge of the Apocalypse, and above all his… contempt for fame.'

Hence, for the latter part of his life, Sime became something of a recluse, leaving the socially conscious artists with 'significant form' and relishing mysteriousness and obscurity, not wanting his art to be explicable. He died on May 22nd 1941 and his grave is marked by a rough block of granite in St Mary's Churchyard, Worplesdon.

Mary Sime's will in 1949 bequeathed all Sime's pictures that remained in her possession for the creation of the Sime Memorial Gallery in Worplesdon, which was opened in 1956. Now 50 years on, the contents of the Gallery remain solely the work of Sidney Sime, his oil paintings, watercolours and black and white illustrations. For admirers of Sidney Sime's work, a visit to the Gallery is highly recommended.

Anne Philps, Honorary Curator

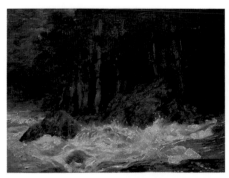

Sime, Sidney Herbert 1867–1941
A River in Scotland
oil on canvas 83.3 x 101
10

Sime, Sidney Herbert 1867–1941
Archway
oil on panel board 8.9 x 8.9
D10/A39

Sime, Sidney Herbert 1867–1941
Autumn Landscape with Pond
oil on panel board 21 x 26.7
D9/V

Sime, Sidney Herbert 1867–1941
Autumn Trees
oil on board 21.6 x 15.2
77/12

Sime, Sidney Herbert 1867–1941
Autumn Trees
oil on board 8.9 x 18.4
77/15

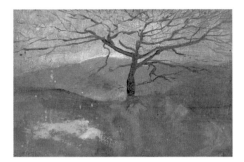

Sime, Sidney Herbert 1867–1941
Bare Tree
oil on panel board 10.2 x 15.2
D10/A26

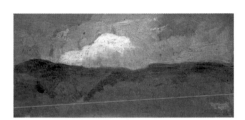

Sime, Sidney Herbert 1867–1941
Cloud over Hill
oil on panel board 8.9 x 18.4
D10/A22

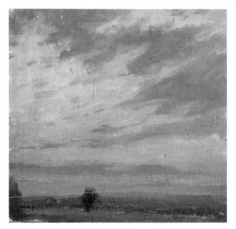

Sime, Sidney Herbert 1867–1941
Clouds
oil on canvas 22.9 x 24.1
D6/28

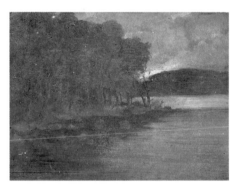

Sime, Sidney Herbert 1867–1941
Dark Lakeside
oil on panel board 15.9 x 20.3
D10/A10

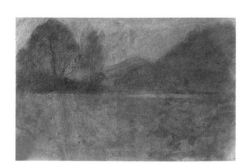

Sime, Sidney Herbert 1867–1941
Dark Landscape
oil on canvas 18.4 x 27.9
D6/54

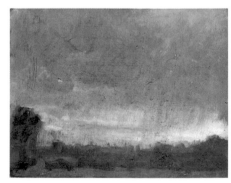

Sime, Sidney Herbert 1867–1941
Dark Landscape
oil on canvas 20.3 x 26
D6/61

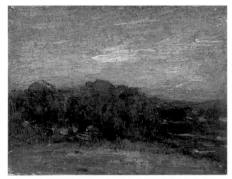

Sime, Sidney Herbert 1867–1941
Dark Landscape
oil on panel board 21 x 26.7
D8/S

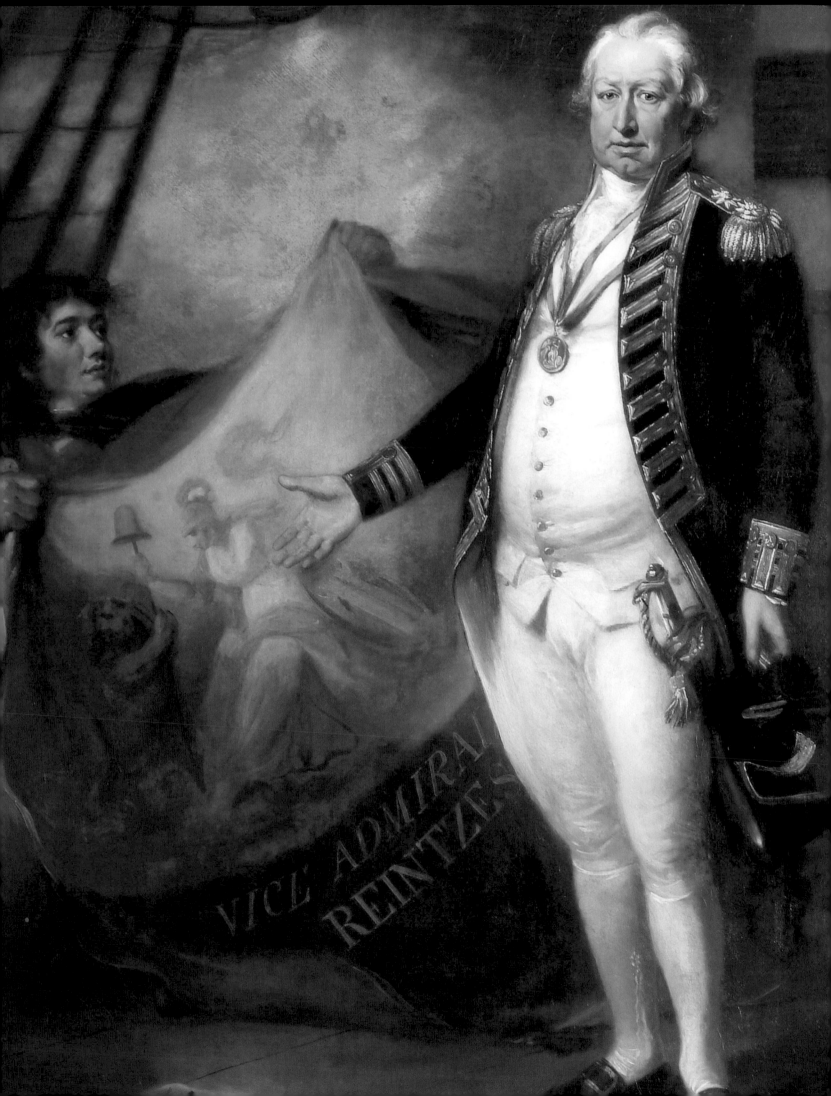

VICE ADMIRAL
REINTZ

Sime, Sidney Herbert 1867–1941
Dark Landscape
oil on panel board 15.2 x 21.6
D9/A7

Sime, Sidney Herbert 1867–1941
Dark Mountains and Boat
oil on panel board 10.2 x 15.2
D8/V

Sime, Sidney Herbert 1867–1941
Dark Mountains and Water
oil on panel board 18.4 x 8.9
D10/A33

Sime, Sidney Herbert 1867–1941
Dark Pine Trees
oil on board 15.2 x 21.6
77/9

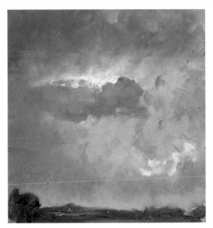

Sime, Sidney Herbert 1867–1941
Dark Sky
oil on canvas 19.7 x 19.1
D6/57

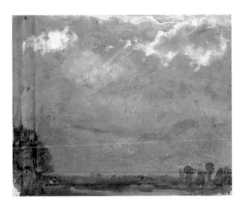

Sime, Sidney Herbert 1867–1941
Dark Sky Tinged White
oil on canvas 23.5 x 27.9
D6/62

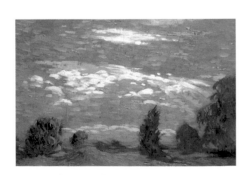

Sime, Sidney Herbert 1867–1941
Dark Sky with White Clouds
oil on canvas 19.1 x 27.9
D6/31

Sime, Sidney Herbert 1867–1941
Dark Trees
oil on board 21.6 x 15.2
77/6

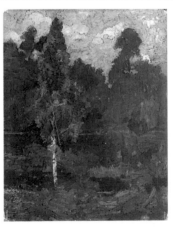

Sime, Sidney Herbert 1867–1941
Dark Trees
oil on board 25.4 x 21
77/20

Facing page: Russell, John, 1745–1806, *Sir Richard Onslow, Bt (1741–1817)* (detail), The Guildhall, (p 109)

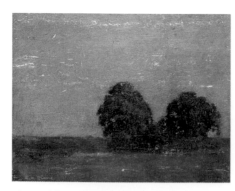

Sime, Sidney Herbert 1867–1941
Dark Trees
oil on panel 21 x 26.7
D9/W

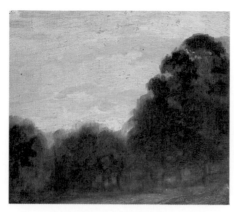

Sime, Sidney Herbert 1867–1941
Dark Trees and Blue Sky
oil on canvas 19.1 x 21
D6/73

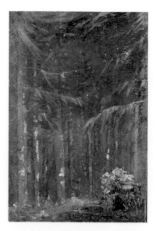

Sime, Sidney Herbert 1867–1941
Dark Trees and Floral Urn
oil on panel board 40.6 x 26.7
D7/A

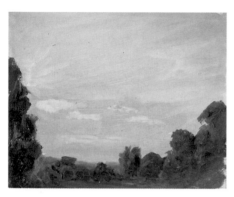

Sime, Sidney Herbert 1867–1941
Dark Trees and Light Sky
oil on canvas 27.3 x 32.4
D6/45

Sime, Sidney Herbert 1867–1941
Dark Trees and Mist
oil on panel board 21.6 x 26.7
D8/P

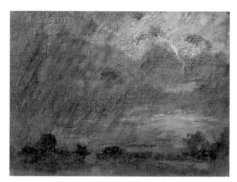

Sime, Sidney Herbert 1867–1941
Dark Trees and Sky
oil on canvas 27.3 x 34.9
D6/41

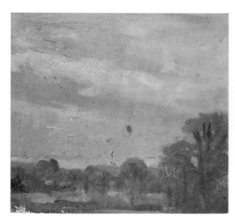

Sime, Sidney Herbert 1867–1941
Dark Trees and Sky
oil on canvas 24.1 x 26.7
D6/43

Sime, Sidney Herbert 1867–1941
Dark Trees and White Houses
oil on panel board 21 x 26.7
D8/R

Sime, Sidney Herbert 1867–1941
Dark Trees and White-Tip Clouds
oil on canvas 23.5 x 25.4
D6/42

Sime, Sidney Herbert 1867–1941
Figure of a Man with Book
oil on panel board 18.4 x 8.9
D10/A20

Sime, Sidney Herbert 1867–1941
Figure of a Woman
oil on panel board 20.3 x 15.9
D10/A19

Sime, Sidney Herbert 1867–1941
Figure of Lady in Grey
oil on board 18.4 x 8.9
77/22

Sime, Sidney Herbert 1867–1941
Figure of Lady in White
oil on board 18.4 x 8.9
77/21

Sime, Sidney Herbert 1867–1941
Fir Trees
oil on panel board 26.7 x 21
D8/I

Sime, Sidney Herbert 1867–1941
Flower Painting
oil on canvas 35.6 x 52.7
12

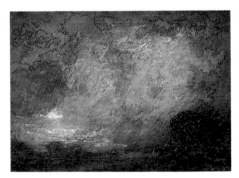

Sime, Sidney Herbert 1867–1941
Flying Creatures
oil on panel board 22.9 x 30.5
D7/F

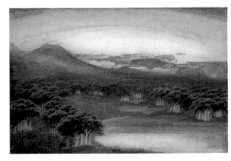

Sime, Sidney Herbert 1867–1941
Forest and Lake
oil on canvas 17.1 x 25.4
D6/74

Sime, Sidney Herbert 1867–1941
Hills
oil on panel board 8.9 x 18.4
D10/A32

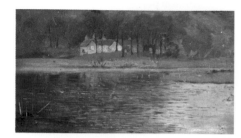

Sime, Sidney Herbert 1867–1941
House by a Lake
oil on board 12.7 x 21.6
77/4

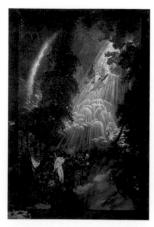

Sime, Sidney Herbert 1867–1941
Illustrative
oil on canvas 139.7 x 91.4
3

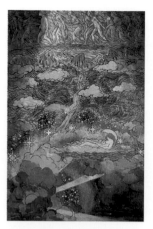

Sime, Sidney Herbert 1867–1941
Illustrative
oil on canvas 106.7 x 70.5
7

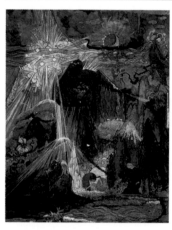

Sime, Sidney Herbert 1867–1941
Illustrative Design of Fountain and Figures
oil on canvas 109.2 x 83.8
5

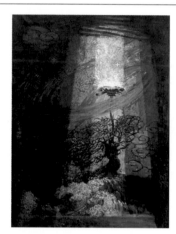

Sime, Sidney Herbert 1867–1941
Imaginary
oil on canvas 106.7 x 80
1

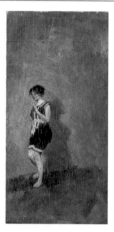

Sime, Sidney Herbert 1867–1941
Lady
oil on panel board 18.4 x 8.9
D10/A21

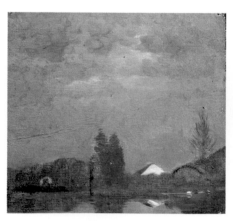

Sime, Sidney Herbert 1867–1941
Lake, House and Trees
oil on canvas 13.3 x 14
D6/33

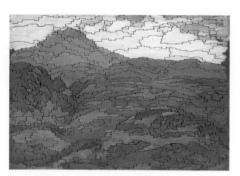

Sime, Sidney Herbert 1867–1941
Landscape
oil on panel board 15.9 x 21.6
D10/A11

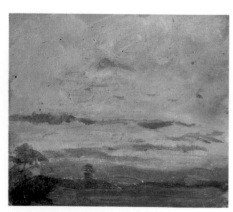

Sime, Sidney Herbert 1867–1941
Landscape and Dark Sky
oil on canvas 21 x 22.9
D6/59

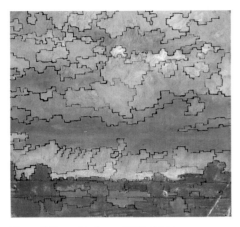

Sime, Sidney Herbert 1867–1941
Landscape and Patterned Sky
oil on canvas 21 x 21.6
D6/52

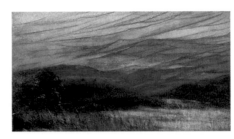

Sime, Sidney Herbert 1867–1941
Landscape and Red Sky
oil on canvas 14 x 25.4
D6/19

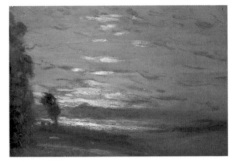

Sime, Sidney Herbert 1867–1941
Landscape and Sky
oil on canvas 21 x 30.5
D6/4

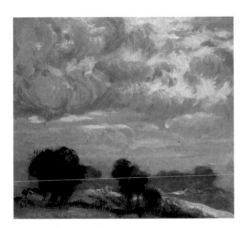

Sime, Sidney Herbert 1867–1941
Landscape and Sky
oil on canvas 22.9 x 24.8
D6/5

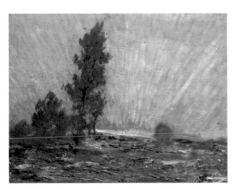

Sime, Sidney Herbert 1867–1941
Landscape and Sky
oil on canvas 19.7 x 24.1
D6/24

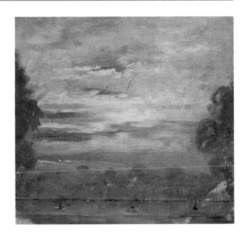

Sime, Sidney Herbert 1867–1941
Landscape and Sunset
oil on canvas 26 x 27.3
D6/7

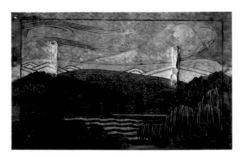

Sime, Sidney Herbert 1867–1941
Landscape Decoration
oil on canvas 69.2 x 104.8
16

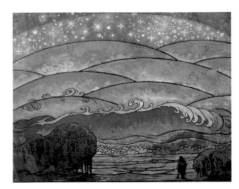

Sime, Sidney Herbert 1867–1941
Landscape Decoration
oil on canvas 66.7 x 79.4
25

Sime, Sidney Herbert 1867–1941
Landscape, Mountain and Lake
oil on board 8.9 x 18.4
77/1

Sime, Sidney Herbert 1867–1941
Landscape, Mountains
oil on board 15.2 x 21.6
77/17

Sime, Sidney Herbert 1867–1941
Landscape of Fields and Bay of Water
oil on canvas 17.8 x 43.8
P537

Sime, Sidney Herbert 1867–1941
Landscape, Scottish Mountains
oil on board 15.2 x 21.6
77/16

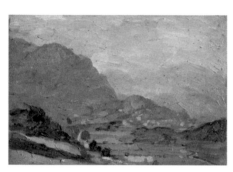

Sime, Sidney Herbert 1867–1941
Landscape, Scottish Mountains
oil on board 15.2 x 21.6
77/18

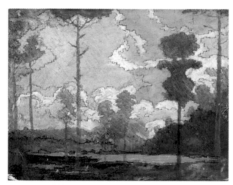

Sime, Sidney Herbert 1867–1941
Landscape, Trees and Green Field
oil on board 21 x 26.7
77/11

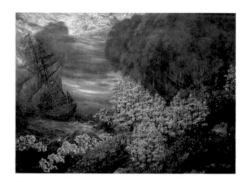

Sime, Sidney Herbert 1867–1941
Landscape with Ship
oil on canvas 82.6 x 107.3
13

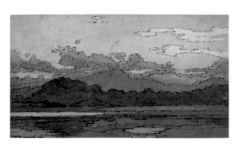

Sime, Sidney Herbert 1867–1941
Landscape with Trees
oil on board 12.7 x 21.6
77/2

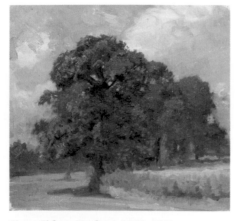

Sime, Sidney Herbert 1867–1941
Large Trees
oil on canvas 23.5 x 25.4
D6/18

Sime, Sidney Herbert 1867–1941
Light Sky and Trees
oil on canvas 24.1 x 30.5
D6/46

Sime, Sidney Herbert 1867–1941
Lowering Sky on Landscape
oil on canvas 20.3 x 26.7
D6/53

Sime, Sidney Herbert 1867–1941
Moonscape
oil on panel board 10.2 x 15.2
D10/A35

Sime, Sidney Herbert 1867–1941
Mountain and Water
oil on panel board 8.9 x 18.4
D10/A36

Sime, Sidney Herbert 1867–1941
Mountains
oil on panel board 15.9 x 18.4
D9/A1

Sime, Sidney Herbert 1867–1941
Mountains
oil on panel board 15.2 x 21.6
D9/A5

Sime, Sidney Herbert 1867–1941
Mountains in Scotland
oil on board 15.2 x 21.6
77/7

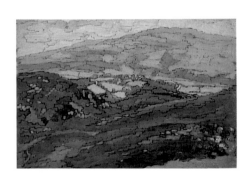

Sime, Sidney Herbert 1867–1941
Mountains in Scotland
oil on board 15.2 x 21.6
77/8

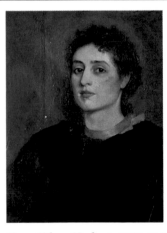

Sime, Sidney Herbert 1867–1941
Mrs Mary Sime
oil on canvas 61 x 48.9
14

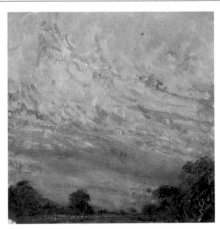

Sime, Sidney Herbert 1867–1941
Multi-Coloured Sky
oil on canvas 21 x 20.3
D6/20

Sime, Sidney Herbert 1867–1941
Mystery by Pool
oil on panel board 15.9 x 21.6
D10/A16

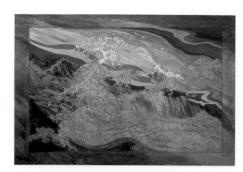

Sime, Sidney Herbert 1867–1941
Painting of Waves
oil on canvas 109.2 x 154.9
4

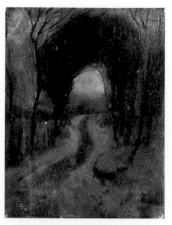

Sime, Sidney Herbert 1867–1941
Path through Trees
oil on canvas 17.1 x 12.7
D6/32

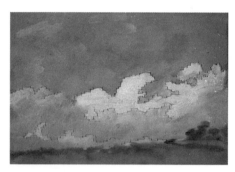

Sime, Sidney Herbert 1867–1941
Patterned Clouds and Sky
oil on panel board 15.9 x 21.6
D10/A15

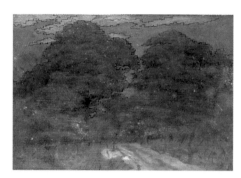

Sime, Sidney Herbert 1867–1941
Patterned Dark Trees
oil on panel board 15.9 x 21.6
D10/A14

Sime, Sidney Herbert 1867–1941
Patterned Hills
oil on panel board 15.2 x 21.6
D9/A3

Sime, Sidney Herbert 1867–1941
Patterned Hills
oil on panel board 15.2 x 21.6
D9/A6

Sime, Sidney Herbert 1867–1941
Patterned Hills
oil on panel board 8.9 x 18.4
D10/A31

Sime, Sidney Herbert 1867–1941
Patterned House and Trees
oil on panel board 10.2 x 15.2
D10/A25

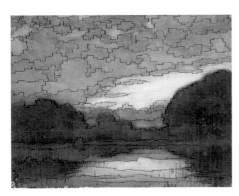

Sime, Sidney Herbert 1867–1941
Patterned Lake, Sky and Trees
oil on canvas 12.7 x 16.5
D6/64

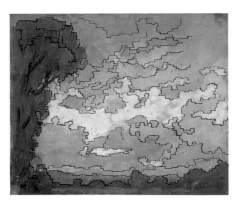

Sime, Sidney Herbert 1867–1941
Patterned Landscape
oil on canvas 25.4 x 30.5
D6/37

Sime, Sidney Herbert 1867–1941
Patterned Landscape
oil on canvas 25.4 x 30.5
D6/40

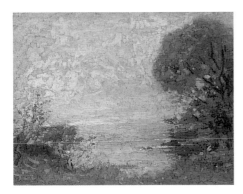

Sime, Sidney Herbert 1867–1941
Patterned Landscape
oil on panel board 21 x 26.7
D8/M

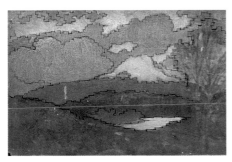

Sime, Sidney Herbert 1867–1941
Patterned Landscape
oil on panel board 10.2 x 15.2
D10/A27

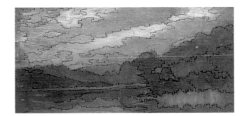

Sime, Sidney Herbert 1867–1941
Patterned Landscape
oil on panel board 8.9 x 18.4
D10/A30

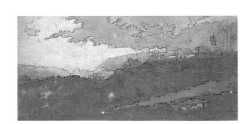

Sime, Sidney Herbert 1867–1941
Patterned Landscape
oil on panel board 8.9 x 18.4
D10/A34

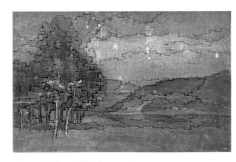

Sime, Sidney Herbert 1867–1941
Patterned Landscape
oil on panel board 10.2 x 15.2
D10/A38

Sime, Sidney Herbert 1867–1941
Patterned Landscape and Trees
oil on canvas 23.5 x 29.8
D6/38

Sime, Sidney Herbert 1867–1941
Patterned Landscape with Figure of Woman
oil on panel board 10.2 x 15.2
D8/W

Sime, Sidney Herbert 1867–1941
Patterned Pool
oil on panel board 15.9 x 21.6
D10/A17

Sime, Sidney Herbert 1867–1941
Patterned Sky
oil on panel board 29.2 x 22.9
D7/G

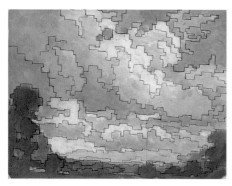

Sime, Sidney Herbert 1867–1941
Patterned Sky and Trees
oil on canvas 24.1 x 30.5
D6/47

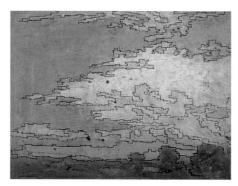

Sime, Sidney Herbert 1867–1941
Patterned Sky and Trees
oil on panel board 21 x 26.7
D9/X

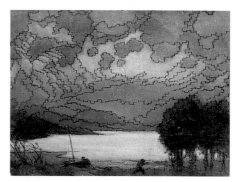

Sime, Sidney Herbert 1867–1941
Patterned Sky, Lake and Figures
oil on canvas 12.7 x 14.6
D6/66

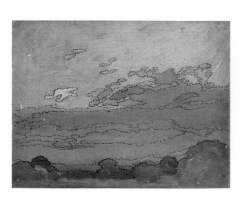

Sime, Sidney Herbert 1867–1941
Patterned Skyscape
oil on panel board 21 x 26.7
D8/J

Sime, Sidney Herbert 1867–1941
Patterned Stream
oil on panel board 15.2 x 10.2
D10/A29

Sime, Sidney Herbert 1867–1941
Patterned Tree
oil on panel board 18.4 x 8.9
D10/A23

Facing page: Fisher, Percy Harland, 1867 –1944, *Washing on the Line* (detail), 1903–1944, Surrey Heath Museum, (p. 9)

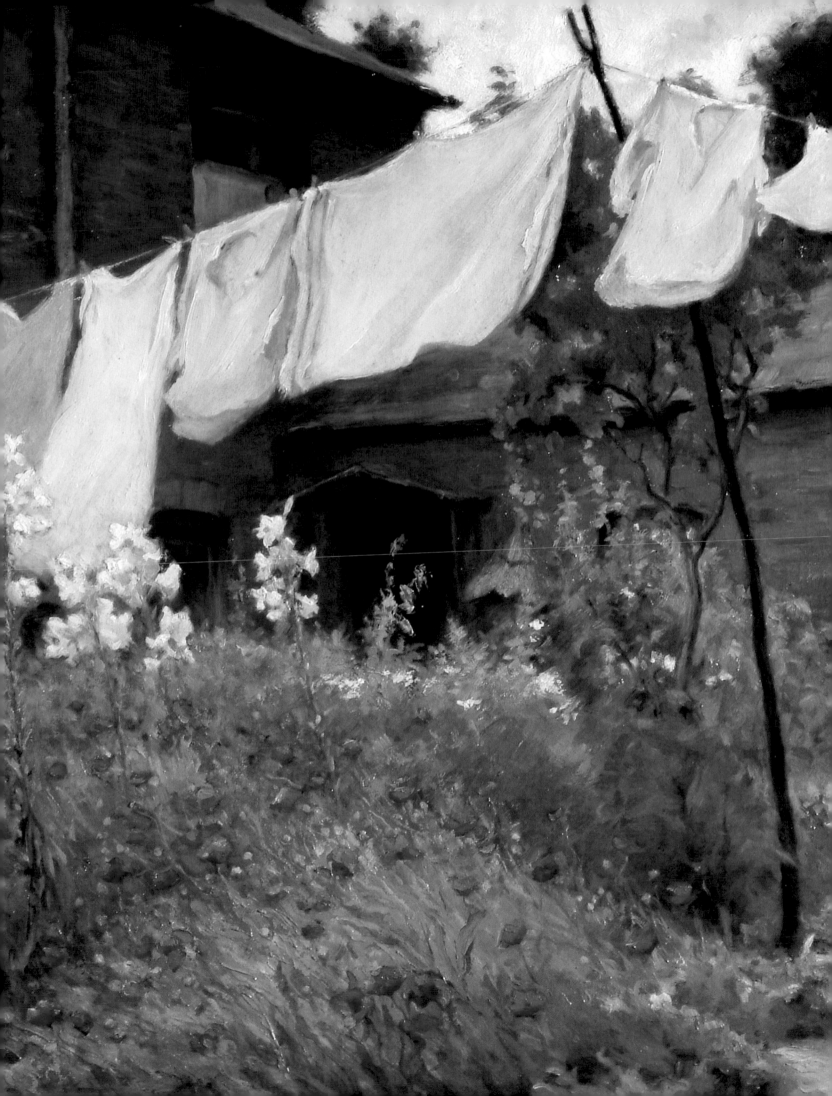

Sime, Sidney Herbert 1867–1941
Patterned Trees
oil on panel board 15.2 x 20.3
D9/Z

Sime, Sidney Herbert 1867–1941
Patterned Trees
oil on panel board 12.7 x 20.3
D10/A18

Sime, Sidney Herbert 1867–1941
Patterned Trees and Sky
oil on canvas 21 x 30.5
D6/58

Sime, Sidney Herbert 1867–1941
Patterned Trees and Sky
oil on canvas 21 x 24.8
D6/72

Sime, Sidney Herbert 1867–1941
Patterned Waves
oil on canvas 25.4 x 30.5
D6/36

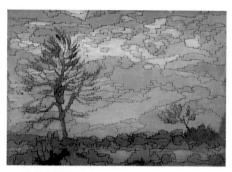

Sime, Sidney Herbert 1867–1941
Patterned Winter Tree
oil on panel board 15.9 x 21.6
D10/A13

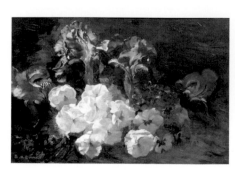

Sime, Sidney Herbert 1867–1941
Purple Iris and White Pansies
oil on canvas 39.4 x 52.1
82

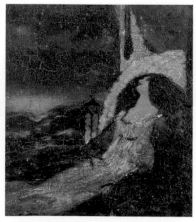

Sime, Sidney Herbert 1867–1941
Reclining Female
oil on panel board 29.2 x 26.7
D7/C

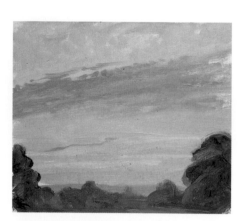

Sime, Sidney Herbert 1867–1941
Red Sky
oil on canvas 19.1 x 22.2
D6/10

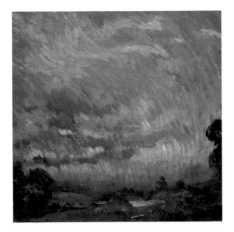

Sime, Sidney Herbert 1867–1941
Red Sky
oil on canvas 24.1 x 24.1
D6/12

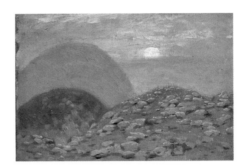

Sime, Sidney Herbert 1867–1941
Scottish Landscape, Mountains with Moon
oil on board 15.2 x 21.6
77/19

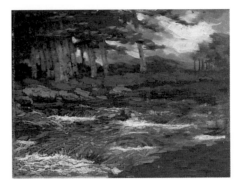

Sime, Sidney Herbert 1867–1941
Scottish River and Trees
oil on board 21 x 26.7
77/13

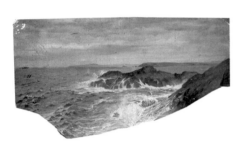

Sime, Sidney Herbert 1867–1941
Sea and Rocks
oil on canvas 25.4 x 45.7
D6/11

Sime, Sidney Herbert 1867–1941
Self Portrait
oil on panel board 16.5 x 7
D10/A40

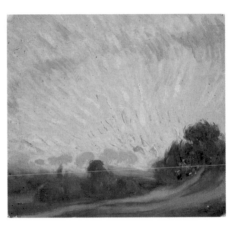

Sime, Sidney Herbert 1867–1941
Sky and Bushes
oil on canvas 21 x 22.9
D6/25

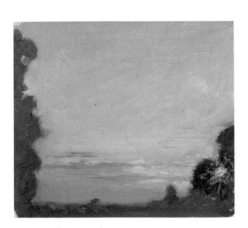

Sime, Sidney Herbert 1867–1941
Skyscape
oil on canvas 21 x 22.9
D6/21

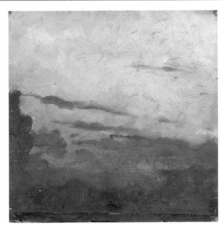

Sime, Sidney Herbert 1867–1941
Skyscape
oil on canvas 24.8 x 25.4
D6/39

Sime, Sidney Herbert 1867–1941
Skyscape
oil on panel board 21.6 x 26.7
D8/H

Sime, Sidney Herbert 1867–1941
Skyscape
oil on panel board 21.6 x 26.7
D8/N

Sime, Sidney Herbert 1867–1941
Snow-Capped Mountain
oil on panel board 10.2 x 15.2
D10/A28

Sime, Sidney Herbert 1867–1941
Storm
oil on canvas 94 x 63.5
9

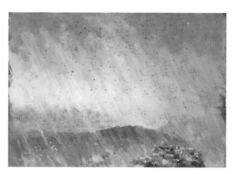

Sime, Sidney Herbert 1867–1941
Storm
oil on panel board 15.9 x 21.6
D10/A8

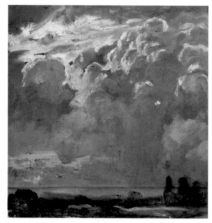

Sime, Sidney Herbert 1867–1941
Storm Clouds and Water
oil on canvas 20.3 x 19.1
D6/50

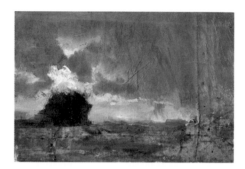

Sime, Sidney Herbert 1867–1941
Storm Scene
oil on canvas 22.2 x 31.8
D6/49

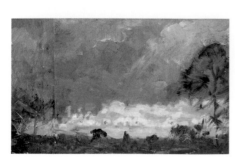

Sime, Sidney Herbert 1867–1941
Stormy Sky
oil on canvas 20.3 x 33
D6/27

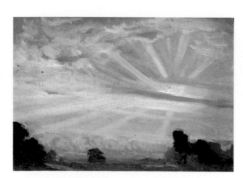

Sime, Sidney Herbert 1867–1941
Sun through Clouds
oil on canvas 21.6 x 29.8
D6/14

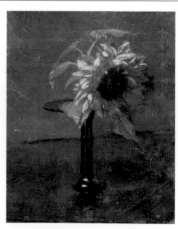

Sime, Sidney Herbert 1867–1941
Sunflower (recto)
oil on panel board 26.7 x 21
D8/Q

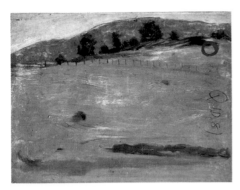

Sime, Sidney Herbert 1867–1941
Across the Field (verso)
oil on panel board 21 x 26.7
D81Q2

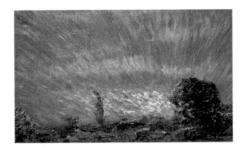

Sime, Sidney Herbert 1867–1941
Sunset Landscape
oil on canvas 33.8 x 43.2
68

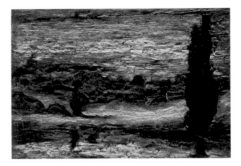

Sime, Sidney Herbert 1867–1941
Sunset Sketch
oil on canvas 15.2 x 21.6
69

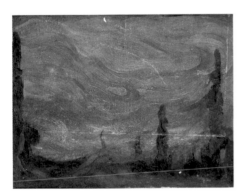

Sime, Sidney Herbert 1867–1941
Swirling Sky
oil on panel board 24.1 x 30.5
D8/O

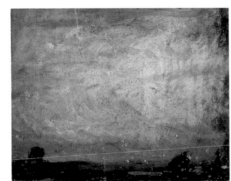

Sime, Sidney Herbert 1867–1941
Swirling Sky
oil on panel board 21 x 26.7
D8/T

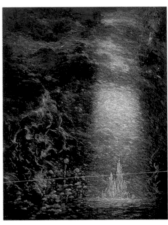

Sime, Sidney Herbert 1867–1941
The Fountain
oil on canvas 89.5 x 72.4
8

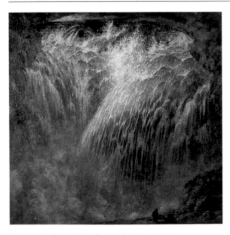

Sime, Sidney Herbert 1867–1941
The Waterfall
oil on canvas 97.8 x 97.8
11

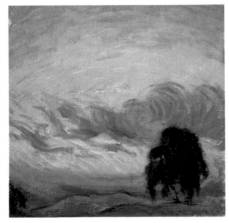

Sime, Sidney Herbert 1867–1941
Tree and Billowing Sky
oil on canvas 20.3 x 20.3
D6/63

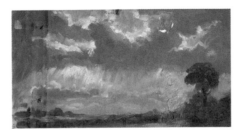

Sime, Sidney Herbert 1867–1941
Tree and Heaped Clouds
oil on canvas 17.1 x 30.5
D6/44

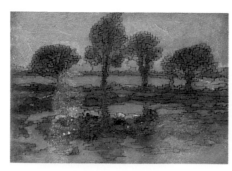

Sime, Sidney Herbert 1867–1941
Tree Reflections
oil on panel board 15.2 x 21.6
D9/A4

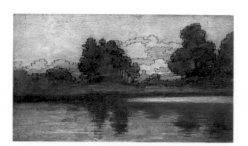

Sime, Sidney Herbert 1867–1941
Tree Reflections
oil on panel board 12.7 x 20.3
D10/A9

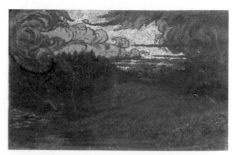

Sime, Sidney Herbert 1867–1941
Tree-Like Scrolls
oil on panel board 25.4 x 38.1
D7/B

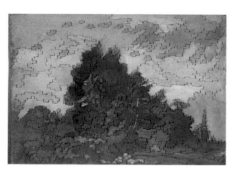

Sime, Sidney Herbert 1867–1941
Trees
oil on board 15.2 x 21.6
77/3

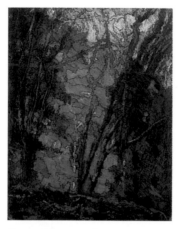

Sime, Sidney Herbert 1867–1941
Trees
oil on board 27.9 x 21
77/5

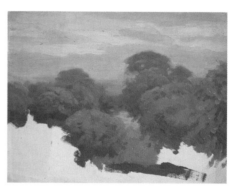

Sime, Sidney Herbert 1867–1941
Trees
oil on canvas 24.8 x 32.4
D6/6

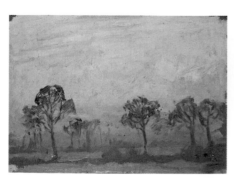

Sime, Sidney Herbert 1867–1941
Trees
oil on canvas 22.9 x 31.8
D6/17

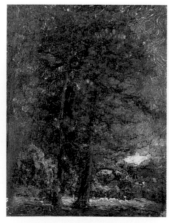

Sime, Sidney Herbert 1867–1941
Trees and Birds in Pool
oil on panel board 26.7 x 21
D7/E

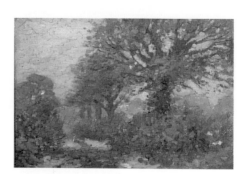

Sime, Sidney Herbert 1867–1941
Trees and Bracken
oil on board 15.2 x 21.6
77/14

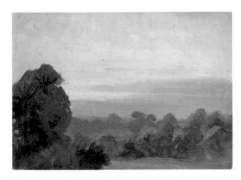

Sime, Sidney Herbert 1867–1941
Trees and Calm Sky
oil on canvas 24.1 x 32.4
D6/35

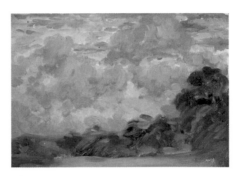

Sime, Sidney Herbert 1867–1941
Trees and Clouds
oil on canvas 22.2 x 29.8
D6/48

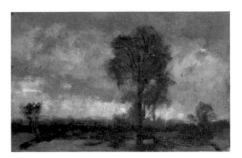

Sime, Sidney Herbert 1867–1941
Trees and Dark Sky
oil on canvas 17.8 x 27.3
D6/30

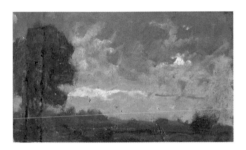

Sime, Sidney Herbert 1867–1941
Trees and Dark Sky
oil on canvas 19.1 x 31.8
D6/65

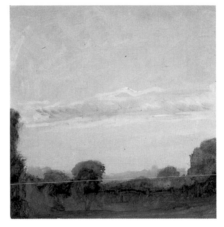

Sime, Sidney Herbert 1867–1941
Trees and Golden Sky
oil on canvas 21 x 21
D6/23

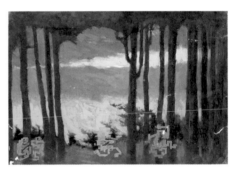

Sime, Sidney Herbert 1867–1941
Trees and Imps
oil on canvas 31.8 x 39.4
D6/1

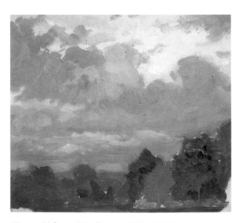

Sime, Sidney Herbert 1867–1941
Trees and Light Clouds
oil on canvas 23.5 x 25.4
D6/67

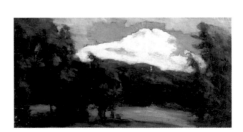

Sime, Sidney Herbert 1867–1941
Trees and Light Clouds
oil on panel board 14 x 26.7
D9/Y

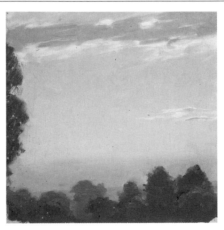

Sime, Sidney Herbert 1867–1941
Trees and Light Sky
oil on canvas 22.9 x 22.9
D6/56

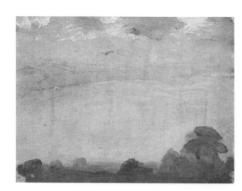

Sime, Sidney Herbert 1867–1941
Trees and Light Sky
oil on canvas 17.8 x 22.9
D6/60

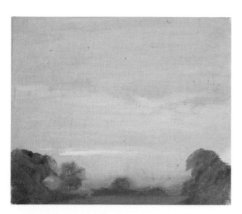

Sime, Sidney Herbert 1867–1941
Trees and Light Sky
oil on canvas 20.3 x 22.9
D6/68

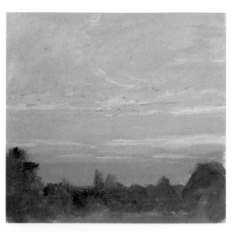

Sime, Sidney Herbert 1867–1941
Trees and Pink Sky
oil on canvas 22.2 x 22.2
D6/29

Sime, Sidney Herbert 1867–1941
Trees and Red-Tinged Hills
oil on panel board 15.9 x 21.6
D10/A12

Sime, Sidney Herbert 1867–1941
Trees and Red-Tinged Sky
oil on panel board 21 x 26.7
D8/K

Sime, Sidney Herbert 1867–1941
Trees and Sky
oil on canvas 19.1 x 22.9
D6/55

Sime, Sidney Herbert 1867–1941
Trees and Sky
oil on canvas 22.9 x 27.3
D6/70

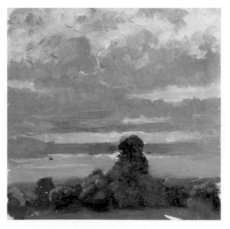

Sime, Sidney Herbert 1867–1941
Trees and Skyscape
oil on canvas 21.6 x 21.6
D6/15

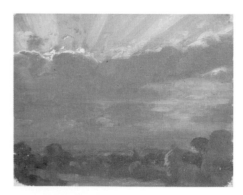

Sime, Sidney Herbert 1867–1941
Trees and Sun
oil on canvas 21.6 x 26.7
D6/9

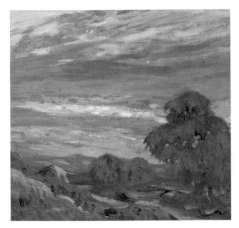

Sime, Sidney Herbert 1867–1941
Trees and Sunset
oil on canvas 22.9 x 23.5
D6/3

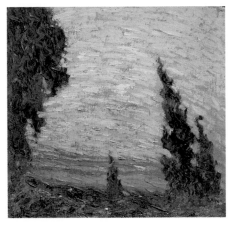

Sime, Sidney Herbert 1867–1941
Trees and Sunset
oil on canvas 24.8 x 24.1
D6/8

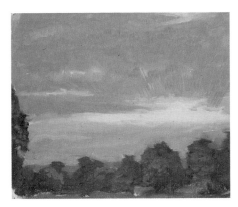

Sime, Sidney Herbert 1867–1941
Trees and Sunset
oil on canvas 21.6 x 24.8
D6/16

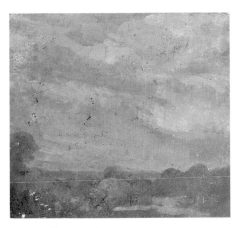

Sime, Sidney Herbert 1867–1941
Trees and Tinged Dark Sky
oil on canvas 23.5 x 25.4
D6/71

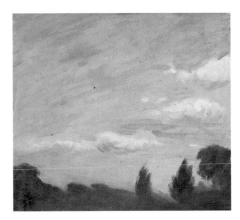

Sime, Sidney Herbert 1867–1941
Trees and White Clouds
oil on canvas 21.6 x 24.1
D6/51

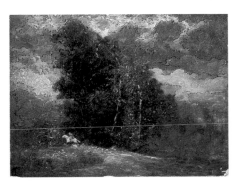

Sime, Sidney Herbert 1867–1941
Trees and White Horse
oil on board 26.7 x 34.9
77/10

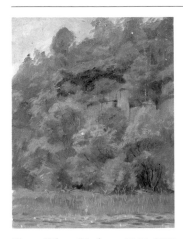

Sime, Sidney Herbert 1867–1941
Trees beside Pool
oil on panel board 31.1 x 23.5
D7/D

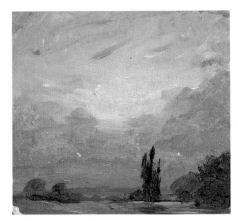

Sime, Sidney Herbert 1867–1941
Trees, House and Red Sky
oil on canvas 20.3 x 21
D6/13

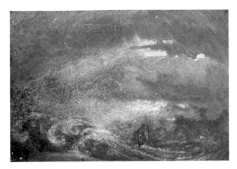

Sime, Sidney Herbert 1867–1941
Turbulent Sea and Ship with Red Sails
oil on canvas 21 x 29.2
P553

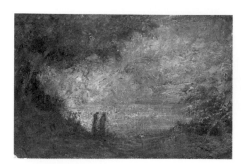

Sime, Sidney Herbert 1867–1941
Two Figures by Lake
oil on panel board 21 x 30.5
D8/L

Sime, Sidney Herbert 1867–1941
Waterfall
oil on panel board 21 x 26.7
D8/U

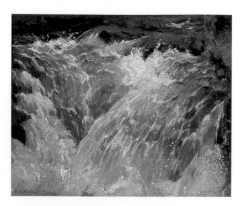

Sime, Sidney Herbert 1867–1941
Waterfall in Scotland
oil on canvas 41.9 x 47
15

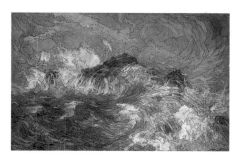

Sime, Sidney Herbert 1867–1941
Waves
oil on canvas 27.9 x 43.2
D6/34

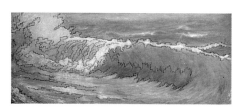

Sime, Sidney Herbert 1867–1941
Waves Breaking
oil on canvas 17.1 x 38.1
P539

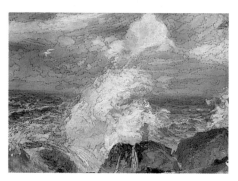

Sime, Sidney Herbert 1867–1941
Waves Breaking on Rocks
oil on canvas 29.2 x 38.7
P536

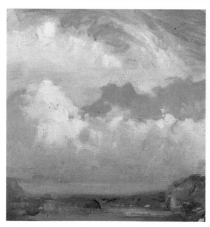

Sime, Sidney Herbert 1867–1941
White and Grey Clouds
oil on canvas 20.3 x 19.7
D6/26

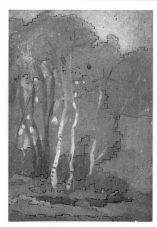

Sime, Sidney Herbert 1867–1941
White-Trunked Trees
oil on panel board 15.2 x 10.2
D10/A37

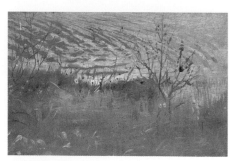

Sime, Sidney Herbert 1867–1941
Wild Landscape
oil on panel board 10.2 x 15.2
D10/A24

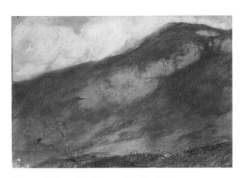

Sime, Sidney Herbert 1867–1941
Windswept Landscape
oil on canvas 19.1 x 26.7
D6/69

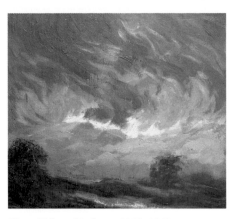

Sime, Sidney Herbert 1867–1941
Windswept Sky
oil on canvas 18.4 x 20.3
D6/22

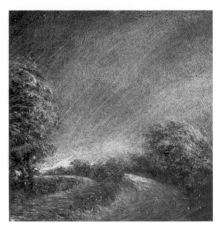

Sime, Sidney Herbert 1867–1941
Windswept Trees
oil on canvas 27.3 x 26.7
D6/2

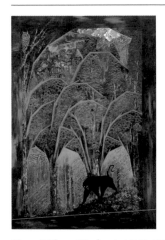

Sime, Sidney Herbert 1867–1941
Woods and Dark Animals
oil on canvas 160 x 104.1
2

Sime, Sidney Herbert 1867–1941
Yellow Bushes by a Pond
oil on panel board 15.2 x 21.6
D9/A2

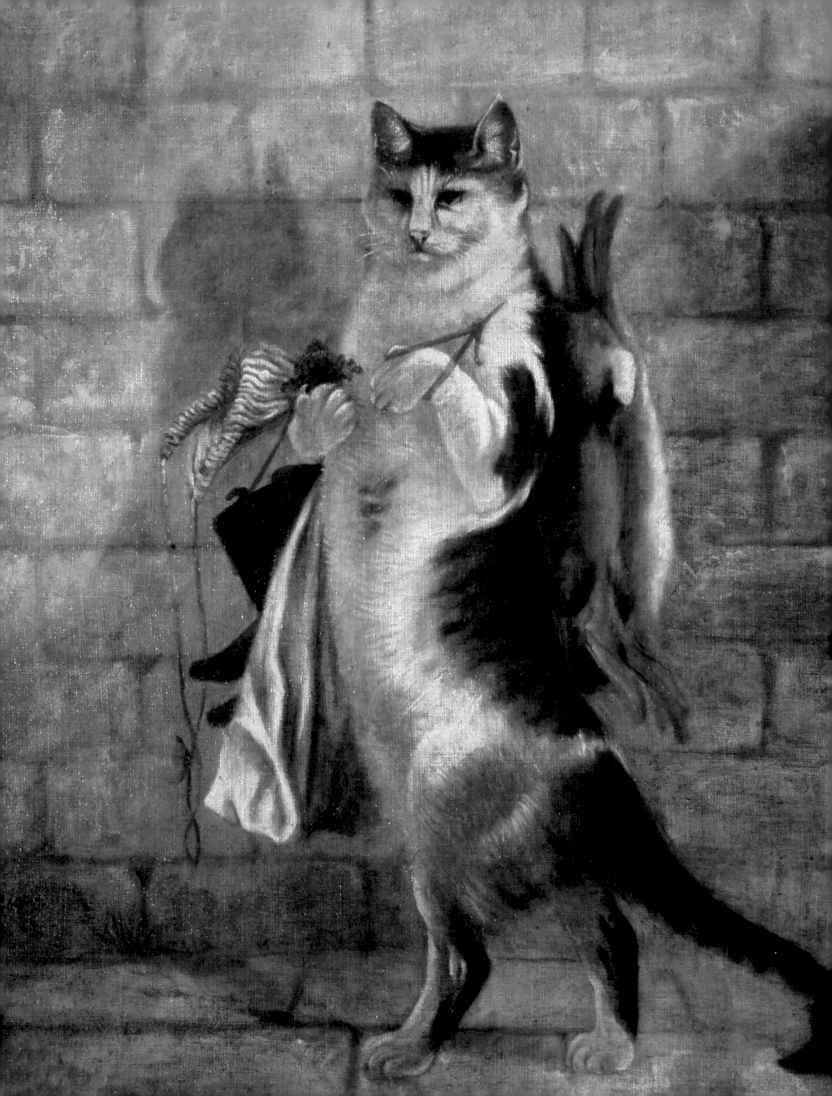

Paintings Without Reproductions

This section lists all the paintings that have not been included in the main pages of the catalogue. They were excluded as it was not possible to photograph them for this project. Additional information relating to acquisition credit lines or loan details is also included. For this reason the information below is not repeated in the Further Information section.

Watts Gallery

Alston, Rowland Wright 1895–1958, *Kestrel*, 46 x 31, oil on canvas, COMWG 582, acquired from the Rowland Alston Estate, 1958, missing at the time of photography

Watts, George Frederick 1817–1904, *Scotch Landscape (Loch Ruthven)*, 1899, 17.8 x 53.3, oil on canvas, COMWG 8, gift from Mrs Michael Chapman (née Lilian Macintosh), 1946, missing at the time of photography

Watts, George Frederick 1817–1904, *Nude Study*, 61 x 23, oil on canvas, COMWG 72, missing at the time of photography

Surrey County Council

Carter, William 1863–1939, *William Brodrick, 8th Viscount Midleton*, 1901, 149.9 x 110.5, oil on canvas, 16, not available on the day of photography

University of Surrey

Graham, Jane *Triangular Form*, oil on canvas, 134.2 x 200.7, 204, donated to the University by the artist after an exhibition, 1986, missing at the time of photography

Facing page: Jekyll, Gertrude, 1843–1932, *Thomas in the Character of Puss in Boots* (detail), 1869, Godalming Museum, (p. 78)

Further Information

The paintings listed in this section have additional information relating to one or more of the five categories outlined below. This extra information is only provided where it is applicable and where it exists. Paintings listed in this section follow the same order as in the illustrated pages of the catalogue.

I The full name of the artist if this was too long to display in the illustrated pages of the catalogue. Such cases are marked in the catalogue with a (…).

II The full title of the painting if this was too long to display in the illustrated pages of the catalogue. Such cases are marked in the catalogue with a (…).

III Acquisition information or acquisition credit lines as well as information about loans, copied from the records of the owner collection.

IV Artist copyright credit lines where the copyright owner has been traced. Exhaustive efforts have been made to locate the copyright owners of all the images included within this catalogue and to meet their requirements. Any omissions or mistakes brought to our attention will be duly attended to and corrected in future publications.

V The credit line of the lender of the transparency if the transparency has been borrowed. Bridgeman images are available subject to any relevant copyright approvals from the Bridgeman Art Library at www.bridgeman.co.uk

Ash Museum

Miles, John James active c.1906–c.1920, *St Peter's Church, Ash*, gift
Miles, John James active c.1906–c.1920, *Battleship*, gift

The Army Medical Services Museum

Bentos, Achille b.1882, *Queen Alexandra's Imperial Military Nursing Service (QAIMNS) Sister, Second World War*
Brown, Mather 1761–1831, *Purveyor, Army Medical Department*, gift from Major General R. Barnsley, 1957
Desanges, Louis William 1822–c.1887, *Assistant Surgeon H. Sylvester*, gift from Mrs H. Silver-Ley, 1964
Frankewitz, Bruno 1897–1982, *B Ward, 64th British General Hospital, Second World War*
Newman, Beryl 1906–1991, *Soldiers in Morton Hampstead Hospital, Second World War*, gift from the artist, 1984
Robinson active 20th C, *Queen Alexandra Military Hospital Chapel*
Swinstead, George Hillyard 1860–1926, *White Comrade*
unknown artist *Hampton Massey*, gift from Colonel G. M. McClavity, 1973
unknown artist *Arthur Martin Leake, VC*
unknown artist *Colonel Alfred L. Robertson*

Byfleet Heritage Society

Bridgman, Marjorie *Foxlake Farm*, bequeathed by Mr Robinson
Henderson, H. B. *Stream Cottages*, bequeathed

Byfleet Village Hall

Lockhart, William Ewart 1846–1900, *Sketch of Queen Victoria Attending Her Diamond Jubilee*

Surrey Heath Borough Council

unknown artist *Bietigheim, the Rathaus*, donated
unknown artist *Bietigheim, Old Town Gate*, donated

Surrey Heath Museum

Biggs, R. Henry active c.1960–1970, *Outdoor Studio*, donated
Biggs, R. Henry active c.1960–1970, *Mill*, donated
Billington, Neville active 1990s, *Camberley Heath Golf Club*, purchased
Cooper, A. L. *Old Pear Tree Cottage*
Cooper, A. L. *The Obelisk*
Fisher, Percy Harland 1867–1944, *Amongst the Reeds*, purchased with the assistance of the Friends of Surrey Heath Museum
Fisher, Percy Harland 1867–1944, *Barossa Common*, purchased with the assistance of the Friends of Surrey Heath Museum
Fisher, Percy Harland 1867–1944, *Chestnut Horse (Cookie the Hunter) (recto)*, purchased with the assistance of Surrey Heath Museum

Fisher, Percy Harland 1867–1944, *Chestnut Horse (verso)*, purchased with the assistance of the Friends of Surrey Heath Museum
Fisher, Percy Harland 1867–1944, *Paddling*, purchased with the assistance of the Friends of Surrey Heath Museum
Fisher, Percy Harland 1867–1944, *Roses in a Vase*, purchased with the assistance of the Friends of Surrey Heath Museum
Fisher, Percy Harland 1867–1944, *The Chestnut Hunter*, purchased with the assistance of the Friends of Surrey Heath Museum
Fisher, Percy Harland 1867–1944, *The Grey Horse (recto)*, purchased with the assistance of the Friends of Surrey Heath Museum
Fisher, Percy Harland 1867–1944, *Lion Standing on Rock (verso)*, purchased with the assistance of the Friends of Surrey Heath Museum
Fisher, Percy Harland 1867–1944, *Washing on the Line*, purchased with the assistance of the Victoria & Albert Museum Purchase Grant Fund and the Friends of Surrey Heath Museum
Fisher, Percy Harland 1867–1944, *Dobbin on the Path (The Wooden Horse)*, purchased with the assistance of the Friends of Surrey Heath Museum
Fisher, Percy Harland 1867–1944, *The Blue Veil*, purchased with the assistance of the Friends of Surrey Heath Museum
Fisher, Percy Harland 1867–1944, *Mrs Hudson*, purchased with the assistance of the Friends of Surrey Heath Museum

Fisher, Percy Harland 1867–1944, *Anthony on a Swing (Boy on a Swing) (recto)*, purchased with the assistance of the Friends of Surrey Heath Museum
Fisher, Percy Harland 1867–1944, *Leaves (verso)*, purchased with the assistance of the Friends of Surrey Heath Museum
Fisher, Percy Harland 1867–1944, *Temptation (The Gypsy Girl)*, purchased with the assistance of the Victoria & Albert Museum Purchase Grant Fund and the Friends of Surrey Heath Museum
Fisher, Percy Harland 1867–1944, *Italian Fruit Stall*, purchased with the assistance of the Friends of Surrey Heath Museum
Fisher, Percy Harland 1867–1944, *Porch, Side of House and Tree*, purchased with the assistance of the Friends of Surrey Heath Museum
Fisher, Percy Harland 1867–1944, *Rushes (recto)*, purchased with the assistance of the Friends of Surrey Heath Museum
Fisher, Percy Harland 1867–1944, *Study of Female Head: Grisaille (verso)*, purchased with the assistance of the Friends of Surrey Heath Museum
Fisher, Percy Harland 1867–1944, *The Italian Donkey*, purchased with the assistance of the Friends of Surrey Heath Museum
Gainsborough, Thomas (after) 1727–1788, *Mrs Siddons*, transferred to Surrey Heath Museum, 1986
Graham, Nora active 1990s, *Basingstoke Canal*, purchased
Green, Phillip active 1980s–1990s,

Graduations, donated by a former mayor
Hadlow, Pauline *Puppet Magic*, purchased
Harrison, Terry b.1947, *King's Head Bridge, Basingstoke Canal*, commissioned by Surrey Heath Borough Council for Surrey Heath Museum
Hill, O. F. *Civic Hall*
Holmes, Betty *Newstead, Camberley Museum*
Jory, Miriam b.1933, *Despair (A Boy in Somalia, 1993)*, purchased, © the artist
Lomas, Rod active 1970s–1980s, *Fisherman's Tale*
Perry, Roy 1935–1993, *Camberley Library*
Perry, Roy 1935–1993, *Chobham Churchyard*
Perry, Roy 1935–1993, *Wells Bakery*
Perry, Roy 1935–1993, *High Street, Camberley*
Perry, Roy 1935–1993, *Chobham Church from the Cricket Field*
Rice, B. A. *Chobham Common*, purchased by the Friends of Surrey Heath Museum
Sams, Ian b.1945, *Frimley Station*, donated, © the artist
Scandrett, Graham active 1960s–2006, *Olive Grove with Goats, Crete*, purchased, © the artist
unknown artist *Signboard from 'The Jolly Farmer' Pub, Side 1*, donated by brewery
unknown artist *Signboard from 'The White Hart' Pub: Front*, donated by brewery
unknown artist *Signboard from 'The White Hart' Pub: Back*, donated by brewery

unknown artist mid-19th C, *Frimley Heath*, donated to Surrey Heath Borough Council by the Wheen family of Chobham, then transferred to Surrey Heath Museum

Wright, Dorothy 1910–1996, *Elmhurst Ballet School*, purchased

The Royal Logistic Corps Museum

Archdale, W. M. *Audu Doso of the Nigeria Military Forces*, transferred from the Royal Corps of Transport Mess, 1983

Ellis, Cuthbert Hamilton 1909–1987, *McMullen Steam Engine*, transferred from the Royal Corps of Transport Mess, 1970

Gilson, J. *Soldier of the King's African Rifles, Ceremonial Dress*, transferred from the Royal Corps of Transport Mess, 1983

May, Robert W. *The 'Lancastria', 17 June 1940*, gift, 1972

Nicoll, John *Tracked Amphibian Neptunes, Kabrit, Little Bitter Lake, 1947*

Painter, R. S. *John Buckley, VC (1813–1876), Deputy Assistant Commissary of Ordnance, Bengal*, acquired, 1953

Redgrove *DUKWs Unloading Supplies, D-Day, 6 June 1944*, transferred from the Royal Corps of Transport Mess, 1987

Reynolds, Joshua (after) 1723–1792, *John Manners, Marquis of Granby*, purchased from Phillips auction, 1991

Shotter, R. *Portrait of an Unknown Gentleman*

Summerville, D. *Diamond 'T' Recovering Tank on Battlefield, North Africa*, gift, 1985

Wanklyn, Joan active 1956–1994, *Horse of the Year Show, 1966*, commissioned by the Royal Corps of Transport, 1966

Caterham Valley Library

Christie, Ernest C. 1863–1937, *Sundials in Gardens*, on loan from the Legrew Trust, Chaldon, Surrey

Christie, Ernest C. 1863–1937, *Chaldon Church*, on loan from the Legrew Trust, Chaldon, Surrey

unknown artist *The Greyhound Public House, Caterham*

unknown artist *Ernest Christie (1863–1937)*, on loan from James Batley

East Surrey Museum

Adams, D. *Old Fred*, gift from Mrs M. Scott of Chaldon Road, Caterham, 2000

Curzon-Price, Paddy *Ruth Chaplin, OBE, in Retirement*

MacLeod, Fay *The Clock in Queen's Park, Caterham*, gift from Mrs E. M. Wilson

Chertsey Museum

Allam active 1878–1880, *Egham Races*, on loan from the S. A. Oliver Charitable Settlement

Allam active 1878–1880, *Egham Races*, on loan from the S. A. Oliver Charitable Settlement

Allam active 1878–1880, *Bells of Ouzeley*, on loan from the S. A. Oliver Charitable Settlement

Allam active 1878–1880, *Windsor Castle from Bishopsgate*, on loan from the S. A. Oliver Charitable Settlement

Bosher, M. A. *View from Cooper's Hill*, on loan from the S. A. Oliver Charitable Settlement

Bosher, M. A. *View from Cooper's Hill*, on loan from the S. A. Oliver Charitable Settlement

Breanski, Alfred de 1852–1928, *Milson's Point on the Thames near Runnymede*, on loan from the S. A. Oliver Charitable Settlement

Brettingham, L. (attributed to) *Almner's Priory*, gift

Carey, Charles William 1862–1943, *Aldridge's Forge*, on loan from the S. A. Oliver Charitable Settlement

Carey, Charles William 1862–1943, *In the Grounds of Royal Holloway College*, on loan from the S. A. Oliver Charitable Settlement

Daniell, William 1769–1837, *Dunford Bridge*, purchased

Earl, William Robert 1806–1880, *Chertsey Preserve*, purchased

Frowd, Thomas T. J. active 1847–1864, *The Lock, Windsor*, on loan from the S. A. Oliver Charitable Settlement

Fuller, Eugene 1889–1968, *Ottershaw School*, gift

Gallon, Robert 1845–1925, *View from Cooper's Hill over Runnymede, with Windsor Castle in Distance*, transferred from Egham Urban District Council when Runnymede Council was formed

Harris, Alfred John 1835–1916, *Cooper's Hill*, on loan from the S. A. Oliver Charitable Settlement

Harris, Alfred John 1835–1916, *View of Runnymede from Towpath with Windsor Castle in the Distance*, on loan from the S. A. Oliver Charitable Settlement

Harris, Alfred John 1835–1916, *View near Staines, Middlesex*, on loan from the S. A. Oliver Charitable Settlement

Harris, Alfred John 1835–1916, *Cooper's Hill*, on loan from the S. A. Oliver Charitable Settlement

Harris, Alfred John 1835–1916, *Cows Grazing*, on loan from the S. A. Oliver Charitable Settlement

Harris, Alfred John 1835–1916, *Cows on the Mead, Egham*, on loan from the S. A. Oliver Charitable Settlement

Harris, Alfred John 1835–1916, *Windsor Castle from Langham's, Runnymede*, on loan from the S. A. Oliver Charitable Settlement

Harris, William E. 1860–1930, *Runnymede Island*, on loan from the S. A. Oliver Charitable Settlement

Howard, E. (attributed to) *Cricketer's Inn*, gift

Jutsum, Henry 1816–1869, *Egham Races, Egham*, on loan from the S. A. Oliver Charitable Settlement

Knight, A. Roland active 1810–1840, *Barbel Fishing at Chertsey*

Lyndon, Herbert active 1860–1922, *Bell Weir Lock and 'Angler's Rest', Staines*, on loan from the S. A. Oliver Charitable Settlement

Melville, Arthur 1855–1904, *Staines Bridge*, on loan from the S. A. Oliver Charitable Settlement

Niemann, Edward H. active 1863–1887, *Staines with St Mary's Church*, on loan from the S. A. Oliver Charitable Settlement

Oades, Emily W. 1836–1897, *Bell Weir and 'Angler's Rest'*, on loan from the S. A. Oliver Charitable Settlement

Pettitt, Charles 1831–1885, *Magna Carta Island, Runnymede*, on loan from the S. A. Oliver Charitable Settlement

Popesco, George b.1962, *Mr Ron Taylor, Greengrocer, in His Shop at 8 Windsor Street, Chertsey*, purchased

Potter, Frank Huddlestone 1845–1887, *Egham from Long Mede, Runnymede*, on loan from the S. A. Oliver Charitable Settlement

Robinson, Margaret J. *Self Portrait*, purchased

Spoade, John *William IV Arriving at Long Mede, Runnymede at the Point of the One Mile Winning Post*, on loan from the S. A. Oliver Charitable Settlement

Tolles, W. *Cooper's Hill Farm, Priest Hill*, on loan from the S. A. Oliver Charitable Settlement

unknown artist *Cooper's Company Fishing Temple, Staines Lane*, on loan from the S. A. Oliver Charitable Settlement

unknown artist *Angler's Rest and Bell Weir*, on loan from the S. A. Oliver Charitable Settlement

unknown artist *William Gardan's Timber Wharf on the Western End of Church Island, Staines*, on loan from the S. A. Oliver Charitable Settlement

Vingoe, Francis b.1880, *Ruins at Virginia Water*, on loan from the S. A. Oliver Charitable Settlement

Vingoe, Francis b.1880, *Virginia Water Tea House*, on loan from the S. A. Oliver Charitable Settlement

J. C. W. *View of Windsor Castle*, on loan from the S. A. Oliver Charitable Settlement

Dorking and District Museum

Assadourigil, H. *Sister Still*, gift from Mr G. Goldsmith, 1997

Beckett, John 1799–1864, *Clarendon House, West Street, Dorking*, bequeathed by Leonard Machin via Mrs Green, 1958

Beckett, John 1799–1864, *St Martin's Medieval Nave, Dorking*, gift from Reverend Lamb, Vicar of St Martin's Church

Beckett, John 1799–1864, *South Street from Pump Corner, Dorking*, bequeathed by Leonard Machin via Mrs Green, 1958

Beckett, John 1799–1864, *St Martin's Medieval Church, Dorking*, gift from H. L. Moore

Beckett, John 1799–1864, *Courtyard with Cat and Robin, South Street, Dorking*, bequeathed by Leonard Machin via Mrs Green, 1958

Beckett, John 1799–1864, *Boxhill, River Mole and Cows, Dorking*, gift from Mr J. Howard

Beckett, John 1799–1864, *Dene Street, Dorking*, bequeathed by Leonard Machin via Mrs Green, 1958

Beckett, John 1799–1864, *Pump Corner, 'Queen's Arms', West Street, Dorking*, gift from A. W. Eade, executor of Clara Philips, 1950

Beckett, John 1799–1864, *St Martin's Intermediate Church, Dorking*, gift from Mrs Eade

Beckett, John 1799–1864, *St Martin's Intermediate Church Exterior, Dorking*, gift from Reverend Lamb, Vicar of St Martin's Church

Beckett, John 1799–1864, *St Martin's Medieval Chancel, Dorking*, gift from Reverend Lamb, Vicar of St Martin's Church

Beckett, John 1799–1864, *South Street, Dorking*, bequeathed by Leonard Machin via Mrs Green, 1958

Beckett, John 1799–1864, *'The Bull's Head', South Street, Dorking*, bequeathed by Leonard Machin via Mrs Green, 1958

Beckett, John 1799–1864, *Westcott Sandpits, Westcott, Surrey*, bequeathed by Leonard Machin via Mrs Green, 1958

Box, Helena d.1914, *Boxhill Mill, Dorking*, gift from Miss Rose of Westcott, 1976

Boxall, William 1862–1937, *The Mill Pond, Dorking*, gift from Mr & Mrs A. W. Eade

Collins, Charles II 1851–1921, *River Mole, Dorking with Cows and Two Figures, Son Robert and Daughter Margaret*, gift from Guy Collins & his grandsons, 1976

Collins, Charles II 1851–1921, *Abinger Mill, Abinger, Surrey*, gift from Guy Collins & his grandsons, 1976

Collins, Charles II 1851–1921, *Autumn Gold', the Nower, Dorking*, gift from Mr J. Howard

Collins, Charles II 1851–1921, *Cattle and Dog on Common*, gift from the widow of R. G. Collins, 1983

Collins, Charles II 1851–1921, *Old Castle Mill Pumping Station, Betchworth Castle Gardens, Dorking*, gift from Miss M. Felgate, 1988

Collins, Helen 1921–1990, *Horses at a Riding School*, gift from Guy Collins & his sister, 1983

Collins, Samuel William 1849–1892, *The Old Rest House, Hampstead Lane, Dorking*, gift from Guy Collins & his sister, 1982

Daws, Philip b.1845, *The Old Mill Pond, Netley, Shere, Surrey*, gift from Mrs R. Brown

Drane, Herbert Cecil 1860–1932, *Garretts Ghyll (Shophouse Farm), Forest Green, Surrey*, gift from M. R. T. of Westcott

Drane, Herbert Cecil 1860–1932, *Waterlands Farm, Forest Green, Surrey*, gift from M. R. T. of Westcott

C. F. G. *Gate to Camilla Lacey, Mrs Ball's Cottage and Barn Mission Room*, gift from T. Cooper

Gibbs, Charles 1834–1910, *Abinger Mill, Abinger, Surrey*, gift from Guy Collins

Harris, Alfred John 1835–1916, *Ranmore Common, Dorking, with Post Office and Dispensary*, bequeathed by S. A. Oliver via B. F. J. Pardoe per Surrey Record Office, 1987

Harris, Alfred John 1835–1916, *Shepherd's Cottage, Dunley Hill near Dorking*, bequeathed by S. A. Oliver via B. F. J. Pardoe per Surrey Record Office, 1987

Harvey, Michael Anthony 1921–2000, *Spring in Westhumble*, gift from Mrs Victoria Houghton, 1996

Jordan, Denham 1836–1920, *Birds of Prey, Falcon and Dead Bird*, gift from P. W. Turner

Jordan, Denham 1836–1920, *Birds of Prey, Kestrel*, gift from P. W. Turner

Jordan, Denham 1836–1920, *Exotic Bird*, gift from Mrs Scragg, 1988

Jordan, Denham 1836–1920, *Exotic Bird on Branch and Flowers*, gift from Mrs Scragg, 1998

Jordan, Denham 1836–1920, *Boar*, gift from Mrs Scragg, 1998

Jordan, Denham 1836–1920, *Marsh Scene*, gift from Mrs Scragg, 1998

Jordan, Denham 1836–1920, *Scarecrow and Two Hares*, gift from Mrs M. Pratt

Kiste, Hans *Floodgate, Castle Mill, Dorking*, gift from Mr J. Howard

Kiste, Hans *The River Mole, Dorking*, gift from Mr J. Howard

Langdon, Dorothy b.1886, *Flowering Tree on Water*, gift from Miss M. Felgate, 1987

Neale, Christine active 1989–1992, *St Martin's Church, Dorking*, gift from Miss C. Mann

Neale, Christine active 1989–1992, *St Martin's Church, Dorking*, gift from Dorking and District Preservation Society in memory of Miss Ethel Clear, 1992

Rose, Walter John 1857–1954, *The Weir and Pump House at Betchworth Castle Gardens (sometimes known as Boxhill Mill)*, gift from Miss M. Felgate

Ruff, Agnes active 1958–2001, *Rose*

Hill Arch, Dorking, gift from the artist, 1997

Stokoe, Elizabeth Calvert active 1933–1937, *St Martin's Church, Dorking*, gift from Mr J. Howard

Stokoe, Elizabeth Calvert active 1933–1937, *Attlee Mill, Station Road, Dorking*, gift from Mr J. Howard

'Sunny', Batchelor *George Baker (Pompey)*, gift from Mr J. Howard

Todman *Young Girl in Punchbowl Lane (The Hollows)*, gift from Mr J. Howard, 1984

unknown artist 19th C, *Thomas Huggins, Aged 9, with Hoop and Dog, Great Grandfather of William Huggins*, gift from unknown donor, 1997

unknown artist 19th C, *William Broad (1759–1862), Dorking Coachman*, purchased from Miss Stockton, 1952

unknown artist late 19th C, *Castle Mill, Dorking*, gift

unknown artist *Willow Walk Painted from Garden of 10 Rothes Road, Dorking*, gift from Miss C. N. Newberry

unknown artist *Brockham Bridge, Brockham, Surrey*, gift from Miss N. Simpson, 1979

unknown artist *Granny Washington's Cottage, Junction Road, Dorking*, gift from Mr J. Howard

unknown artist *Willow Walk and Millpond, Dorking*, gift from Miss N. Simpson, 1979

Warrenne, Joan (attributed to) *Canadian TOC H Social Club*, gift from the artist in memory of Sydney Ison

Watson, Stella d.1980s, *Washing Day at Lyons Cottages, Dorking*, gift from Mrs N. Cellier, 1994

Wright, Joseph 1756–1793, *Major Peter Labilliere (d.1800)*, bequeathed by Leonard Machin via Mrs Green, 1958

Mole Valley District Council

Caffyn, Walter Wallor 1845–1898, *In the Garden of the Grove, Boxhill*, on display at Dorking Library

Hulk, Abraham 1813–1897, *On the Mole*, on display at Dorking Library

Waite, Edward Wilkins 1854–1924, *Shepherd and Flock in Wooded Landscape*, on display at Dorking Library

Egham Museum

Arnold, Harriet Gouldsmith c.1787–1863, *River Thames with Fish Weir*, purchased from T. Cursine, 1985

Arnold, Harriet Gouldsmith c.1787–1863, *Magna Carta Island*, purchased from T. Cursine, 1985

Body, A. M. *'Castle Inn', 1910*, donated by the artist, 1982

Carey, Charles William 1862–

1943, *Mount Lee Farm*, donated by Miss I. M. White, 1991

Cleaver, James 1911–2003, *Horse and Trap, Egham Show*, donated by Mr Cleaver Jr, 1995

Cleaver, James 1911–2003, *'King's Arms', Egham*, donated by Mr Cleaver Jr, 1995

Cowdrey *Glanty Cottages*, donated by the artist, 1993

Harris, Alfred John 1835–1916, *Expecting the Grand Master*, anonymous donation, 1984

Hayward, J. F. *Rusham House*, donated by Shell Research, 1977

Holland, Doreen *Sunset at Longside Lake, Thorpe*, donated by Mrs J. Whitfield, 2001

King, N. H. *Still Life: Fruit*, donated by Mr Eldridge, 1987

Nasmyth, Patrick 1787–1831, *Virginia Water*, purchased from Rayner McConnell, 1991

unknown artist *Baron Octave George Lecca*, donated by R. B. C., 1984

unknown artist *'Red Lion Inn', Egham*, donated by the landlord at the Red Lion Inn, 1995

unknown artist *Vera Katherine Blackett*, donated by R. B. C., 1984

Royal Holloway, University of London

Annear, Jeremy b.1949, *Untitled Abstract in Blue and Grey*, anonymous gift, 2001

Ansdell, Richard 1815–1885, *The Drover's Halt, Island of Mull in the Distance*, purchased for Thomas Holloway, 1882

Atherton, Linda b.1952, *Professor Drummond Bone*, commissioned by Royal Holloway, University of London, 2002

Atroshenko, Viacheslav 1935–1994, *Musical Moment*, presented by the Warwick Arts Trust, London, 2005

Atroshenko, Viacheslav 1935–1994, *New York I (of a series of six)*, presented by the Warwick Arts Trust, London, 2005

Backer *Girl with Siamese Cat*

Bernhardt, Sarah 1844–1923, *Le retour de l'église*

Bigland, Percy 1858–1926, *Henrietta Busk*, acquired on the merger with Bedford College, 1985

Brason, Paul b.1952, *Professor Dorothy Wedderburn*, commissioned by Royal Holloway, University of London, 1991

Bratby, John Randall 1928–1992, *Washline, Little Bridge*, anonymous donation, 2001, © courtesy of the artist's estate/www.bridgeman. co.uk

Brett, John 1830–1902, *Carthillon Cliffs*, purchased for Thomas Holloway, 1883

British School early 19th C, *Wooded Landscape with Goat and Figures*

British School 19th C, *Thomas Holloway Senior (d.1836)*,

presented by the Misses Blanche & Grace Young, 1941

British School late 19th C, *Dame Emily Penrose (1858–1942)*

British School late 19th C, *Mrs Louise d'Este Oliver (1850–1919)*

British School late 19th C, *Mrs Maria Louisa Carlile (1826–1908)*, acquired on the merger with Bedford College, 1985

British School *Dr Nora L. Penston*, acquired on the merger with Bedford College, 1985

British School *Abstract Composition*

British School 20th C, *Dame Margaret Janson Tuke (1862–1947)*, acquired on the merger with Bedford College, 1985

British School 20th C, *Dame Margaret Janson Tuke (1862–1947)*, acquired on the merger with Bedford College, 1985

British School late 20th C, *Harbour*

British School late 20th C, *Winter Landscape with Lake*

Bruce, H. A. *Miss Anna Swanwick (1813–1899)*, acquired on the merger with Bedford College, 1985

Bruce, H. A. *Miss Anna Swanwick (1813–1899)*, acquired on the merger with Bedford College, 1985

Burgess, John Bagnold 1830–1897, *Licensing the Beggars in Spain*, purchased for Thomas Holloway, 1883

Butler, H. C. *Boats*

Butler, H. C. *Lakeside Landscape*

Carey, Charles William 1862–1943, *Farm House, Mount Lee*, donated by the artist, Curator of the Royal Holloway Collection (1887–1943)

Carey, Charles William 1862–1943, *South East Corner of Royal Holloway College*, donated by the artist, Curator of the Royal Holloway Collection (1887–1943)

Carey, Charles William 1862–1943, *South West Terrace Steps, Royal Holloway*, donated by the artist, Curator of the Royal Holloway Collection (1887–1943)

Carey, Charles William 1862–1943, *Egham Station*, on loan from the S. A. Oliver Charitable Settlement

Chamberlain, Brenda 1912–1971, *Seascape in Red*

Collins, William 1788–1847, *Borrowdale, Cumberland, with Children Playing by the Banks of a Brook*, purchased by Thomas Holloway, 1881

Conti, Tito 1842–1924, *Goodbye*, purchased for Thomas Holloway, 1883

Conti, Tito 1842–1924, *Approved*, purchased for Thomas Holloway, 1883

Conti, Tito 1842–1924, *Paying Her Respects to His High Mightiness*, purchased for Thomas Holloway, 1883

Cooke, Edward William 1811–1880, *Scheveningen Beach*, purchased for Thomas Holloway,

1882

Cooke, Edward William 1811–1880, *A Dutch Beurtman Aground on the Terschelling Sands, in the North Sea after a Snowstorm*, purchased for Thomas Holloway, 1882

Cooper, Thomas Sidney 1803–1902, *Landscape with Cows and Sheep*, purchased by Thomas Holloway, 1881

Cooper, Thomas Sidney 1803–1902, *Landscape with Sheep and Goats*, purchased by Thomas Holloway, 1881

Courtnell, Louise b.1963, *Mr Shoa the Younger*, purchased with assistance from the Esmée Fairbairn Donation, 1993, © the artist

Covey, Molly Sale 1880–1917, *Portrait of an Elderly Gentleman*

Creswick, Thomas 1811–1869, *The First Glimpse of the Sea*, purchased for Thomas Holloway, 1883

Creswick, Thomas 1811–1869, *Trentside*, purchased by Thomas Holloway, 1881

Crome, John (follower of) 1768–1821, *A Woodland Scene*, purchased by Thomas Holloway, 1881

Daele, Charles van den d.1873, *The Letter*, given through the Cranbrook Bequest

Dawson, Henry 1811–1878, *Sheerness, Guardship Saluting*, purchased for Thomas Holloway, 1882

Dawson, Henry Thomas 1841/1842–after 1896, *Salcombe Estuary, South Devon*, purchased for Thomas Holloway, 1882

Dillon, Frank 1823–1909, *Tombs of the Khedives in Old Cairo*

Dixon, G. *Seascape with Cliffs*

Dodd, Francis 1874–1949, *Dame Margaret Janson Tuke (1862–1947)*, acquired on the merger with Bedford College, 1985, © the artist's estate

Ellis, Edwin 1841–1895, *The Harbour Bar*, purchased for Thomas Holloway, 1883

Elmore, Alfred 1815–1881, *The Emperor Charles V at the Convent of St Yuste*, purchased for Thomas Holloway, 1883

Faed, Thomas 1826–1900, *Taking Rest*, purchased for Thomas Holloway, 1882

Fielding, Anthony V. C. 1787–1855, *Travellers in a Storm, Approach to Winchester*, purchased by Thomas Holloway, 1881

Fildes, Luke 1844–1927, *Applicants for Admission to a Casual Ward*, purchased for Thomas Holloway, 1883

Frith, William Powell 1819–1909, *Sketch for 'The Railway Station'*

Frith, William Powell 1819–1909, *The Railway Station*, purchased by Thomas Holloway, 1883

Gere, Margaret 1878–1965, *The Garden of the Slothful*, presented to Bedford College by Sir Wilmot Herringham, 1918

Girardot, Ernest Gustave 1840–

1904, *Jane Holloway (posthumous)*, commissioned by Thomas Holloway, 1882

Girardot, Ernest Gustave 1840–1904, *Thomas Holloway*, commissioned by Thomas Holloway, 1882

Glindoni, Henry Gillard 1852–1913, *The Musician*, given through the Cranbrook Bequest

Gowing, Lawrence 1918–1991, *Mrs E. M. Chilvers*, acquired on the merger with Bedford College, 1985, © the estate of (the late) Sir Lawrence Gowing

Graham, Peter 1836–1921, *A Highland Croft*, purchased for Thomas Holloway, 1883

Greenham, Peter 1909–1992, *Professor Dorothy Wedderburn*, acquired on the merger with Bedford College, 1985, © courtesy of the artist's estate/ www. bridgeman.co.uk

Groom, Jon b.1953, *The Moorish House, V*, anonymous gift, 2001

Gunn, Herbert James 1893–1964, *Miss Geraldine E. M. Jebb, CBE*, acquired on the merger with Bedford College, 1985, © the artist's estate

Gunn, Herbert James 1893–1964, *Sir Wilmot Herringham KCMG, CB, MD (1855–1936)*, acquired on the merger with Bedford College, 1985, © the artist's estate

Hamme, Alexis van 1818–1875, *Feeding the Parrot*

Hardy, Frederick Daniel 1826–1911, *Expectation: Interior of Cottage with Mother and Children*, purchased for Thomas Holloway, 1883

Hardy, James II 1832–1889, *A Young Gillie, with Setters and Dead Game*, purchased for Thomas Holloway, 1883

Haughton, Desmond b.1968, *Self Portrait in a Yellow Waistcoat*, purchased with assistance from the Esmée Fairbairn Donation, 1993

Hazelwood, David B. 1932–1994, *Fluttering*, © the artist's estate

Hepple, Norman 1908–1994, *Sir Charles Tennyson, 1954*, acquired on the merger with Bedford College, 1985, © courtesy of the artist's estate/ www.bridgeman. co.uk

Herkomer, Hubert von 1849–1914, *Marie Douglas (Mrs Arthur Stothert)*, presented by Miss S. M. Barker

Herringham, Christiana Jane 1852–1929, *Asphodel*, presented to Bedford College by Sir Wilmot Herringham, 1918. Acquired on the merger with Bedford College, 1985

Herringham, Christiana Jane 1852–1929, *Battle of Love and Chastity (after Gherardo di Giovanni del Fora)*, presented to Bedford College by Sir Wilmot Herringham, 1918. Acquired on the merger with Bedford College, 1985

Herringham, Christiana Jane

1852–1929, *Head of St Catherine (after Sandro Botticelli)*, presented to Bedford College by Sir Wilmot Herringham, 1918. Acquired on the merger with Bedford College, 1985

Herringham, Christiana Jane 1852–1929, *Head of the Magdalene (after Sandro Botticelli)*, presented to Bedford College by Sir Wilmot Herringham, 1918. Acquired on the merger with Bedford College, 1985

Herringham, Christiana Jane 1852–1929, *Landscape with Farm*

Herringham, Christiana Jane 1852–1929, *Madonna and Child (after Cosmè Tura)*, presented to Bedford College by Sir Wilmot Herringham, 1918. Acquired on the merger with Bedford College, 1985

Herringham, Christiana Jane 1852–1929, *Pink Aquilegia, Yellow Foxgloves, Cow Parsley*, presented to Bedford College by Sir Wilmot Herringham, 1918. Acquired on the merger with Bedford College, 1985

Herringham, Christiana Jane 1852–1929, *Red Lilies on Blue Ground*, presented to Bedford College by Sir Wilmot Herringham, 1918. Acquired on the merger with Bedford College, 1985

Herringham, Christiana Jane 1852–1929, *Smeralda Bandinelli (after Sandro Botticelli)*, presented to Bedford College by Sir Wilmot Herringham, 1918. Acquired on the merger with Bedford College, 1985

Herringham, Christiana Jane 1852–1929, *Virgin and Child (after Sandro Botticelli)*, presented to Bedford College by Sir Wilmot Herringham, 1918. Acquired on the merger with Bedford College, 1985

Heydorn, S. *Seascape*

Hodgson, John Evan 1831–1895, *Relatives in Bond*, purchased for Thomas Holloway, 1883

Holl, Frank 1845–1888, *Newgate: Committed for Trial*, purchased for Thomas Holloway, 1882

Holland, James 1800–1870, *Piazza dei Signori, Verona, with the Market Place*, purchased by Thomas Holloway, 1881

Holland, James 1800–1870, *Venice, Piazza di San Marco*, purchased for Thomas Holloway, 1883

Hook, James Clarke 1819–1907, *Leaving at Low Water*, purchased, 1883

Horsley, John Callcott 1817–1903, *The Banker's Private Room, Negotiating a Loan*, purchased for Thomas Holloway, 1883

Hubbard, Steven b.1954, *Self Portrait with Objects*, purchased through the Alfred McAlpine Donation, 1993

Jagger, David 1891–1958, *Miss Janet Ruth Bacon*, commissioned by Royal Holloway, University of

London, 1946

Kerr-Lawson, James 1865–1939, *The Forum with the Arch of Constantine, Rome*

Kerr-Lawson, James 1865–1939, *The Forum with Trajan's Column, Rome*

Koike, Masahiro *La fontaine*, purchased through Mrs Eileen Stansfield Bequest, 2004

Landseer, Edwin Henry 1802–1873, *Man Proposes, God Disposes*, purchased by Thomas Holloway, 1881

László, Philip Alexius de 1869–1937, *Dame Emily Penrose (1858–1942)*, commissioned by Royal Holloway, University of London, 1907, © courtesy of the artist's estate/www.bridgeman.co.uk

László, Philip Alexius de 1869–1937, *Sketch for 'Dame Emily Penrose (1858–1942)'*, bequeathed by Dame Marjorie Williamson, 2003, © courtesy of the artist's estate/www.bridgeman.co.uk

László, Philip Alexius de 1869–1937, *Elizabeth Maude Guinness*, presented to the College by its past and present members, 1911, © courtesy of the artist's estate/www.bridgeman.co.uk

Leader, Benjamin Williams 1831–1923, *The Rocky Bed of a Welsh River*, purchased for Thomas Holloway, 1883

Leader, Benjamin Williams 1831–1923, *Unterseen, Interlaken, Autumn in Switzerland*, purchased for Thomas Holloway, 1883

Leighton, Edmund Blair 1853–1922, *A Flaw in the Title*, purchased for Thomas Holloway, 1883

Lejeune, Henry 1820–1904, *Early Sorrow*, purchased for Thomas Holloway, 1883

Leslie, Charles 1835–1890, *Loch Katrine, Ellen's Isle*, presented by Dr Edith M. Guest

Linnell, John 1792–1882, *Wayfarers*, purchased for Thomas Holloway, 1883

Long, Edwin 1829–1891, *The Suppliants: Expulsion of the Gypsies from Spain*, purchased for Thomas Holloway, 1882

Long, Edwin 1829–1891, *The Babylonian Marriage Market*, purchased for Thomas Holloway, 1882

Maclise, Daniel 1806–1870, *Peter the Great at Deptford Dockyard*, purchased for Thomas Holloway, 1883

MacWhirter, John 1839–1911, *'Night, most glorious night, thou wert not made for slumber'*, purchased for Thomas Holloway, 1882

MacWhirter, John 1839–1911, *Spindrift*, purchased for Thomas Holloway, 1883

Mann, Joshua Hargrave Sams active 1849–1884, *The Cauld Blast*, purchased for Thomas Holloway, 1882

Millais, John Everett 1829–1896, *The Princes in the Tower*, purchased

by Thomas Holloway, 1881

Millais, John Everett 1829–1896, *Princess Elizabeth in Prison at St James's*, purchased by Thomas Holloway, 1881

Morland, George 1763–1804, *The Cottage Door*, purchased for Thomas Holloway, 1883

Morland, George 1763–1804, *The Press-Gang*, purchased for Thomas Holloway, 1883

Morland, George 1763–1804, *The Carrier Preparing to Set Out*, purchased by Thomas Holloway, 1881

Morpurgo, Simonetta *Senigallia*

Müller, William James 1812–1845, *Interior of a Cottage in Wales*, purchased for Thomas Holloway, 1883

Müller, William James 1812–1845, *Opium Stall*, purchased for Thomas Holloway, 1883

Müller, William James 1812–1845, *Tomb in the Water, Telmessos, Lycia*, purchased by Thomas Holloway, 1881

Munthe, Ludwig 1841–1896, *Snow Scene*, purchased for Thomas Holloway, 1883

Murray, David 1849–1933, *Spring in the Alps (Spring Blossoms to the Mountain Snows)*, presented to Royal Holloway, University of London, by the artist's executors

Nash, John Northcote 1893–1977, *Mountain Landscape with Distant Lake*, © artistic trustee of the estate of John Nash

Nasmyth, Patrick 1787–1831, *Landscape with Trees and Figures in the Foreground, a Church in the Distance*, purchased for Thomas Holloway, 1883

Nicol, Erskine 1825–1904, *The Missing Boat*, purchased for Thomas Holloway, 1883

Noël, Jules Achille 1815–1881, *Abbeville, with Peasants and Horses in the Foreground*, purchased for Thomas Holloway, 1883

Noël, Jules Achille 1815–1881, *The Quay, Hennebont, with Boats and Figures*, purchased for Thomas Holloway, 1883

Olivier, Herbert Arnold 1861–1952, *William James Russell (1830–1909)*, acquired on the merger with Bedford College, 1985

Orpen, William 1878–1931, *Miss Ellen Charlotte Higgins*, commissioned by Royal Holloway, University of London, 1926

Pettie, John 1839–1893, *A State Secret*, purchased for Thomas Holloway, 1882

Phillips, Patrick Edward 1907–1976, *Dr Edith Batho*, commissioned by Royal Holloway, University of London, c.1961

Pollock, Fred b.1937, *Trossachs Blossom*, anonymous gift, 2001

Poole, Paul Falconer 1807–1879, *Crossing the Stream*, purchased for Thomas Holloway, 1883

Poole, Paul Falconer 1807–1879, *The Gleaner*, purchased for Thomas Holloway, 1883

Poole, R. F. *Dr Roy Frank Miller*, commissioned by Royal Holloway, University of London, c.1985

Pyne, James Baker 1800–1870, *Haweswater from Waller Gill Force*, purchased by Thomas Holloway, 1881

Riley-Smith, Louise b.1946, *Norman Gowar*, commissioned by Royal Holloway, University of London, 1999, © the artist

Riviere, Briton 1840–1920, *Sympathy*, purchased for Thomas Holloway, 1883

Riviere, Briton 1840–1920, *An Anxious Moment*, purchased for Thomas Holloway, 1883

Riviere, Hugh Goldwin 1869–1956, *Miss Peggy Wood*

Roberts, David 1796–1864, *Pilgrims Approaching Jerusalem*, purchased, 1883

Roberts, David 1796–1864, *A Street in Cairo*, purchased for Thomas Holloway, 1883

Scott, William Wallace 1795–1883, *Jane Holloway*, commissioned by Thomas Holloway, 1845

Scott, William Wallace 1795–1883, *Thomas Holloway*, commissioned by Thomas Holloway, 1845

Scott-Moore, Elizabeth 1904–1993, *Sir John Cameron (1903–1968)*, © Royal Watercolour Society

Shannon, James Jebusa 1862–1923, *Miss Matilda Ellen Bishop*, commissioned by Royal Holloway, University of London, 1897

Shephard, Rupert 1909–1992, *Professor Lionel Butler*, commissioned by Royal Holloway, University of London, c.1982/1983

Solomon, Abraham 1824–1862, *Departure of the Diligence 'Biarritz'*, purchased for Thomas Holloway, 1883

Stanfield, Clarkson 1793–1867, *The Battle of Roveredo, 1796*, purchased by Thomas Holloway, 1881

Stanfield, Clarkson 1793–1867, *View of the Pic du Midi d'Ossau in the Pyrenees, with Brigands*, purchased by Thomas Holloway, 1881

Stanfield, Clarkson 1793–1867, *After a Storm*, purchased for Thomas Holloway, 1883

Swynnerton, Annie Louisa 1844–1933, *Geoffrey and Christopher Herringham*

Syer, John 1815–1885, *The Windmill*, purchased for Thomas Holloway, 1882

Syer, John 1815–1885, *Welsh Drovers*, purchased for Thomas Holloway, 1882

Todd, Daphne b.1947, *Dr John Nicholson Black*, acquired on the merger with Bedford College, 1985, © the artist

Tolansky, Ottilie 1912–1977, *Dame Marjorie Williamson*, commissioned by Royal Holloway, University of London, 1973

Tolansky, Ottilie 1912–1977, *Professor Samuel Tolansky (d.1973)*

Troyon, Constant 1810–1865, *Evening, Driving Cattle*, purchased for Thomas Holloway, 1883

Webb, James c.1825–1895, *Dordrecht*, purchased for Thomas Holloway, 1883

Webb, James c.1825–1895, *Cartagena, Spain*, purchased for Thomas Holloway, 1882

Weber, Theodor Alexander 1838–1907, *Dover Pilot and Fishing Boats*, purchased for Thomas Holloway, 1882

Wells, Henry Tanworth 1828–1903, *William Shaen*, acquired on the merger with Bedford College, 1985

Wilkins, Clive *Woman with a Shielded Candle*, purchased with assistance from the Esmée Fairbairn Donation, 1993

Wragg, Gary b.1946, *Medusa*, anonymous gift, 2001, © the artist

Wragg, Gary b.1946, *Blue Dragon*, anonymous gift, 2001, © the artist

Epsom & Ewell Borough Council

Birch, William Henry David 1895–1968, *Epsom and Ewell from the Grandstand*, gift from Stanley Longhurst to the Borough of Epsom & Ewell, 1954

Danckerts, Hendrick (attributed to) 1625–1680, *Nonsuch Palace from the North East*, gift to the Nonsuch Park Joint Management Committee by the Kynnersley-Browne family, 1980s

Esher Library

Dawe, George (copy of) 1781–1829, *Princess Charlotte Augusta of Wales (1796–1817)*, donated by Reverend H. Gordon French, c.1974

L. E. S. *Ember Lane, with a Woman and a Child*, donated, before 1933

H. W. *Preacher at Christchurch, Esher, Surrey*, donated, before 1974

Bourne Hall Museum

Cullerne, Rennie *Mill Lane, Ewell*, gift from the executors of Rennie Cullerne, 1998

Pettit, D. *Lower Mill*, gift from Miss Phyllis Davies, 1969–1990

Stone, Helen C. 1884–1947, *Bridge over the Hogsmill River, West Ewell*, gift from Miss Margaret Stone, 1970

Stone, Helen C. 1884–1947, *Old Cottages in West Ewell, Ewell*, gift from Miss Margaret Stone, 1970

unknown artist *Mary Williams*, gift from the management of Glyn House, 2002

unknown artist *Sir Arthur Glyn*, gift from the management of Glyn House, 2002

unknown artist *The Amato Inn*, on permanent loan from Ewell

239

Library

unknown artist *Gervas Powell Glyn*, gift from an unknown donor, 1969–1990

unknown artist *Gervas Powell Glyn*, gift from an unknown donor, 1969–1990

unknown artist *Margaret Glyn*, gift from an unknown donor, 1969–1990

unknown artist *Arthur Glyn*, gift from West Ewell Social Club, 1969–1990

Ewell Court Library

Langer, D. *As I Remembered, Ewell Court Grounds*, gift, 1980s

Langer, D. *As I Remembered, Hogsmill River*, gift, 1980s

Crafts Study Centre, University College for the Creative Arts

Larcher, Dorothy 1884–1952, *Black Prince and Jackanapes*

Larcher, Dorothy 1884–1952, *Bunch for a Birthday*, bequeathed by Nan Youngman, Cambridge, after 1982

Farnham Maltings Association Limited

Anderson, Will *Kiln Conversion by DIY*, donated by the artist

Bryson, Frank *Mr C. Biles*, gift from the Mr & Mrs M. O'Donnell Collection

Krish, Raymond *The Philospher*, donated

Verney, John 1913–1993, *Castle Street, Farnham*, donated, © the artist's estate

Verney, John 1913–1993, *Pictures of Farnham*, donated, © the artist's estate

Verney, John 1913–1993, *Pictures of Farnham*, donated, © the artist's estate

Museum of Farnham

Allen, William Herbert 1863–1943, *Bertha Clapshaw*, gift from Dr T. S. Allen, 1965

Allen, William Herbert 1863–1943, *Winifred Clapshaw*, gift from Dr T. S. Allen, 1965

Allen, William Herbert 1863–1943, *Stranger's Corner*, gift from Dr T. S. Allen, 1965

Allen, William Herbert 1863–1943, *James Sydney Longhurst (d.1921)*, gift from Ruth Moulton, 2005

Allen, William Herbert 1863–1943, *Phoebe Ellen Longhurst (d.1914)*, gift from Ruth Moulton, 2005

Allen, William Herbert 1863–1943, *Harvest Field with Elms*, gift from Mr & Mrs R. C. I. Mason, 1970

Allen, William Herbert 1863–1943, *Italian Lake Scene*, gift from R. C. I. Mason, 1970

Booth, Ashton b.c.1925, *Hawk*, gift from Mrs Elfreda Manning, 1986

Brockman, Dale *The Maltings*, gift from Vicky King, 1991

Elmer, Stephen c.1714–1796, *Thomas Ashburne, Aged 11 Years*, purchased from Anthony Mould Ltd, New Bond Street with grants from the MGC/Victoria & Albert Museum Purchase Grant Fund, the National Art Collections Fund, and the Friends of the Museum of Farnham, 1996

Elmer, Stephen c.1714–1796, *A Cockerel Facing Left*, bequeathed by Margaret Ida Mason, 1961

Elmer, Stephen c.1714–1796, *Brace of Pheasant*, bequeathed by Margaret Ida Mason, 1961

Elmer, Stephen c.1714–1796, *Brace of Woodcock*, bequeathed by Margaret Ida Mason, 1961

Elmer, Stephen c.1714–1796, *Cock and Hen Black Grouse in Landscape*, gift from S. A. Mason, 1961

Elmer, Stephen c.1714–1796, *Cock and Hen Red Grouse in Landscape*, gift from S. A. Mason, 1961

Elmer, Stephen c.1714–1796, *Dead Cock Pheasant*, gift from R. C. R. Mason, 1961

Elmer, Stephen c.1714–1796, *Dead Game with Pheasant*, gift from S. A. Mason, 1961

Elmer, Stephen c.1714–1796, *Dead Hare and Wild Fowl*, gift from R. C. R. Mason, 1961

Elmer, Stephen c.1714–1796, *Still Life with Pineapple and Other Fruit*, gift from Miss A. C. Mason, 1961

Elmer, Stephen c.1714–1796, *The Last Supper*, commissioned to hang above the altar in Farnham Parish Church, presumably paid for by Mr Henry Halsey who presented it to the Church in the late 18th century

Elmer, Stephen c.1714–1796, *William Elmer, Nephew of Artist*, transferred from the Council Offices, 1974

Grace, James Edward 1851–1908, *Windmill*, gift, between 1961–1979

Harris, William E. 1860–1930, *Cows Grazing in a Meadow*, gift, between 1961–1979

Hunter, Thomas Sr b.1771, *Harriet Harding (d.1880)*, gift from Geoffrey Box, 2002

Hunter, Thomas Jr b.1821, *Willmer House, Farnham*

Hutton, John Campbell 1906–1978, *Making Ammunition Boxes*, on permanent loan to Farnham Library

Hutton, John Campbell 1906–1978, *Railway Carriages*, on permanent loan to Farnham Library

Hutton, John Campbell 1906–1978, *Wartime Wood Machining*, on permanent loan to Farnham Library

Hutton, John Campbell 1906–1978, *Women Making Munitions Boxes*, on permanent loan to Farnham Library

Loutherbourg, Philip James de 1740–1812, *Sea Battle*, gift, between 1961–1979

Loutherbourg, Philip James de 1740–1812, *Seascape*, gift, between 1961–1979

McCannell, Ursula Vivian b.1923, *'We don't know'*, gift from the artist, 2006

McCannell, William Otway 1883–1969, *Colour*, gift from the McCannell family, 1970

McCannell, William Otway 1883–1969, *The Farmers*, gift from the McCannell family, 1970

Morley, Robert 1857–1941, *River at Twilight*, gift, between 1961–1979

Murphy, Clara Joan 1900–1986, *The Last Hop-Picking in the Chantries, Farnham*, on loan from the Farnham Society

Newyin, R. Graham *View Looking from Mr Borelli's Courtyard*, gift from Father Borelli, 1991

Peacock, Ralph 1868–1946, *Eileen Fox*, gift from Miss Adeley, 1978

Ransom, George 1843–1935, *Coastal Landscape with Castle*, purchased from F. W. Simmonds, 1965

Ransom, George 1843–1935, *Black Lake, Waverley*, presented to the Council by the artist on the occasion of his 90th birthday in 1933, then transferred to the Museum from the Council offices

Reeves, Sidney b.c.1925, *Old Bourne Church*, gift from the artist, c.1974

Reeves, Sidney b.c.1925, *Landscape with Oasthouses*, gift from the artist, 1960s or 1970s

Russell, H. M. active mid-20th C, *The Old Book Shop*, gift from Mrs H. M. Russell, 1961

Seaby, Allan William 1867–1953, *The Wakes from the Park*, gift

Turk, W. *Farnham Castle*, gift from Mrs B. Willis, 1996

Turk, W. *Farnham Park Castle Approach*, gift from Mrs B. Willis, 1996

unknown artist *View over Bridgewater Bay*, gift from Mrs R. G. Mills, 1965

unknown artist *Panorama of Farnham*, gift from A. H. Stevens, 1965

unknown artist 18th C, *Mr Cranston*

unknown artist 18th C, *Portrait of a Lady*, gift

unknown artist *View of Farnham*, purchased from Caelt Gallery, London, 1991

unknown artist early 19th C, *Portrait of a Member of the Duncan Family*, gift from Potter, Kempson & White, solicitors

unknown artist early 19th C, *Sir David Ochterlony (1758–1825)*, gift from Potter, Kempson & White, solicitors

unknown artist 19th C, *Blacksmith Pulling Teeth*, purchased from Jordans, 1968

unknown artist 19th C, *Landscape at Night*, gift

unknown artist 19th C, *Poet Reading to a Seated Muse*, bequeathed by Wilson

unknown artist 19th C, *Riverscape with Windmill and Fishermen*, gift from Mrs C. B. Murray

unknown artist 19th C, *Seascape with Castle and Fisherman*, gift from Mrs C. B. Murray

unknown artist 19th C, *William Cobbett (1763–1835)*, on loan from Lady Lathbury

unknown artist 19th C, *Mrs William Cobbett (1774–1848)*, on loan from Lady Lathbury

unknown artist late 19th C, *Angel*, bequeathed by Wilson

unknown artist *The Maltings*, gift from Vicky King, 1994

unknown artist *Abstract*

unknown artist early 20th C, *Tilford Green and Cobbett's Oak*, gift

unknown artist early 20th C, *Weydon Mill*, gift from Mrs V. A. Dedman

unknown artist 20th C, *Shore Scene with Lighthouse*

unknown artist *Still Life with Bread and Meat*, gift

Verney, John 1913–1993, *The Three Graces*, gift from Peter Lloyd, 1999, © the artist's estate

Wonnacott, Thomas 1835–1918, *Black Lake, Waverley*, bequeathed by Miss F. M. Tomsett, 1987

Wonnacott, Thomas 1835–1918, *Weydon Mill*, gift from Mr S. F. Mundy, 1981

Wooderson, J. *Evening at Weydon Mill*, gift

University College for the Creative Arts at the Farnham Campus

Ball, Robin 1910–1979, *The Lovers*, purchased from the Institute Fine Art Degree Show, 2001

Butler, Paul b.1947, *Bus Stop*, purchased for the University College Collection, 1997

Butler, Paul b.1947, *City Night II*

Clamp, Laura b.1980, *Lips and Blue Straw*, purchased from the Institute Fine Art Degree Show, 2002, © the artist

Edmonds, Frances b.1953, *Blue Room*, © the artist

Hockey, James 1904–1990, *A Cyclamen*, purchased from Stephen Daffen, 2001

Hossain, Zahura Sultana *Where Am I?*, purchased for the University College Collection, 2001

Muszynski, Leszek b.1923, *James Hockey, RBA (1904–1990)*, probably donated, before 1990, © the artist

Northwood, Sally b.1935, *Two Figures*, Graduate Fine Art, 1994, © the artist

unknown artist late 20th C, *Untitled*, purchased from a student

Whamond, Andrew b.1947, *Leaning Figure*, donated by Christine Kapteijn, 2005, © the artist

Godalming Library

Wondrausch, Mary b.1923, *Dead Magpie*, gift, 1963–1965, © presented by Mary Wondrausch

Godalming Museum

Collier, John 1850–1934, *Thomas Henry Huxley (1825–1895)*

Duff, Pamela b.1920, *Miss Jekyll's Boots (after William Nicholson)*, gift, 1991

Duff, Pamela b.1920, *Gertrude Jekyll (after William Nicholson)*, gift, 1999

Harwood Eve *Great Pond, Frensham*

Jekyll, Gertrude 1843–1932, *Thomas in the Character of Puss in Boots*, purchased, 1999

Jekyll, Gertrude 1843–1932, *The Sun of Venice Going to Sea (after Joseph Mallord William Turner)*, gift, 1989

Lewis, J. active early 20th C, *Godalming: A Bit of the Old Town*, purchased

Martin, Ellis 1881–1977, *Jack Phillips (1887–1912)*, donated, 2004

O'Brian, Henry active 1950s, *Low Tide at Maldon, Essex*

O'Brian, Henry active 1950s, *Berkshire Downs*

O'Brian, Henry active 1950s, *Brixham Harbour*

O'Brian, Henry active 1950s, *Country Scene*

O'Brian, Henry active 1950s, *Glengarriff, Kerry*

O'Brian, Henry active 1950s, *Hastings Beach*

O'Brian, Henry active 1950s, *Killarney from Muckross House Terrace, Co. Kerry*

O'Brian, Henry active 1950s, *Lake Geneva, Montreux*

O'Brian, Henry active 1950s, *Lakeside*

O'Brian, Henry active 1950s, *Nocturne*

O'Brian, Henry active 1950s, *River Glaslyn, Wales*

O'Brian, Henry active 1950s, *Rolling Breakers at Evening*

O'Brian, Henry active 1950s, *Sea View with a Boat*

O'Brian, Henry active 1950s, *Self Portrait*

O'Brian, Henry active 1950s, *Studland Bay, Dorset*

O'Brian, Henry active 1950s, *Sussex Harvest*

O'Brian, Henry active 1950s, *The Church on the Hill*

O'Brian, Henry active 1950s, *Welsh Coast*

Peel, James 1811–1906, *Roke Farm, Witley, Surrey*, gift, 1984

Smallman-Tew, F. active 20th C, *Church Street, Godalming*, gift
Smallman-Tew, F. active 20th C, *Church Street, Godalming*
Smallman-Tew, F. active 20th C, *Old Godalming by Moonlight*
Smallman-Tew, F. active 20th C, *The Millstream at Godalming*
Smart, W. H. active mid-20th C, *Godalming Church*, gift, 2000
unknown artist *Dr Owen Manning*, purchased, 1985
unknown artist 19th C, *Ironstone Bridge, Tilthams Green*
unknown artist 20th C, *Old Borden Bridge*, donated by Miss Mountney, 1984

Godalming Town Council

British (English) School mid-19th C, *Sir Richard Balchin, Surgeon, Mayor of Godalming*
Donne, Walter J. 1867–1930, *Alderman Thomas Rea*
Kneller, Godfrey (style of) 1646–1723, *Vice Admiral Sir John Balchin*
Schumacher, Vera active 1911–1913, *Joseph E. Sparkes, Mayor of Godalming (1890–1892)*
unknown artist 19th C, *Henry Marshall, First Mayor of Godalming, 1836*
Watson, D. *John Simmonds, Mayor (1871 & 1875)*

Waverley Borough Council

Hollams, F. Mabel 1877–1963, *Horses Ploughing a Field*
Langley, Walter 1852–1922, *Cornish Village Scene*
unknown artist *Farnham Church from the Meadows*, on loan from the Museum of Farnham

The White Hart Barn, Godstone Village Hall

Burford, Eva active 1970–1985, *Godstone Pond*, presented in memory of Miss 'Vi' Amos, 1985
Butcher, Fred *Godstone High Street with the Clayton Arms*, presented by the widow of Arthur Dumville, apprentice to the artist, 2002
Hayner, D. (attributed to) *The Bay Pond, Godstone*, presented by Ted Simpson
unknown artist *Ivy Mill Pond, Godstone*, presented by Miss A. Goad

Guildford House Gallery

Allison, Jane b.1959, *Rose Cottage, Pockford Road, Chiddingfold*, purchased from the artist, 2005, © the artist
Allison, Jane b.1959, *View from the Chantries with Hawthorn Tree*, donated by the artist, 2005, © the artist
Boughton, Thomas 1812–1893,

Guildford High Street, purchased, 1990
Caffyn, Walter Wallor 1845–1898, *The Weald of Surrey*, purchased with the assistance of the Friends of Guildford House Gallery and the Victoria & Albert Museum Purchase Grant Fund, 1989
Carter, William 1863–1939, *Mayor Ferdinand Smallpeice*, acquired, 1955
Charlton, Mervyn b.1945, *Moon Glow*, purchased from the artist, 1983, © the artist
Cheesman, Harold 1915–1983, *Landscape*, purchased at auction, 1991, © the artist's estate
Collins, Helen 1921–1990, *North Street, Guildford*, donated, 1996, © the artist's estate
Collins, Helen 1921–1990, *George Edward Collins*, donated, 1996, © the artist's estate
Cracknell, Jennifer active 1960s–1970s, *Rockfall*, purchased with the assistance of the Friends of Guildford House Gallery, 1973
Cripps, Clara *Narrow Lane, Guildford*
Dunn, John Selwyn 1895–1978, *St Martha's*, donated by the artist's daughter, 1998
Fedden, Mary b.1915, *The Lamp*, purchased from the Royal West of England Academy, Bristol, 1988, © the artist
Harris Hughes, Susanna b.1947, *St Catherine's, February*, purchased from the artist, 1997, © the artist
Harrison, Christopher b.1935, *Below Coldharbour*, purchased, 1971, © the artist
Harwood Eve *Old Guildford House*, acquired, 1962
Herringham, Christiana Jane 1852–1929, *Madonna and Child (after Sandro Botticelli)*, bequeathed by Alderman Laurence Powell
Hoyt Desmond, Charlotte d.1971, *Pot of Marigolds*, purchased with the assistance of the Victoria & Albert Museum Purchase Grant Fund, 1980
Huston active mid-20th C, *View of Guildford Castle*, donated by a benefactor, 2001
Hyde, William 1859–1925, *Landscape towards Peaslake*, donated by the artist's daughter, 1980
Laurence, Samuel 1812–1884, *The Fletcher Children*, transferred from Guildford Museum Collection, 1985
Le Mare, Frederick b.1846, *Landscape Millmead*, donated by a benefactor to Guildford Museum, 1959. Transferred to Guildford House Gallery, 1985
Lee, Ada *Cows and Boy in Landscape*, acquired, 1985
Marsham, Cara *Millmead Lock*, purchased, 1953
May, F. T. active c.1957–1968, *River Wey in Winter*, transferred from Guildford Museum, 1985
McCannell, Ursula Vivian b.1923,

Birches and Hollies, purchased from New Ashgate Gallery, 1988, © the artist
Morris, Mali b.1945, *In Apple Blossom Time*, presented by the Contemporary Art Society, 1986, © the artist
Morshead, Arminell 1889–1966, *Guildford Cattle Market*, donated by the artist to Guildford Museum, 1966. Transferred to Guildford House Gallery, 1985
Narraway, William Edward 1915–1979, *Alderman Lawrence Powell*, purchased from the artist's widow, 1984
Parfitt, Ida 1910–1977, *Guildford Old and New*, purchased from the Guildford Art Society Exhibition, 1962
Passey, Charles Henry active 1870–c.1894, *A Lane at Albury, Surrey*, purchased, 1990
Penycate, Dorothy 1910–1969, *Roses*, donated, 1996
Perraudin, Wilfrid b.1912, *Black Forest Landscape and Farm Buildings*, donated by the artist, 1989
Pether, Henry active 1828–1865, *Old Guildford*, purchased with the assistance of the Victoria & Albert Museum Purchase Grant Fund, 1982
Pether, Henry (circle of) active 1828–1865, *St Mary's, Guildford*, purchased with the assistance of the Victoria & Albert Museum Purchase Grant Fund, 1995
Randoll, F. *The Eccentric Billy Hicks, Shere*, donated to Guildford Museum, 1962. Transferred to Guildford House Gallery, 1985
Ranken, Marguerite 1897–1973, *The Estuary*, purchased, 1979
Russell, John 1745–1806, *Micoc and Tootac*, purchased with the assistance of the Friends of Guildford House Gallery and the Victoria & Albert Museum Purchase Grant Fund, 1997
Russell, John 1745–1806, *Portrait of a Lady with Her Child*, purchased with the assistance of the Victoria & Albert Museum Purchase Grant Fund and the Museum and Galleries Commission, 1990
Russell, William 1780–1870, *Samuel Russell, Mayor of Guildford*, acquired, 1988
Schofield, Winifred d.2000, *The Oil Mills, Thames Lock*, donated by the artist to Guildford Museum and transferred to Guildford House Gallery, 1985
Schofield, Winifred d.2000, *The Oil Mills, Weybridge, Surrey*, transferred from Guildford Museum, 1985
Schofield, Winifred d.2000, *The Lone Manor House*, donated by the artist to Guildford Museum, 1979. Transferred to Guildford House Gallery, 1985
Scholfield, Margaret active 1922–1932, *Impression: Wey Navigation Canal*, transferred from Guildford

Museum, 1984
Smoothey, Ronald 1913–1996, *Winter Landscape*, purchased with the assistance of the National Art Collections Fund, 1988
Smoothey, Ronald 1913–1996, *Headlamps*, purchased, 1990
Smoothey, Ronald 1913–1996, *Mutation*, donated by the artist's widow, 2005
Smoothey, Ronald 1913–1996, *Stress Forms*, purchased, 1970
Smoothey, Ronald 1913–1996, *Volcanic Creation*, acquired, 1988
Smoothey, Ronald 1913–1996, *Shadows of a Sculpture*, purchased, 1997
Smoothey, Ronald 1913–1996, *The Hawthorn Tree*, purchased with the assistance of the National Art Collections Fund, 1988
Smoothey, Ronald 1913–1996, *Space Horizons*, purchased, 1997
Smoothey, Ronald 1913–1996, *Howard Humphreys and Partners*, purchased, 1997
Smoothey, Ronald 1913–1996, *Howard Humphreys and Partners*, purchased, 1997
Smoothey, Ronald 1913–1996, *Skyscrapers 2*, purchased, 1997
Spurrier, Lanta c.1910–c.1980, *Floods*, purchased, 1982
Stedman, Roy b.1933, *Frosty Morning, Albury Park*, purchased from the artist, 1996, © the artist
Stoneham, Olive d.1966, *Great Quarry, Warwick's Bench*, donated to Guildford Museum and transferred to Guildford House Gallery, 1985
Stuart, Margaret active 1924–1988, *The Pest House, Pilgrim's Way, Shalford*, donated by the artist, 1988
Ta'Bois, Zweena *Through the Fields to Farnham*, purchased, 1980
Tenison, W. R. C. active 1926–1929, *Domenico*, donated, 1998
Tenison, W. R. C. active 1926–1929, *Souvenir de l'orient*, donated, 1998
unknown artist *Portrait of an Unknown Mayor (1810–1820)*, transferred from Guildford Museum, 1985
unknown artist *Abbot's Hospital, High Street*, transferred from Guildford Museum, 1985
unknown artist *Guildford Castle from the River Wey*, donated, 2005
unknown artist *The Mill, Guildford*, donated, 2005
unknown artist late 19th C, *Mayor Henry Neville*, transferred from Guildford Museum, 1985
unknown artist early 20th C, *Richard Heath*, transferred from Guildford Museum, 1985
Unwin, Ida M. 1869–1953, *Charles Baker*, donated by Mr Granger to Guildford House, 1960. Transferred to Guildford House Gallery, 1985
Waite, Edward Wilkins 1854–1924, *The Time of Wild Roses*, purchased with the assistance of the Victoria & Albert Museum Purchase Grant Fund and the

Museum and Galleries Commission, 1987
Wesson, Edward 1910–1983, *River Meadow Landscape*, purchased, 1998, © the artist's estate
Widdes, C. A. *Richard Sparkes*, transferred from Guildford Museum, 1985
Wilkie, Mary b.1915, *Farley Heath Wood*, purchased, 1970, © the artist

Guildford Museum

Carter, William 1863–1939, *Mayor Ferdinand Smallpeice*, donated by Royal Surrey County Hospital, 2004
Eddis, Eden Upton 1812–1901, *Henry Sharp Taylor*, donated by Royal Surrey County Hospital, 2004
Eddis, Eden Upton 1812–1901, *R. J. Shepherd*, donated by Royal Surrey County Hospital, 2004
Eddis, Eden Upton 1812–1901, *Lieutenant Colonel Hankin*, donated by Royal Surrey County Hospital, 2004
Eddis, Eden Upton 1812–1901, *George Chilton*, donated by Royal Surrey County Hospital, 2004
Eddis, Eden Upton 1812–1901, *Reverend Robson*, donated by Royal Surrey County Hospital, 2004
Lintott, (Miss) *View of Park Street*, donated by Miss L. Boswell, St Catherine's, 1986
May, F. T. *View of South Hill*, donated by the artist, Hindhead, 1968
May, F. T. *View of Park Street*, donated by the artist, Hindhead, 1968
May, F. T. *View of 'The Old White Lion'*, donated by the artist, Hindhead, 1968
unknown artist *View of Guildford Town Bridge*, purchased from R. S. Hunt, Godalming, 1956
Van Jones active 1917–1941, *Artwork for Friary Ales Poster*, purchased from Nicholas Bagshawe, Nursling, 2001

Queen's Royal Surrey Regimental Museum

Bennett, John active 20th C, *Salerno 43*, gift from the artist
Daniell, William 1769–1837, *Burning of 'The Kent', 1st March 1825*, gift from the Sergeants' Mess
Davidson, Thomas *The Queen's (Second) Royal Regiment of Foot, c.1830*, gift
Deayton-Groom, (Major) active 20th C, *The East Surrey Regiment Passing through Cassino, 18th May 1944*, gift from the artist
Grant, Henry active 1950–1980, *Sergeant Major Lynch (d.1917)*, gift from the artist, 1952
Rocke, R. Hill (Major) *The Queen's (Second) Royal Regiment of Foot in South Africa*, gift

Surrey Archaeological Society

Christie, Ernest C. 1863–1937, *Interior View of Unidentified Cottage in East Surrey*, gift from the Christie family, 1974–1978

Christie, Ernest C. 1863–1937, *Interior of Room in a Cottage at Chaldon, with Fireplace*, gift from the Christie family, 1974–1978

Christie, Ernest C. 1863–1937, *Wall with Arched Gateway Opening on to a Field with Trees, Identified as the Entrance to Oxted Church*, gift from the Christie family, 1974–1978

Christie, Ernest C. 1863–1937, *Staircase in Cottage at Limpsfield*, gift from the Christie family, 1974–1978

Christie, Ernest C. 1863–1937, *Barn at Godstone*, gift from the Christie family, 1974–1978

Christie, Ernest C. 1863–1937, *Exterior of Cottage near Oxted*, gift from the Christie family, 1974–1978

Christie, Ernest C. 1863–1937, *Doorway between Two Rooms in Cottage at Godstone*, gift from the Christie family, 1974–1978

Christie, Ernest C. 1863–1937, *Interior View of a Cart Shed in East Surrey*, gift from the Christie family, 1974–1978

Christie, Ernest C. 1863–1937, *Room in Cottage at Godstone*, gift from the Christie family, 1974–1978

Christie, Ernest C. 1863–1937, *High Street, Bletchingley*, gift from the Christie family, 1974–1978

Christie, Ernest C. 1863–1937, *Kitchen Range at the Hare and Hounds, Godstone*, gift from the Christie family, 1974–1978

Christie, Ernest C. 1863–1937, *Staircase in Cottage at Godstone*, gift from the Christie family, 1974–1978

Christie, Ernest C. 1863–1937, *Exterior View of Unidentified Barn at Bletchingley or Godstone*, gift from the Christie family, 1974–1978

Christie, Ernest C. 1863–1937, *1 and 2 Needles Bank, Godstone*, gift from the Christie family, 1974–1978

Christie, Ernest C. 1863–1937, *Exterior View of Unidentified Cottage in East Surrey*, gift from the Christie family, 1974–1978

Christie, Ernest C. 1863–1937, *Exterior View of Unidentified Cottage near Bletchingley*, gift from the Christie family, 1974–1978

Christie, Ernest C. 1863–1937, *Fireplace and Post in Centre of Room in Cottage at Godstone*, gift from the Christie family, 1974–1978

Christie, Ernest C. 1863–1937, *Rear of Cottage at Godstone (probably Forge Cottage)*, gift from the Christie family, 1974–1978

Christie, Ernest C. 1863–1937, *Staircase in Cottage at Godstone*,

Christie, Ernest C. 1863–1937, gift from the Christie family, 1974–1978

Christie, Ernest C. 1863–1937, *Streeters, Terrace and Huddle Cottages, High Street, Oxted*, gift from the Christie family, 1974–1978

Christie, Ernest C. 1863–1937, *Bonet's Farm, Capel*, gift from the Christie family, 1974–1978

Christie, Ernest C. 1863–1937, *Exterior View of Cottage at Oakwood*, gift from the Christie family, 1974–1978

Christie, Ernest C. 1863–1937, *Exterior View of Cottage at Ockley*, gift from the Christie family, 1974–1978

Christie, Ernest C. 1863–1937, *Exterior View of Cottage at Outwood*, gift from the Christie family, 1974–1978

Christie, Ernest C. 1863–1937, *Exterior View of Cottage at Outwood*, gift from the Christie family, 1974–1978

Christie, Ernest C. 1863–1937, *Exterior View of Cottages at Ockley*, gift from the Christie family, 1974–1978

Christie, Ernest C. 1863–1937, *Exterior View of Unidentified Cottage in East Surrey, with Prominent Chimney and Porch*, gift from the Christie family, 1974–1978

Christie, Ernest C. 1863–1937, *Exterior View of Unidentified House in East Surrey*, gift from the Christie family, 1974–1978

Christie, Ernest C. 1863–1937, *Exterior View of West End of Unidentified Church in East Surrey*, gift from the Christie family, 1974–1978

Christie, Ernest C. 1863–1937, *Part of 'The Barracks', Oakwood Hill, Ockley, near Dorking*, gift from the Christie family, 1974–1978

Christie, Ernest C. 1863–1937, *Shiremark Windmill, Capel*, gift from the Christie family, 1974–1978

Christie, Ernest C. 1863–1937, *Shiremark Windmill, with Mill Cottage on Bonet's Farm, Capel*, gift from the Christie family, 1974–1978

Christie, Ernest C. 1863–1937, *Brewer Street Farm, Bletchingley*, gift from the Christie family, 1974–1978

Christie, Ernest C. 1863–1937, *Ockley Windmill*, gift from the Christie family, 1974–1978

Christie, Ernest C. 1863–1937, *Pollingfold, Abinger (front view)*, gift from the Christie family, 1974–1978

Christie, Ernest C. 1863–1937, *View of North Downs in East Surrey*, gift from the Christie family, 1974–1978

Christie, Ernest C. 1863–1937, *Walton Heath Windmill*, gift from the Christie family, 1974–1978

Christie, Ernest C. 1863–1937, *Ockley Windmill*, gift from the

Christie, Ernest C. 1863–1937, *School House, Ockley*, gift from the Christie family, 1974–1978

Christie, Ernest C. 1863–1937, *Interior of Cottage, Ockley*, gift from the Christie family, 1974–1978

Christie, Ernest C. 1863–1937, *St John the Baptist Church, Okewood, near Ockley*, gift from the Christie family, 1974–1978

Christie, Ernest C. 1863–1937, *Exterior of Cottage at Forest Green*, gift from the Christie family, 1974–1978

Christie, Ernest C. 1863–1937, *Exterior of House at Dorking*, gift from the Christie family, 1974–1978

Christie, Ernest C. 1863–1937, *Pinkhurst, Oakwood Hill*, gift from the Christie family, 1974–1978

Christie, Ernest C. 1863–1937, *Distant View of Leith Hill, with Tower*, gift from the Christie family, 1974–1978

Christie, Ernest C. 1863–1937, *Farm Buildings at Dorking*, gift from the Christie family, 1974–1978

Christie, Ernest C. 1863–1937, *Gosterwood Manor, Forest Green*, gift from the Christie family, 1974–1978

Christie, Ernest C. 1863–1937, *Pollingfold, Abinger (rear view)*, gift from the Christie family, 1974–1978

Christie, Ernest C. 1863–1937, *Tudor Barn at Standen Farm, Ockley*, gift from the Christie family, 1974–1978

Christie, Ernest C. 1863–1937, *Gosterwood Manor Farm, Forest Green*, gift from the Christie family, 1974–1978

Christie, Ernest C. 1863–1937, *Pollingfold, Abinger (view towards a landing)*, gift from the Christie family, 1974–1978

Christie, Ernest C. 1863–1937, *Volvens Farm, Forest Green*, gift from the Christie family, 1974–1978

Christie, Ernest C. 1863–1937, *Pollingfold, Abinger (view of a landing)*, gift from the Christie family, 1974–1978

Christie, Ernest C. 1863–1937, *Exterior Chimney of Cottage at Mayes Green*, gift from the Christie family, 1974–1978

Christie, Ernest C. 1863–1937, *Exterior Chimney of Cottage at Mayes Green*, gift from the Christie family, 1974–1978

Christie, Ernest C. 1863–1937, *Exterior Chimney of Cottage at Mayes Green*, gift from the Christie family, 1974–1978

Christie, Ernest C. 1863–1937, *Fireplace in Cottage at Mayes Green*, gift from the Christie family, 1974–1978

Christie, Ernest C. 1863–1937, *Interior of Olde Bell Inn, Oxted*, gift from the Christie family,

1974–1978

Christie, Ernest C. 1863–1937, *Exterior View of Cottage at Mayes Green*, gift from the Christie family, 1974–1978

Kneller, Godfrey (after) 1646–1723, *John Evelyn, 1687*, presented to the Surrey Archaeological Society by Mr C. J. A. Evelyn, a Vice President of the Society, 1948

unknown artist *Study of a Castle on a Hill*, gift from Ann Christie, 1974–1978

The Guildford Institute of the University of Surrey

Harris, W. J. *George William Downes (1831–1915)*, presented by the artist, 1916

Russian School *Three-Quarter Length Portrait of a Female Saint*, possibly presented by a soldier of the 2nd Royal Surrey Regiment of Militia stationed in the Crimea, 1854–1856

unknown artist *James Macnab by the River Wey, with a View of Guildford Castle*, presented by Mrs Hill, 1866

Willis-Pryce, George 1866–1949, *High Street, Guildford, Looking West, with a View of Holy Trinity Church*

The Guildhall

Halliday, Edward Irvine 1902–1984, *Elizabeth II (b.1926)*, © the artist's estate

Highmore, Joseph (circle of) 1692–1780, *Portrait of a Gentleman, Wearing a Brown Coat, White Glove and an Academic Gown, Holding a Letter*

Lely, Peter (circle of) 1618–1680, *Charles II (1630–1685)*

Lely, Peter (circle of) 1618–1680, *James II (1633–1701)*

Lewis *Queen's Regiment Parade before the Mayor of Guildford*

Richardson, Jonathan the elder (circle of) 1665–1745, *The Right Honourable Arthur Onslow (1691–1768)*

Riley, John (studio of) 1646–1691, *Mary II (1662–1694)*

Riley, John (studio of) 1646–1691, *William III (1650–1702)*

Russell, John 1745–1806, *Sir Richard Onslow, Bt (1741–1817)*

Somer, Paulus van I (circle of) 1576–1621, *James I (1566–1625)*

University of Surrey

Allen, Michael b.1976, *Barriers*, winner of the Vice-Chancellor's Prize for Student Art at Wimbledon School of Art, 1999, © the artist

Allison, Jane b.1959, *Lord Nugent*, commissioned by Bill Simpson, former University of Surrey Librarian, to record the former

High Officers of the University, 1989, © the artist

Allison, Jane b.1959, *Lord Robens of Woldingham*, commissioned by Bill Simpson, former University of Surrey Librarian, to record the former High Officers of the University, 1989, © the artist

Allison, Jane b.1959, *Sir George Edwards*, commissioned by Bill Simpson, former University of Surrey Librarian, to record the former High Officers of the University, 1989, © the artist

Allison, Jane b.1959, *Sir William Mullens*, commissioned by Bill Simpson, former University of Surrey Librarian, to record the former High Officers of the University, 1989, © the artist

Allison, Jane b.1959, *Daphne Jackson (1936–1991)*, commissioned by the University, 2001, © the artist

Anderson, Freda b.1942, *Emma Jerman*, donated by Emma Jerman's family with funding for a suite of laboratories named after their daughter, who died, 2005, © the artist

Bachba, Emma & Powell, Alex *The Storm, October 1987*, commissioned from students at Roehampton Institute Art Department (now Roehampton University) for vegetarian restaurant by Allan Collinson, Head of Catering, after storm of 1987

Bachba, Emma & Powell, Alex *The Storm, October 1987*, commissioned from students at Roehampton Institute Art Department (now Roehampton University) for vegetarian restaurant by Allan Collinson, Head of Catering, after storm of 1987

Bachba, Emma & Powell, Alex *The Storm, October 1987*, commissioned from students at Roehampton Institute Art Department (now Roehampton University) for vegetarian restaurant by Allan Collinson, Head of Catering, after storm of 1987

Bachba, Emma & Powell, Alex *The Storm, October 1987*, commissioned from students at Roehampton Institute Art Department (now Roehampton University) for vegetarian restaurant by Allan Collinson, Head of Catering, after storm of 1987

Bachba, Emma & Powell, Alex *The Storm, October 1987*, commissioned from students at Roehampton Institute Art Department (now Roehampton University) for vegetarian restaurant by Allan Collinson, Head of Catering, after storm of 1987

Bachba, Emma & Powell, Alex *The Storm, October 1987*, commissioned from students

at Roehampton Institute Art Department (now Roehampton University) for vegetarian restaurant by Allan Collinson, Head of Catering, after storm of 1987

Bachba, Emma & Powell, Alex *The Storm, October 1987*, commissioned from students at Roehampton Institute Art Department (now Roehampton University) for vegetarian restaurant by Allan Collinson, Head of Catering, after storm of 1987

Bachba, Emma & Powell, Alex *The Storm, October 1987*, commissioned from students at Roehampton Institute Art Department (now Roehampton University) for vegetarian restaurant by Allan Collinson, Head of Catering, after storm of 1987

Bachba, Emma & Powell, Alex *The Storm, October 1987*, commissioned from students at Roehampton Institute Art Department (now Roehampton University) for vegetarian restaurant by Allan Collinson, Head of Catering, after storm of 1987

Bachba, Emma & Powell, Alex *The Storm, October 1987*, commissioned from students at Roehampton Institute Art Department (now Roehampton University) for vegetarian restaurant by Allan Collinson, Head of Catering, after storm of 1987

Bachba, Emma & Powell, Alex *The Storm, October 1987*, commissioned from students at Roehampton Institute Art Department (now Roehampton University) for vegetarian restaurant by Allan Collinson, Head of Catering, after storm of 1987

Bachba, Emma & Powell, Alex *The Storm, October 1987*, commissioned from students at Roehampton Institute Art Department (now Roehampton University) for vegetarian restaurant by Allan Collinson, Head of Catering, after storm of 1987

Bachba, Emma & Powell, Alex *The Storm, October 1987*, commissioned from students at Roehampton Institute Art Department (now Roehampton University) for vegetarian restaurant by Allan Collinson, Head of Catering, after storm of 1987

Bachba, Emma & Powell, Alex *The Storm, October 1987*, commissioned from students at Roehampton Institute Art Department (now Roehampton University) for vegetarian restaurant by Allan Collinson, Head of Catering, after storm of 1987

Barratt, Krome 1924–1990, *Cadmium and Compliments*, acquired, before 1983

Barter, Paul b.1945, *130204*, purchased from the artist after an exhibition, 2005, © the artist

Cuthbert, Alan 1931–1995, *Abstract: Yellow Series 3/13*, presented to the University by Mr & Mrs Peter Carreras, 1986

Daghani, Arnold 1909–1985, *Abstract: Portrait*, donated by Professor Carola Grindea, the artist's sister-in-law, 1989, © Arnold Daghani Trust

Daghani, Arnold 1909–1985, *Abstract*, donated by Professor Carola Grindea, the artist's sister-in-law, 1989, © Arnold Daghani Trust

Daghani, Arnold 1909–1985, *Portrait in Profile*, donated by Professor Carola Grindea, the artist's sister-in-law, 1989, © Arnold Daghani Trust

Daghani, Arnold 1909–1985, *Musical Abstract No.2*, donated by Professor Carola Grindea, the artist's sister-in-law, 1989, © Arnold Daghani Trust

Daghani, Arnold 1909–1985, *Décaméron: Studies of a Female in Metamorphosis*, donated by Professor Carola Grindea, the artist's sister-in-law, 1989, © Arnold Daghani Trust

Daghani, Arnold 1909–1985, *Abstract: House*, donated by Professor Carola Grindea, the artist's sister-in-law, 1989, © Arnold Daghani Trust

Daghani, Arnold 1909–1985, *Abstract*, presented to the University by Mr & Mrs Peter Carreras, 1986, © Arnold Daghani Trust

Dellar, Roger b.1949, *One Piano, Four Hands (Guildford International Music Festival)*, purchased at Guildford Arts annual exhibition, 2005, © the artist

Devitt, Margaret b.1944, *Mirabib, Namibia*, purchased from the artist, 2005

Devitt, Margaret b.1944, *Red Desert*, purchased from the artist, 2005

Di Duca, Adrian b.1966, *Big Red*, winner of the Vice-Chancellor's

Prize for Student Art at Wimbledon School of Art, 1997, acquired 1999, © the artist

Edwards, George 1908–2003, *Boy Fishing*, purchased by the University from the artist's exhibition, 2004, © the artist's estate

Edwards, George 1908–2003, *Balloons over Longdown*, purchased by the University Library from the artist's exhibition, 2004, © the artist's estate

Edwards, George 1908–2003, *Newlands Corner*, purchased by the University from the artist's exhibition, 2004, © the artist's estate

Edwards, George 1908–2003, *St Martha's Hill*, purchased by the University Library from the artist's exhibition, 2004, © the artist's estate

Edwards, George 1908–2003, *Tyting Farm*, purchased by the University Library from the artist's exhibition, 2004, © the artist's estate

Enright, Madeleine *Mont Pilat*, donated by the artist after an exhibition, 1993

Farthing, Stephen b.1950, *The Eye of Information*, commissioned by the University, 2000, © the artist

Fitzgerald, Paul b.1922, *HRH the Duke of Kent*, commissioned by the University, 1999, © the artist

Fitzgerald, Paul b.1922, *HRH the Duke of Kent*, commissioned by the University, 1999, © the artist

Ganley, Brogan b.1971, *Cuenca Recollection*, purchased from the Guildford Arts Exhibition when the artist was a student at Wimbledon School of Art

Gildea, Paul b.1956, *White Cups and Shell*, purchased from the artist after an exhibition, 1995, © the artist

Gotlib, Henryk 1890–1966, *Sketch for 'Knossos'*, purchased for the University, 1980s, © the artist's estate

Grant, Keith b.1930, *Launch of the Ariane Rocket Carrying UOSAT*, donated to the University by the artist after an exhibition in the Library Gallery, 1984, © the artist

Grant, Keith b.1930, *Design for a Mural on the Leggett Building of UOSAT in the Night Sky*, donated by the artist, 1985, © the artist

Grant, Keith b.1930, *Design for a Mural on the Leggett Building of UOSAT in the Night Sky*, donated by the artist, 1985, © the artist

Grant, Keith b.1930, *Design for a Mural on the Leggett Building of UOSAT in the Night Sky*, donated by the artist, 1985, © the artist

Hardy, Anne *Blue Abstract*, purchased from an exhibition at the Lewis Elton Gallery, 2003, © the artist

Hepple, Norman 1908–1994, *Dr Peter Leggett*, commissioned by the University, 1974, © the artist's estate/ www.bridgeman.co.uk

Hornsby-Smith, Stephen b.1969, *Man outside a Nightclub in San Francisco*, acquired by the Sociology Department after an exhibition, 2000

Hornsby-Smith, Stephen b.1969, *Seascape II*, acquired by the Sociology Department after an exhibition, 2000

Jackowski, Andrzej b.1947, *The Way (Falmouth): Lovers II*, acquired when the artist was in residence at the university, 1976, © the artist

Jackowski, Andrzej b.1947, *Dinner Party for Four*, acquired when the artist was in residence at the University, 1976, © the artist

Jackowski, Andrzej b.1947, *Room at Midday*, acquired when the artist was in residence at the University, 1976, © the artist

Jackowski, Andrzej b.1947, *Room with Blinds*, acquired when the artist was in residence at the University, 1976, © the artist

Jackowski, Andrzej b.1947, *Room with Surprised Guest*, acquired when the artist was in residence at the University, 1976, © the artist

Jackowski, Andrzej b.1947, *Reclining Nude*, acquired when the artist was in residence at the University, 1976, © the artist

Jackowski, Andrzej b.1947, *Room with a View of the Road*, acquired when the artist was in residence at the University, 1976, © the artist

Jackowski, Andrzej b.1947, *The Room (A Lady Seated at a Table)*, acquired when the artist was in residence at the University, 1976, © the artist

Jordan, Valerie *I Wish Bonnard Could Come to Tea*, purchased from an exhibition at the Lewis Elton Gallery, 2002, © the artist

Jordan, Valerie *Kurdistan Garden*, purchased from the Vice-Chancellor's Discretionary Fund and Arts Budget, 2002, © the artist

Kannreuther, Caroline b.1964, *Movement in Four Colours: Large Pink (panel 1 of 4)*, winner of the Vice-Chancellor's Prize for Student Art at Wimbledon School of Art, 2005

Kannreuther, Caroline b.1964, *Movement in Four Colours: Red (panel 2 of 4)*, winner of the Vice-Chancellor's Prize for Student Art at Wimbledon School of Art, 2005

Kannreuther, Caroline b.1964, *Movement in Four Colours: Green (panel 3 of 4)*, winner of the Vice-Chancellor's Prize for Student Art at Wimbledon School of Art, 2005

Kannreuther, Caroline b.1964, *Movement in Four Colours: Yellow (panel 4 of 4)*, winner of the Vice-Chancellor's Prize for Student Art at Wimbledon School of Art, 2005

Kilpatrick, Alan b.1963, *Beijing Opera*, purchased from an exhibition in the Library Gallery, 1992

Lang, Kathryn b.1979, *Motion Pictures (panel 1 of 3)*, winner of

the Vice-Chancellor's Prize for Student Art at Wimbledon School of Art, 2001

Lang, Kathryn b.1979, *Motion Pictures (panel 2 of 3)*, winner of the Vice-Chancellor's Prize for Student Art at Wimbledon School of Art, 2001

Lang, Kathryn b.1979, *Motion Pictures (panel 3 of 3)*, winner of the Vice-Chancellor's Prize for Student Art at Wimbledon School of Art, 2001

Lawrence, William b.1957, *The Painting Studio*, donated by the artist, 2006, © the artist

McClure, David 1926–1998, *Between Two Easels*, acquired, before 1983

McLynn, Rebecca b.1966, *Perspectives on the Wey (triptych)*, commissioned as part of a joint University and Guildford Borough Council millennium project of photos, paintings and poems in an exhibition, 2001

Mendoza, June active 1960–2006, *Professor Anthony Kelly*, commissioned by the University, 1994, © the artist

Mendoza, June active 1960–2006, *Professor Patrick Dowling*, commissioned by the University, 2005, © the artist

Mohanty, Michael *Abstract*, acquired through Wimbledon School of Art, 2000

Mohanty, Michael *Abstract*, acquired through Wimbledon School of Art, 2000

Muszynski, Leszek b.1923, *Sunrise (triptych)*, purchased by the University, 1996, © the artist

Muszynski, Leszek b.1923, *Heat of the Day (triptych)*, purchased by the University, 1996, © the artist

Muszynski, Leszek b.1923, *Twilight (triptych)*, purchased by the University, 1996, © the artist

Muszynski, Leszek b.1923, *Lemons*, purchased by the University, 2002, © the artist

Newbolt, Thomas b.1951, *Battersea Power Station*, acquired from the artist, 1984, © the artist

Oki, Yuji b.1949, *Dancing Tree*, donated by the artist after an exhibition at the Lewis Elton Gallery, 1998, © the artist/ www. bridgeman.co.uk

Paxson, Pat b.1938, *The Broken Dream (triptych)*, purchased from the artist, 2000, © the artist

Paxson, Pat b.1938, *The Broken Dream (triptych)*, purchased from the artist, 2000, © the artist

Paxson, Pat b.1938, *The Broken Dream (triptych)*, purchased from the artist, 2000, © the artist

Penn, William Charles 1877–1968, *Major F. H. Johnson, VC*, duplicate of a painting presented to the sitter by Battersea Polytechnic, in recognition of Major Johnson's outstanding contribution to the Polytechnic during his studies, 1916

Penn, William Charles 1877–1968,

Sidney G. Rawson, DC, Principal of Battersea Polytechnic (1907–1915), acquired from Battersea College of Technology

Prokofiev, Oleg 1928–1998, *Belle-Ile*, donated by the artist when he was the artist in residence at the University, 1970s

Prokofiev, Oleg 1928–1998, *Bodies*, donated by the artist when he was the artist in residence at the University, 1970s

Prokofiev, Oleg 1928–1998, *The Tree of Life*, donated by the artist when he was the artist in residence at the University, 1970s

Prokofiev, Oleg 1928–1998, *Allegory of Calumny*, donated by the artist when he was the artist in residence at the University, 1970s

Ramos, Theodore b.1928, *Lord Robens*, purchased from the artist, © the artist

Reason, Cyril b.1931, *Salome*, acquired, before 1983

Sajó, Gyula 1918–1979, *Yellow Flowers*, donated to the University, © the artist's daughter

Satchel, Hannah b.1980, *South Africa (pair)*, purchased from the artist when she was a student at Wimbledon School of Art, 2003

Satchel, Hannah b.1980, *South Africa III (pair)*, purchased from the artist when she was a student at Wimbledon School of Art, 2003

Spooner, Wendy *A New Moon and a Vortex (The Wave)*, donated by the artist before moving abroad, 1980s

Spooner, Wendy *Abstract Design: The Blue Tree*, donated by the artist before moving abroad, 1980s

Spooner, Wendy *Abstract: Street Light*, donated by the artist before moving abroad, 1980s

Spooner, Wendy *Christ in Gethsemane*, donated by the artist before moving abroad, 1980s

Spooner, Wendy *Flower Rocks*, donated by the artist before moving abroad, 1980s

Spooner, Wendy *Summer Wind*, donated by the artist before moving abroad, 1980s

Spooner, Wendy *The Annunciation*, donated by the artist before moving abroad, 1980s

Spooner, Wendy *The Garden*, donated by the artist before moving abroad, 1980s

Spooner, Wendy *The Hand*, donated by the artist before moving abroad, 1980s

Spooner, Wendy *Winter Wind*, donated by the artist before moving abroad, 1980s

Spooner, Wendy *Wooden Collage*, donated by the artist before moving abroad, 1980s

Stockbridge, Gill b.1938, *Populoso*, purchased by the University from Guildford Arts Exhibition when the artist was a student at Wimbledon School of Art, 2004, © the artist

Stokoe, Jack b.1980, *Two Figures*, winner of the Vice-Chancellor's

Prize for Student Art at Wimbledon School of Art, 2003

Swann, Marilyn b.1932, *Galloping Horse*, acquired, before 1983

Swift, Richard b.1918, *Manor House Hall of Residence*, acquired, before 1983

Taylor, Frank b.1946, *Methoni, Greece*, purchased from the artist, 2000, © the artist

Taylor, Frank b.1946, *Punch*, purchased from the artist, 2000, © the artist

Tipton, Heather b.1941, *Colin Tipton*, purchased by the Sociology Department when the artist's husband Colin worked there

Tipton, Heather b.1941, *Still Life: Plant*, purchased by the Sociology Department when the artist's husband Colin worked there

unknown artist late 20th C, *View of a Bridge in Richmond*, acquired, before 1983

unknown artist late 20th C, *View of a Bridge in Richmond*, acquired, before 1983

unknown artist *Jardinière of Flowers*, purchased for the University, 1994

Verrall, Nicholas b.1945, *Cerisiers dans le jardin*, acquired from an exhibition, 2006, © the artist

Wei, Feng *The Transfiguration of Landscape*, donated by the artist after his exhibition, 1989

Whishaw, Anthony b.1930, *Green Landscape*, on long-term loan from the estate of Henry Roland, © the artist

Windsor, Alan b.1931, *Stars, Fields and Trees*, purchased from an exhibition at the Lewis Elton Gallery, 2004

Windsor, Alan b.1931, *Gem II*, purchased from an exhibition at the Lewis Elton Gallery, 2004

Wolf, Tim *Abstract*, donated, 2006

Wright, Peter *East Coast*, acquired, before 1983

Wright, Steve b.1975, *Bonsai 1 (panel 1 of 2)*, acquired, 1998, © the artist

Wright, Steve b.1975, *Bonsai 2 (panel 2 of 2)*, acquired,1998, © the artist

Watts Gallery

Alston, Rowland Wright 1895–1958, *Lough Conn, Ireland*

Alston, Rowland Wright 1895–1958, *Dead Bird (Sheldrake)*, acquired from the Rowland Alston Estate, 1958

Bauerle, Karl Wilhelm Friedrich 1831–1912, *Graham Robertson as a Boy*, bequeathed by the Graham Robertson Estate, 1951

Blunt, Wilfrid 1901–1987, *Michael Severne*, acquired from the estate of Wilfrid Blunt

Burne-Jones, Edward 1833–1898, *Laus Veneris*, bequeathed by Cecil French, 1954

Couzens, Charles active 1838–1875, *G. F. Watts*, gift from

Mrs Michael Chapman (née Lilian Macintosh), 1946

Graves, Henry Richard (attributed to) 1818–1882, *Mrs Graham Robertson, in Her Youth*, bequeathed by the Graham Robertson Estate, 1951

Hughes, Arthur 1832–1915, *Memories*

Leighton, Frederic, 1st Baron Leighton of Stretton 1830–1896, *Female Head*, bequeathed by Cecil French, 1954

Melville, Arthur 1855–1904, *Mrs Graham Robertson*, bequeathed by the Graham Robertson Estate, 1951

Prinsep, Valentine Cameron 1838–1904, *Nancy Hitchens*, acquired from the Hitchens Estate

Robertson, Walford Graham 1866–1948, *Binkie*, purchased by the Watts Gallery Trustees from Messrs Agnews, 1951

Robertson, Walford Graham 1866–1948, *Olga Brandon*, purchased by the Watts Gallery Trustees from Messrs Agnews, 1951

Robertson, Walford Graham 1866–1948, *The Amber Necklace*

Sargent, John Singer 1856–1925, *Mrs Graham Robertson*, purchased by the Watts Gallery Trustees from Messrs Agnews, 1951

Shannon, Charles Haslewood 1863–1937, *The Garland*, bequeathed by Cecil French, 1954

Shannon, Charles Haslewood 1863–1937, *The Bathers*, bequeathed by Cecil French, 1954

Shannon, Charles Haslewood 1863–1937, *The Toilet*, bequeathed by Cecil French, 1954

Shannon, Charles Haslewood 1863–1937, *An Idyll*, bequeathed by Cecil French, 1954

Shannon, Charles Haslewood 1863–1937, *The Pursuit*, bequeathed by Cecil French, 1954

Stott, William 1857–1900, *Washing Day*, bequeathed by Cecil French, 1954

unknown artist *Group Portrait*

Watts, George Frederick 1817–1904, *Early Copy from an Unidentified Baroque Portrait*, gift from Mrs Michael Chapman (née Lilian Macintosh), 1946

Watts, George Frederick 1817–1904, *Self Portrait, Aged 17*, gift from Mrs Michael Chapman (née Lilian Macintosh), 1946

Watts, George Frederick 1817–1904, *The Artist's Father*, purchased from Mrs Michael Chapman (née Lilian Macintosh), 1958

Watts, George Frederick 1817–1904, *The Artist's Father, Half-Length*, gift from Mrs Michael Chapman (née Lilian Macintosh), 1946

Watts, George Frederick 1817–1904, *The Falconer*, gift from Mrs Michael Chapman (née Lilian Macintosh), 1946

Watts, George Frederick 1817–1904, *Undine*, gift from Mary Seton Watts, 1913

Watts, George Frederick 1817–1904, *A Kneeling Figure (A Man of Sorrows)*

Watts, George Frederick 1817–1904, *Little Miss Hopkins*

Watts, George Frederick 1817–1904, *Portrait of a Boy's Head (Cornellius)*, possibly part of the original G. F. Watts Memorial Collection. Bequeathed, 1905

Watts, George Frederick 1817–1904, *The Wounded Heron*, part of the original G. F. Watts Memorial Collection. Bequeathed, 1905

Watts, George Frederick 1817–1904, *Reverend A. Wellsted*, purchased, 1961

Watts, George Frederick 1817–1904, *Gerald Hamilton as an Infant*, possibly part of the original G. F. Watts Memorial Collection. Bequeathed, 1905

Watts, George Frederick 1817–1904, *Blondel*

Watts, George Frederick 1817–1904, *Alexander Constantine Ionides and His Wife Euterpe, with Their Children Constantine, Alexander, Aglaia and Alecco*, purchased from Sotheby's with the assistance of the Heritage Lottery Fund and the National Art Collections Fund, 2005

Watts, George Frederick 1817–1904, *Lady Holland on Daybed*, purchased, 1942

Watts, George Frederick 1817–1904, *Lady Augusta Holland*, gift from Lord Ilchester, 1940

Watts, George Frederick 1817–1904, *Drowning of the Doctor*, gift from Mrs Michael Chapman (née Lilian Macintosh), 1946

Watts, George Frederick 1817–1904, *Fiesole, Tuscany*, gift from Mrs Michael Chapman (née Lilian Macintosh), 1946

Watts, George Frederick 1817–1904, *Villa Petraia*, purchased from Sotheby's with the assistance of the National Art Collections Fund, 2004

Watts, George Frederick 1817–1904, *Echo*, on long-term loan from Tate, London

Watts, George Frederick 1817–1904, *Miss Marietta Lockhart*

Watts, George Frederick 1817–1904, *Orderic and the Witch*, gift from Mrs Michael Chapman (née Lilian Macintosh), 1946

Watts, George Frederick 1817–1904, *Orderic and the Witch (large version in colour)*, part of the original G. F. Watts Memorial Collection. Bequeathed, 1905

Watts, George Frederick 1817–1904, *Diana's Nymphs*, part of the original G. F. Watts Memorial Collection. Bequeathed, 1905

Watts, George Frederick 1817–1904, *Guelphs and Ghibellines*, gift from Mrs Michael Chapman (née Lilian Macintosh), 1946

Watts, George Frederick 1817–1904, *Satan*, part of the original G. F. Watts Memorial Collection. Bequeathed, 1905

Watts, George Frederick 1817–1904, *Found Drowned*, part of the original G. F. Watts Memorial Collection. Bequeathed, 1905

Watts, George Frederick 1817–1904, *Aristides and the Shepherd*, part of the original G. F. Watts Memorial Collection. Bequeathed, 1905

Watts, George Frederick 1817–1904, *The Titans*, gift from Mary Seton Watts, 1931

Watts, George Frederick 1817–1904, *Olympus*, purchased from Mrs Michael Chapman (née Lilian Macintosh), 1958

Watts, George Frederick 1817–1904, *Under the Dry Arch*, part of the original G. F. Watts Memorial Collection. Bequeathed, 1905

Watts, George Frederick 1817–1904, *The Good Samaritan*, part of the original G. F. Watts Memorial Collection. Bequeathed, 1905

Watts, George Frederick 1817–1904, *Irish Famine*, part of the original G. F. Watts Memorial Collection. Bequeathed, 1905

Watts, George Frederick 1817–1904, *Song of the Shirt*, part of the original G. F. Watts Memorial Collection. Bequeathed, 1905

Watts, George Frederick 1817–1904, *Mrs Morris*, acquired via the Morris Bequest, 1943

Watts, George Frederick 1817–1904, *Lady Dalrymple*, bequeathed by Sir Weldon Dalrymple-Champneys, 1981

Watts, George Frederick 1817–1904, *St George*, gift from Mrs Michael Chapman (née Lilian Macintosh), 1946

Watts, George Frederick 1817–1904, *Study for Carlton House Terrace Frescoes*

Watts, George Frederick 1817–1904, *James Barr Mitchell*, bequeathed by Miss Marjory Isobel Mitchell Usher, 1997

Watts, George Frederick 1817–1904, *Miss Mildmay*, part of the original G. F. Watts Memorial Collection. Bequeathed, 1905

Watts, George Frederick 1817–1904, *Admiral Lord Lyons*, gift from Mrs Michael Chapman (née Lilian Macintosh), 1946

Watts, George Frederick 1817–1904, *The Sisters*, gift from Mrs Michael Chapman (née Lilian Macintosh), 1946 (originally part of the Memorial Collection)

Watts, George Frederick 1817–1904, *Georgina Treherne*, purchased from Sotheby's with the assistance of the National Art Collections Fund, 2004

Watts, George Frederick 1817–1904, *Bodrum, Asia Minor*, gift from Mrs Michael Chapman (née Lilian Macintosh), 1946

Watts, George Frederick 1817–1904, *In Asia Minor*, gift from Mrs Michael Chapman (née Lilian Macintosh), 1946

Watts, George Frederick 1817–1904, *Dr Zambaco*

Watts, George Frederick 1817–1904, *Study for Fresco of Corialanus for Bowood House*

Watts, George Frederick 1817–1904, *Study for Fresco of Corialanus for Bowood House*

Watts, George Frederick 1817–1904, *Study for Fresco of Corialanus for Bowood House*

Watts, George Frederick 1817–1904, *Achilles and Briseis*, presented by Lord Lansdowne, 1956

Watts, George Frederick 1817–1904, *Aileen Spring-Rice*, gift from Mrs Michael Chapman (née Lilian Macintosh), 1946

Watts, George Frederick 1817–1904, *Lady Lilford*, part of the original G. F. Watts Memorial Collection. Bequeathed, 1905

Watts, George Frederick 1817–1904, *Lady Somers*, given by Mary Seton Watts in exchange for another picture from the original core collection of 109 works, 1908

Watts, George Frederick 1817–1904, *Lord Campbell*, part of the original G. F. Watts Memorial Collection. Bequeathed, 1905

Watts, George Frederick 1817–1904, *Esau*, part of the original G. F. Watts Memorial Collection. Bequeathed, 1905

Watts, George Frederick 1817–1904, *'Long Mary'*, gift from Mrs Michael Chapman (née Lilian Macintosh), 1946

Watts, George Frederick 1817–1904, *Eve Repentant*, gift from Mrs Michael Chapman (née Lilian Macintosh), 1946

Watts, George Frederick 1817–1904, *Lady Archibald Campbell*

Watts, George Frederick 1817–1904, *Europa*, gift from Mrs Michael Chapman (née Lilian Macintosh), 1946

Watts, George Frederick 1817–1904, *Earl of Shrewsbury*, gift from Mrs Michael Chapman (née Lilian Macintosh), 1946

Watts, George Frederick 1817–1904, *Lord Lyndhurst*, gift from Mrs Michael Chapman (née Lilian Macintosh), 1946

Watts, George Frederick 1817–1904, *Head of an Ass*, part of the original G. F. Watts Memorial Collection. Bequeathed, 1905

Watts, George Frederick 1817–1904, *The Building of the Ark*, part of the original G. F. Watts Memorial Collection. Bequeathed, 1905

Watts, George Frederick 1817–1904, *The Midday Rest (Dray Horses)*, part of the original G. F. Watts Memorial Collection. Bequeathed, 1905

Watts, George Frederick 1817–1904, *Preaching of Jonah (or Noah)*

Watts, George Frederick 1817–1904, *Ganymede (Son of Dr Zambaco and Miss Mary Cassavetti)*, part of the original G. F. Watts Memorial Collection. Bequeathed, 1905

Watts, George Frederick 1817–1904, *Giuseppe Garibaldi (1807–1882)*, part of the original G. F. Watts Memorial Collection. Bequeathed, 1905

Watts, George Frederick 1817–1904, *Britomart*, part of the original G. F. Watts Memorial Collection. Bequeathed, 1905

Watts, George Frederick 1817–1904, *Dr J. Joachim*, part of the original G. F. Watts Memorial Collection. Bequeathed, 1905

Watts, George Frederick 1817–1904, *Sir Henry Taylor (unfinished)*, gift from Mrs Michael Chapman (née Lilian Macintosh), 1946

Watts, George Frederick 1817–1904, *The Standard-Bearer*, part of the original G. F. Watts Memorial Collection. Bequeathed, 1905

Watts, George Frederick 1817–1904, *Miss May Prinsep*, gift from Mrs A. K. Hitchens, 1907

Watts, George Frederick 1817–1904, *Thetis*, gift from Lord Iveagh, 1951

Watts, George Frederick 1817–1904, *Thetis*, bequeathed by Cecil French, 1955

Watts, George Frederick 1817–1904, *Mrs Percy Wyndham*, gift from Mrs Michael Chapman (née Lilian Macintosh), 1946

Watts, George Frederick 1817–1904, *Eve Tempted*, gift from Mrs Michael Chapman (née Lilian Macintosh), 1946 (originally part of the Memorial Collection)

Watts, George Frederick 1817–1904, *Florence Nightingale (1820–1910)*, gift from Mrs Michael Chapman (née Lilian Macintosh), 1945

Watts, George Frederick 1817–1904, *Rhodopis*, probably bequeathed by Cecil French, 1955

Watts, George Frederick 1817–1904, *Cedar Tree*, acquired via the Hitchens Gift

Watts, George Frederick 1817–1904, *A Fair Saxon*, part of the original G. F. Watts Memorial Collection. Bequeathed, 1905

Watts, George Frederick 1817–1904, *Orpheus and Euridice (small version)*, bequeathed by Cecil French, 1955

Watts, George Frederick 1817–1904, *Eve Repentant*, part of the original G. F. Watts Memorial Collection. Bequeathed, 1905

Watts, George Frederick 1817–1904, *Clytie*, bequeathed by Cecil French, 1955

Watts, George Frederick 1817–1904, *Donders Frans*

Watts, George Frederick 1817–1904, *George Peabody*, gift from Mrs Michael Chapman (née Lilian Macintosh), 1946

Watts, George Frederick 1817–1904, *Thomas Hughes*, gift from Mrs Michael Chapman (née Lilian Macintosh), 1946

Watts, George Frederick 1817–1904, *H. Toby Prinsep*, gift from Mrs A. K. Hitchens, 1908

Watts, George Frederick 1817–1904, *P. H. Calderon*

Watts, George Frederick 1817–1904, *Samson*, bequeathed by Cecil French, 1955

Watts, George Frederick 1817–1904, *The Denunciation of Cain*, part of the original G. F. Watts Memorial Collection. Bequeathed, 1905

Watts, George Frederick 1817–1904, *The Court of Death*, part of the original G. F. Watts Memorial Collection. Bequeathed, 1905

Watts, George Frederick 1817–1904, *Miss Virginia Julian Dalrymple (Mrs Francis Champneys)*, bequeathed by Sir Weldon Dalrymple-Champneys, 1981. Received by the gallery on Lady Dalrymple-Champneys' death, 1998

Watts, George Frederick 1817–1904, *Rith H. Wallis-Dunlop*, on loan from a private collection

Watts, George Frederick 1817–1904, *The Prodigal Son*, part of the original G. F. Watts Memorial Collection. Bequeathed, 1905

Watts, George Frederick 1817–1904, *The Prodigal Son (bust-length figure)*, part of the original G. F. Watts Memorial Collection. Bequeathed, 1905

Watts, George Frederick 1817–1904, *Paolo and Francesca*, part of the original G. F. Watts Memorial Collection. Bequeathed, 1905

Watts, George Frederick 1817–1904, *The Spirit of Christianity*, part of the original G. F. Watts Memorial Collection. Bequeathed, 1905

Watts, George Frederick 1817–1904, *John Stuart Mill (1806–1873)*, gift from Mrs Michael Chapman (née Lilian Macintosh), 1946

Watts, George Frederick 1817–1904, *The Denunciation of Adam and Eve*, gift from Mrs Michael Chapman (née Lilian Macintosh), 1946

Watts, George Frederick 1817–1904, *The Denunciation of Adam and Eve*, part of the original G. F. Watts Memorial Collection. Bequeathed, 1905

Watts, George Frederick 1817–1904, *Chaos*, part of the original G. F. Watts Memorial Collection. Bequeathed, 1905

Watts, George Frederick 1817–1904, *King Edward VII (1841–1910)*, possibly part of the original G. F. Watts Memorial Collection. Bequeathed, 1905

Watts, George Frederick 1817–1904, *Lady Garvagh*, part of the original G. F. Watts Memorial Collection. Bequeathed, 1905

Watts, George Frederick 1817–1904, *Study of Nude (Standing Figure)*, part of the original G. F. Watts Memorial Collection. Bequeathed, 1905

Watts, George Frederick 1817–1904, *Freshwater, near Farringford*, part of the original G. F. Watts Memorial Collection. Bequeathed, 1905

Watts, George Frederick 1817–1904, *Freshwater Farm Buildings*, part of the original G. F. Watts Memorial Collection. Bequeathed, 1905

Watts, George Frederick 1817–1904, *Ophelia*, part of the original G. F. Watts Memorial Collection. Bequeathed, 1905

Watts, George Frederick 1817–1904, *Genius of Greek Poetry*, part of the original G. F. Watts Memorial Collection. Bequeathed, 1905

Watts, George Frederick 1817–1904, *Jacob and Esau*, part of the original G. F. Watts Memorial Collection. Bequeathed, 1905

Watts, George Frederick 1817–1904, *King Edward VII (1841–1910)*

Watts, George Frederick 1817–1904, *Arcadia*, part of the original G. F. Watts Memorial Collection. Bequeathed, 1905

Watts, George Frederick 1817–1904, *Self Portrait*, gift from Mary Seton Watts, 1913

Watts, George Frederick 1817–1904, *Violet Lindsay*, part of the original G. F. Watts Memorial Collection. Bequeathed, 1905

Watts, George Frederick 1817–1904, *Sir Richard Burton*, part of the original G. F. Watts Memorial Collection. Bequeathed, 1905

Watts, George Frederick 1817–1904, *Lucy Bond*

Watts, George Frederick 1817–1904, *Mrs Lillie Langtry*, part of the original G. F. Watts Memorial Collection. Bequeathed, 1905

Watts, George Frederick 1817–1904, *Sketch of Lord Dufferin*

Watts, George Frederick 1817–1904, *Lady Godiva*, part of the original G. F. Watts Memorial Collection. Bequeathed, 1905

Watts, George Frederick 1817–1904, *Daphne's Bath*, bequeathed by Cecil French, 1955

Watts, George Frederick 1817–1904, *Laura Gurney (later Lady Troubridge)*

Watts, George Frederick 1817–1904, *Love and Life*, part of the original G. F. Watts Memorial Collection. Bequeathed, 1905

Watts, George Frederick 1817–1904, *Miss Blanche Maynard*, part of the original G. F. Watts Memorial Collection. Bequeathed, 1905

Watts, George Frederick 1817–1904, *The Creation of Eve*, part of the original G. F. Watts Memorial Collection. Bequeathed, 1905

Watts, George Frederick 1817–1904, *The Creation of Eve (unfinished)*, gift from Mrs Michael Chapman (née Lilian Macintosh), 1946

Watts, George Frederick

Watts, George Frederick 1817–1904, *G. F. Watts*, on loan from Compton Village Hall

Watts, George Frederick 1817–1904, *Tasting the First Oyster*, part of the original G. F. Watts Memorial Collection. Bequeathed, 1905

Watts, George Frederick 1817–1904, *The Condottiere*, part of the original G. F. Watts Memorial Collection. Bequeathed, 1905

Watts, George Frederick 1817–1904, *Time, Death and Judgement*, on long-term loan from St Paul's Cathedral

Watts, George Frederick 1817–1904, *Uldra*, purchased with the assistance of the National Art Collections Fund, 1995

Watts, George Frederick 1817–1904, *The Messenger*, part of the original G. F. Watts Memorial Collection. Bequeathed, 1905

Watts, George Frederick 1817–1904, *Idle Child of Fancy*, part of the original G. F. Watts Memorial Collection. Bequeathed, 1905

Watts, George Frederick 1817–1904, *Mammon*, purchased from Mr Arthur Spencer, 1948

Watts, George Frederick 1817–1904, *Near Brighton*, part of the original G. F. Watts Memorial Collection. Bequeathed, 1905

Watts, George Frederick 1817–1904, *Olympus on Ida*, gift from Mrs Michael Chapman (née Lilian Macintosh), 1946

Watts, George Frederick 1817–1904, *Rachel Gurney*, gift from Mrs Michael Chapman (née Lilian Macintosh), 1946

Watts, George Frederick 1817–1904, *After the Deluge*, part of the original G. F. Watts Memorial Collection. Bequeathed, 1905

Watts, George Frederick 1817–1904, *Study for 'Achilles and Briseis'*

Watts, George Frederick 1817–1904, *Study for 'Corialanus'*

Watts, George Frederick 1817–1904, *The Death of Cain*, part of the original G. F. Watts Memorial Collection. Bequeathed, 1905

Watts, George Frederick 1817–1904, *A Sea Ghost*, part of the original G. F. Watts Memorial Collection. Bequeathed, 1905

Watts, George Frederick 1817–1904, *Egyptian Landscape*, gift from Mrs Michael Chapman (née Lilian Macintosh), 1946

Watts, George Frederick 1817–1904, *Mrs G. F. Watts*, bequeathed by Mrs Edward Liddel, 1931

Watts, George Frederick 1817–1904, *Mrs G. F. Watts*, gift from Mrs Michael Chapman (née Lilian Macintosh), 1946

Watts, George Frederick 1817–1904, *Mrs G. F. Watts in a Straw Hat*, purchased from Sotheby's with the assistance of the National Art Collections Fund, 2004

Watts, George Frederick 1817–1904, *Peace and Goodwill*, part of the original G. F. Watts Memorial

Collection. Bequeathed, 1905
Watts, George Frederick 1817–1904, *Self Portrait, Aged 24*, gift from Mrs Michael Chapman (née Lilian Macintosh), 1946
Watts, George Frederick 1817–1904, *Sunset on the Nile*, purchased from the Maas Gallery
Watts, George Frederick 1817–1904, *The All-Pervading*
Watts, George Frederick 1817–1904, *The Sphinx*, part of the original G. F. Watts Memorial Collection. Bequeathed, 1905
Watts, George Frederick 1817–1904, *Recording Angel*, gift from Mrs Michael Chapman (née Lilian Macintosh), 1946
Watts, George Frederick 1817–1904, *Sunset on the Alps*, part of the original G. F. Watts Memorial Collection. Bequeathed, 1905
Watts, George Frederick 1817–1904, *The Alps near Monnetier*, part of the original G. F. Watts Memorial Collection. Bequeathed, 1905
Watts, George Frederick 1817–1904, *Progress*, part of the original G. F. Watts Memorial Collection. Bequeathed, 1905
Watts, George Frederick 1817–1904, *Naples*, gift from Mrs Michael Chapman (née Lilian Macintosh), 1946 (originally part of the Memorial Collection)
Watts, George Frederick 1817–1904, *The Bay of Naples*, part of the original G. F. Watts Memorial Collection. Bequeathed, 1905
Watts, George Frederick 1817–1904, *Lila Prinsep*, on long-term loan
Watts, George Frederick 1817–1904, *Patient Life of Unrequited Toil*, part of the original G. F. Watts Memorial Collection. Bequeathed, 1905
Watts, George Frederick 1817–1904, *Evening Landscape*, bequeathed by Cecil French, 1955
Watts, George Frederick 1817–1904, *Sympathy*, part of the original G. F. Watts Memorial Collection. Bequeathed, 1905
Watts, George Frederick 1817–1904, *Love Triumphant*, part of the original G. F. Watts Memorial Collection. Bequeathed, 1905
Watts, George Frederick 1817–1904, *'For he had great possessions'*
Watts, George Frederick 1817–1904, *In the Land of Weissnichtwo*, part of the original G. F. Watts Memorial Collection. Bequeathed, 1905
Watts, George Frederick 1817–1904, *Earth*, part of the original G. F. Watts Memorial Collection. Bequeathed, 1905
Watts, George Frederick 1817–1904, *Outcast Goodwill*, part of the original G. F. Watts Memorial Collection. Bequeathed, 1905
Watts, George Frederick 1817–1904, *John Burns*
Watts, George Frederick 1817–1904, *Can These Bones Live?*,

part of the original G. F. Watts Memorial Collection. Bequeathed, 1905
Watts, George Frederick 1817–1904, *George Andrews*, part of the original G. F. Watts Memorial Collection. Bequeathed, 1905
Watts, George Frederick 1817–1904, *A Dedication*, part of the original G. F. Watts Memorial Collection. Bequeathed, 1905
Watts, George Frederick 1817–1904, *Evolution*, part of the original G. F. Watts Memorial Collection. Bequeathed, 1905
Watts, George Frederick 1817–1904, *Invernesshire Landscape (Loch Ruthven)*, purchased from Mrs Michael Chapman (née Lilian Macintosh), 1958
Watts, George Frederick 1817–1904, *Seen from the Train*, part of the original G. F. Watts Memorial Collection. Bequeathed, 1905
Watts, George Frederick 1817–1904, *Study of Moorland, Invernesshire*, probably gift from Mrs Michael Chapman (née Lilian Macintosh), 1946
Watts, George Frederick 1817–1904, *The Right Honourable Gerald Balfour*
Watts, George Frederick 1817–1904, *Love Steering the Boat of Humanity*, gift from Mrs Michael Chapman (née Lilian Macintosh), 1946 (originally part of the Memorial Collection)
Watts, George Frederick 1817–1904, *Sun, Earth and Their Daughter Moon*, part of the original G. F. Watts Memorial Collection. Bequeathed, 1905
Watts, George Frederick 1817–1904, *Industry and Greed*, part of the original G. F. Watts Memorial Collection. Bequeathed, 1905
Watts, George Frederick 1817–1904, *Orpheus and Euridice*, part of the original G. F. Watts Memorial Collection. Bequeathed, 1905
Watts, George Frederick 1817–1904, *Fugue*, given by Mary Seton Watts in exchange for another picture from the original core collection of 109 works, 1908
Watts, George Frederick 1817–1904, *The Slumber of the Ages*, part of the original G. F. Watts Memorial Collection. Bequeathed, 1905
Watts, George Frederick 1817–1904, *Autumn*, gift from Mrs Michael Chapman (née Lilian Macintosh), 1946
Watts, George Frederick 1817–1904, *Sower of the Systems*, part of the original G. F. Watts Memorial Collection. Bequeathed, 1905
Watts, George Frederick 1817–1904, *End of the Day (Surrey Woodland)*, gift from Mrs Michael Chapman (née Lilian Macintosh), 1946
Watts, George Frederick 1817–1904, *Surrey Woodland*, gift from Mrs Michael Chapman (née Lilian Macintosh), 1946

Watts, George Frederick 1817–1904, *A Parasite*, part of the original G. F. Watts Memorial Collection. Bequeathed, 1905
Watts, George Frederick 1817–1904, *C. J. G. Montefiore*
Watts, George Frederick 1817–1904, *Endymion*, given by Mary Seton Watts in exchange for another picture from the original core collection of 109 works, 1908
Watts, George Frederick 1817–1904, *Green Summer*, given by Mary Seton Watts in exchange for another picture from the original core collection of 109 works, 1908
Watts, George Frederick 1817–1904, *Mother and Child*, part of the original G. F. Watts Memorial Collection. Bequeathed, 1905
Watts, George Frederick 1817–1904, *Self Portrait in Old Age*, gift from Mrs Michael Chapman (née Lilian Macintosh), 1946
Watts, George Frederick 1817–1904, *Destiny*, part of the original G. F. Watts Memorial Collection. Bequeathed, 1905
Watts, George Frederick 1817–1904, *Iris*, gift from Mrs Michael Chapman (née Lilian Macintosh), 1946
Watts, George Frederick 1817–1904, *Lilian*, given by Mary Seton Watts in exchange for another picture from the original core collection of 109 works, 1908
Watts, George Frederick 1817–1904, *Prometheus*, part of the original G. F. Watts Memorial Collection. Bequeathed, 1905
Watts, George Frederick 1817–1904, *A Fragment*
Watts, George Frederick 1817–1904, *Death with Two Angels*, gift from Mrs Michael Chapman (née Lilian Macintosh), 1946
Watts, George Frederick 1817–1904, *Lady Halle*
Watts, George Frederick 1817–1904, *Magdalen*, purchased, 1961
Watts, George Frederick 1817–1904, *Malta*
Watts, George Frederick 1817–1904, *Monochrome Study*
Watts, George Frederick 1817–1904, *Nude Standing (The Pool)*
Watts, George Frederick 1817–1904, *Portrait of a Small Girl with Fair Hair and Full Face*
Watts, George Frederick 1817–1904, *Portrait of an Unknown Lady (possibly Lilian Macintosh)*
Watts, George Frederick 1817–1904, *Prince de Joinville (1818–1900)*, gift from Mrs Michael Chapman (née Lilian Macintosh), 1946 (originally part of the Memorial Collection)
Watts, George Frederick 1817–1904, *Psyche*
Watts, George Frederick 1817–1904, *St George*, bequeathed by Sir Weldon Dalrymple-Champneys, 1981
Watts, George Frederick 1817–1904, *Study for 'Lady Godiva'*
Watts, George Frederick 1817–

1904, *Study for 'The Messenger'*
Watts, George Frederick 1817–1904, *Study of Armour*, part of the original G. F. Watts Memorial Collection. Bequeathed, 1905
Watts, George Frederick 1817–1904, *Study of Armour*, part of the original G. F. Watts Memorial Collection. Bequeathed, 1905
Watts, George Frederick 1817–1904, *The Countess of Kenmare (My Lady Peacock)*, gift from Mrs Michael Chapman (née Lilian Macintosh), 1946
Watts, George Frederick 1817–1904, *The Wine-Bearer*, gift from Mrs Michael Chapman (née Lilian Macintosh), 1946
Watts, George Frederick 1817–1904, *Unknown Landscape*
Watts, George Frederick 1817–1904, *Unknown Landscape, possibly Ireland*
Watts, George Frederick 1817–1904, *Unknown Portrait (possibly Lady Somers or Lady Lothian)*
Watts, George Frederick 1817–1904, *View from Monkshatch, Compton*

Watts Mortuary Chapel

Watts, George Frederick 1817–1904, *The All-Pervading*, possibly a gift to the parish when the chapel was complete, 1904

Yvonne Arnaud Theatre

Charters, Cecil *Yvonne Arnaud (1890–1958)*, presented by Mrs M. Dutton

Haslemere Educational Museum

Aborn, John d.1915, *Country Scene with Caravans and Peasants*, gift from Mrs H. Montaner, 1991
Ainsworth *Fungi*
S. E. B. *The Fish Shop, Haslemere*, gift from A. Williamson, 1964
Chandler, Allen 1887–1969, *Ann*
Chandler, Allen 1887–1969, *Opposite Shottermill*
Chandler, Allen 1887–1969, *A Woodland Industry (Glass Production)*
Chandler, Allen 1887–1969, *Early Old Stone Age*
Chandler, Allen 1887–1969, *Later Old Stone Age*
Chandler, Allen 1887–1969, *New Stone Age*
Cooper, Byron 1850–1933, *Blackdown from Hascombe*, gift from Mr G. G. Cooper, 1961
Cooper, Byron 1850–1933, *Aldworth*, gift from Mr G. G. Cooper, 1961
Cooper, Byron 1850–1933, *Freshwater Bay, Summer Moonlight*, gift from Mr G. G. Cooper, 1961
Cooper, Byron 1850–1933, *Freshwater Church*, gift from Mr G.

G. Cooper, 1961
Cooper, Byron 1850–1933, *Moonrise from the Downs*, gift from Mr G. G. Cooper, 1961
Cooper, Byron 1850–1933, *Stream through Countryside*, gift from Mr G. G. Cooper, 1961
Cooper, Byron 1850–1933, *Tennyson's Private Road from the Downs*, gift from Mr G. G. Cooper, 1961
Cooper, Byron 1850–1933, *The Brook*, gift from Mr G. G. Cooper, 1961
Cooper, Byron 1850–1933, *Moonrise on the Old Canal, Bude*, gift from Mr G. G. Cooper, 1961
Cooper, Byron 1850–1933, *Brook, May Morning*, gift from Mr G. G. Cooper, 1961
Cooper, Byron 1850–1933, *A Quiet Pool, near Haslemere*, gift from Mr G. G. Cooper, 1961
Cooper, Byron 1850–1933, *Sussex Weald*, gift from Mr G. G. Cooper, 1961
Cooper, Byron 1850–1933, *Barley Field*, gift from Mr G. G. Cooper, 1961
Cooper, Byron 1850–1933, *Gull Rock, Tintagel*, gift from Mr G. G. Cooper, 1961
Cooper, Byron 1850–1933, *In the Woods*, gift from Mr G. G. Cooper, 1961
Cooper, Byron 1850–1933, *Maple Tree*, gift from Mr G. G. Cooper, 1961
Cooper, Byron 1850–1933, *Moonlit Atlantic from Tintagel*, gift from Mr G. G. Cooper, 1961
Cooper, Byron 1850–1933, *Near Haslemere, Sunset*, gift from Mr G. G. Cooper, 1961
Cooper, Byron 1850–1933, *On the Cliffs, Tintagel*, gift from Mr G. G. Cooper, 1961
Cooper, Byron 1850–1933, *Solent from Farringford*, gift from Mr G. G. Cooper, 1961
Cooper, Byron 1850–1933, *Summer Moonlight*, gift from Mr G. G. Cooper, 1961
Cooper, Byron 1850–1933, *The Birches*, gift from Mr G. G. Cooper, 1961
Cooper, Byron 1850–1933, *The Poppy Field*, gift from Mr G. G. Cooper, 1961
Cooper, Byron 1850–1933, *Tintagel Coast*, gift from Mr G. G. Cooper, 1961
Cooper, Byron 1850–1933, *View from Farringford*, gift from Mr G. G. Cooper, 1961
Cooper, Byron 1850–1933, *View from Farringford*, gift from Mr G. G. Cooper, 1961
Cooper, Byron 1850–1933, *View of a Sunset over Water by a Tree*, gift from Mr G. G. Cooper, 1961
Cooper, Byron 1850–1933, *View of Countryside Hills*, gift from Mr G. G. Cooper, 1961
Cooper, Byron 1850–1933, *View over a Pool*, gift from Mr G. G. Cooper, 1961
Cummings, Vera 1891–1949, *Portrait of a Maori Woman*, gift from Mr T. Harper
Dicksee, Frank 1853–1928, *Miss*

Edith Fitton, bequeathed by Mrs Lillian Fitton, 1951
Dobie, Joan *Waggoners Wells*, gift from Ted Orchard, 2005
Ewbank, S. *Pass of Elsinore*
Gridnev, Valery b.1956, *Fisherman*, gift from Ted Orchard, 2005
Hill, J. R. *View of Cottage Surrounded by Woodland*
Leizle, Eric *The Devil's Punchbowl*, gift from Mrs Barbara Dell, 1998
Nilsson, Johannes 1757–1827, *The Three Kings and the Wise and Foolish Virgins*, gift from Haslemere Peasant Handicraft Museum, 1926
Potter, Violet *Potter (after George Romney)*, gift from Mrs J. Dodge, 1998
Prossen, Henry *Killinghurst, Haslemere*, gift from Elkins
Storr, Milton active 1888–1891, *Cottage with a Man, Woman and a Dog*, bequeathed by C. G. Stephens, 1971
Swedish School *The Three Kings and the Wise and Foolish Virgins*, gift from Haslemere Peasant Handicraft Museum, 1926
Swedish School *The Three Kings and the Wise and Foolish Virgins*, gift from Haslemere Peasant Handicraft Museum, 1926
Swedish School *The Three Kings and the Wise and Foolish Virgins*, gift from Haslemere Peasant Handicraft Museum, 1926
Swedish School *The Three Kings and the Wise and Foolish Virgins*, gift from Haslemere Peasant Handicraft Museum, 1926
Tomes, Marjorie *On the Beach*, purchased, 2001
Tomes, Marjorie *The Anniversary*, purchased, 2001
Tomes, Marjorie *Two Men and Two Women Sitting in Deckchairs*, purchased, 2001
unknown artist *The London to Chichester Coach on Shepherd's Hill, Haslemere*, gift from Dr Rolston, 1948
unknown artist *New Mill*
unknown artist late 19th C, *Beach Scene*
unknown artist late 19th C, *Woodland Scene by a Lake*
unknown artist *Hammer Valley*
unknown artist *Haslemere Society of Artists Exhibition: Landscape*
unknown artist *Landscape of Iceland*
unknown artist *Landscape of Iceland*
unknown artist *Portrait of a Man*
unknown artist *Study of Dead Game Bird*
unknown artist *The Pigsties, Inval*
unknown artist *Winter Landscape with Reindeer and Sledges*
Whymper, Emily 1833–1886, *Still Life*, gift from Miss E. Morrish, 1970
Williams, Juliet Nora d.1937, *Winter Morning*, gift from Miss J. Williams, 1955
Wolski, Stanislaw Polian 1859–1894, *Winter Landscape with Horse Drawn Carriage*

Surrey County Council

Birch, David 1895–1968, *Morning in June, the Vale of Dedham*
Bloemen, Jan Frans van 1662–1749, *View of Rome from the Baberini Palace*, presented to Surrey County Council by H. M. Chester of Poyle Park, Tongham, Surrey, 1902
Bone, Charles b.1926, *Oxenford Grange, Peper Harow*, © courtesy of the artist/www.bridgeman.co.uk
Briggs, Henry Perronet (circle of) 1791/1793–1844, *John Leech*
Brooks, Henry Jamyn 1865–1925, *Sir William Vincent, Bt*
Carter, William 1863–1939, *Henry Yool Esq.*
Carter, William 1863–1939, *Edward Joseph Halsey*
Carter, William 1863–1939, *The Right Honourable St John Broderick, 9th Viscount Midleton*
Carter, William 1863–1939, *Thomas Weeding Weeding (1847–1929)*
Chamberlin, Mason the elder (circle of) 1727–1787, *Richard, 3rd Earl of Onslow*
Clay, Arthur 1842–1928, *Sir William Hardman, QC*
Daniels, Alfred b.1924, *Boats Moored on the River Thames*
Fildes, Luke (after) 1844–1927, *King Edward VII (1841–1910)*
Gunn, Herbert James 1893–1964, *Sir Lawrence Edward Halsey, KBE, JP*, © the artist's estate
Herkomer, Herman 1863–1935, *Edward Hugh Leycester Penrhyn, First Chairman of Surrey County Council (1889–1893)*
Jervas, Charles (style of) c.1675–1739, *Thomas Onslow, 2nd Lord Onslow (1680–1740)*
Kneller, Godfrey (style of) 1646–1723, *Sir Richard Onslow, 1st Lord Onslow (1654–1717)*
Llewellyn, William Samuel Henry 1854–1941, *The Right Honourable Lord Ashcombe, CB, TD*
Noakes, Michael b.1933, *The Right Honourable James Chuter Ede, CH, JP, DL*, © the artist
Phillips, Thomas 1770–1845, *Florance Young Esq.*
Ramsay, Allan (studio of) 1713–1784, *King George III (1738–1820)*, gift from Sir Joseph Lawrence, 1913
Ramsay, Allan (studio of) 1713–1784, *Queen Charlotte (1744–1818)*, gift from Sir Joseph Lawrence, 1913
Stewardson, Thomas 1781–1859, *The Right Honourable George, 4th Baron and 1st Earl of Onslow*
Symonds, William Robert 1851–1934, *The Right Honourable George Viscount Cave, CC, MC*

Leatherhead and District Local History Society

unknown artist *Mickleham Church*, gift from Mr Dowland, 1985
unknown artist *Mr S. Maw*

The Guest House, Lingfield Library

Akehurst, R. D. *Lingfield Coronation Decorations*

Oxted Library

Christie, Ernest C. (attributed to) 1863–1937, *Kentish Farm, E. Christie War Coppice*, on long-term loan from the Bourne Society
Christie, Ernest C. (attributed to) 1863–1937, *Prucks Works at Links Corner, Limpsfield (now demolished)*, on long-term loan from the Bourne Society
Christie, Ernest C. (attributed to) 1863–1937, *View of Pond Gate and Farm*, on long-term loan from the Bourne Society

Tandridge District Council

Collier, John 1850–1934, *Colonel Arthur Stuart Daniel, Chairman of Godstone Rural District Council (1900–1935)*
Grace, Harriet Edith active 1877–1909, *William Garland Soper, First Chairman of Caterham & Warlingham Urban District Council (1899–1908)*
Curzon-Price, Paddy *Councillor Mrs M. D. Wilks, First Lady Chair of Tandridge District Council (1977–1978)*
unknown artist *Marjory Pease, JP (1911–1947)*
unknown artist *Old Oxted*

East Surrey Hospital

Dorman, Ernest A. b.1928, *Darkness on Face of the Deep*, gift from the artist, 1999, © the artist
Dorman, Ernest A. b.1928, *Earth without Form and Void*, gift from the artist, 1999, © the artist
Dorman, Ernest A. b.1928, *Gathering of the Waters unto One Place and Dry Land Appearing*, gift from the artist, 1999, © the artist
Dorman, Ernest A. b.1928, *God Created Lights to Rule the Day and Night*, gift from the artist, 1999, © the artist
Dorman, Ernest A. b.1928, *Let There Be Light*, gift from the artist, 1999, © the artist
Dorman, Ernest A. b.1928, *Produce of the Earth by Nature and Creation of Every Living Creature*, gift from the artist, 1999, © the artist
Dorman, Ernest A. b.1928, *The Four Seasons, Winter*, gift from the artist, 1999, © the artist
Dorman, Ernest A. b.1928, *The Four Seasons, Spring*, gift from the artist, 1999, © the artist
Dorman, Ernest A. b.1928, *The Four Seasons, Summer*, gift from the artist, 1999, © the artist
Dorman, Ernest A. b.1928, *The Four Seasons, Autumn*, gift from the artist, 1999, © the artist

Dorman, Ernest A. b.1928, *Winter Tree*, gift from the artist, 1999, © the artist
Moosajee, Mariya *A Not So Funny Bone*, commissioned by East Surrey Hospital Arts Project, 2004
Moosajee, Mariya *High Heels and Fashion Fractures*, commissioned by East Surrey Hospital Arts Project, 2004
Moosajee, Mariya *Rugby Kicks and Patella Nicks*, commissioned by East Surrey Hospital Arts Project, 2004
Shepherd, Frank *Pastoral Scene via Open Window*, commissioned and purchased by East Surrey Hospital Arts Project, 2003
Stevens active mid-20th C, *Seascape*, donated by an ex-patient

Holmsdale Natural History Club

unknown artist early 19th C, *Portrait of a Man (possibly Baron von Humbolt)*, gift from Mrs Prentice (believed to be Baron von Humboldt), 1862
unknown artist 19th C, *Portrait of an Unknown Victorian Lady*

Reigate & Banstead Borough Council

Gogin, Alma 1854–1948, *Regrets*, presented by Mr Charles Gogin
Hooper, George 1910–1994, *The Garden at Loxwood, Redhill*
Little, George Leon 1862–1941, *Cows in a Landscape*
Little, George Leon 1862–1941, *Evening Lake Scene*
Little, George Leon 1862–1941, *Sheep in a Landscape*
Wells, Henry Tanworth 1828–1903, *Loading at the Quarry, Holmbury Hill*, presented by Mrs J. M. Hadley

Reigate Priory Museum

British (English) School *John Lymden (elected 1530, surrendered 1536), the Last Prior of Reigate*, purchased for a token sum from the Honourable Sir George Bellows, KCB, KCVO, 1974
Noakes, Michael b.1933, *F. E. Claytor, Headmaster (1948–1957)*, possibly presented to the school, © the artist

Send and Ripley Museum

Baigent, R. active c.1920–c.1940, *Newark Mill, Ripley, Surrey*, gift from Roland Mells, 1985
Brown, Frank active 1950s–1970s, *Ripley Village*, gift from Mrs Hilary Street, 1995

Spelthorne Borough Council

Marion *At Sea 1*, acquired, 1974
Marion *At Sea 2*, acquired, 1974

Spelthorne Museum

unknown artist *Cottages in Thames Street*, donated
Vasey, M. *A Mother's Rosary*, donated
Winfield, G. E. *A Cottage on the Corner of Manygate Lane and Rope Walk, Shepperton*, donated
Winfield, G. E. *A Cottage on the Corner of Manygate Lane and Rope Walk, Shepperton*, donated

Sunbury Library

The Sunbury Art Group *The Thames at Sunbury*, presented to the library by the Sunbury Art Group, 1968

Dittons Library

Freeman, William c.1838–1918, *Thames Villa*
Freeman, William c.1838–1918, *'The Swan' at Claygate*
Freeman, William c.1838–1918, *'The White Lion', Esher*
Freeman, William c.1838–1918, *High Street, Thames Ditton?*
P. W. J. active mid-20th C, *'Ye Olde Swan', Thames Ditton?*, donated by P. J. Whitehorn
Stevens, Thomas active 1889–1893, *Cottage at Weston Green*
Stevens, Thomas active 1889–1893, *Weston Green Pond*

Warlingham Library, Lockton Collection

Lockton, Charles Langton 1856–1932, *All Saints' Church, North-West, before Enlargement*, bequeathed to the parish of Warlingham
Lockton, Charles Langton 1856–1932, *All Saints' Church, South Side, before Enlargement*, bequeathed to the parish of Warlingham
Lockton, Charles Langton 1856–1932, *Cottage on the Corner of Westhall Road and Ridley Road (demolished in 1898), Site of 'Teeton', the Artist's Home*, bequeathed to the parish of Warlingham
Lockton, Charles Langton 1856–1932, *Westhall Road, Corner of Workhouse Lane (now Hillbury Road)*, bequeathed to the parish of Warlingham
Lockton, Charles Langton 1856–1932, *Cottage between 'The Leather Bottle' and Mill House*, bequeathed to the parish of Warlingham
Lockton, Charles Langton 1856–1932, *'The Leather Bottle', with Butcher's Shop on the Left as it*

was in the 1880s, bequeathed to the parish of Warlingham

Lockton, Charles Langton 1856–1932, *All Saints' Church*, bequeathed to the parish of Warlingham, 1970

Lockton, Charles Langton 1856–1932, *All Saints' Church, Footpath from Village*, bequeathed to the parish of Warlingham

Lockton, Charles Langton 1856–1932, *All Saints' Church, Footpath from Village*, bequeathed to the parish of Warlingham

Lockton, Charles Langton 1856–1932, *Hamsey Green Pond*, bequeathed to the parish of Warlingham

Lockton, Charles Langton 1856–1932, *'The White Lion' as it was in the 1880s*, bequeathed to the parish of Warlingham

Lockton, Charles Langton 1856–1932, *Village Green, South-East Corner*, bequeathed to the parish of Warlingham

Lockton, Charles Langton 1856–1932, *Westhall Road, Warlingham (near Searchwood Road)*, bequeathed to the parish of Warlingham

Lockton, Charles Langton 1856–1932, *Tydcombe Farm*, bequeathed to the parish of Warlingham

Lockton, Charles Langton 1856–1932, *Blanchman's Farm from the South-East*, bequeathed to the parish of Warlingham

Lockton, Charles Langton 1856–1932, *Shops on the Village Green*, bequeathed to the parish of Warlingham

Lockton, Charles Langton 1856–1932, *Warlingham Vicarage*, donated, 1981

Lockton, Charles Langton 1856–1932, *All Saints' Church*, bequeathed to the parish of Warlingham

Lockton, Charles Langton 1856–1932, *All Saints' Church, before Enlargement*, bequeathed to the parish of Warlingham

Lockton, Charles Langton 1856–1932, *Alms Houses, Leas Road*, bequeathed to the parish of Warlingham

Lockton, Charles Langton 1856–1932, *Baker's Wheelrights Shop on Farleigh Road*, bequeathed to the parish of Warlingham

Lockton, Charles Langton 1856–1932, *Barn and Post Office Cottage by 'The White Lion'*, bequeathed to the parish of Warlingham

Lockton, Charles Langton 1856–1932, *Barn between Glebe Road and 'The White Lion' (long since demolished)*, bequeathed to the parish of Warlingham

Lockton, Charles Langton 1856–1932, *Blanchard's Smithy, Farleigh Road*, bequeathed to the parish of Warlingham

Lockton, Charles Langton 1856–1932, *Bug Hill Road (Now Leas Road)*, bequeathed to the parish of Warlingham

Lockton, Charles Langton 1856–1932, *Bug Hill Road from the Village (Leas Road)*, bequeathed to the parish of Warlingham

Lockton, Charles Langton 1856–1932, *Cottage, Westhall Road, Demolished 1898 (The site of the artist's house 'Teeton')*, bequeathed to the parish of Warlingham

Lockton, Charles Langton 1856–1932, *Cottages and Baker's Wheelrights, Farleigh Road*, bequeathed to the parish of Warlingham

Lockton, Charles Langton 1856–1932, *Cottages and Baker's Wheelrights, Farleigh Road*, bequeathed to the parish of Warlingham

Lockton, Charles Langton 1856–1932, *Cottages between 'The Leather Bottle' and Mill House*, bequeathed to the parish of Warlingham

Lockton, Charles Langton 1856–1932, *Court Cottage, North Side (front view), Hamsey Green*, bequeathed to the parish of Warlingham

Lockton, Charles Langton 1856–1932, *Court Cottage, South Side (rear view), Hamsey Green*, bequeathed to the parish of Warlingham

Lockton, Charles Langton 1856–1932, *Crewes Cottages, opposite 'The Leather Bottle'*, bequeathed to the parish of Warlingham

Lockton, Charles Langton 1856–1932, *Horseshoe Cottages, Side/Rear View from Mint Walk, Farleigh Road*, bequeathed to the parish of Warlingham

Lockton, Charles Langton 1856–1932, *Post Office on North-East Side of the Green next to 'The White Lion' Cottage*, bequeathed to the parish of Warlingham

Lockton, Charles Langton 1856–1932, *Side/Rear view of Horseshoe Cottages from Mint Walk*, bequeathed to the parish of Warlingham

Lockton, Charles Langton 1856–1932, *The Font, All Saints' Church*, bequeathed to the parish of Warlingham, 1970

Lockton, Charles Langton 1856–1932, *The Forge, Farleigh Road*, bequeathed to the parish of Warlingham

Lockton, Charles Langton 1856–1932, *'The Leather Bottle' as it was in the 1880s*, bequeathed to the parish of Warlingham

Lockton, Charles Langton 1856–1932, *'The White Lion' as it was in the 1880s*, bequeathed to the parish of Warlingham

Lockton, Charles Langton 1856–1932, *Tydcombe Farm*, bequeathed to the parish of Warlingham

Lockton, Charles Langton 1856–1932, *Tydcombe Farm*, bequeathed to the parish of Warlingham

Lockton, Charles Langton 1856–1932, *Tydcombe Farm from the North-West*, bequeathed to the parish of Warlingham

Lockton, Charles Langton 1856–1932, *Unidentified Farm Buildings (possibly Crewes Farm)*, bequeathed to the parish of Warlingham

Lockton, Charles Langton 1856–1932, *Village Green, South-East Corner*, bequeathed to the parish of Warlingham

Lockton, Charles Langton 1856–1932, *Webbs Cottage, Farleigh Road*, bequeathed to the parish of Warlingham

Lockton, Charles Langton 1856–1932, *Westhall Cottage*, bequeathed to the parish of Warlingham

Lockton, Charles Langton 1856–1932, *Westhall Road (Narrow Lane to Right)*, bequeathed to the parish of Warlingham

Lockton, Charles Langton 1856–1932, *Woodland Scene*, bequeathed to the parish of Warlingham

Lockton, Charles Langton 1856–1932, *Woodland Scene*, bequeathed to the parish of Warlingham

Molesey Library

Helcke, Arnold active 1880–1911, *The Bridge over the Mole*, donated by Veronica Tudor-Williams

Brooklands Museum

Allison, Jane b.1959, *Sir George Edwards (1909–2003)*, donated, © the artist

Alton, Martin b.1957, *Vertical Reality*, donated, © the artist

Aveline, Josephine b.1914, *Hugh Locke King (1856–1926)*, on loan from the Brooklands Society

Boorer, Norman 1916–2004, *Prototype Wellington*, donated

Bromley, Mark *Avro Lancaster*, donated

Broomfield, Keith *Aircraft Designs from Weybridge and Kingston British Aerospace Projects Office since the 1940s*, donated

Broomfield, Keith *Some Aircraft in which Weybridge Design Office Has Been Involved since 1948*, donated

Burnside, Dudley 1912–2005, *Wellingtons in Hangar*, purchased, © the artist's estate

Carless active 20th C, *Hunters Attacking Tanks*, donated

Gaunt, David *Grindlay Peerless on Track*, on loan fom the artist

Hitchman, Fred (attributed to) d.1975, *SE5a in First World War Dogfight*, donated

Linnell, John 1792–1882, *Lady King*, on loan from the Harvey family

Lovesey, Roderick b.1944, *Incident in the Battle*, donated

Miller, Edmund b.1929, *Wellington on Airfield*, donated, © the artist

Nockolds, Roy Anthony 1911–1979, *Breaking the Brooklands Track Record, Kaye Don in Sunbeam*, donated

Nockolds, Roy Anthony 1911–1979, *Bentley on Banking*, on loan from the Brooklands Society

Nockolds, Roy Anthony 1911–1979, *Napier-Railton and Duesenberg on Banking*, on loan from the Brooklands Society

Preston, L. A. *Flight of Wellington Bombers over Airfield at Dusk*, donated

Reid Taylor, Alistair d.c.1993, *Green Racing Car No.6 (possibly a Lotus)*

Reid Taylor, Alistair d.c.1993, *Blue and White Racing Car No.4*

Reid Taylor, Alistair d.c.1993, *Blue Veteran Car*, donated

Reid Taylor, Alistair d.c.1993, *ERA No.6*, donated

Reid Taylor, Alistair d.c.1993, *Three Cars Racing on Brooklands Banking (seen from behind)*, donated

Reid Taylor, Alistair d.c.1993, *Yellow Racing Car No.3*

Reid Taylor, Alistair d.c.1993, *Ronnie Peterson Driving Orange Formula 1 Racing Car*

Reid Taylor, Alistair d.c.1993, *Three Formula 1 Racing Cars (seen from behind)*

Robertson, Duncan *Wellington 'R' for 'Robert' on Daytime Raid*, donated

Smith, David T. *Wellington Maintenance Scene*, purchased

Steel, Roger b.1928, *Jeffrey Quill, OBE, AFC*, donated

Steel, Roger b.1928, *First Flight of the Spitfire*, donated

Sturgess, Arthur c.1930–c.1995, *'Defender of this Sceptred Isle', Spitfire over the Needles*, donated

Sturgess, Arthur c.1930–c.1995, *'R' for 'Robert'*, donated

Surman, David *Wellington 'R' for 'Robert' Ditching in Loch Ness*, donated

Tootall, Ray *Sir Thomas Sopwith*, purchased

Turner, Graham b.1964, *A. V. Roe's First Flight*, on loan from the Verdon-Roe family

unknown artist *Sir Thomas Gore-Brown*, on loan from the Harvey family

unknown artist *Sir Percival Perry, Founder, Ford of Britain*, on loan from the Ford Motor Co.

unknown artist *Storm over Benevenagh*, donated

unknown artist *Wellington 'R' for 'Robert' Ditched in Loch Ness*, donated

unknown artist 20th C, *Hawker Horsley Biplanes in Flight*, donated

unknown artist *Tail Fin Section on Tow*, donated

Waller, Claude b.c.1920, *Vickers Valiant Night Scene*, donated

Waller, Claude b.c.1920, *Tiger Moth over Brooklands*, donated

Weekley, Barry active 1993–2006, *Wellington 'R' for 'Robert' in Flight*

Wells, Henry Tanworth 1828–1903, *Peter Locke King*, on loan from Elmbridge Borough Council

Wilson, Colin b.1949, *Hurricane Landing*, donated

Wootton, Frank 1914–1998, *BOAC Shorts S45A Solent Seaplane, 'Salisbury'*, donated, © the artist's estate

Elmbridge Museum

Bradley *Robert Gill, Railway Pioneer (1796–1871)*, gift from the estate of Mrs Madeline Allen, née Gill, 1986

Brewer, Derek *Cedar House, Cobham*, purchased as part of the Millennium Art Project 'Painting for Posterity' scheme funded by the R. C. Sherriff Rosebriars Trust, 2000

Butler, Villers *Amy Gentry, OBE*, on loan from Weybridge Ladies Rowing Club

Cobb, Charles David b.1921, *HM Torpedo Boat 2015*, donated to the Museum by the Mayor's Secretary, 1985

Dalby, John 1810–1865, *A White Horse with Dappled Legs Standing in a Stable*, gift, 1986

Dawson, M. *Cobham Mill with Houses on Right Bank of a River in the Distance*, purchased after being exhibited at the Thames Valley Art Society's annual exhibition at Kingston Library and Museum, 1974

Edwards (attributed to) *Going to the Post, Goodwood*, on loan

Ewan, Eileen *Swans on the River Wey*, purchased by Avril Lansdell (former Curator of Museum) from Weybridge Arts Society, c.1983

Godfrey, J. *A View of St George's Hill, with Dead Man's Pool in the Foreground*, on permanent loan from Mr Herringshaw

Gray, M. *Esher Road, Showing a Rustic Bridge (now demolished)*, donated anonymously to the Museum via Weybridge Library, 1982

Grosvenor, Jennifer b.1931, *Oxshott Station*, purchased as part of the Millennium Art Project 'Painting for Posterity' scheme funded by the R. C. Sherriff Rosebriars Trust, 2000, © the artist

Hobbes, Ian b.1969, *Cardinal Godfrey School, Sunbury*

Houssard, Charles 1884–1958, *Weybridge Park College*, possibly a gift from Peter Curchod, 1996

Lefevre, M. *The Lock-Keeper's Cottage by the Oil Mills on the River Wey*, gift, 1969

Lock, Edwin active 1929–1961, *The Duchess of York's Monument at Monument Green, Weybridge*, on long-term loan from Miss Lock

Lock, Edwin active 1929–1961, *An Old Chestnut Tree, Which Stood near the 'Ship Inn', High Street, Weybridge*, on long term loan from Miss Lock

Lock, Edwin active 1929–1961, *Shops in the High Street: 'Sough & Son'*, on long-term loan from Miss Lock

Lock, Edwin active 1929–1961, *The Entrance to Springfield Lane*,

Weybridge, on long-term loan from Miss Lock

Outram, Lance *Robert John Brook Gill, Aged Two*, donated as part of the Gill family collection of objects and artefacts, 1985, on loan to Elmbridge Borough Council, Esher

Saunders, Jutta *The Wey Bridge*, purchased, 1970

Scott, Peter Markham 1909–1989, *Flying Geese*, purchased, 1909–1989, on loan from the Rosebriars Trust, © C. Philippa Scott

unknown artist *Lady Louisa Egerton, Wife of Admiral Francis Egerton*, gift, 1973

unknown artist *Beach and Seascape*

unknown artist *Hamm Court Farm, Weybridge*, on long-term loan from Miss Millson

unknown artist *John Phillip Fletcher, Son of Sir Henry Fletcher, of Ashley House, Walton*, gift from Walter Sarel, 1936, on loan to Elmbridge Borough Council, Esher

unknown artist *Maypole on Monument Green, with Figures in 18th Century Costume*, possibly a gift from Mrs Charles Routh, 1914

unknown artist *Portion of Fresco from East Wall of Old St James' Church*, gift, 1910

unknown artist *Prince Charles (b.1948)*, donated by the Borough Surveyor, 1980

unknown artist *Second Walton Bridge*, on loan from Walton Library

unknown artist *'The Newcastle Arms'*, donated to the Council by G. Jarvis & Co. Ltd, 1938

unknown artist *Walton Bridge, with a Cottage on the Left, (possibly 'The Angler's Rest') and a Boat Drawn Up on a Bank of Pebbles*, purchased from Mr G. H. Clark, Sutton, Surrey, 1967

Wallis, Nancy *Baker Street, Weybridge in 1880s (taken from a postcard)*, possibly a gift from Mrs K. Charge, 1972

Wilcox, Doreen *The Ruined Temple*, unclaimed after School Art Exhibition, c.1985

Williams, F. S. *The Weir*, presented by Mrs Lilian Roome, 1955

Surrey History Centre

Lowther, Micheal Angelo *Dog*, on long-term loan from the Dodgson Family Trustees

unknown artist *Dorking Church and Churchyard*, on long-term loan from the Rector and the Parochial Church Council

unknown artist *An Alpine Village*, gift

Sidney H. Sime Memorial Gallery

Sime, Sidney Herbert 1867–1941, *A River in Scotland*, bequeathed by the artist's wife as a memorial to

her husband, © the trustees of the Sidney Sime Memorial Gallery

Sime, Sidney Herbert 1867–1941, *Archway*, bequeathed by the artist's wife as a memorial to her husband, © the trustees of the Sidney Sime Memorial Gallery

Sime, Sidney Herbert 1867–1941, *Autumn Landscape with Pond*, bequeathed by the artist's wife as a memorial to her husband, © the trustees of the Sidney Sime Memorial Gallery

Sime, Sidney Herbert 1867–1941, *Autumn Trees*, bequeathed by the artist's wife as a memorial to her husband, © the trustees of the Sidney Sime Memorial Gallery

Sime, Sidney Herbert 1867–1941, *Autumn Trees*, bequeathed by the artist's wife as a memorial to her husband, © the trustees of the Sidney Sime Memorial Gallery

Sime, Sidney Herbert 1867–1941, *Bare Tree*, bequeathed by the artist's wife as a memorial to her husband, © the trustees of the Sidney Sime Memorial Gallery

Sime, Sidney Herbert 1867–1941, *Cloud over Hill*, bequeathed by the artist's wife as a memorial to her husband, © the trustees of the Sidney Sime Memorial Gallery

Sime, Sidney Herbert 1867–1941, *Clouds*, bequeathed by the artist's wife as a memorial to her husband, © the trustees of the Sidney Sime Memorial Gallery

Sime, Sidney Herbert 1867–1941, *Dark Lakeside*, bequeathed by the artist's wife as a memorial to her husband, © the trustees of the Sidney Sime Memorial Gallery

Sime, Sidney Herbert 1867–1941, *Dark Landscape*, bequeathed by the artist's wife as a memorial to her husband, © the trustees of the Sidney Sime Memorial Gallery

Sime, Sidney Herbert 1867–1941, *Dark Landscape*, bequeathed by the artist's wife as a memorial to her husband, © the trustees of the Sidney Sime Memorial Gallery

Sime, Sidney Herbert 1867–1941, *Dark Landscape*, bequeathed by the artist's wife as a memorial to her husband, © the trustees of the Sidney Sime Memorial Gallery

Sime, Sidney Herbert 1867–1941, *Dark Landscape*, bequeathed by the artist's wife as a memorial to her husband, © the trustees of the Sidney Sime Memorial Gallery

Sime, Sidney Herbert 1867–1941, *Dark Mountains and Boat*, bequeathed by the artist's wife as a memorial to her husband, © the trustees of the Sidney Sime Memorial Gallery

Sime, Sidney Herbert 1867–1941, *Dark Mountains and Water*, bequeathed by the artist's wife as a memorial to her husband, © the trustees of the Sidney Sime Memorial Gallery

Sime, Sidney Herbert 1867–1941, *Dark Pine Trees*, bequeathed by the artist's wife as a memorial to

her husband, © the trustees of the Sidney Sime Memorial Gallery

Sime, Sidney Herbert 1867–1941, *Dark Sky*, bequeathed by the artist's wife as a memorial to her husband, © the trustees of the Sidney Sime Memorial Gallery

Sime, Sidney Herbert 1867–1941, *Dark Sky Tinged White*, bequeathed by the artist's wife as a memorial to her husband, © the trustees of the Sidney Sime Memorial Gallery

Sime, Sidney Herbert 1867–1941, *Dark Sky with White Clouds*, bequeathed by the artist's wife as a memorial to her husband, © the trustees of the Sidney Sime Memorial Gallery

Sime, Sidney Herbert 1867–1941, *Dark Trees*, bequeathed by the artist's wife as a memorial to her husband, © the trustees of the Sidney Sime Memorial Gallery

Sime, Sidney Herbert 1867–1941, *Dark Trees*, bequeathed by the artist's wife as a memorial to her husband, © the trustees of the Sidney Sime Memorial Gallery

Sime, Sidney Herbert 1867–1941, *Dark Trees*, bequeathed by the artist's wife as a memorial to her husband, © the trustees of the Sidney Sime Memorial Gallery

Sime, Sidney Herbert 1867–1941, *Dark Trees and Blue Sky*, bequeathed by the artist's wife as a memorial to her husband, © the trustees of the Sidney Sime Memorial Gallery

Sime, Sidney Herbert 1867–1941, *Dark Trees and Floral Urn*, bequeathed by the artist's wife as a memorial to her husband, © the trustees of the Sidney Sime Memorial Gallery

Sime, Sidney Herbert 1867–1941, *Dark Trees and Light Sky*, bequeathed by the artist's wife as a memorial to her husband, © the trustees of the Sidney Sime Memorial Gallery

Sime, Sidney Herbert 1867–1941, *Dark Trees and Mist*, bequeathed by the artist's wife as a memorial to her husband, © the trustees of the Sidney Sime Memorial Gallery

Sime, Sidney Herbert 1867–1941, *Dark Trees and Sky*, bequeathed by the artist's wife as a memorial to her husband, © the trustees of the Sidney Sime Memorial Gallery

Sime, Sidney Herbert 1867–1941, *Dark Trees and Sky*, bequeathed by the artist's wife as a memorial to her husband, © the trustees of the Sidney Sime Memorial Gallery

Sime, Sidney Herbert 1867–1941, *Dark Trees and White Houses*, bequeathed by the artist's wife as a memorial to her husband, © the trustees of the Sidney Sime Memorial Gallery

Sime, Sidney Herbert 1867–1941, *Dark Trees and White-Tip Clouds*, bequeathed by the artist's wife as a memorial to her husband, © the trustees of the Sidney Sime Memorial Gallery

Sime, Sidney Herbert 1867–1941, *Figure of a Man with Book*, bequeathed by the artist's wife as a memorial to her husband, © the trustees of the Sidney Sime Memorial Gallery

Sime, Sidney Herbert 1867–1941, *Figure of a Woman*, bequeathed by the artist's wife as a memorial to her husband, © the trustees of the Sidney Sime Memorial Gallery

Sime, Sidney Herbert 1867–1941, *Figure of Lady in Grey*, bequeathed by the artist's wife as a memorial to her husband, © the trustees of the Sidney Sime Memorial Gallery

Sime, Sidney Herbert 1867–1941, *Figure of Lady in White*, bequeathed by the artist's wife as a memorial to her husband, © the trustees of the Sidney Sime Memorial Gallery

Sime, Sidney Herbert 1867–1941, *Fir Trees*, bequeathed by the artist's wife as a memorial to her husband, © the trustees of the Sidney Sime Memorial Gallery

Sime, Sidney Herbert 1867–1941, *Flower Painting*, bequeathed by the artist's wife as a memorial to her husband, © the trustees of the Sidney Sime Memorial Gallery

Sime, Sidney Herbert 1867–1941, *Flying Creatures*, bequeathed by the artist's wife as a memorial to her husband, © the trustees of the Sidney Sime Memorial Gallery

Sime, Sidney Herbert 1867–1941, *Forest and Lake*, bequeathed by the artist's wife as a memorial to her husband, © the trustees of the Sidney Sime Memorial Gallery

Sime, Sidney Herbert 1867–1941, *Hills*, bequeathed by the artist's wife as a memorial to her husband, © the trustees of the Sidney Sime Memorial Gallery

Sime, Sidney Herbert 1867–1941, *House by a Lake*, bequeathed by the artist's wife as a memorial to her husband, © the trustees of the Sidney Sime Memorial Gallery

Sime, Sidney Herbert 1867–1941, *Illustrative*, bequeathed by the artist's wife as a memorial to her husband, © the trustees of the Sidney Sime Memorial Gallery

Sime, Sidney Herbert 1867–1941, *Illustrative*, bequeathed by the artist's wife as a memorial to her husband, © the trustees of the Sidney Sime Memorial Gallery

Sime, Sidney Herbert 1867–1941, *Illustrative Design of Fountain and Figures*, bequeathed by the artist's wife as a memorial to her husband, © the trustees of the Sidney Sime Memorial Gallery

Sime, Sidney Herbert 1867–1941, *Imaginary*, bequeathed by the artist's wife as a memorial to her husband, © the trustees of the Sidney Sime Memorial Gallery

Sime, Sidney Herbert 1867–1941, *Lady*, bequeathed by the artist's wife as a memorial to her husband, © the trustees of the Sidney Sime Memorial Gallery

Sime, Sidney Herbert 1867–1941, *Lake, House and Trees*, bequeathed by the artist's wife as a memorial to her husband, © the trustees of the Sidney Sime Memorial Gallery

Sime, Sidney Herbert 1867–1941, *Landscape*, bequeathed by the artist's wife as a memorial to her husband, © the trustees of the Sidney Sime Memorial Gallery

Sime, Sidney Herbert 1867–1941, *Landscape and Dark Sky*, bequeathed by the artist's wife as a memorial to her husband, © the trustees of the Sidney Sime Memorial Gallery

Sime, Sidney Herbert 1867–1941, *Landscape and Patterned Sky*, bequeathed by the artist's wife as a memorial to her husband, © the trustees of the Sidney Sime Memorial Gallery

Sime, Sidney Herbert 1867–1941, *Landscape and Red Sky*, bequeathed by the artist's wife as a memorial to her husband, © the trustees of the Sidney Sime Memorial Gallery

Sime, Sidney Herbert 1867–1941, *Landscape and Sky*, bequeathed by the artist's wife as a memorial to her husband, © the trustees of the Sidney Sime Memorial Gallery

Sime, Sidney Herbert 1867–1941, *Landscape and Sky*, bequeathed by the artist's wife as a memorial to her husband, © the trustees of the Sidney Sime Memorial Gallery

Sime, Sidney Herbert 1867–1941, *Landscape and Sky*, bequeathed by the artist's wife as a memorial to her husband, © the trustees of the Sidney Sime Memorial Gallery

Sime, Sidney Herbert 1867–1941, *Landscape and Sunset*, bequeathed by the artist's wife as a memorial to her husband, © the trustees of the Sidney Sime Memorial Gallery

Sime, Sidney Herbert 1867–1941, *Landscape Decoration*, bequeathed by the artist's wife as a memorial to her husband, © the trustees of the Sidney Sime Memorial Gallery

Sime, Sidney Herbert 1867–1941, *Landscape Decoration*, bequeathed by the artist's wife as a memorial to her husband, © the trustees of the Sidney Sime Memorial Gallery

Sime, Sidney Herbert 1867–1941, *Landscape, Mountain and Lake*, bequeathed by the artist's wife as a memorial to her husband, © the trustees of the Sidney Sime Memorial Gallery

Sime, Sidney Herbert 1867–1941, *Landscape, Mountains*, bequeathed by the artist's wife as a memorial to her husband, © the trustees of the Sidney Sime Memorial Gallery

Sime, Sidney Herbert 1867–1941, *Landscape of Fields and Bay of Water*, bequeathed by the artist's wife as a memorial to her husband, © the trustees of the Sidney Sime Memorial Gallery

Sime, Sidney Herbert 1867–1941, *Landscape, Scottish Mountains*, bequeathed by the artist's wife as a memorial to her husband, ©

The Fountain, bequeathed by the artist's wife as a memorial to her husband, © the trustees of the Sidney Sime Memorial Gallery

Sime, Sidney Herbert 1867–1941, *The Waterfall*, bequeathed by the artist's wife as a memorial to her husband, © the trustees of the Sidney Sime Memorial Gallery

Sime, Sidney Herbert 1867–1941, *Tree and Billowing Sky*, bequeathed by the artist's wife as a memorial to her husband, © the trustees of the Sidney Sime Memorial Gallery

Sime, Sidney Herbert 1867–1941, *Tree and Heaped Clouds*, bequeathed by the artist's wife as a memorial to her husband, © the trustees of the Sidney Sime Memorial Gallery

Sime, Sidney Herbert 1867–1941, *Tree Reflections*, bequeathed by the artist's wife as a memorial to her husband, © the trustees of the Sidney Sime Memorial Gallery

Sime, Sidney Herbert 1867–1941, *Tree Reflections*, bequeathed by the artist's wife as a memorial to her husband, © the trustees of the Sidney Sime Memorial Gallery

Sime, Sidney Herbert 1867–1941, *Tree-Like Scrolls*, bequeathed by the artist's wife as a memorial to her husband, © the trustees of the Sidney Sime Memorial Gallery

Sime, Sidney Herbert 1867–1941, *Trees*, bequeathed by the artist's wife as a memorial to her husband, © the trustees of the Sidney Sime Memorial Gallery

Sime, Sidney Herbert 1867–1941, *Trees*, bequeathed by the artist's wife as a memorial to her husband, © the trustees of the Sidney Sime Memorial Gallery

Sime, Sidney Herbert 1867–1941, *Trees*, bequeathed by the artist's wife as a memorial to her husband, © the trustees of the Sidney Sime Memorial Gallery

Sime, Sidney Herbert 1867–1941, *Trees and Birds in Pool*, bequeathed by the artist's wife as a memorial to her husband, © the trustees of the Sidney Sime Memorial Gallery

Sime, Sidney Herbert 1867–1941, *Trees and Bracken*, bequeathed by the artist's wife as a memorial to her husband, © the trustees of the Sidney Sime Memorial Gallery

Sime, Sidney Herbert 1867–1941, *Trees and Calm Sky*, bequeathed by the artist's wife as a memorial to her husband, © the trustees of the Sidney Sime Memorial Gallery

Sime, Sidney Herbert 1867–1941, *Trees and Clouds*, bequeathed by the artist's wife as a memorial to her husband, © the trustees of the Sidney Sime Memorial Gallery

Sime, Sidney Herbert 1867–1941, *Trees and Dark Sky*, bequeathed by the artist's wife as a memorial to

her husband, © the trustees of the Sidney Sime Memorial Gallery

Sime, Sidney Herbert 1867–1941, *Trees and Dark Sky*, bequeathed by the artist's wife as a memorial to her husband, © the trustees of the Sidney Sime Memorial Gallery

Sime, Sidney Herbert 1867–1941, *Trees and Golden Sky*, bequeathed by the artist's wife as a memorial to her husband, © the trustees of the Sidney Sime Memorial Gallery

Sime, Sidney Herbert 1867–1941, *Trees and Imps*, bequeathed by the artist's wife as a memorial to her husband, © the trustees of the Sidney Sime Memorial Gallery

Sime, Sidney Herbert 1867–1941, *Trees and Light Clouds*, bequeathed by the artist's wife as a memorial to her husband, © the trustees of the Sidney Sime Memorial Gallery

Sime, Sidney Herbert 1867–1941, *Trees and Light Cloud*, bequeathed by the artist's wife as a memorial to her husband, © the trustees of the Sidney Sime Memorial Gallery

Sime, Sidney Herbert 1867–1941, *Trees and Light Sky*, bequeathed by the artist's wife as a memorial to her husband, © the trustees of the Sidney Sime Memorial Gallery

Sime, Sidney Herbert 1867–1941, *Trees and Light Sky*, bequeathed by the artist's wife as a memorial to her husband, © the trustees of the Sidney Sime Memorial Gallery

Sime, Sidney Herbert 1867–1941, *Trees and Light Sky*, bequeathed by the artist's wife as a memorial to her husband, © the trustees of the Sidney Sime Memorial Gallery

Sime, Sidney Herbert 1867–1941, *Trees and Pink Sky*, bequeathed by the artist's wife as a memorial to her husband, © the trustees of the Sidney Sime Memorial Gallery

Sime, Sidney Herbert 1867–1941, *Trees and Red-Tinged Hills*, bequeathed by the artist's wife as a memorial to her husband, © the trustees of the Sidney Sime Memorial Gallery

Sime, Sidney Herbert 1867–1941, *Trees and Red-Tinged Sky*, bequeathed by the artist's wife as a memorial to her husband, © the trustees of the Sidney Sime Memorial Gallery

Sime, Sidney Herbert 1867–1941, *Trees and Sky*, bequeathed by the artist's wife as a memorial to her husband, © the trustees of the Sidney Sime Memorial Gallery

Sime, Sidney Herbert 1867–1941, *Trees and Sky*, bequeathed by the artist's wife as a memorial to her husband, © the trustees of the Sidney Sime Memorial Gallery

Sime, Sidney Herbert 1867–1941, *Trees and Skyscape*, bequeathed by the artist's wife as a memorial to her husband, © the trustees of the Sidney Sime Memorial Gallery

Sime, Sidney Herbert 1867–1941, *Trees and Sun*, bequeathed by the artist's wife as a memorial to her husband, © the trustees of the

Sidney Sime Memorial Gallery

Sime, Sidney Herbert 1867–1941, *Trees and Sunset*, bequeathed by the artist's wife as a memorial to her husband, © the trustees of the Sidney Sime Memorial Gallery

Sime, Sidney Herbert 1867–1941, *Trees and Sunset*, bequeathed by the artist's wife as a memorial to her husband, © the trustees of the Sidney Sime Memorial Gallery

Sime, Sidney Herbert 1867–1941, *Trees and Sunset*, bequeathed by the artist's wife as a memorial to her husband, © the trustees of the Sidney Sime Memorial Gallery

Sime, Sidney Herbert 1867–1941, *Trees and Tinged Dark Sky*, bequeathed by the artist's wife as a memorial to her husband, © the trustees of the Sidney Sime Memorial Gallery

Sime, Sidney Herbert 1867–1941, *Trees and White Clouds*, bequeathed by the artist's wife as a memorial to her husband, © the trustees of the Sidney Sime Memorial Gallery

Sime, Sidney Herbert 1867–1941, *Trees and White Horse*, bequeathed by the artist's wife as a memorial to her husband, © the trustees of the Sidney Sime Memorial Gallery

Sime, Sidney Herbert 1867–1941, *Trees beside Pool*, bequeathed by the artist's wife as a memorial to her husband, © the trustees of the Sidney Sime Memorial Gallery

Sime, Sidney Herbert 1867–1941, *Trees, House and Red Sky*, bequeathed by the artist's wife as a memorial to her husband, © the trustees of the Sidney Sime Memorial Gallery

Sime, Sidney Herbert 1867–1941, *Turbulent Sea and Ship with Red Sails*, bequeathed by the artist's wife as a memorial to her husband, © the trustees of the Sidney Sime Memorial Gallery

Sime, Sidney Herbert 1867–1941, *Two Figures by Lake*, bequeathed by the artist's wife as a memorial to her husband, © the trustees of the Sidney Sime Memorial Gallery

Sime, Sidney Herbert 1867–1941, *Waterfall*, bequeathed by the artist's wife as a memorial to her husband, © the trustees of the Sidney Sime Memorial Gallery

Sime, Sidney Herbert 1867–1941, *Waterfall in Scotland*, bequeathed by the artist's wife as a memorial to her husband, © the trustees of the Sidney Sime Memorial Gallery

Sime, Sidney Herbert 1867–1941, *Waves*, bequeathed by the artist's wife as a memorial to her husband, © the trustees of the Sidney Sime Memorial Gallery

Sime, Sidney Herbert 1867–1941, *Waves Breaking*, bequeathed by the artist's wife as a memorial to her husband, © the trustees of the Sidney Sime Memorial Gallery

Sime, Sidney Herbert 1867–1941, *Waves Breaking on Rocks*, bequeathed by the artist's wife

as a memorial to her husband, © the trustees of the Sidney Sime Memorial Gallery

Sime, Sidney Herbert 1867–1941, *White and Grey Clouds*, bequeathed by the artist's wife as a memorial to her husband, © the trustees of the Sidney Sime Memorial Gallery

Sime, Sidney Herbert 1867–1941, *White-Trunked Trees*, bequeathed by the artist's wife as a memorial to her husband, © the trustees of the Sidney Sime Memorial Gallery

Sime, Sidney Herbert 1867–1941, *Wild Landscape*, bequeathed by the artist's wife as a memorial to her husband, © the trustees of the Sidney Sime Memorial Gallery

Sime, Sidney Herbert 1867–1941, *Windswept Landscape*, bequeathed by the artist's wife as a memorial to her husband, © the trustees of the Sidney Sime Memorial Gallery

Sime, Sidney Herbert 1867–1941, *Windswept Sky*, bequeathed by the artist's wife as a memorial to her husband, © the trustees of the Sidney Sime Memorial Gallery

Sime, Sidney Herbert 1867–1941, *Windswept Trees*, bequeathed by the artist's wife as a memorial to her husband, © the trustees of the Sidney Sime Memorial Gallery

Sime, Sidney Herbert 1867–1941, *Woods and Dark Animals*, bequeathed by the artist's wife as a memorial to her husband, © the trustees of the Sidney Sime Memorial Gallery

Sime, Sidney Herbert 1867–1941, *Yellow Bushes by a Pond*, bequeathed by the artist's wife as a memorial to her husband, © the trustees of the Sidney Sime Memorial Gallery

251

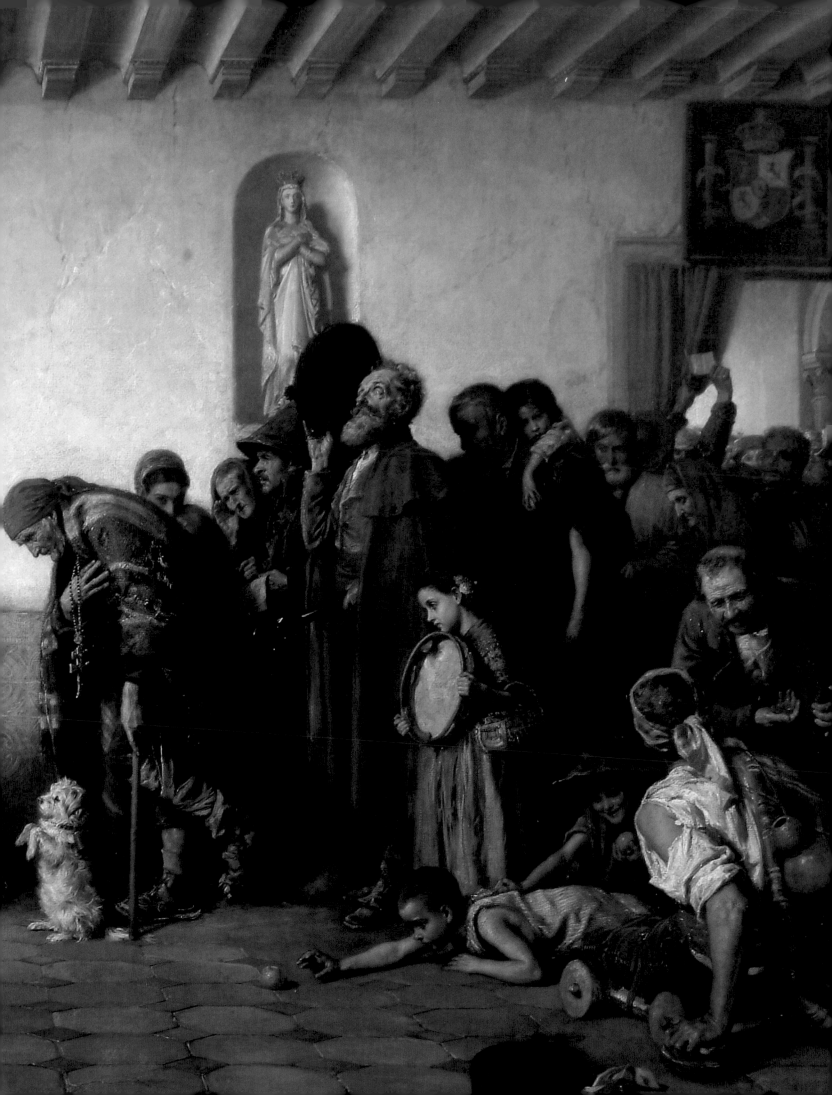

Collection Addresses

Ash

Ash Museum
Cemetery Chapel, Ash Church Road GU12 6LX
Telephone 01252 542341

Ash Vale

The Army Medical Services Museum
Keogh Barracks, Ash Vale GU12 5RQ
Telephone 01252 868612

Byfleet

Byfleet Heritage Society
Byfleet Library, High Road, Byfleet KT14 7QN
Telephone 01932 351559

Byfleet Village Hall
54 High Road, Byfleet KT14 7QL
Telephone 01932 336236

Camberley

Surrey Heath Borough Council
Surrey Heath House, Knoll Road, Camberley GU15 3HD
Telephone 01276 707100

Surrey Heath Museum
Surrey Heath House, Knoll Road, Camberley GU15 3HD
Telephone 01276 707284

The Royal Logistic Corps Museum
Princess Royal Barracks, Deepcut, Camberley GU16 6RW
Telephone 01252 833371

Caterham

Caterham Valley Library
Stafford Road, Caterham CR3 6JG
Telephone 01883 343580

East Surrey Museum
1 Stafford Road, Caterham CR3 6JG
Telephone 01883 340275

Chertsey

Chertsey Museum
The Cedars, 33 Windsor Street, Chertsey KT16 8AT
Telephone 01932 565764

Dorking

Dorking and District Museum
The Old Foundry, 62 West Street, Dorking RH4 1BS
Telephone 01306 876591

Mole Valley District Council
Pippbrook, Dorking RH4 1SL
Telephone 01306 882948

Egham

Egham Museum
Literary Institute, High Street, Egham GU25 4AN
Telephone 01784 434483

Royal Holloway, University of London
Egham Hill, Egham TW20 0EX
Telephone 01784 443664

Epsom

Epsom & Ewell Borough Council
The Town Hall, The Parade, Surrey KT18 5BY
Telephone 01372 732100

Esher

Esher Library
Old Church Path, Esher KT10 9NS
Telephone 01372 465036

Ewell

Bourne Hall Museum
Spring Street, Ewell KT17 1UF
Telephone 0208 394 1734

Ewell Court Library
Ewell Court House, Lakehurst Road, Ewell KT19 0EB
Telephone 0208 393 1069

Facing page: Burgess, John Bagnold, 1830–1897, *Licensing the Beggars in Spain* (detail), 1877, Royal Holloway, University of London, (p. 40)

Farnham

Crafts Study Centre, University College
for the Creative Arts
Falkner Road, Farnham GU9 7DS
Telephone 01252 891450

Farnham Maltings Association Limited
Bridge Square, Farnham GU9 7QR
Telephone 01252 718001

Museum of Farnham
Willmer House, 38 West Street, Farnham GU9 7DX
Telephone 01252 715094

University College for the Creative Arts
at the Farnham Campus
Falkner Road, Farnham GU9 7DS
Telephone 01252 892668

Godalming

Godalming Library
Bridge Street, Godalming GU7 1HT
Telephone 01483 422743

Godalming Museum
109a High Street, Godalming GU7 1AQ
Telephone 01483 426510

Godalming Town Council
Municipal Buildings, Bridge Street, Godalming GU7 1HR
Telephone 01483 523074

Waverley Borough Council
The Berrys, Council Offices, Godalming GU7 1HR
Telephone 01483 523000

Godstone

The White Hart Barn, Godstone Village Hall
High Street, Godstone RH9 8DT
Telephone 01883 742224

Guildford

Guildford House Gallery
155 High Street, Guildford GU1 3AJ
Telephone 01483 444741

Guildford Museum
Castle Arch, Quarry Street, Guildford GU1 3SX
Telephone 01483 444865

Queen's Royal Surrey Regimental Museum
Clandon Park, West Clandon, Guildford GU4 7RQ
Telephone 01483 223419

Surrey Archaeological Society
Castle Arch, Quarry Street, Guildford GU1 3SX
Telephone 01483 532454

The Guildford Institute of the University of Surrey
Ward Street, Guildford GU1 4LH
Telephone 01483 562142

The Guildhall
High Street, Guildford GU1 3AA
Telephone 01483 444035

University of Surrey
Guildford GU2 7XH
Telephone 01483 689167

Watts Gallery
Down Lane, Compton, Near Guildford GU3 1DQ
Telephone 01483 810235

Watts Mortuary Chapel
Down Lane, Compton, Near Guildford GU3 1DN
Telephone 01483 810684

Yvonne Arnaud Theatre
Millbrook, Guildford GU1 3UX
Telephone 01483 440077

Haslemere

Haslemere Educational Museum
78 High Street, Haslemere GU27 2LA
Telephone 01428 642112

Kingston-Upon-Thames

Surrey County Council
County Hall, Penrhyn Road, Kingston-Upon-Thames
KT1 2DW
Telephone 0208 541 9098

Leatherhead

Leatherhead and District Local History Society
Hampton Cottage, 64 Church Street,
Leatherhead KT22 8DP
Telephone 01372 386348

Lingfield

The Guest House, Lingfield Library
Vicarage Road, Lingfield RH7 6HA
Telephone 01342 832058

Oxted

Oxted Library
12 Gresham Road, Oxted RH8 0BQ
Telephone 01883 714225

Tandridge District Council
Station Road East, Oxted RH8 0BT
Telephone 01883 732973

Redhill

East Surrey Hospital
Canada Avenue, Redhill RH1 5RH
Telephone 01737 231719

Reigate

Holmsdale Natural History Club
14 Croydon Road, Reigate RH2 0PG
Telephone 01737 767411

Reigate & Banstead Borough Council
Town Hall, Castlefield Road, Reigate RH2 0SH
Telephone 01737 276000

Reigate Priory Museum
Reigate Priory, Bell Street, Reigate RH2 7RL
Telephone 01737 222550

Ripley

Send and Ripley Museum
Village Hall Car Park, Portsmouth Road GU23 6AF
Telephone 01483 725517

Staines

Spelthorne Borough Council
Council Offices, Knowle Green, Staines TW18 1XB
Telephone 01784 446433

Spelthorne Museum
1 Elmsleigh Road, Staines TW18 4PN
Telephone 01784 457970

Sunbury-on-Thames

Sunbury Library
The Parade, Staines Road West,
Sunbury-on-Thames TW16 7AB
Telephone 01932 783131

Thames Ditton

Dittons Library
Mercer Close, Thames Ditton KT7 0BS
Telephone 0208 398 2521

Warlingham

Warlingham Library, Lockton Collection
Shelton Avenue, Warlingham CR6 9NF
Telephone 01883 622479

West Molesey

Molesey Library
The Forum, Walton Road, West Molesey KT8 2HZ
Telephone 0208 979 6348

Weybridge

Brooklands Museum
Brooklands Road, Weybridge KT13 0QN
Telephone 01932 857381

Elmbridge Museum
Public Library, Church Street, Weybridge KT13 8HJ
Telephone 01932 843573

Woking

Surrey History Centre
130 Goldsworth Road, Woking GU21 6ND
Telephone 01483 518760

Worplesdon

Sidney H. Sime Memorial Gallery
Worplesdon Memorial Hall, Perry Hill,
Worplesdon GU3 3RF
Telephone 01483 232117

Index of Artists

In this catalogue, artists' names and the spelling of their names follow the preferred presentation of the name in the Getty Union List of Artist Names (ULAN) as of February 2004, if the artist is listed in ULAN.

The page numbers next to each artist's name below direct readers to paintings that are by the artist; are attributed to the artist; or, in a few cases, are more loosely related to the artist being, for example, 'after', 'the circle of' or copies of a painting by the artist. The precise relationship between the artist and the painting is listed in the catalogue.

Supporters of the Public Catalogue Foundation

Master Patrons

The Public Catalogue Foundation is greatly indebted to the following Master Patrons who have helped it in the past or are currently working with it to raise funds for the publication of their county catalogues. All of them have given freely of their time and have made an enormous contribution to the work of the Foundation.

Peter Andreae, High Sheriff for Hampshire (*Hampshire*)

Sir Nicholas Bacon, DL, High Sheriff for Norfolk (*Norfolk*)

Peter Bretherton (*West Yorkshire: Leeds*)

Richard Compton (*North Yorkshire*)

George Courtauld, Vice Lord Lieutenant for Essex (*Essex*)

The Marquess of Downshire (*North Yorkshire*)

Patricia Grayburn, MBE DL (*Surrey*)

Tommy Jowitt (*West Yorkshire*)

Sir Michael Lickiss (*Cornwall*)

Lord Marlesford, DL (*Suffolk*)

Phyllida Stewart-Roberts, OBE, Lord Lieutenant for East Sussex (*East Sussex*)

Leslie Weller, DL (*West Sussex*)

Financial Support

The Public Catalogue Foundation is particularly grateful to the following organisations and individuals who have given it generous financial support since the project started in 2003.

National Sponsor

Christie's

Benefactors (£10,000–£50,000)

Bradford City Council
The Bulldog Trust
A. & S. Burton 1960 Charitable Trust
The John S. Cohen Foundation
Christie's
Deborah Loeb Brice Foundation
The Foyle Foundation
Hampshire County Council
Peter Harrison Foundation
Hiscox plc
ICAP plc
Kent County Council
The Linbury Trust

The Manifold Trust
Robert Warren Miller
The Monument Trust
Miles Morland
Stavros S. Niarchos Foundation
Norfolk County Council
Provident Financial
RAB Capital
Renaissance West Midlands
Saga Group Ltd
University College, London
University of Leeds
Garfield Weston Foundation

Series Patrons (Minimum donation of £2,500)

Harry Bott
Janey Buchan
Dr Peter Cannon-Brookes
Paul & Kathrine Haworth
Neil Honebon
The Keatley Trust

David & Amanda Leathers
Miles Morland
Stuart M. Southall
University of Surrey
Peter Wolton Charitable Trust